INFOWHELM

LITERATURE NOW

Matthew Hart, David James, and Rebecca L. Walkowitz, Series Editors

Literature Now offers a distinct vision of late-twentieth- and early-twenty-first-century
literary culture. Addressing contemporary literature and the ways we understand its meaning,
the series includes books that are comparative and transnational in scope as well
as those that focus on national and regional literary cultures.

Infowhelm

ENVIRONMENTAL ART AND LITERATURE
IN AN AGE OF DATA

Heather Houser

Columbia University Press
New York

Columbia University Press
Publishers Since 1893
New York Chichester, West Sussex
cup.columbia.edu
Copyright © 2020 Columbia University Press
All rights reserved

Library of Congress Cataloging-in-Publication Data
Names: Houser, Heather, author.
Title: Infowhelm : environmental art and literature in an age of data / Heather Houser.
Description: New York : Columbia University Press, 2020. | Series: Literature now |
Includes bibliographical references and index.
Identifiers: LCCN 2019052362 | ISBN 9780231187329 (cloth) |
ISBN 9780231187336 (paperback) | ISBN 9780231547208 (ebook)
Subjects: LCSH: Environmentalism in art. | Environmentalism in literature. |
Arts, Modern—Themes, motives. | Global environmental change. |
Information behavior. | Science and the arts.
Classification: LCC NX650.E58 H68 2020 | DDC 704.9/4933372—dc23
LC record available at https://lccn.loc.gov/2019052362

Columbia University Press books are printed on permanent and durable acid-free paper.

Printed in the United States of America

Cover design: Noah Arlow
Cover image: Mary Iverson, *Everglades National Park with Containers* (2017).

In loving memory of Anne Louise Maas (1918–2017)

CONTENTS

INFOWHELM

INTRODUCTION
Environmental Art in the Infowhelm

In the scenes of its childhood, *information* had to do, it seems, with the active shaping of the world and with the conferral of form on matter.

—JOHN DURHAM PETERS (1988)

Infowhelm: Environmental Art and Literature in an Age of Data gazes on scenes in which information makes worlds and gives form. Such capacities, I will argue, endure beyond information's "childhood" as John Durham Peters defines it and into a twenty-first century defined by environmental disruption and *infowhelm*, a term that captures the abundance and ready availability of information as well as its contestation.[1] I prefer *infowhelm* to alternatives because it evokes emotional inundation without specifying the content of the emotion.[2] In 1988 media theorist Peters gives information a history that it lacked when it became a buzzword thanks to computational technologies like personal computers. Over thirty years later, histories of information are plentiful as media and social critics grapple with the fact that mobile technology users increasingly see ourselves in, through, and even *as* data. Less common are accounts of how information confers form on creative works. This book offers such an account with attention to visual and literary culture that depicts unfolding environmental degradation. I consider a specific kind of *information*—scientific data about climate change, land use, and species threat, and the methods used to attain it—and how it becomes constitutive of creative works largely produced in the 2000s.[3] Detailing the uptake of scientific information in environmental art—from poetry, novels, and memoir to data visualization, painting, and photography—is a way of identifying how new ways of thinking become

possible when art speaks back to forms of epistemological mastery. I take this as a pressing task that follows from Donna Haraway's demand that "we must find another relationship to nature besides reification, possession, appropriation, and nostalgia" because, without new ways of thinking, new relations are impossible.[4]

Focusing on information might seem to lead us deeper into the reification and appropriation Haraway decries because the term has entrenched associations with rationalist forms of environmental management and technological boosterism. My contention is that the opposite can be the case when information becomes central to environmental cultural production. I argue that recent environmental art incorporates scientific information in order to understand positivist epistemologies that have dominated environmental understanding and decision making in the Eurowest, and to integrate positivism with ways of knowing rooted in the body and emotion and in states of ambiguity, speculation, self-reflexivity, and even unknowing, thus producing *entangled epistemologies*. Artists entangle epistemologies by turning scientific information into a representational device in its own right. That is, information becomes a distinct aesthetic element and a space of interpretive activity that diagnoses infowhelm—and, in some cases, even reproduces it—and experiments with ways of managing it. Understood in this way, information in environmental art calls for entangled methodologies, especially close reading of form, genre, and medium that adds dimension to theories of the social and technoscientific sources for environmental crises.

Paul Schrader's film *First Reformed* (2017) provides an illuminating case of how infowhelm enters narrative and mise-en-scène and how epistemologies entangle when art becomes a crucible for environmental knowledge production. With its lauded cast and director, *First Reformed* has been heralded as one of the most poignant narrative films to tackle climate crisis to date. The film situates the psychological impacts of climate in a context of religious faith and doubt that audiences rarely find in mainstream climate fiction. What are shots of climate visualizations doing in a feature film starring the likes of Ethan Hawke, Amanda Seyfried, and Cedric the Entertainer? These visualizations appear in the scene that brings Ernst Toller (Hawke), the pastor of a small church in rural New York, to the precipice of climate terrorism. The pastor goes to the home of Mary (Seyfried) and Michael Mansana (Philip Ettinger) to speak with Michael about his

deepening despondency. The twelve-minute conversation awakens Toller to the destruction humans have wrought on the planet. "Can God forgive us for what we've done to this world?" Michael queries.[5] At this point, Toller is evasive and responds, "Who can know the mind of God," but Michael's question rings in his mind in the nights and days following. The film explains what "we've done to this world" through Michael's recitation of statistics on climate collapse: "The earth's temperature will be 3°C higher. Four is the threshold. You know? 'Severe, widespread, and irreversible impacts.' . . . By 2050, sea levels two feet higher on the East Coast. Low-lying areas underwater across the world. Bangladesh, twenty percent loss of land-mass. Central Africa, fifty percent reduction in crops due to drought. The Western reservoirs dried up. Climate change refugees. Epidemics. Extreme weather." As chapter 2 of *Infowhelm* will show, delivering a barrage of data via conversations between the more and the less informed is a common fea-ture of contemporary narratives of climate crisis, as is embedding data visualizations. Schrader adopts both approaches through the combination of dialogue and mise-en-scène. As Toller and Michael speak, a line graph that resembles Michael Mann's famous "hockey stick graph" comes into view on the wall over Michael's left shoulder. Simultaneously, a laptop on the desk behind his right shoulder displays an animated visualization of a global map changing color from white and pale blues and yellows to orange and vermillion as the years 1960 to 2030 tick away. The graph remains out of focus, but, when Michael stands up, the animation comes into focus to show the animation's title: "Global Warming Heat Map."[6] Though Michael never explains these visualizations for Toller, the audience assumes the visu-alization shows the climb to that 4°C threshold to which Michael refers and roughly corresponds to the mounting line on the paper graph. Both animation and graph are visual complements to the conversation but do not enter into it as direct evidence.

What interests me about this and similar moments of infowhelm in art is how they constitute both the film's aesthetic fabric—the mise-en-scène—and its propositions about how individuals come to environmental knowl-edge. The conversation between Michael and Toller is a hinge in the plot; instead of the pastor successfully appealing to faith to relieve his con-gregant's climate depression, the congregant converts the pastor to climate concern and eventually radicalism. The visualizations are implicated in Toller's conversion—and, one assumes, Michael's before him—in that

they contain representational strategies that, while subtle when appearing in an academic journal, help incite the fervent emotions that thread through the men's conversation, emotions of existential hopelessness, religious doubt, and responsibility for future generations. These representational strategies, which I examine in climate model visualizations in chapter 1, include an aerial map of the globe, a color palette that runs from innocuous whites and pastel blues to dire oranges and reds, and complex time signatures that point backward and forward. As that chapter demonstrates, these strategies make data experiential and position viewers between states of mastery and humility, control and failure. In this respect, the climate visualizations amplify Toller's point that "wisdom is holding two contradictory truths in our mind, simultaneously." Temporal complexity helps produce this epistemological and emotional complexity in the scene. As the visualization runs from 1960 to 2030, a slew of date markers fills the conversation. Michael asks Toller's age and reports his own; he informs the pastor that his wife is twenty weeks along in her pregnancy and that the child will be thirty-three years old come 2050, two years older than his current age of thirty-one. This numerical data leads into Michael's question, "Hey, you know what the world will be like in 2050?," and the barrage of data from climate scenarios quoted earlier. Where they fall within the overlaid temporalities in this scene—the mounting years in the animated visualization, the predictions tied to individuals' ages, the threshold points for action—influences how characters inhabit the coexisting "contradictory truths" of hope and despair.

The visualizations, which seem to be devices for conveying physical facts of climate change, also convey how climate data participates in religious debates, generate contradictory emotions, and possibly even drive someone to environmental martyrdom.[7] *First Reformed* makes a strong case for how climate data travels beyond its origins in academic research and makes radical ways of thinking, feeling, and acting possible. The chapters of *Infowhelm* elaborate on the strategies of juxtaposition, contradiction, and temporal layering, among others, that surface in Schrader's scene. As this book establishes, art plays out how scientific information entangles with social positions, complex emotions, and embodied realities. By weaving climate information into the mise-en-scène, *First Reformed* does not only relay climate data in service of a deficit model of climate communication, which holds that the public's lack of information and comprehension is the

primary obstacle to environmental action. More important, it stages how people arrive at climate knowledge and how ways of knowing yield ways of being.

First Reformed plays out answers to a question that appears in my first book, *Ecosickness in Contemporary U.S. Fiction: Environment and Affect* (2014), and that inspires the current one. *Ecosickness* detailed noncausal, narrative, and affective frameworks for understanding "ecosickness," that is, the interdependence of environmental decline and bodily dysfunction.[8] I concluded that study with the question, how does environmental information *feel* when it appears in day-to-day life? For example, when talking to a coworker or family member about recent droughts, hurricanes, or wildfires; when opening a news app on a smartphone; when watching a movie or reading a book of poems. I wondered how data instigated emotion. *Infowhelm* emerges from this query and from *Ecosickness*'s claims that adherence to positivist epistemologies around sickness can affect environmental awareness and action in surprising ways. *Infowhelm* revisits this interest by studying how artists incorporate scientific information into the form of their works to address both the necessity of and the limits to *positivist epistemology* under conditions of environmental devastation and infowhelm. Positivist epistemology is often esteemed as the ideal of Eurowestern natural sciences. It holds that legitimate knowledge of real-world phenomena is based in logic, observability, objectivity, and universality and is verifiable, preferably through quantitative measures. It is one of the "epistemologies of mastery" that thinkers in indigenous studies and feminist science studies have eroded by detailing the affordances of ways of knowing based in speculation, multigenerational experience, social relations, metaphor and story, and the sensing and feeling body.[9]

Readers might assume this book and the art it examines roundly denounce positivism for being linked to that trio of actions Haraway condemns: "reification, possession, appropriation." And this might seem unwise at a historical moment when there are powerful partisan efforts to undermine and even destroy scientific knowledge, specifically about pollution and climate change.[10] However, I want to underscore the *necessity of* as well as the *limits to* positivism for environmental understanding today. All the artists and activists I consider here are indebted to positivist approaches to measuring, analyzing, and representing nature, whether they be methods of entomological data collection in Barbara Kingsolver's *Flight Behavior*

(chapter 2), acts of standardization in Bryan James's *In Pieces* (chapter 4), or satellite-eye descriptions of ruined landscapes in Claire Vaye Watkins's *Gold Fame Citrus* (chapter 6). These approaches are invaluable to adjudicating truth claims about the crises of climate change, extinction, and land degradation, and they organize the book's three parts. Each of these parts—on climate data processing through culture, the new natural history, and aerial imaging—begins with a preface that uses the speakers of Juliana Spahr's poems in *well then there now* (2011) as guides to the major concepts and historical shifts germane to the readings to come.

Positivist traditions of knowledge production also organize *Infowhelm* because they have helped instrumentalize and dominate nature and have suppressed and supplanted bodies of knowledge cultivated by storytellers, women, indigenous peoples, and long-term inhabitants of places. Given the history of positivism's epistemological dominance, environmental artists must often acknowledge their potential complicity in this paradigm of knowledge making when they repurpose scientific information. They do so by incorporating information in ways that foreground the history of the positivist paradigm and the technologies and media affiliated with it. Yet they also remake these histories, technologies, and media to produce what feminist philosopher Lorraine Code calls "successor epistemologies."[11] For *Infowhelm* artists, scientific data and methods become the raw material for thinking about how knowledge is made: through bodies, communities, institutions, technologies, media, and the entanglements they produce. This is not an attempt "to model a reality in which environmental action takes place *outside* of knowledge," as Nicole Seymour writes, but to propose there is no "outside of knowledge" when what counts as knowledge expands beyond the parameters set by Eurowestern positivism.[12]

In addition to offering accounts of "*how we know what we know*" about the environment,[13] focusing on information in the arts provides a way to change the subject within ecocriticism, the field dedicated to cultural analysis of environmental representation. This study will also veer away from the potential dead-end of casting success-fail verdicts on particular cultural works.[14] Addressing the question of whether a text "gets it right" on an issue of environmental representation—whether it be scale, the temporality of the Anthropocene, or the dominance of the fossil fuel economy—is undoubtedly valuable. That approach, however, can minimize the combined aesthetic and epistemological importance of the environmental arts. Whether

a text succeeds or fails according to specific metrics, it models modes of thought that clarify the ways knowledge about the environment has been made and might be made otherwise through artistic means. *Infowhelm* understands these creative works as complex inscriptions of knowledge and ways of knowing in contexts where the fate of environmental knowledge is insecure.[15] What's more, knowledge making is inextricable from the artistic mediations of scientific information; environmental understanding does not emerge from a vacuum of quantification but out of a cauldron mixing information, imagination, speculation, feeling, and even unknowing.

To detail how aesthetic strategies produce these entangled epistemologies, I lay more bricks on the path toward diversifying the archive for ecocriticism.[16] Data visualizations are both an obvious type of media to study given my inquiries and one in need of more attention from those trained in cultural analysis. When this book idea was first percolating in 2014, few such studies existed. That scene is morphing thanks to the work of Lev Manovich and Johanna Drucker.[17] Drucker's *Graphesis: Visual Forms of Knowledge Production* (2014) encourages cultural scholars to "fin[d] critical languages for the graphics that predominate in the networked environment: information graphics, interface, and other schematic formats, specifically in relation to humanistic problems of interpretation."[18] Finding these languages is urgent not only because of the proliferation of such objects but also because even humanists have "seem[ed] ready and eager to suspend critical judgment in a rush to visualization" rather than bringing to this media type our attunement to "the *interpretative* nature of knowledge, that the *display* itself is conceived to *embody qualitative* expressions and that the *information* is understood as *graphically constituted*."[19] When visualizations are analyzed at all, the modes of analysis applied to them are insufficient for explaining how aesthetic form produces knowledge, a key aim of *Infowhelm*. Given Drucker's points and the fact that all manner of visualizations—satellite maps of wildfires, time lapses of global temperature rise, charts of carbon dioxide emissions, infographics urging "green" consumerism—are ubiquitous today, "the study of the visual production of knowledge,"[20] or "graphesis," must find a home in the environmental humanities, and visual culture must encompass more than the film and photography that have been the focus of most ecocritical studies.[21]

Investigating visualizations, however, also leads me back to more familiar creative works because scientific information and visualization are

interlopers in other media, for example, a poem by Juliana Spahr, a novel by Michael Crichton, a memorial by Maya Lin. These works, which appear in the coming pages, dissolve the idea that visualizations are transparent data delivery systems. Resulting from the research journey that began at the conclusion of *Ecosickness*, this book combines literary and visual culture analysis with a focus on how environmental art repurposes scientific information to surprising epistemological ends. And because methods of scientific inquiry travel with data when they appear in art, I use *scientific information* throughout this book to capture the aesthetic integration of quantitative measures as well as explanations and methods native to the sciences. For example, when Bryan James, a visualization designer featured in chapter 4, depicts species threat in his digital project *In Pieces* (2015), he not only integrates the statistics of biodiversity loss but also employs methods of classical natural history and modern biodiversity science such as selection, abstraction, and fragmentation to visualize threatened species. The quantitative data of species loss motivates *In Pieces* and is a crucial element of its content, but the form of the project also could not exist without methods of scientific inquiry and display.

My distinctions between *data* and *information* will not be as sharp as those found in cybernetics and communications theory.[22] I use *information* as an umbrella term that captures *data*, which I take to be quantitative measurements that are available for classification, comparison, and transformation through computation.[23] *Information* in my definition also includes scientific explanations and methods. Taken this way, *scientific information* encompasses the ways of collecting and analyzing data, of presenting that analysis to audiences, and of developing explanations based on that analysis. Studying information as raw material for art contributes to the vision of "data as media" that digital humanities scholars Lauren Klein and Miriam Posner promote.[24] While digital humanists have taken data and computational tools in hand as instruments for cultural interpretation and science studies, and scholars have analyzed the sociocultural factors shaping the queries, data, and tools employed in the technosciences, few studies take scientific information as a representational mode with epistemological effects crucial to contemporary life.[25]

For the sake of clarity, my use of *science* and *scientific* accords with Lisa Parks's and Barbara Herrnstein Smith's definitions of "a discourse of . . . rationalism that is associated with the intellectual project of the

Enlightenment" and that strives to produce facts corresponding "to the autonomously determinate features of an external reality."[26] *Technoscience* underscores that technology is the inexorable companion of science, always but especially in the United States during and after World War II. This is not to say that practices of observing, measuring, calculating, archiving, and developing accounts about the material world do not appear in other traditions of thought. To take just one example, though cartography has undoubtedly been a tool and output of Eurowestern science as defined above, its functions exceed those bounds. In addition to producing knowledge through indigenous and other epistemologies, maps can be used to combat Enlightenment knowledge practices.[27] Indeed, far from reinforcing the idea that science "owns" knowledge about the material world, the project of this book is to show how environmental art is a crucible for producing knowledge of that world that is reducible neither to positivism nor to epistemologies rooted in speculation, emotion, embodiment, or unknowing.

This central insight of *Infowhelm* extends teachings from feminist science studies and indigenous epistemology. Thinkers in these fields describe and envision ways of knowing that break out of epistemologies of mastery and inspire my approach to art's potential to produce environmental knowledge. I share David Turnbull's conviction that "much can be learned about the production of scientific and technological knowledge from a consideration of the differing ways in which its heterogeneous components are assembled. Knowledge is in effect a 'motley.'"[28] I also share Kyle Powys Whyte's conviction that indigenous knowledges are invaluable for "negotiat[ing] today's environmental issues; . . . [and are] a significant strategy for achieving successful adaptation planning." Whyte specifies the activities that constitute these knowledges: "systems of monitoring, recording, communicating, and learning about the relationships among humans, nonhuman plants and animals, and ecosystems that are required for any society to survive and flourish in particular ecosystems."[29] From this list, we can identify overlapping techniques for producing indigenous knowledges and for producing Eurowestern science as well as potential points of friction; I pursue these overlaps and frictions most directly in chapter 2. Finally, theories of situatedness from Haraway and of "negative knowledge" thread through my analysis. For Haraway, *situatedness* points to two conditions: knowing from "somewhere in particular" rather than from a

universalizing nowhere, and knowing the sites of knowledge, that is, calling them to account for their origins and implications.[30] Calling the sites of knowledge production to account is of a piece with Karin Knorr Cetina's "negative knowledge," a concept that also reverberates through kindred feminist investigations of scientific epistemologies, notably from Herrnstein Smith, Helen Longino, and Londa Schiebinger.[31] Negative knowledge is "not nonknowledge, but knowledge of the limits of knowing, of the mistakes we make in trying to know, of the things that interfere with our knowing, of what we are not interested in and do not really want to know."[32]

These teachings from feminist and indigenous epistemology speak back to mastery, as a directive, as a practice, and as a value that inflects scientific pursuits and, crucially for my inquiry, generates the environmental degradation to which artists respond. *Mastery* is a recurrent motif in environmental art that uses scientific information to displace epistemologies that have led to domination and/or neglect. Scenes in which the presumed mastery of scientific positivism comes under scrutiny abound in the archive of *Infowhelm*: When the tortoise narrator of Verlyn Klinkenborg's novel *Timothy; or, Notes of an Abject Reptile* (2006) questions humans' fitness to classify and name creatures like him (chapter 3). When environmental watchdogs SkyTruth produce countermedia using satellite imagery of offshore oil spills and reflect on the media specificity of satellite technologies (chapter 5). When science writer Charles Wohlforth juxtaposes computational models of climate change in the Arctic with Iñupiat practices of experiencing and assessing change through traditional whale hunting (chapter 2). These scenes all raise the question of whether Eurowestern technoscience should be accorded intellectual authority over more-than-human nature, its deterioration, and its recovery. Raising this question—which, I underscore, does not necessarily lead to the rejection of technoscience—places these cultural works among the theories of mastery.

"Ethical self-mastery, political mastery over unruly and aberrant Others, and epistemic mastery over the 'external' world pose as the still-attainable goals of the Enlightenment legacy," writes Lorraine Code.[33] And what is wrong with this? Code's word choice provides some hints, but she puts a finer point on what is clearly a repudiation of masterful postures and interventions: "the rhetoric of mastery and possession" consists of "knowledge acquired for manipulation, prediction, and control over nature and human nature; knowledge as a prized commodity legitimating its

possessors' authoritative occupancy . . . of positions of power and recasting 'the natural world' as a resource for human gratification."[34] Code encapsulates the problems with mastery that we find in fellow feminist thinkers Carolyn Merchant and Val Plumwood, and in Michel Foucault, Bruno Latour, and James Scott, among others.[35] Because mastery points to a host of relations to the self, to human others, and to more-than-human others, delineating its contours is a first step to making other modes of environmental thought possible for contemporary artists.[36] When we recognize mastery as a disposition that characterizes environmental relations of all sorts—whether the taxonomic methods of a naturalist, the extractivist agenda of a timber company, or the wilderness individualism of an adventurer like Edward Abbey—then we can start to identify how that disposition derives from centuries of scientific thought and remains nested in even well-intentioned efforts at climate mitigation or disaster recovery. The artists *Infowhelm* studies show the enduring legacies of this disposition as they imagine ways out of informational mastery and situate information in its entanglements with emotions such as the radicalized despair of *First Reformed* or the multifaceted loss of Maya Lin's online memorial (chapter 4).

A key claim of this book is that epistemology is all around us; environmental artists make this palpable but without privileging one epistemological mode. Knowledge of climate disturbance, species threat, and land use change is not only in the hands of the self-proclaimed masters. Modes of knowledge production abound if we cast our eyes beyond the lab and the field and, when in those spaces, account for the unexpected actors residing therein. When literary scholar Mary Poovey tells the "history of the modern fact," she states how cultural works enact epistemology: "modes of representation inform what we can know, and . . . modes of representation embody or articulate available ways of organizing and making sense of the world." What's needed are finely honed "tools to investigate the conditions that make knowledge possible."[37] Environmental art is one of these tools, as is the combined aesthetic-epistemological analysis that *Infowhelm* performs.

To detail how environmental culture takes up scientific information and proposes alternatives to mastery, I pursue a threefold approach that spans methods developed within the environmental humanities (especially ecocriticism), media studies, and science and technology studies (STS). I detail

how creative works incorporate scientific data and methods within famil-
iar genres; for example, in chapter 2 Kingsolver's inclusion of precise data
on climate change and lepidoptery in her domestic realist novel *Flight
Behavior* (2012), and Michael Crichton's embedding of line graphs of tem-
perature data in his popular thriller *State of Fear* (2004). This engages skills
of close reading across the textual and the visual as well as knowledge of
the novels' debts to genre conventions and participation in contemporane-
ous climate debates. Having detailed the aesthetic features of information,
I query where the texts position themselves relative to science and scien-
tific information: as observers, as promulgators, as repudiators, or as some
combination thereof. For example, in chapter 3, when novelists Reif Larsen
and Cormac McCarthy repurpose the traditions of natural history to depict
resource extraction and land use in the U.S. West, do they merely repro-
duce imperial-capitalist appropriation? In addition to methods of formal
analysis that can tease out how natural history threads through these novels,
answering such a question requires insights from the history and philoso-
phy of science. The third aspect of my methodology, therefore, examines
how these elements—that is, aesthetic experiment with scientific infor-
mation and complex stances toward that information—yield multi-
pronged epistemologies. In chapter 5, as one instance, I argue that when
Fazal Sheikh takes an oblique angle in his aerial photography of the Negev
desert in Israel, he continues to associate the aerial with positivist values of
objectivity and transparency but also promotes an epistemology dependent
on embodiment, technological materiality, and the mediations of atmo-
sphere and history. Such a claim relies on the study of media history as
well as the enmeshed environmental and colonial politics of the region.

The steps of this methodology deliver us to epistemologies that do not
abandon the force of science. By integrating scientific information into the
aesthetic fabric of their works, artists do not shun the insights that positiv-
ism can provide. Positivist science undoubtedly generates invaluable infor-
mation about the phenomenal world, and this information produces
explanations that, in sociologist Daniel Bell's words, "take a finding and
generalize from any one context to another."[38] Generalizability and trans-
portability can also lead to trouble, however. In generalizing "from *any*
context to another," without accounting for the situations in which a find-
ing arose—situations that are subjective, geographical, historical, institu-
tional, and technologically mediated—and without accounting for the

ramifications of those findings, scientific information threatens to overwrite traditional knowledges produced over centuries of interaction with a place, its lifeforms, and its processes. In Schiebinger's evocative words, generalization threatens to "leave certain forms of knowledge unplucked from the tree of life."[39] Leaving no knowledge unplucked, environmental art pays some deference to scientific information, but the creative works in the coming chapters enact entangled epistemologies in which information derived from positivist science activates epistemologies that are affective, embodied, speculative, ambiguous, self-reflexive, and unknowing.

To offer one example here, chapter 1 shows the extent of this entanglement by studying data visualizations with instrumental origins. Subsequent chapters will examine visualizations embedded in other media (e.g., the line graphs in Crichton's *State of Fear* in chapter 2 and the diagrams in Larsen's *The Selected Works of T. S. Spivet* in chapter 3) and those with origins in aesthetic design (e.g., James's *In Pieces* in chapter 4); *Infowhelm* begins, though, with visualizations that are explicit tools of scientific communication. In an animated visualization of New York City's carbon dioxide (CO_2) emissions, the Carbon Visuals consulting firm activates the affects embedded in the genre conventions of horror and disaster narratives. By giving CO_2 data mass in the form of floating orbs and presenting the metastasis of those orbs, the designers implicate the viewer's own body in the risks of accumulating greenhouse gases. When the city's emissions data takes these aesthetic forms, this data detaches from the scientific contexts in which it was produced and yields knowledge dependent on viewer's emotional and embodied responses. Carbon Visuals' piece, like many others featured in *Infowhelm*, participates in "negotiated empiricism," that is, "an empirically based, evidence-respecting position that takes empirical evidence seriously while contending that evidence rarely speaks for itself either in its claims to count *as* evidence or in its meanings and implications."[40] Unable to "speak for itself," scientific information enters environmental art and yields epistemologies that are orthogonal to their origins, still touching but heading off toward unforeseen destinations. One epistemological mode—quantification—can swerve to produce another—emotion—in the face of climatological complexity.

At this point, I want to be clear that ambiguity, uncertainty, unknowing, speculation, and the like are also drivers of scientific knowledge production. Science-studies scholarship on high-energy physics, quantum

mechanics, and the hunt for the quark, along with the discourse on climate modeling I investigate in part 1, all point to the ways the investigative process passes through these epistemological positions.[41] When I differentiate positivist epistemologies from these alternatives or "successors," I am suggesting that values of rationality, mastery, universality, and correspondence between scientific explanations and determinate aspects of the world remain ideals within the sciences.[42] In so many ways, still, environmental science and policy presuppose human distance from and control over the more-than-human realm. Even as the theories and tools applicable to crises like extinction and climate change have evolved significantly over the centuries, Eurowestern sciences have inherited the presuppositions of their pasts. Individually and collectively, environmental actors are always the sometimes acquiescent, sometimes resistant products of these enduring templates for producing knowledge. Understanding those legacies, how they endure, and how they mutate motivates many of the creative works taking on the challenges of environmental representation today.

Examining how environmental art produces epistemologies through aesthetic techniques requires attention to works that some might not typically consider artistic, such as Carbon Visuals' animation referenced above or the media that activist groups produce. The phrases *environmental art* and *environmental culture* encapsulate instrumental objects such as climate model visualizations as well as prose, poetry, painting, and photography because they all deploy formal strategies whose meanings are best unpacked through tools of literary and visual analysis. *Infowhelm* assembles aesthetic experiments with knowledge production occurring in media ranging from Global Footprint Network's carbon footprint calculator (chapter 1) and SkyTruth's satellite imagery analysis (chapter 5) to Juliana Spahr's prose poetry (prefaces) and Kim Stanley Robinson's speculative fiction (chapter 6). I address literature by writers with hordes of devoted fans—e.g., Michael Crichton, Barbara Kingsolver, Cormac McCarthy, Robinson—as well as those less well-known—e.g., Reif Larsen, Indra Sinha, Claire Vaye Watkins. I privilege visual media one might find while flipping through a newsfeed (e.g., climate model visualizations), attending a town hall or reading a press release (municipal emissions visualizations), searching for activist campaigns (Global Footprint Network, SkyTruth), reading mainstream media coverage of environmental art (Maya Lin), or perusing artbooks or an art gallery (James Prosek, Fazal Sheikh). With this archive, I share Susan

Mizruchi's stance toward works that are not typically designated "art." "The challenge," she writes, "is to grasp the un-literary dimensions of literature [or visual culture] while preserving a sophisticated appraisal of its literary qualities, to discover the aesthetic or narrative dimensions of the nonliterary, without losing sight of its objective status as, say," a climate model visualization or a satellite image.[43] Keeping sights on a text's "objective status" (in addition to being an ironic phrase for my study) encourages attention to genre and medium as well as formal strategies such as use of simile, narrative structure, color palette, and temporality.

Expanding our purview beyond conventional artworks bloats the potential archive for *Infowhelm*, especially given the premise that epistemology is all around us. The vastness of this corpus demonstrates the analytic potential of scientific information for the environmental humanities but also demands that selection must occur. While the twenty-first century is not the first moment when artworks put varied epistemologies into tension, I focus on contemporary cultural production because it emerges from a confluence of conditions that make the arts' potential to interrogate and propose epistemological positions especially poignant. Infowhelm is just one of those conditions; it is coupled with awareness that the instruments of environmental manipulation have not separated humanity from nature but have instead abolished the illusion "that we live today somehow outside or beyond or at the very least defended against nature" and have made undeniable that humans live "inescapably within and literally overwhelmed by it."[44] Dominant modes of producing the knowledge and tools enabling environmental manipulation come under suspicion at the same time as they provide access to how those manipulations are endangering all planetary life. Under these conditions, artists assume responsibility for depicting environmental crises as also crises of knowledge. They repurpose the data and methods of Eurowestern technoscience not to acquiesce to its ways of making our world but to provide historical awareness of how that world has been made and, in some cases, to speculate on possibilities for making it otherwise.

In addition to working primarily in the twenty-first century, the artists *Infowhelm* assembles are from the Anglophone world, specifically the United States, United Kingdom, and Australia. These countries do not hold a monopoly on knowledge production about environmental emergencies, and my text selections certainly reflect my more intimate familiarity with

these cultural traditions. More substantively, however, I privilege U.S. works because the country bears an outsized responsibility for environmental emergencies unfolding globally. Not only is the United States the birthplace of oil modernity, its consumerist appetites contribute mightily to the exhaustion of lands and waters and to the decimation of creatures both at home and abroad. American artists are taking into hand the tools of technological modernity that have served this ecological domination in order to erode its epistemological underpinnings.[45] They model a way to challenge scientific mastery toward the ends of environmental care rather than negligence or, worse, destruction. Moreover, the environment is a knowledge battleground in America today, with the United States having an ignominious reputation as a hotbed for antiscience sentiment and environmentally regressive policies that worsened with the election of Donald Trump to the presidency in 2016. Artists such as Kim Stanley Robinson are already producing works in the shadow of these circumstances. For all these reasons, texts from the United States provide influential models for apprehending how scientific information circulates and gains or loses currency and how cultural responses to information can push back against environmental apathy without reinforcing the technoscientific mastery that has led to environmental crises.

With these archival parameters, *Infowhelm* is organized into three parts on the themes of climate data processing, natural history, and the aerial perspective. These domains deeply structure Eurowestern apprehension of nature and environmental degradation in the twenty-first century. They have also inspired rich representational traditions in varied media that cross over between scientific and artistic production. They therefore offer explanations for the interdependence of aesthetics and epistemology while also providing a cross-section of artistic production today.

The book begins in part 1 with *data processing* within the visual and narrative culture of climate change. These media encompass data visualizations from government (National Oceanic and Atmospheric Administration), nonprofit (Global Footprint Network), and for-profit (Carbon Visuals) entities; domestic realist (Kingsolver) and thriller (Crichton) novels; and memoiristic science writing (Charles Wohlforth). I demonstrate the dialectics between information and experience in climate culture. Visual culture makes data experiential by activating the emotional life of scientific

information while literature details climate forces such that protagonists turn into data processors through an activity I call *coming-of-mind*.

As with the two subsequent parts of *Infowhelm*, part 1 opens with a preface in which the poems of Juliana Spahr's *well then there now* (2011) expose the lived experience of scientific information and the quandaries that result from data encounters. Spahr serves as an unconventional muse for *Infowhelm*, offering experiments with data manipulation, as when she runs found text through an online translation engine to produce lines of poetry, as well as establishing the intricate ways data manipulates emotions, relationships, and dispositions toward media. What's more, *well then there now* synthesizes the epistemological terrain of *Infowhelm* in that it harbors and creatively remixes all *three* of this book's themes—data processing through climate culture, natural history, and aerial technomedia.

Part 2 studies the *new natural history*, a prevalent but overlooked trend within the contemporary arts in which natural history provides both theme and method for cultural production. The themes of naturalism include the variety of life found on the planet and the relationships among humans, more-than-human animals, plants, and minerals. Its methods include ways of collecting, quantifying, classifying, and displaying nature, from the curiosity cabinet and its successor the natural history museum to binomial nomenclature and botanical illustration. These methods get repurposed in visual media from the Audubon Society, Bryan James, Maya Lin, James Prosek, and The Tissue Culture & Art Project, and novels by Verlyn Klinkenborg, Reif Larsen, and Cormac McCarthy. These creators follow the classificatory impulse of natural history not out of nostalgic yearning or to unleash a zombie Enlightenment but to show the endurance of naturalism's epistemological and representational traditions. They test the limits of these traditions and bend them toward epistemological positions natural history attempts to elide, those based in subjectivity, emotion, ignorance, imagination, and disorder.

If part 2 turns back, part 3 goes high, to the technologies and media that offer an *aerial perspective* on the planet, a key vantage affiliated with environmental consciousness as well as a tool of resource extraction and land development. Whether aerial perspectives come through visual media—as in the work of SkyTruth, Laura Kurgan, and Fazal Sheikh—or through verbal description—as in novels by Kim Stanley Robinson, Indra Sinha, Jeff

VanderMeer, and Claire Vaye Watkins—they propose what I call *episte-mologies of the aftermath*. These artists traffic in the technological and political histories of the tools that make the aerial possible (cameras, planes, satellites, etc.) and tactically deploy them to depict serial aftermaths of environmental devastation rather than finite "befores" and "afters." They propose epistemological values of not-seeing, incompleteness, situatedness, and materiality as against the values of transparency, totality, and universality that are typically associated with the view from above.

Within these organizing themes of data processing, natural history, and the aerial perspective, the aesthetic lives of scientific information emerge in all their variety. *Infowhelm: Environmental Art and Literature in an Age of Data* is unique in treating this information as a representational resource in its own right and in thereby explaining environmental art's modes of producing knowledge. There is no denying the ethical importance of epistemology in the midst of unfolding environmental emergencies and no denying contemporary art's role in experimenting with epistemology toward "the active shaping of the world."[46]

PART 1
Cultural Climate Knowledge

PREFACE

In 1939 Walter Benjamin records a distressing condition: at the outbreak of World War II, Europeans are "increasingly unable to assimilate the data of the world around [them] by way of experience." Newspapers contribute to the "isolation of information from experience" because they deliver bits (we might now call them bytes) of information without the mooring that storytelling provides. Benjamin explains, "The replacement of the older narration by information, of information by sensation, reflects the increasing atrophy of experience. . . . It is not the object of the story to convey a happening *per se*, which is the purpose of information; rather, it embeds it in the life of the storyteller in order to pass it on as experience to those listening."[1] Though aged eighty years, these remarks readily apply to the wired present. "Happenings" bombard media consumers, quite often without the contextualization that stories provide and that slot information into experience.

But is this the case? Might we find experience *in* infowhelm, that state of being overcome by the onslaught of information, especially information that is contested? There is perhaps no more apt and exigent "happening" for answering this question than climate change precisely because myriad streams of information types—scientific, demographic, experiential, economic, cultural—gush out from this tentacular, ongoing crisis. What's more, "climate change seems abstract." As literary critic Anne McClintock

continues, "Scientists tell us that 344 billion tons of Arctic ice has melted. But 344 billion tons is magical counting. . . . The problem is not precision. The problem is perception."[2] Setting aside the fact that imprecision does cause problems for climate politics (a point chapter 1 will address), McClintock's observation is a refrain in writing on climate crisis from quarters as disparate as climatology, journalism, anthropology, religion, and cultural criticism. This refrain transforms into a call-to-arms for writers and visual artists who strive to alter perception of climate processes and humans' and more-than-humans' lived experiences of them. Artists are key players not only in making sense of climate crisis but in making meaning from it. Or, as geographer Noel Castree writes, in helping "matters of fact about the earth to become facts that matter for people outside geoscience."[3]

Chiming with Benjamin, environmental humanists appeal to storytelling for this conversion of fact into mattering. Science editor Michael Segal laments the "missing climate change narrative," while some ecocritics locate what seems missing in "narrative forms that combine individual biography with environmental history" or another literary, visual, or cinematic genre.[4] But what of quantitative genres such as charts, graphs, and visualizations of all kinds? And what of narrative objects that embed scientific data, representations, and methods? The ensuing chapters tilt inquiry toward the aesthetics of such works. In environmental literary studies, data and quantitative representations are typically of marginal interest relative to the richness of language-based story. Without discarding such stories—indeed, approaching them from a different vantage—part 1 details how climate data and processes accrue meaning in works such as online carbon footprint calculators, data visualizations and animations, novels, and memoir. To understand how these works of climate culture produce knowledge and bring knowledge publics into being, quantitative representational modes must be central rather than peripheral.

The "public understanding of science" model, which is primarily about increasing scientific literacy and imparting authoritative facts to the public, is already morphing into a model of apprehending and addressing beliefs, meanings, and feelings around climate change.[5] To play off the title of a recent essay collection, numbers are giving way to nerves.[6] In Juliana Spahr's poetry, climate information, sensation, feeling, and meaning feature not as disparate entities but as entities in perpetual orbit. She brings the quantitative and experiential aspects of climate change to the page

through an imaginative poetics that captures mundane data encounters in our current climate emergency. "Unnamed Dragonfly Species" (2002), a prose poem collected in *well then there now* (2011), dramatizes the stings of climate data so readily available to privileged, screen-bound Americans.[7] It also entertains strategies for soothing or numbing those stings that expose the affective intricacy of environmental information. From "Unnamed" I extract several problematics in the genres of climate knowledge that I analyze in the two ensuing chapters: how to depict the experience of data, what counts as evidence and memory of climate disturbances that are amorphous and yet omnipresent, how to balance the quotidian and the catastrophic, and how to respond given the exigencies of culture, geography, and economics.

In "Unnamed" an anonymous "they" (one of the title's "unnamed" species) set out on an information binge instigated by images of a calving Antarctic glacier. As they seek information about climate catastrophe, another dataset threads through the poem. A bolded, alphabetical list of names from a list of species with "endangered, threatened and special concern" status in New York State—from "**A Noctuid Moth**" to **"Yellow-breasted Chat"**— interrupts the lines and reproduces the pricks of information exposure.[8] As species of Lepidoptera and Aves are disappearing,[9] glaciers spectacularly disintegrate on "a series of six or so satellite photographs" (77). They watch as "a big piece of the Antarctic Pine Island glacier broke off. **Banded Sunfish** A crack had formed in the glacier in the middle of the previous year. **Barrens Buckmoth** And then by November the piece had just broken off. **Bicknell's Thrush**" (76). Confusion spurs curiosity and then obsessive watching: they "just watched it over and over" (77). "Just" is a keyword in the poem. What at first seems to be a disruptive linguistic tic gathers significance through repetition. In one sense, it is a filler word, akin to "um" or "er." In other uses, it suggests temporal proximity as well as speed to provoke a sense of urgency. Yet "just" is also synonymous with "merely" or "only" and therefore diminishes the significance of the breaking glacier even as the event fuels unease.

The multivalence of "just" accentuates the epistemological and affective complexities of climate crisis. To manage the "information on what was going on" in this faraway but digitally nearby place,[10] they speculate about sensation (77). "What does this breaking off sound like? **Canada Lynx** Or what it was like to be there on the piece that was breaking off. **Cerulean**

Warbler . . . What had it been like for the penguins or the fish?" (77). These interrogative lines establish a pattern for the poem: information sparks sensation and feeling as well as musings on these experiences and on their ignorance. On why, though global temperatures rose each year beginning in 1988, "they had no memory of any year being any hotter than any other year in general" (80). Distraught by their inattention toward or inability to feel the heat, they seek more information, a quest that stirs up a mélange of data, speculation, mediated sensation, and messy feelings. "They" yearn to think like a penguin, to modify Aldo Leopold's famous injunction, but geographical and phenomenological gaps keep them "On the internet" rather than on the ice (78). Necessarily mediated, environmental information yields mixed embodied emotions if not understanding.

In a run-on sentence that deviates from the poem's tendency toward brevity, the narrator describes the information situation in the early 2000s: "There was more to read than ever before and it was easier than ever before to acquire as it came through their computers and all the time the computers had newer and better search engines making more and more specific information easier to find" (86). But acquiring more and more, over and over, leaves the plural speaker with "eyes blurring and . . . shoulders tight" (82). Across this sequence of lines, their bodies register the quiet consternation that suffuses the poem. Data-diving leaves affective as well as somatic marks, producing a cocktail of curiosity, consternation, apathy, concern, self-delusion, and ultimately stoic endurance in the status quo. Unable to "figure out what to blame" (86) or "what else to do . . . they just went on living while talking loudly. **Worm Snake**" (93). Deluged by disturbing data, Spahr's characters also face a choice: between going on just watching and living or registering the extinction and loss that accompany climate crisis and doing more. The minor word "just," appearing in the poem's penultimate line, intimates this significant but, for that, no less understandable failure. In life as in the poem, the bold retreats to background as life goes on in the present progressive tense.

"Unnamed" ends then on a falling note, but Spahr's poetic strategies put into play the intimacy of information and experience. Spahr's characters attempt, to paraphrase Benjamin, to assimilate the information the internet delivers into sensations that make glacial melt experiential.[11] Yet they also demonstrate what's absent in Benjamin's account: that information is always embedded in experience and has its own poetics. The note of

resignation and they's low-grade but troubling feelings perform the emotional dimensions of information and the many mechanisms we engage—or disable—to manage mediated data and images of catastrophe.

The aesthetics of information and these mechanisms of intellectual and emotional engagement are the focus of the ensuing chapters on digital visualizations—of the sort that might captivate the poem's speakers—and on novels of knowledge production about climate. The poem stages data encounters that are revealing for these chapters in several ways. First, as contemporary environmental art makes information its theme, it both *depicts* the knowledge spaces that twenty-first-century environmental citizens inhabit and *becomes* one of those knowledge spaces. Cultural works thus goad inquiry into processes of knowledge production, especially into how aesthetic strategies—from the color scheme and timescale of a digital animation to the persistence of simile in a realist novel—function as epistemological devices. Second, the poem adduces the range of sources for climate information: it might come by word-of-mouth, through experts' reports and interviews, from perusing lists or reading stories, and, most spectacularly for the poem's characters, from viewing visualizations and videos. For those in the Global North, climatic disturbance is typically highly mediated by digital representations, even if it undoubtedly affects people in quotidian ways. The mediated nature of climate information is underscored by the historical coincidence of public awareness of climate change and the popularization of the internet in the late 1990s.[12] Third, though information gleaned from these sources is at the heart of environmental consciousness, that information easily overwhelms and deflates us. Environmental crisis competes for attention, not only from other news events but also from life's concerns: "Some of them were trying to rid themselves of drunk boyfriends and thought so much about this that there was little room for thinking about other things like the warmth or beaches" (81). Finally, "Unnamed" thematizes the question of what those who "used the most stuff up, who burned the most stuff" (87)—a group to which many readers in the Global North belong, if to varying degrees—allow to seep into our awareness, what we keep out of sight, and what we reframe to make palatable.

For these reasons, "Unnamed" sets off the queries that drive part 1 just as the cracking glacier sets off they's data journey in "Unnamed." Climate culture—that is, the literary and visual objects that depict climate crisis and

reach nonspecialist audiences—is a crucial intermediary between the hard data and concepts of environmental science and public understanding. Works like Spahr's poem mediate these domains by delivering climate information and conceptualizing the experience of infowhelm through varied representational strategies. I argue that these strategies activate *epistemological procedures*, that is, thought processes that highlight *how* we know what we know. The epistemological procedures staged in climate culture foreground obstructions and conduits to knowledge and to positions on climate change: on whether it requires attention today or after the bills are paid; on whether it is masterable, indomitable, or a complex amalgam of the two; on whether it elicits allegiance to a particular epistemology or sociocultural position. As chapters 1 and 2 demonstrate, in works by data visualizers, climate consultants, novelists, and science writers, epistemology is deeply aesthetic. We therefore need accounts not only of the data that climate culture delivers but also of the processes of *knowing* that data that climate culture sets in motion through its form.

Most broadly, *Infowhelm: Environmental Art and Literature in an Age of Data* contends that environmental humanists must treat information as a representational mode in its own right, one that shapes contemporary aesthetics as well as environmental politics. Climate visualizations and creative writing act as information management systems that establish and expand the limits of how individuals and groups understand environmental change. In different ways, these works activate a dialectic between information and experience. Chapter 1 contends that visualizations from the U.S. National Oceanic and Atmospheric Administration, consulting firm Carbon Visuals, and nonprofit Global Footprint Network make data experiential using sophisticated technologies of calculation and computation. My arguments accord with Sean Cubitt's point that "data visualization aims to mobilize demand in the people by translating the empirical data of experts into visually legible symbols for the mass population, ostensibly to persuade through reason but actually to mobilize at an affective level."[13] Examining the affective qualities of the formal strategies in climate visualizations, chapter 1 highlights the tension between scientific realism and invention, and the interplay between abstract data and individuals' understanding. Whether a visualization quantifies the earth system, as in climate model visualizations, or quantifies the self, as in personal carbon footprint calculators, they build worlds whose value inheres not so much in their

accordance with measurable conditions as in the emotions the works elicit and the norms of environmental citizenship they establish.

Chapter 2 zeroes in on data encounters presented through "coming-of-mind" plots within creative climate writing. I track this mode through the genres of the regional realist novel (Barbara Kingsolver's *Flight Behavior* [2012]), the science memoir (Charles Wohlforth's *The Whale and the Supercomputer: On the Northern Front of Climate Change* [2004]), and the popular thriller (Michael Crichton's *State of Fear* [2004]). These texts depict intellectual formation under conditions of environmental change by turning protagonists into data processors. They undergo epistemological dilemmas—What tools of data collection are most efficacious? What data sources can we trust? On what scale is climate information meaningful?—in scenarios where there is friction between data and experience and between a person's environmental convictions and social roles. In the coming-of-mind narrative mode, these dilemmas are as cognitive as they are aesthetic, ethical, and ideological.

MAKING DATA EXPERIENTIAL

The Eleventh United Nations Climate Change Conference (COP11) in Montreal, Canada, included an unlikely attendee. For two weeks in late November and early December 2005, photographer Joel Sternfeld mingled with diplomats, researchers, activists, consultants, and a former U.S. president at the largest and most high-profile climate meeting yet held. Sternfeld was confused about climate change, though not a committed denier, and experienced a minor conversion: "Even though I considered myself to be a landscapist with an abiding interest in seasonality, and even though I had clipped articles about the possibility of 'global warming' from the newspaper since 1989, the information and disinformation surrounding the subject left me and the American public with a vague sense of discomfort about the subject but little to help formulate a concrete understanding." As a nature appreciator, he had noticed cyclic environmental changes, but changes to the climate system were much harder to grasp, a sentiment expressed in those scare quotes around *global warming*. The amount of climate information and its contentiousness elicit "vague" feelings in the artist. Those feelings go from vague to vehement soon after Sternfeld arrives at COP11. "What I heard and saw in Montreal shocked me as nothing else," he relates. "I went there wondering if climate change existed but most of the twenty thousand delegates were already considering the possibility that it not only existed but was about to become irreversible. I took photographs

of the participants at moments when the horror of what they were hearing about ecological collapse was most visible on their faces."[1]

Those photographs compose the Prix Pictet–winning collection *When It Changed* and appeared in *Weather Report: Art and Climate Change*, the Boulder Museum of Contemporary Art's major exhibition on the subject, in 2007. As in Juliana Spahr's "Unnamed Dragonfly Species," infowhelm motivates Sternfeld's art.[2] At COP11 he produces portraits of people confronting climate change information rather than the places, people, and other creatures affected by it. On first look, the images do not demonstrate much artistry. The conference context creates banal backdrops: gray walls, a wash of dark suits, paper-strewn conference tables. The aesthetic impact comes with close attention to facial expression and bodily posture and gesture. These aspects of the photographs highlight the disbelief, despair, and even boredom and fatigue (he shoots some participants sleeping) that climate data creates. *John T. Brinkman, Priest, Commission on Ecology and Religion, Maryknoll, Japan* excludes the information that is stimulating the attendees' reactions (figure 1.1). With his hands propping up his head and the flesh of his forehead molded into deep wrinkles, the priest may only be taking notes or massaging out a headache. We don't know, but the framing of the image heightens the gravitas of Brinkman's posture. In this portrait as in most

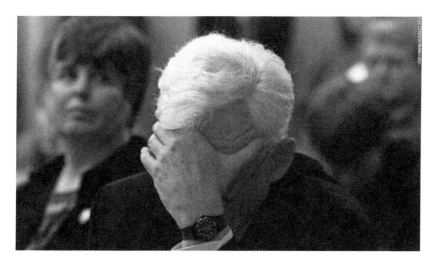

FIGURE 1.1. Joel Sternfeld, *John T. Brinkman, Priest, Commission on Ecology and Religion, Maryknoll, Japan,* 2007. Courtesy of the artist.

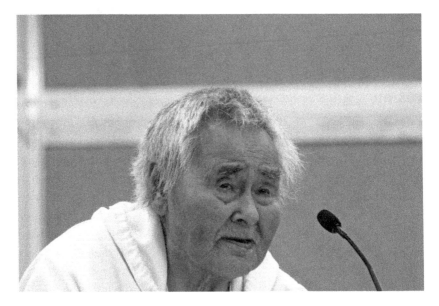

FIGURE 1.2. Sternfeld, *Naalak Nappaaluk, Inuk Elder, Kangirsujuaq, Nunavik, Canada*, 2007. Courtesy of the artist.

others, a single person is in focus and cropped at the bust. Surrounding conference participants are either in half-focus or entirely blurred. The presence of other attendees in the frame establishes that this information encounter is communal; the focus on an individual, meanwhile, insists that the person is the locus for apprehending and emotionally processing that information.

Curator Lucy Lippard reads Sternfeld's title, *When It Changed*, as possibly "referring to a hopeful turning point" when climate change mitigation makes it onto state, corporate, and individual agendas.[3] From the photographs alone, however, this reading does not come ready to hand. Take, for example, *Naalak Nappaaluk, Inuk Elder, Kangirsujuaq, Nunavik, Canada* (figure 1.2). This subject, whose gender is indeterminate based on the photo alone, stands out from the other attendees. Wearing what looks to be a white robe rather than the standard dark suit, Nappaaluk appears spectral and yet utterly embodied. The subject enters this bureaucratic context from an Arctic hot spot for climate disturbance. With troubled brow and despairing, deep-set eyes, the subject looks to be haunting the meeting from a devastated time and place toward which the rest of the planet is hurtling.

If the hope Lippard detects is evident in this photo, it must only be in the fact of concern and despair itself.

For Sternfeld these embodied emotions are the beating heart of climate change. Though scientific data is central to the minor affective dramas Sternfeld captures, it rarely enters the frame. An exception is *Yoshiaki Nishimura, Senior Staff, Central Research Institute of Electric Power Industry, Japan*, in which the subject stands in front of a visualization of global temperature anomalies (figure 1.3). Nishimura's eyes and slightly stooped posture give away his fatigue. Yet he is largely stoic and stern, and his lips betray only a hint of disappointment. In this case, the photographic subject appears to be communicating climate data rather than only receiving it. Viewed with the others in the series, this photograph embedding a climate model visualization rekindles the question posed in the preface to part 1: Might we find experience *in* infowhelm? How does data *feel*?

Like Spahr's "they" in "Unnamed," Sternfeld's shocked and bored subjects have data encounters that display the emotional and embodied marks of infowhelm. Read together, these artists' works remind us of the transportability of climate data, how it travels from the convention table to films

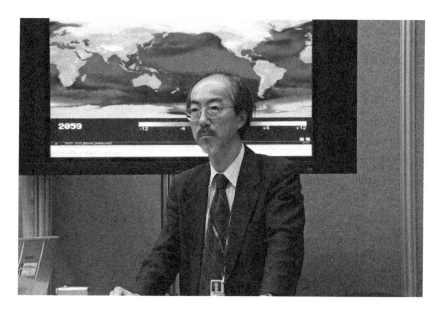

FIGURE 1.3. Sternfeld, *Yoshiaki Nishimura, Senior Staff, Central Research Institute of Electric Power Industry, Japan*, 2007. Courtesy of the artist.

such as *First Reformed* and on to curious browsers' laptops. This chapter travels with climate information as it appears in visualizations from varied sources. Across these texts, aesthetic strategies incite epistemological procedures that are rich in emotion. Do visualizations of climate change elicit the horror, disappointment, exhaustion, and/or despair that Sternfeld's subjects appear to feel? Do they promote mastery or humility, control or failure? Close attention to their aesthetic qualities—qualities such as sophistication, color, perspective, materialization, and allusions to popular genres—reveals the ways data becomes experiential. It also presses against the tendency, even within the interpretative humanities, to read over or through data visualizations or to employ them as research tools rather than objects requiring analysis. Climate visualizations require modes of interpretation that can account for their origins in quantitative methods as well as their ability to elicit qualitative dispositions toward real-world conditions.

As this chapter demonstrates, data never stands alone. It is situated in frameworks for producing scientific knowledge that, while naturalized precisely because they are not read closely, are in fact highly determinant of how viewers might respond to data. Visualizations from government agencies such as the U.S. National Oceanic and Atmospheric Administration (NOAA), a for-profit consultancy, and an environmental nonprofit demonstrate that formal aesthetics spur emotions that then promote epistemological values. While these visualizations emerge from positivist traditions of producing knowledge, they yield entangled epistemologies dependent on culturally contingent responses to color, temporality, and genre conventions. They are neither transparent renderings of so-called raw data nor biased constructions of data. This is because the aesthetic strategies that render data visual are always affectively dense. For this reason, climate visualizations process data through affectivity and not only through computational algorithms. They employ color, sophistication, sound, interactivity, temporal difficulty, and genre conventions in ways that render data experiential because they produce emotional responses. The emotional cocktails of overwhelm and control, of ordinariness and engulfment, of play and empowerment produced by the climate visualizations I analyze here are not separate from knowledge production but are inextricable from it. They are what make knowledge move.

MODELS: BETWEEN DATA AND FIGURATION

In real estate, it's location, location, location. In climate change communications . . .
it's visualizations, visualizations, visualizations.

—SARA PEACH (2011)

In 2012 Bill McKibben reenergized and rebranded twenty-first-century cli-
mate activism with a *Rolling Stone* article that put numeracy ahead of
other forms of environmental literacy. Instead of highlighting the imper-
iled flora, fauna, and peoples of the Arctic, McKibben jumpstarted climate
activism with "three simple numbers that add up to global catastrophe" and
amount to "global warming's terrifying new Math": 2 degrees Celsius
(allowable threshold for atmospheric temperature increase), 565 gigatons
(amount of carbon dioxide humanity can emit before 2050 to avoid cross-
ing this threshold), 2795 gigatons (amount of coal currently in petroleum
corporations' reserves).[4] From these calculations McKibben proposed a
worldwide campaign to pressure institutions to divest from fossil fuel com-
panies and keep those 2795 gigatons in the ground. If, as many cultural
scholars worry, polar bear images can "block perceptual understanding of
the humanistic dimensions of [climate] crisis" because their plight feels dis-
tant, vast, and insurmountable,[5] what "perceptual understanding" do
quantitative forms produce? Does McKibben's math move us? What of the
graphical representations such as bar graphs, scatter plots, and temperature
maps that visualize that math?

The power of these representations is incontestable. We need only recall
Michael Mann, Raymond Bradley, and Malcolm Hughes's controversial
"hockey stick graph," which first appeared in 1998.[6] Such data-based repre-
sentations make up climate visual culture as much as polar bear photo-
graphs; they are as "embedded into the metanarratives of climate change,
i.e. the plot of threat, realization, morality and possible salvation through
timely action."[7] Therefore, just as we must acknowledge the passion for
information among contemporary artists such as Spahr and Sternfeld, we
must also acknowledge and theorize the artistry of data visualizations com-
ing out of research organizations, consulting firms, and nonprofits.

Arguably, one reason that such graphical objects receive less attention
in the humanities is the longstanding separation of number and narrative,

of methods of quantification from methods of interpretation. Literary scholar Mary Poovey explains the isolation of these domains in her "history of the modern fact." The story of how the fact, an "epistemological unit that organizes most of the knowledge projects of the past four centuries," became central to economics, governance, and science is "the story of how one kind of representation—numbers—came to seem immune from theory or interpretation." Poovey recounts how numbers started to speak for themselves beginning in the seventeenth century. They were conceived as transparent at the same time as they came to describe big systems such as "the" economy. However, numerical description and narrative and moral interpretation were not in fact separable, she maintains. Instead, they were deliberately cordoned off from each other so that numbers could serve as universal, disinterested "instrument[s] of rule." Recent scholarship such as Poovey's reminds us that what appear to be "simple descriptors of phenomenal particulars" are shaped rhetorically and require humanistic interpretation.[8]

In scholarship on climate change, the legacy of separating number from interpretation endures. Numbers, and the visualizations that relay them to publics, too readily slip out of the purview of the interpretive humanities. And yet climate change is a particularly apt site for bringing quantification and interpretation together because models, the dominant research tool for climate projections, inherently muddle the lines separating them. What's more, the importance of models is incontestable because they are public stages for climate debate and have become knowledge battlegrounds.

Now, to say models are representations requiring humanistic interpretation does not mean that they are wild guesses or culturally constructed fantasies. Nor am I espousing a version of the Strong Program of the sociology of scientific knowledge, which holds that science "is primarily the congruence of a hypothesis or theory with social interests of members of a scientific community that determines its acceptance by that community."[9] My point here is that climate models are symbiotic with data (more on this in a moment) but also have an inventive dimension. They propose relations—for example, between aerosols in the atmosphere and temperature—given a set of factors such as year, season, geography, and topography. The metrics for assessing models are not truth versus falsehood but efficacy versus failure according to accepted criteria. They either ably or ineptly "represent the world in a way that facilitates the interactions its users seek to have with

the modeled domain."[10] To do so, climate models use scenarios and projections, which are neither constructed myths nor snapshots of a fixed reality.

Despite the complexity of climate models, their visualizations are largely "looked *through*" rather than *at* because "they are thought to be either self-evident or mere instruments for mediating ('illustrating') scientific results."[11] Treating them as transparent places their meaning solely within scientific discourse. "Suspend[ing] critical judgment" in this way stymies climate communication because it impedes understanding of how visualizations enter the public sphere and produce knowledge publics that take stances on environmental issues. Studying model visualizations within the humanities, as this chapter does, also redistributes the "extraordinary epistemological privilege" that the sciences have typically been accorded in climate discourse.[12]

First, what are the models on which visualizations are based? Models are technological marvels and morasses: marvels for the staggering data, diverse forms of expertise, and stochastic mechanisms for which they account; morasses because they are contested reference points in climate policy debates. In principle, they target specialist audiences of climate scientists and policy wonks such as those pictured in Sternfeld's photographs, but in practice they circulate widely and reach an array of media consumers. Model data and visualizations detach from their explanatory contexts and become reference points in climate discourse even when audiences do not necessarily understand the science and computation behind them. Because visualizations rove and reach multiple audiences, the representational conventions we find in these graphical displays signify even more than they might if they stayed within research circles.

Models first developed out of regional weather forecasting when computer-processing power swelled in the 1960s, and they are now heuristics for understanding the climate system at different scales.[13] They simulate this multivariable system using core principles of physics as well as chemical, biological, and geoscientific datasets. Today's most discussed models account for changing anthropic forcings, that is, discrete events or long-term patterns that alter the energy in the climate system. Forcings in turn affect changes in global mean temperature—what's known as climate sensitivity—in response to mounting carbon dioxide (CO_2) concentrations since the Industrial Revolution. General circulation models, or GCMs, are

the most important models of this type and are the ones that enter my read-
ing here.[14]

Models cross over from number into figuration, from quantification into
interpretation, because they are built on scenarios and require tweaks that
make them nonrealist. I use "realism" in a sense current in science stud-
ies, to refer to "an *objective match* between, on the one hand, statements,
beliefs, descriptions or models and, on the other hand, a fixed reality."[15]
For sociologist Andrew Pickering, the question for classical realists is,
"Does scientific knowledge mirror, correspond to, represent truly, how
the world really is?"[16] For a climate model to be realist in the sense of
"matching" or "mirroring," it would have to capture accurately the func-
tioning of all processes in the climate—from cloud formation and ice
albedo effect to jet stream and circulation of aerosols—at all places and
points in time. Matching and mirroring are impossible not only because
supercomputers are not yet up to this task but also because a GCM may
lose accuracy the more data it incorporates.[17]

Another reason models swerve from realism is the limited availability
of empirical data. Some phenomena are not easily observed and measured.
For other phenomena, there are records reaching back into the past, but
those records have gaps or are inconsistent. Historian Paul Edwards esti-
mates that, as of his writing in 2010, "only about ten percent of the data used
by global weather prediction models originate in actual instrument read-
ings"; the percentage used by GCMs is even lower. To account for these gaps
and other unknowns, modelers insert parameters, "a kind of proxy—a
stand-in for something that cannot be modeled directly but can still be esti-
mated or at least guessed."[18] As one science journalist bluntly puts it, "In
climate modeling, nearly everybody cheats a little."[19] But the word *cheat-
ing* misleads. Climate researchers must fill in aspects of models just as they
must use theoretical constructs. Therefore GCMs, like models in general,
"involve a partial independence from both theories and the world but also
a partial dependence on them both."[20] As hybrids of theoretical principles,
observational data, and parameters, models are not very satisfying for
someone with a classically realist view of the scientific enterprise. They build
worlds that hover between theory, observable reality, and invention; it's this
hybridity that makes them generative for climate research and policy.

Models' projective function contributes to their status as inventive: they
rely on scenarios to simulate futures. Again, these practices of "building

worlds," inventing, and simulating make some uneasy. To point out these functions is not tantamount to dismissing models as mere social and cultural constructions. Climate modelers constantly compare simulations and projections to ensure the greatest accuracy possible.[21] The varying scenarios help make this possible. Essentially, scenarios are deeply informed narratives of the effects of perturbations to the climate system. The Intergovernmental Panel on Climate Change (IPCC), which synthesizes thousands of climate change studies approximately every six years, defines a scenario as a "plausible description of how the future may develop based on a coherent and internally consistent set of assumptions about key driving forces (e.g., rate of technological change [TC], prices) and relationships. Note that scenarios are neither predictions nor forecasts but are used to provide a view of the implications of developments and actions."[22] The IPCC definition reminds us that efficacy, not mimesis, is the coin of the realm. The scenarios that feed models are then neither guesses nor amalgamations of physical observations. They are projective rather than predictive because the imagined futures of scenarios "are not assigned probabilities or other indicators of expectation."[23] In line with Edwards, we can approach model scenarios as a form of world building rather than picture taking.[24] With this approach, mimesis takes a backseat to simulating climate sensitivity to design better research trajectories and planning strategies.

In sum, models make knowledge move rather than fix facts about present and future states of the climate system. This speaks to the notion that uncertainty is a certainty in scientific pursuits, a refrain we revisit in parts 2 and 3 of this book. Even if we acknowledge this axiom, however, models, with all their uncertainties and use of scenarios, enter charged social and political spaces. They invite questions of epistemological legitimacy and authority that arise in the visualizations to which I turn now and in the creative writing featured in chapter 2. And more so as they travel further from their original contexts of production and intended specialist audiences; that is, when their place as cultural—and not strictly specialized—climate artifacts is established. When models are visualized, their already muddied status as positivist objects becomes more contested because the data takes aesthetic forms that influence the model's sometimes contested authority and legitimacy. For these reasons, model visualizations are rich sites for understanding how aesthetic strategies such as color and temporality manage information about climate disturbance. Yet because these

visualizations make data experiential, as I argue below, they also demonstrate the entangled epistemologies that information activates.

MODEL VISUALIZATIONS: BETWEEN MASTERY AND HUMILITY

The complexity of such representational strategies—and their interaction—is on display in numerous visualizations available on agency websites and circulating under the #climateviz hashtag on Twitter, Instagram, and Flickr. I focus here on a visualization by NOAA's Geophysical Fluid Dynamics Laboratory (GFDL), one of the world's premier climate research and modeling institutions, located at Princeton University. The visualization is from 2005 and therefore ancient by visualization standards. Though countless other media are ripe for interpretation, I privilege this one because of the compelling mix of features it contains that set a precedent for visualization strategy today. My interpretations are as much about the convergence of aesthetic features that visualizers began using in the early 2000s and that this object instances as they are about this particular visualization. The features I analyze in GFDL's 2005 animation—among them, time-lapse, Earth-from-space base maps, color maps, and a combination of graphical objects—continue to appear in visualizations. For example, they appear in the suite of animations that NASA's Goddard Space Flight Center produced to communicate that 2018 was the fourth hottest year on record and in those that Finnish scientist Antti Lipponen creates from open source data and disseminates on social media.[25]

Working toward "understanding regional and global climate change," GFDL simulates temperature variation over land and sea through computational modeling.[26] As Paul Edwards reports, GFDL's mission was initially inward-focused; that is, the lab "used GCMs to diagnose what remained poorly understood or poorly modeled, and simpler models to refine both theoretical approaches and model techniques."[27] Though this may be the case, GFDL's efforts have a prominent public life in the internet age. The visualizations they create do not only inform NOAA's and other climatologists' practices. On the group's website, any web user (you, I, Spahr's "they") can access the often captivating, sometimes perplexing visualizations of models, and they also circulate on social media and in news reports on climate change.

Frequently, visualizations are collaborations between model developers and visualization designers.[28] These objects, which are usually conceived as purely quantitative, have figurative and aesthetic dimensions that influence how lay viewers comprehend highly mediated data. Model visualizations thus serve multiple, sometimes conflicting purposes that guide my analysis here. First, they deliver quantitative information about climate forcings; second, they register and propagate the values underpinning the modeling enterprise; and third, their aesthetic features ignite emotions and thought procedures that sometimes confirm those values and other times revise them.

I focus here on "Surface Air Temperature Anomalies" (2005, hereafter "Anomalies") because it incorporates myriad visualization strategies into one object and has a historical sweep. The visualization appears on GFDL's website as a still image that projects out to 2100, and as a twenty-one-second animation; the related research publications and explanations do not accompany these media files on the website. Though most audiences, myself included, cannot evaluate the algorithms, computer code, and physical concepts and laws that form the substrate of the model that is visualized, the popular reception of models is crucial to climate politics. "Climate models need to be 'seen' to be performing credibly and reliably," climate scientist Mike Hulme emphasizes. "To earn their social authority climate models therefore need to inhabit public venues, displaying to all their epistemic claims of offering credible climate predictions." They require these "public witness[es]" as well as acceptance within research communities.[29] When models appear in news reports, blog posts, policy documents, climate deniers' arguments, and artworks such as Sternfeld's photographs, the aesthetic features of visualizations do even more work because these features are rarely placed in the context of climate modeling writ large. And yet, still, these visualizations register the epistemological values of the modeling enterprise, values such as sophistication and mastery, even as their aesthetic features might complicate those values.

"Anomalies," by scientist Keith Dixon and visualizer Remik Ziemlinski, estimates temperature variations out to the year 2100 based on a mean established between 1971 and 2000 (figure 1.4).[30] The visualization communicates temperature variation through an ensemble of components: a captivating two-dimensional color map with scalar data whose palette morphs

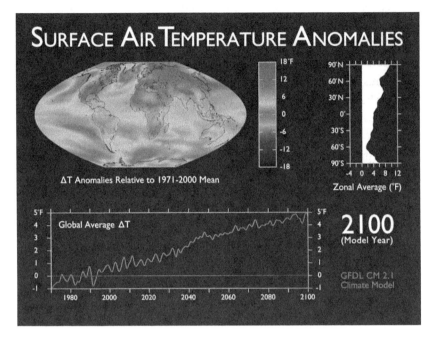

FIGURE 1.4. "Surface Air Temperature Anomalies." Coupled Climate Model (CM 2.1) projection of surface air temperature anomalies from years 1971–2100. NOAA, GFDL. Scientist, Keith Dixon. Visualizer, Remik Ziemlinski, October 2005. Courtesy of NOAA/GFDL.

over the runtime, a static legend linking temperature and color, a time chart graphing the upswing in global average temperatures from 1971 to 2100, and a dynamic bar chart indicating the latitudinal zones in which those varia- tions occur. The elements position the viewer in one unit of measure (degrees Fahrenheit) but across varied geographical scales (the globe and the region) and temporal scales (year, decade, and even second if we include the time slider on the media player for the animated version).

The large number of components is obvious and important for reasons I analyze below. Also obvious but easily overlooked is the visualization's sophistication, which contributes to its allure. Unlike a line graph, time chart, or standalone color map, "Anomalies" is animated and multimodal. What's more, its components are interdependent. Attending to sophisti- cation reminds us that the elements Dixon and Ziemlinski chose are just that: choices and not givens. Hulme explains that elements bespeaking sophistication contribute to "the performative demonstration of [a model's]

epistemic authority."[31] Specifically, they convey the investments of money, infrastructure, and expertise that modeling requires and that keep the practice in the hands of wealthy nations such as the United States, Germany, Japan, and Russia. Media theorist Rita Raley notes that "'design' as such is constituted by the architecture of corporate power";[32] here, design conveys the power of Big Science. It suggests that scientific data, methods, and results have an authority that, for Hulme, is integral to climate modeling's public viability. Crucially, this sophistication can stand on its own. Anyone who does an internet search for the animation can potentially perceive sophistication even if they cannot evaluate the scientific or computational metrics that would establish credibility. The visualization's sophistication also helps us forget that models cannot precisely mirror the physical world and instead rely on scenarios and parameters. This feature of the design thus gives the visualization a patina of objectivity, an epistemological value that, in Lorraine Daston and Peter Galison's account, presumes to "filter out the noise that undermines certainty . . . [and] aspire[s] to knowledge that bears no trace of the knower."[33] That is to say that a sophisticated visualization such as "Anomalies" can gloss over, without any deceptive intent, the fact that it does not offer a one-to-one correspondence with the physical world and that it offers one visual interpretation of the model data.

The impression of sophistication, however, easily yields to the feeling of infowhelm. The aesthetic features of "Anomalies" set off epistemological procedures through which its components come to make sense and produce knowledge of temperature projections. Yet these same features draw attention to the very difficulty of comprehending climate data and its meaning. Because of the multimodality of "Anomalies," it is difficult to hold all its components in view simultaneously. It thus produces twenty-first-century infowhelm—data's power to engulf rather than enlighten and empower—at the same time as it attempts to mediate and make sense of that information. The animation runs quickly, and the media players are not fine-tuned enough to allow easy pausing. It's therefore a challenge to toggle between the color map, time and bar charts, and legend. And this is just the first of many steps. Viewers must also check the time stamp in the lower corner while accounting for seasonal fluctuations displayed in the left-hand time chart, correlate the colors to the legend, and compare zonal averages. The visualization thus figures infowhelm even as it attempts to

wrangle proliferating climate data. The piece's interactivity, which, on the one hand, imparts a sense of mastery, also imparts a feeling of impotence, a feeling that the climate datascape in general so readily produces.

Collocating, correlating, comparing, toggling between pause and animation, projecting: these viewing procedures are also epistemological procedures. The audience is not just a vessel into which information is poured. Rather, aesthetic strategies such as sophistication and multimodality produce interactions between viewer and data such that data becomes experiential. These experiences are epistemological and thus mold understanding of climate change and how it potentially comes to matter for individuals.

In addition to sophistication and multimodality, color and the aerial global map activate feelings as they visually mediate the data. To better understand this, let's pause the animation at recent years: 2017–2019. The average temperature in all zones is at or above the mean: at the equator, there is only a slight temperature anomaly; the change in the Arctic (90°N) can range from 6°F above the mean for 2017 to 2°F above the mean for 2019. The strip of gray girdling Earth's midline in the color map signifies little change, and splashes of yellow over Iceland indicate a 3–4°F change. Gray blanketing the oceans may mean that no observational inputs are available or that air temperatures are stable. In addition to toggling between many data elements, the viewer also compares the present back to 1971 and projects into a future—2100—just outside their lifespan. Travel out to 2050, a year some viewers will live to see and a frequent touchstone for climate planning, and the dominant palette of the map morphs: burnt orange in the Arctic; orange over northern Africa, the Middle East, central Europe, and parts of the United States and Australia; and yellow covering much of the rest of the globe. Travel further into the future, to the turn of the twenty-second century, and the planet will be on average 5°F warmer, with the northern latitudes entering the "red zone" of a ~15°F anomaly.

The specific color patches are key to making data experiential because color is scientific visualization's primary emotional stimulus. As the animation traverses the model period in one-year increments, it ranges through a familiar color scheme for representing temperature: from cerulean blue to fire-engine red, passing through the rainbow. The symbolism of these colors in this rainbow color map is so natural that they hardly feel like symbols at all. Naturally, blue connotes cold and red heat, we might think.[34]

As anthropologist Kirsten Hastrup notes, the vivid, naturalized palette of model visualizations lends them "a reality of their own," even for the modelers who make them and would temper claims to verisimilitude or realism.[35] Such colors are transparent because they seem to correspond to realities we experience; yet they also deliver powerful feelings. Therefore color is essential to the triggering mechanism of visualizations and is not just a practical device for differentiating temperatures. Red is not only hot in temperature; it is hot in temperament. It signals danger and provokes agitation and reaction.[36] By contrast, blue is pacifying.[37] It makes the data affective and thereby renders it experiential.

This color symbolism may seem too obvious to merit comment, but it has political weight in security and environmental debates. In the United States, the correlation between red and danger was revivified in the Department of Homeland Security (DHS)'s now-defunct terror threat alert system. Instituted after September 11, 2001, it codes the risk of a terrorist attack using red (severe), orange (high), yellow (elevated), blue (guarded), and green (low). As in the climate model, the colors red, orange, and yellow require response, or at least suggest response is preferable. Authors of the IPCC Fourth Assessment Report (2009) realized the catalytic power of these colors when they designed the "burning embers" diagram to measure the risk of climate change impacts. IPCC editors cut the diagram from the report precisely because they deemed the colors—ranging from white for very low risk and positive or minimal impacts through yellow and orange to red for high risks and extreme impacts—too incendiary.[38] In the "burning embers" diagram, as in the GFDL animation, the correlation between red, threat, and charged emotions outstrips the color's everyday association with temperature. Encountering climate data in these chromatically rich images, the viewer can forget this is a putatively instrumental scientific representation. The IPCC4 editors clearly wanted to dodge this diversion from fact into meaning in 2009, but the panel's more recent visualizations reintroduce the provocative color scheme. "Observed and Projected Changes in Annual Average Surface Temperature," a visualization appearing in the IPCC's Fifth Assessment Report on climate change impacts and risks, is based on updated emissions scenarios run through an ensemble of models (figure 1.5). It projects out to 2100, but relative to a mean established between 1986 and 2005 rather than 1971 and 2000 as in "Anomalies." The high-emission scenario on the right anticipates

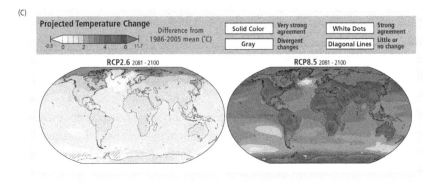

FIGURE 1.5. IPCC, "Observed and Projected Changes in Annual Average Surface Temperature," in *Working Group II Contribution to the IPCC Fifth Assessment Report (AR5), Climate Change 2014: Impacts, Adaptation, and Vulnerability. Summary for Policy Makers,* 2014. Courtesy of IPCC.

changes of 4°C to 11.7°C on all seven continents by the end of this century (note that the metric here is Celsius, not Fahrenheit as in "Anomalies"). In the 2014 image, fiery red blankets all of Earth's landmass. When we look between the low-emission and high-emission visualizations, we perhaps best feel just how agitating the pervasiveness of red can be. And we can speculate on the damages that such increases will wreak on human and more-than-human life.

The naturalized red-to-blue color scheme encourages viewers to treat design as transparent; that is, it gives the impression that the design transmits the data without subjective interference. However, paying attention to the emotional valences of color reminds us of this cultural shaping, or what art historian Erwin Panofsky terms "disguised symbolism."[39] The epistemological procedure for taking in the information occurs alongside the feelings the visualization's palette ignites. The chromatic features of "Anomalies" establish a baseline of urgency and planetary endangerment that, for U.S. audiences familiar with the DHS alert system, may also suggest national security threats. Yet this sense of urgency produces friction with the feeling of being overwhelmed; this friction between urgency and overwhelm is characteristic of climate model visualizations and of the discourse of climate crisis more broadly.

Like the color scheme, the aerial perspective on Earth in "Anomalies" feels natural but produces epistemological friction. Where color

naturalizes climate phenomena even as it alerts and overwhelms viewers, the aerial inspires a sense of mastery even as it reveals human limitations. As scholars of cartography attest, the use of the aerial in the West has a history that its ubiquity occludes, and much of this history corresponds to imperialist projects and Enlightenment values.[40] The aerial hails audiences as those privileged to know it all. If "climate simulations are based on the assumption that nature can be quantified," the aerial is based on the parallel assumption that Earth can be laid out for consumption.[41] Flattened for visual digestibility, the planet becomes apprehensible at a glance. But just as one cannot avoid uncertainty, error, and incompleteness when quantifying planetary systems in modeling, imprecision travels with the aerial. Parts of the globe necessarily distend in a two-dimensional view from above; the world becomes strange even as it is made visible.[42] Shapes distort at the lateral edges, and the heart of the Arctic and Antarctica, regions inevitably endangered by climate change, are not in view. With the aerial, "Anomalies" engenders a feature of visualizations that Thomas Nocke points out: "the tension of complexity of the data and the underlying knowledge on the one hand and the required simplicity of its visual analysis and representation on the other."[43] Epistemological dilemmas inherent to the modeling enterprise then unintentionally surface in the friction the aerial generates: the aerial veers away from mastery of the global space even as it strives for it.

Such unavoidable friction comes out when we pause to examine the emotional and epistemological effects of the aesthetic strategies of "Anomalies." These frictions, or what art historian Barbara Stafford terms "sutures," "force homogeneous data to exhibit its heterogeneity."[44] In the GFDL visualization, the sutures register that, as we explored earlier, models are necessarily heterogeneous artifacts of climate inquiry. On the one hand, the visualization's multimodality, color scheme, and use of the aerial suggest mastery over the climate datascape. The visualization depicts the latest climatological research the model aggregates, conveying trends and projections in temperature variation but also, as Edwards instructs, developing "new ways of thinking globally."[45] On the other hand, the very representational features that produce this knowledge emphasize the limitations to any effort to master and display climate data and disturbances.[46] These claims call up Hastrup's assertion that, while models are often taken as realistic and truth bearing, "there is a built-in humility in most

processes of climate modelling; they can never stand alone, and never claim to be more than approximations."[47] Visualizations unexpectedly record the elusiveness of mastery and can lead to a productive humility that counters anthropocentrism and environmental domination. At the same time, though, they can perplex viewers.

Bruno Latour views perplexity as a way that "the collective makes itself attentive and sensitive to the presence outside itself of the multitude of propositions that may want to be part of the same common world."[48] As Juliana Spahr's poem dramatizes, however, perplexity may not be terribly comforting. This is especially true in the face of a geophysical, ecosystemic, and existential threat like climate change. The visualization's multimodality, color scheme, and use of the aerial all contribute to the overwhelming feeling that leaves Spahr's initially inquisitive characters inert, "living and watching on a screen things far away from them melting."[49] It's not a stretch to imagine they viewing GFDL's animation online; watching as orange, red, and even purple splatter most of the globe; realizing that few refuges will remain by the end of their lives.[50]

In the information encounter that "Anomalies" creates, sophistication, transparency, and mastery compete with overwhelm, humility, and perhaps defeat. At first glance, the classical tradition of the sublime might offer a promising way for understanding this amalgam because the aesthetic category addresses the copresence of the overwhelming and a person's epistemological capacities. The category of the sublime readily surges to mind in the face of the warmer-than-ever temperatures of climate change that produce stronger-than-ever hurricanes and higher-than-ever storm surges. In addition to these geophysical and weather phenomena, the quantitative complexity of climate science invites thoughts of Immanuel Kant's accounts of the mathematical sublime in *The Critique of Judgment*.[51]

However, "Anomalies" and the disturbances it visualizes make clear that older aesthetic categories such as the classical sublime are not adequate to the responses these media elicit. Instead, they provoke a new sense of being overwhelmed that is related to this aesthetic emotion though varies from it by yielding a different end state. Kant's dynamical sublime well captures the sense of humility that I am arguing climate data and its visualizations produce.[52] The individual feels incapable of representing or overcoming the threat that a violent hurricane or a towering mountain poses. In the sublime, however, the individual arrives at a state of epistemological

satisfaction that goes beyond the knowledge of one's own limitations. Glossing Kant, Sianne Ngai argues the self arrives at an "'inspiriting' feeling of being able to transcend the deficiencies of its own imagination through the faculty of reason . . . and its feeling of autonomy from nature [*Critique of Judgment* §28]."[53] The sublime passes through an experience of epistemological limitation and even humiliation, but that is not its final resting state.[54] The Kantian account thus helps us elaborate the interplay between mastery and limitation. However, the closing note of the sublime is superiority while "Anomalies" and climate disturbance more generally keep mastery and limitation in competition without offering a definite victor.

We can identify several reasons for this misfit between the Kantian sublime and the epistemological and aesthetic experience that the visualization produces. First, climate change is an ongoing, if sometimes imperceptible, occurrence unlike the more singular events that yield the Kantian sublime.[55] Second, the mind does not definitively rise to superiority because one mind cannot tame this serialized, tentacular catastrophe that travels from far in the air to deep in the soil, from the reaches of distant oceans to the tissues of animals. In the climate emergency, inferiority and humility temper superiority and mastery without entirely erasing them. The suite of representational strategies studied here sets off a dynamic toggling between them. There is no triumphant recompense at the end of the overwhelming, no elevation of the human in the face of anthropogenic geophysical change, despite humanity's dazzling computational and technological acumen. What we get instead is a version of Ngai's "stuplimity," though without the linguistic stimuli that are central to her account. If Kant's sublimity travels from "shock" to "serenity," stuplimity involves "a concatenation of boredom and astonishment . . . of sharp, sudden excitation and prolonged desensitization, exhaustion, or fatigue."[56] We need only reread Spahr's "Unnamed Dragonfly Species" to see this result recounted. We can only hope that, as in Ngai's take on stuplimity, the experience might "mak[e] possible a kind of resistance."[57]

In GFDL's "Surface Air Temperature Anomalies," representational strategies make data experiential owing to the combination of epistemological and emotional work they require. Taken together, sophistication, multimodality, temporality, color, and the aerial activate procedures of thought without which the visualization's components could not make sense, and

these procedures dispose viewers emotionally toward the information that constitutes the object. My analysis conforms to other readings of climate models that examine their substrates and institutional contexts to conclude that they do not yield stable, incontrovertible knowledge but instead produce inquiry, discourse, and further refinement of model protocols and research agendas. My reading of "Anomalies," however, also adds that the emotionally charged epistemological procedures climate visualizations spark give data an emotional reality that is dependent on scientific information but also distinct from the realities it aims to capture. Specifically, these procedures enact a toggling between mastery and humility, between control and failure. On the one hand, the work's multimodality, color scheme, and aerial view suggest mastery over the climate datascape. The visualization depicts the latest stunning climatological research, conveying trends and projections in temperature variation. On the other hand, the very representational features that produce this knowledge emphasize our failure to fully grasp and represent climate data and environmental crisis more broadly. The information situation, like that of the imperiled planet, is not masterable. In short, the contradictions and tensions that are constitutive of the modeling enterprise surface in the aesthetic features of the model visualization.

CARBON CONSULTING: THE MATTER OF DATA

High-powered research centers like GFDL do not monopolize the practice of visualizing climate crisis; it has become a profit-driven enterprise for visualization consultancies as well. Clients for environmental visualization services range from universities and environmental groups like 350.org and the World Wildlife Fund (WWF) to municipalities and behemoth oil corporations like BP. The success of climate visualization consulting firms suggests that the media that government research labs produce are not always tailored to meet market and policy demands, which might involve branding, public relations, or developing long-range sustainability plans. If, as UK consulting firm Carbon Visuals puts it, "the climate actions of organisations and their people are . . . invisible or inaccessible [and] real change is lost in a haze of numbers and spreadsheets," then visualizations such as "Anomalies" can easily become part of the blur.[58] "Making the invisible visible" is the key task of firms like Carbon Visuals.[59] Whereas the GFDL

visualization makes data matter by making it experiential through aesthetic strategies that hold mastery and humility in tension, Carbon Visuals' products make data matter by giving it virtual mass. These commercial products deemphasize the scientific processes behind the data in favor of appeals to an unexpected cocktail of ordinariness and horror. In imagining what it might be like to be surrounded by solid, rather than gaseous, carbon dioxide, Carbon Visuals paradoxically creates a vision in which the human endangerment that clients hope to mitigate has already come to pass.

Carbon Visuals "creat[es] scientifically accurate volumetric images that help audiences make sense of data. We call this 'concrete visualisation'—an approach that provides quantitative insight physically."[60] In other words, the firm aims to produce insight into climate change by making data weighty, by turning it into (digital) matter.[61] Partnering with Environmental Defense Fund (EDF) in 2012, Carbon Visuals created a prize-winning suite of images and animations that depict the rate and extent of New York City's emissions based on data from 2010 (figure 1.6).[62] The animation was featured on numerous data blogs and in publications as varied as *Village Voice* and *Scientific American*. To "make sense of data," Carbon Visuals converted statistics about CO_2 emissions per second into a volume of the gas

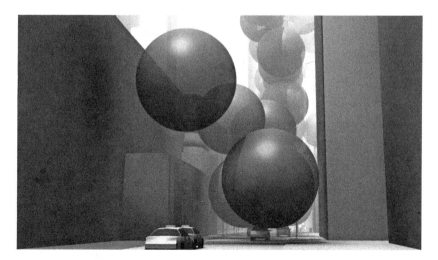

FIGURE 1.6. Carbon Visuals, still from "New York City's carbon dioxide emissions as one-tonne spheres." Flickr.com, 2012. Image permission via Creative Commons license, https://creativecommons .org/licenses/by/2.0/.

(its "volumetric" approach). By its calculation, "at standard pressure and 59°F a metric ton of carbon dioxide gas would fill a sphere 33 feet across (density of CO_2 = 1.87 kg/m^3),"[63] and New York City is emitting a sphere's-worth of CO_2 almost every second. Following on the analysis of climate models above, it is worth noting that the data itself does not come under scrutiny in these and most other commercial visualizations. Carbon Visuals assiduously cites an online encyclopedia from corporation Air Liquide for its information on the mass of CO_2, but climate science's complexities lie outside the visualizers' purview.

In the animation, spheres representing—or "concretising"—carbon bounce through New York's streets to ambient car noise and murmuring voices. We first hear these sounds before a title screen, colored charcoal and evoking hydrocarbon sources, relates data on the city's emissions: "In 2010 New York City added over 54 million metric tons of carbon dioxide to the atmosphere[.] That's nearly 2 tons every second." As each second of the animation ticks away, a translucent blue sphere materializes in a schematized New York City thoroughfare, sometimes popping out of a taxi's exhaust pipe. The statistic ceases to be an airy abstraction; instead, it disrupts the urban landscape by impeding traffic. Rather than employ a tool like Google Street View, which would place the audience in a specific, traceable Manhattan location, the designers create a schematic topography. The buildings resemble generic clay models, a strategy that can have divergent effects: for non–New Yorkers, the lack of specificity allows them to transpose the data onto their own streets; alternatively, it could render abstract—or, deconcretize—the very data Carbon Visuals wants to make palpable.

Though the animation eventually gives an aerial view of these buildings, it begins at street level. This ground-level perspective contrasts the world-from-above approach common to climate model visualizations and corresponds to this animation's more grounded, municipal scale. We're reminded that the global phenomenon of climate change is happening in our streets because of mundane behaviors like hailing a taxi rather than walking or taking public transportation. The caption to the film on YouTube repeats the 54 million metric tons per year statistic and equivocates, "but that number means little to most people because few of us have a sense of scale for atmospheric pollution." The scalar challenge of climate crisis is often expressed as its being "complex in its causality, widespread in its impacts," and stretching across centuries—even millennia when we consider the deep history of the

fossil fuels humanity burns today.[64] Carbon Visuals reminds viewers that humans must stretch our imaginations to apprehend how something invisible and required for life—CO_2—accumulates at scales that render human and more-than-human life precarious.

To overcome these scalar challenges and "engage the 'person on the street,'" Carbon Visuals gets down low and gives information mass. To make environmental change matter, it visualizes data *as* matter. However, though the designers give carbon statistics volume, they do not elaborate on why the numbers should concern us. For that information, a user must read the city's report on emissions, which is not linked on the YouTube or Flickr sites that host the visualizations and which includes only one sentence on the impacts of rising CO_2.[65] Instead of contextualizing the data, Carbon Visuals amasses it. Its aesthetic choices tackle infowhelm by giving data physicality but within the domain of the digital. This is more apparent when the street-level animation stops, and the next frames show hourly, daily, and annual emissions. When annual totals for 2010 reach 54,349,650 metric tons, the spheres have consumed lower Manhattan (figure 1.7). After only one day, the Empire State Building is nearly submerged in carbon molecules (figure 1.8).

FIGURE 1.7. Carbon Visuals, "New York City's annual carbon dioxide emissions as one-tonne spheres." Flickr.com, 2012. Image permission via Creative Commons license, https://creativecommons.org /licenses/by/2.0/.

FIGURE 1.8. Carbon Visuals, "New York City's daily carbon dioxide emissions as one-tonne spheres." Flickr.com, 2012. Image permission via Creative Commons license, https://creativecommons.org /licenses/by/2.0/.

In this sequence of frames, Carbon Visuals trades on the formal conventions of science fiction and disaster thrillers and applies them to urban climate futures. Undergoing mutant metastasis, carbon spheres suffocate the city's corridors while a soundtrack of ambient city noises—honking horns, tires swooshing on asphalt, murmuring voices, squawking seagulls, rushing wind—normalizes the extraordinary urban transformation taking place. Though the visualization does not detail the health effects of rising CO_2, viewers sense their own bodies are at risk from this uncontrollable accumulation. In this respect, the carbon data becomes medicalized, bringing information to the body.[66] The orbs resemble a cluster of insects or an alien invasion once they engulf skyscrapers. They thus call to mind not only science fiction films like *Invasion of the Body Snatchers* (1956, 1978) or *The Swarm* (1978) but also disaster films in which the destruction of a national monument symbolizes planetary endangerment, either from outer space as in Roland Emmerich's *Independence Day* (1996) or from environmental catastrophe as in his *The Day After Tomorrow* (2004). Key differences distinguish Carbon Visuals' imagined New York from the places these thrillers depict. First, the destruction is rendered mundane. Everyday noises and an almost toy-like abstract rendering do not immediately get the viewer's

heart pumping with suspense, anticipation, or fear. Second, this New York is already depeopled. Aside from those faint murmurings in the soundtrack, there is no evidence of human life. This could well be a vision of a future in which autonomous cars shuttle around town without human drivers or even passengers. EDF, which commissioned the firm to make the animation, advocates staunching the flow of carbon dioxide into the atmosphere, and the text supplementing the visualization emphasizes New York's successes in this effort thus far. Yet the image presents a world without us that suggests mass human extinction is a fait accompli.[67] The film traffics in the defamiliarizing potential of science fiction films that show bodies rendered alien by invaders or disaster films in which iconic landscapes turn to rubble. At the same time, however, its abstractions can mute the threat of the emissions it visualizes.

The playful quality of the floating spheres and the toy-like topography may offset the urgency of crushingly high levels of CO_2, but, as the visualization materializes data in line with sci-fi and disaster films, both popular genres of threat, it removes human bodies. In concretizing CO_2 and disappearing bodies, "New York City's Emissions" underlines a feature of visualization that Rita Raley finds in new media about speculative capital: "this seeming antinomy of materiality and virtuality."[68] In its mission to render environmental data less abstract, Carbon Visuals activates the antinomy Raley identifies. Like the visualizations of market capital she studies, the climate visualization materializes an intangible element—CO_2—into blue spheres. It thereby alludes to the paradox that molecules that are odorless, tasteless, and invisible to the eye when in their gaseous state have outsized ecological, social, and physical—indeed, geophysical—consequences when overabundant. The project activates this dynamic between the material and the immaterial in the domain of the virtual. By disappearing humans, it affirms that the data of climate change anticipates an end state of human engulfment. However, that end state, which EDF and Carbon Visuals work to prevent, has already come to pass.

Relaying quantitative information about climate crisis, the visualization activates affective ways of knowing. Sensations of suffocation and the horrors of invasion and extinction crowd out the science lurking behind the statistics and the lived impacts of runaway greenhouse gas emissions. If GFDL's "Anomalies" created a data encounter that was overwhelming because of the visualization's sophisticated multimodal composition,

cartographic projection, and color scheme pointing toward a refugeless future, Carbon Visuals' animation virtually materializes data and overwhelms by showing that humans have already succumbed to our own emissions. Employing strikingly different representational strategies and emerging from institutions with varying intentions and investments in climate discourse, both visualizations indicate that climate information exceeds our mastery. They do so through the very aesthetic strategies designed to manage that unruly data.

FOOTPRINT CALCULATORS: THE QUANTIFIED CARBON SELF

The globe, the city, the individual. All three entities are implicated in climate visualizations precisely because of the pervasiveness of climate crisis. Though these domains are implicated in all visualizations, the imaginary of each object operates at its own scale: the globe for "Anomalies," the city for "New York City's Emissions," and, as I demonstrate here, the individual for carbon footprint calculators. Popular data visualizers aspire to devise objects that "represent the personal subjective experience of a person living in a data society."[69] The carbon footprint calculator approaches this mission by putting climate threat directly into the wallets of users imagined as consumers and carbon emitters.[70] According to environmental historian James Turner, the World Resources Institute created the first online calculator in 2001.[71] The U.S. Environmental Protection Agency, environmentalist groups such as the Nature Conservancy, and even known environmental criminal BP offer carbon calculators to the curious consumer and internaut.[72] The popularity of these tools arguably rose as the internet entered more individuals' homes and as technologies made possible the notion of the "quantified self." A burgeoning trend—perhaps even a movement—the quantified self is the subject understood *as* data. How many calories did I consume snacking at work? How many miles did I bike, and what was my average heart rate during the trip? How productive am I between 2:00 P.M. and 3:00 P.M.? How does my blood-glucose level fluctuate throughout the day? Smartphones and other wired devices enable constant monitoring of individual behaviors to generate data self-portraits. Carbon calculators add another packet of information to the personal database: how much carbon dioxide went into the atmosphere to get that burger to my plate? To get me to a friend's wedding across the country? To

air condition my home in a blistering Texas summer? Calculators are inter-
faces between the data of climate crisis and the consumer actions that help
fuel it. Rather than just experience data, the individual becomes it.

Calculating *ecological* footprints predates *carbon* footprinting by about
a decade. The former measures the capacity of the planet to renew itself
given human resource use. More technically, ecological footprinting "mon-
itors the combined impact of anthropogenic pressures that are more typi-
cally evaluated independently (CO_2 emissions, fish consumption, land-use
change, etc.) and can thus be used to understand the environmental con-
sequences of the pressures humans place on the biosphere and its compos-
ing ecosystems."[73] Ecological footprints are expressed spatially, in terms of
hectares or acres of land required to provide the food, water, energy, shel-
ter, and other amenities that different communities require for their life-
styles. They "communicate the existence of physical limits to the growth of
human economies" and provide a scalable instrument for comparing con-
sumption between entities (e.g., the United States and Brazil) and for devel-
oping offsetting programs in which designated lands become sinks for
greenhouse gas (GHG) emissions.[74] Ecological footprints thus conceive of
the planet as quantifiable in line with modeling but have a specific outcome
in mind: balancing the ledger so that the Earth can continue to meet human
demands on resources.

Carbon footprint calculators use a different metric for expressing
their results: tons of CO_2 emitted per annum. They offer "a measure of the
exclusive total amount of carbon dioxide emissions that is directly and
indirectly caused by an activity or is accumulated over the life stages of a
product."[75] The rub here is in the distinction between "direct" and "indi-
rect."[76] For many climate researchers and sustainability analysts, the most
accurate calculator would include both kinds of emissions, but most of
the instruments, especially those available to curious consumers online,
fall short of this ideal because they exclude indirect outputs. So when a
user inserts how often they fly or how many kilowatt hours of electricity
their home appliances use, the tool typically does not account for vapor
trails from commercial jets that change the atmosphere's energy balance,
or whether the user's electricity comes from a coal-, hydro-, or natural gas–
powered plant. Because some calculators include indirect emissions while
others do not and because they run on different algorithms, they produce
remarkably variable results. For example, according to CoolClimate I emit

11 tons per year, while the Nature Conservancy puts me at 20 tons.[77] Turner attests that early examples of the tool employed "the simplest methodology," that is, "estimating the carbon footprint for electricity consumption, household heating, and travel."[78]

Though riddled with gaps, "the carbon footprint [is] seemingly concrete"; it provides "data an individual could act on," data that appears to have scientific and computational integrity.[79] What has been a tool for establishing baseline metrics from which to develop sustainability policy and climate mitigation strategies has now moved into the personal sphere and become a tool for quantifying the self. More specifically, carbon calculators make climate change a matter of personal budgeting. Unlike climate model visualizations, carbon calculator visualizations situate climate threat in a narrative of personal economic prosperity. It figures users' contributions to GHG emissions as a drain on household finances as much as a drain on fossil fuel reserves, land use, and ecosystem vitality.

The fiscal focus of footprinting is apparent in the Global Footprint Network (GFN) calculator. This nonprofit consultancy appears frequently in the scholarship on footprinting.[80] Established in 2003 and based in Oakland, California, and Geneva, Switzerland, GFN calculates clients' contributions to climate disruption and, for a fee, advises on how to minimize them. Its target clients are nations, cities, and businesses, but it has a prominent web presence that puts it before a wider public. GFN's calculator, or "resource accounting tool," "measures how much nature we have, how much we use, and who uses what."[81] The group defines the carbon footprint as "demand on biocapacity required to sequester (through photosynthesis) the carbon dioxide (CO_2) emissions from fossil fuel combustion. . . . [It] includes the biocapacity, typically that of unharvested forests, needed to absorb that fraction of fossil CO_2 that is not absorbed by the ocean."[82] GFN computes one's carbon footprint and then translates that number into an ecological footprint, one of the few open-access calculators that is a hybrid of the two calculator types. It converts a GHG emissions number (e.g., 25 tons of CO_2 emitted per year) into consumption of the planet, telling users how many Earths are necessary to soak up their hydrocarbon outputs.

Reflecting this methodology, the version of the calculator I first used in 2015 begins with the question, "How many planets do we need if everybody lives like you?"[83] The user then creates an avatar as she would when playing a video game and builds a world out of consumption patterns. The

avatar walks through a graphical background that incorporates elements
of the city and the country—a skyline, a stream running through a field,
rolling hills—as her resource-intensive life takes shape to the sound of
ambient music (figure 1.9). The input data gets translated into images of
the objects that produce the emissions: in my case at the time, a small
house powered by electricity, an airplane jetting overhead, a bicycle at a
bus stop, a market featuring produce to reflect a vegetarian diet, recycling
bins. A cluster of graphical representations then appear on the screen:
icons showing the number of Earths these activities consume (3.7, in my
case); the number of "global acres of the Earth's productive area" required
(16.6); and a breakdown of the footprint into the categories of food, shelter,
mobility, goods, and services.

GFN's ultimate goal is to make the metric of carbon emissions as cen-
tral to policy making and business planning as gross domestic and gross
national products currently are. To this end, it produces a detailed Ecologi-
cal Footprint Atlas that breaks down the pressures on planetary capacity
for 150 nations and displays the data by region. This comparative analysis
exemplifies a key practice and output of calculators: standardization and
comparison. Calculators provide a standardized datum that can circulate
so that users can compare themselves to others and take action outside of
what Turner terms "calculative space."[84] As of 2016, the most recent data

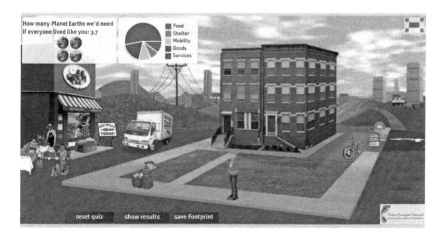

FIGURE 1.9. Global Footprint Network, "Footprint Calculator," 2015, http://www.footprintnetwork.org.
Courtesy of Global Footprint Network.

GFN makes available, the average American consumed almost five times more resources than the Earth can replace or, in the case of carbon dioxide, absorb.[85] This figure easily shatters optimism for mitigating the impact of human activity on the planet.[86] Yet GFN eschews despair by making data experiential in an interactive visualization that emphasizes play and agency. With these attributes, personal footprint calculators resemble the instructive games and "rational recreations" that Barbara Stafford studies in that calculators continue the tradition of "popular education as amusement."[87] The ludic aspects of the GFN tool temper the sense of inevitable failure to balance one's way of life with Earth's regenerative capacities.

Interactivity and play underscore another feature of the calculator that alleviates negative feeling: its individualist focus. GFN offers people measures they can take to live a leaner carbon existence while also fattening their bank accounts. In comparison to climate model visualizations, calculators are prescriptive rather than projective. The user is accorded agency with the invitation to "explore *simple* actions to change your Footprint." It's worth noting that, after agreeing to undertake all the actions listed, I reduced my footprint by only 0.1 Earth, a paltry reduction that suggests that living in the United States—no matter one's choices—exceeds the planet's biocapacity. Despite this, the tool correlates inputs and outputs and thereby implies that environmental disturbance is as manageable as a household budget.

GFN's concept of carbon footprinting may position the individual within the planet's processes of balancing energy, but the calculator has a narrower orientation. The tool visualizes data that has meaning insofar as it reflects well or poorly on the user. The calculator's prescriptions for combatting overconsumption parallel responses to other metrics of self-quantification such as weight, cholesterol, and credit score. Adopting "*simple* actions to change your Footprint" is akin to frequenting the gym and attending a diet group to shed pounds, or using budgeting apps and other tools to get an excellent credit rating. In this respect, the GFN calculator shares a family resemblance with genres of personal accounting and self-help such as the diary, checkbook, and how-to manual. This footprint calculator then glides between the ludic and the confessional. Users must expose, if only to themselves, habits whose effects carry downstream and across the jet stream. Even eco-conscious Americans cannot deny that those occasional

transcontinental flights accumulate to outweigh so-called green behaviors that give the illusion of carbon minimalism.

Personal carbon footprint calculators ultimately body forth a *homo economicus*. The person of carbon calculators is an economic being whose behaviors are quantifiable and thus available for improvement. This is especially notable in the EPA calculator, which expresses emissions as pounds of CO_2 as well as expenditures and savings in dollars. GFN's metric of Earths consumed tempers this economic orientation but does not abandon it entirely. It too hails an economic subject whose agency can halt the dilated effects of past and current behaviors. Crucially, agency gets expressed at the level of the *oikos*. Calculators make planetary threat palpable by quantifying it at the household scale of dollars and cents. The temporal focus of calculators contributes to this sense of domestic control. Carbon calculators punctuate actions in the now that can make you a quantifiably "better" person.[88] They are pegged to a continuum of individual human time. Measuring carbon footprints in terms of the regenerative powers of the Earth puts one in planetary time, yet the calculator paints a picture of a lived present extending only as far as the next electric bill or quarterly financial statement rather than back into the deep past or forward decades or centuries, as climate model visualizations often do. The temporal frame of these calculators works with their ludic and confessional attributes to counteract pessimism. Even as the GFN calculator describes GHG emissions as a release of fossilized matter, it does not acknowledge the protracted nature of emissions' effects. Specifically, calculators gesture toward but do not address a knotty time problem within climate ethics: the individual won't reap the rewards of present GHG asceticism.

This is where the shoe pinches. Present CO_2 reductions will do little for those currently living on the planet because the carbon cycle moves to tempos different from human lifecycles. As geoscientist David Archer notes, "After several centuries when the oceans have inhaled their fill, a significant fraction of the fossil fuel CO_2 will remain in the atmosphere, affecting the climate for millennia into the future."[89] In the final analysis, the agency that GFN's calculator accords its users presumes an individual person operating on their own time scale. With its tight focus on quantifying and cultivating a self—a consuming self above all else—the calculator elides the geophysical whole that is larger than the sum of its individual parts.

The outcomes of the carbon footprint calculator propose that the power to control elevated GHG concentrations is in our hands, in our purse, and on our clock. Compared to "Anomalies" and "New York City's Emissions," the calculator brings climate change data closest to home. The gap between data and experience closes as these devices walk a user through a year in their CO_2 life and delineate a kind of climate agency. Data and experience fuse here to the extent that we see ourselves *as* climate data, and climate data *as* us. Though they quantify CO_2 outputs and planetary stresses created by even efficient lifestyles, the emotions that result from calculators are not necessarily despair, fatalism, or alarmism. Well-defined, if not terribly efficacious, paths to a trimmer carbon lifestyle replace the sense of inevitable carbon overload produced by the refugeless maps in the "Anomalies" visualization. The GFN calculator's temporal scope, ludic aspects, and resemblance to genres of quantification, confession, and self-improvement privilege control and containment. This contrasts the cocktail of emotions one experiences through GFDL's and Carbon Visuals' visualizations: overwhelm, humility, and contradiction, in the former, and ordinariness, threat, and engulfment, in the latter. Ultimately, carbon calculators appease anxiety about planetary consumption by putting the Earth under the same forms of control as personal economy.

The spectrum of representational strategies and generic conventions that climate change visualizations employ—multimodality and interactivity, views from space and from the street, normalized color schemes and depeopled landscapes, calculation and confession—activate the affectivity of data. They make knowledge move. Climate visualizations are not self-evident translations of scientific data, nor are they "mere" cultural constructions. Their aesthetic approaches and media components make data experiential to produce climate knowledge that, while dependent on scientific information, deviates from its sources. Climate visualizations thus reveal as much about the emotional trajectories of the forms information takes as they do about the state of the planet's biological, chemical, and geophysical systems. In the next chapter, information takes the form of prose narratives, and knowledge moves as protagonists become data processors embedded in sociocultural milieu that are in friction with Eurowestern climate science.

COMING-OF-MIND IN CLIMATE NARRATIVES

In Juliana Spahr's "Unnamed Dragonfly Species," verbs of perception, cognition, and interpretation track the protagonists' state of everyday worry. They heard, watched, read, tried to see, wondered, remembered, realized, thought (even "could not stop thinking"), figured out, knew. In the end, "they were anxious and they were paralyzed by the largeness and the connectedness of systems."[1] This declaration marks the dénouement of the poem. The business-as-usual ending may be deflating, but the poem represents a process of what I call *coming-of-mind*, that, deflation aside, provides its own narrative satisfactions. "Cli-fi" has come into its own as an object of critical and popular attention.[2] The coming-of-mind plot is a significant mode within cli-fi, a corpus of stories primarily defined by thematic attention to climate change impacts. Coming-of-mind plots turn protagonists into climate data processors and thereby make data personal. As they encounter the climate infowhelm and bewildering transformations to the environment, these characters simultaneously undergo processes of intellectual development. If the visualizations I studied in chapter 1 make data experiential, the novels and memoir I study here play out frictions between data and experience that climate information generates.

In isolating the coming-of-mind narrative mode, I propose reading climate fiction not as science fiction, as cli-fi enthusiasts often have, but as a fiction *of* science. These texts unfold processes of knowing overwhelming

but also beguiling and contested climate science and thereby approach science as essential to positioning the self in relation to social formations, whether they revolve around gender, class, race, profession, or geography. Approaching this literature as a fiction of science pushes at the seams of "fiction" and focuses analysis on creative climate writing writ large. Therefore this chapter analyzes novels—Barbara Kingsolver's *Flight Behavior* (2012) and Michael Crichton's *State of Fear* (2004)—as well as science writing—Charles Wohlforth's *The Whale and the Supercomputer: On the Northern Front of Climate Change* (2004). We can slot these books into the genres of, respectively, regional realism, popular thriller, and science memoir, but their shared efforts to depict protagonists' encounters with data and to narrate the entangled epistemologies of climate change connect them across these generic differences. The term *coming-of-mind* intentionally evokes a more familiar genre: the bildungsroman, those "long narrative[s] concerned with a fictional individual's maturation," or coming-of-age.[3] I use the framework of the bildungsroman not to offer a new typology of that genre but to import into cli-fi study its attention to individuals' ongoing processes of positioning themselves relative to the values dominant in the social groups to which they belong.

Franco Moretti argues that, starting in the eighteenth century, the person in a bildungsroman is typically—and crucially—a youth at an "age which holds the 'meaning of life'" and, at this critical juncture, either achieves "a stable and 'final' identity" or "cannot and does not want to give way to maturity."[4] The path to a stable identity may not be smooth even if the person does arrive there. As Patricia Spacks notes, the person may feel "the melancholy of [social] conformity" yet conform nonetheless.[5] Coming-of-mind in the infowhelm extends the maturation process into adulthood, after characters have already achieved an identity but find it rocked by climate crisis. In Kingsolver, Wohlforth, and Crichton, characters' identities as mother, science writer, and lawyer, respectively, are remade as gaps or errors in their knowledge emerge. In this respect, coming-of-mind plots demonstrate that "formation" sometimes runs in reverse: the "'final' identity" is revisited and even remade. This is because earlier springs, melting ice, record temperatures, and the threats to local ecosystems and economies unsettle the structures in which those identities took shape. Epistemological identity and planetary survival become the stakes for twenty-first-century coming-of-mind plots. Instead of creating "an image of man

growing in national-historical time," Mikhail Bakhtin's angle on the bil-
dungsroman,[6] this mode creates an image of women and men growing in
the geological timescale of the Anthropocene. Environmental transforma-
tion prods intellectual transformation. When people become processors of
climate data, epistemological dilemmas soon follow: What counts as evi-
dence? What sources for data can we trust? Whose knowledge "counts"?
On what scale is climate information meaningful? These questions are as
based in scientific information as they are in emotion, social position, and
aesthetic form.

Epistemological dilemmas present representational challenges; it's in
working through these challenges that climate literature explores the limi-
tations and possibilities of various strategies that are at once epistemologi-
cal and aesthetic. Kingsolver, Wohlforth, and Crichton incorporate cli-
mate information through analogy, generic hybridity, and graphical
interpretation; these strategies animate frictions between data and experi-
ence, between environmental knowledge and social identity. Creatively
managing scientific information, the coming-of-mind mode of cli-fi does
not so much resolve these frictions as use infowhelm to champion episte-
mological values of plasticity, intuition, and so-called common sense.

PLASTICITY THROUGH ANALOGY IN *FLIGHT BEHAVIOR*

In Kingsolver's *Flight Behavior* the coming-of-mind plot develops in tan-
dem with a regional domestic plot in the fictional Appalachian town of
Feathertown, Tennessee. "Maturation" neatly characterizes the process at
work here despite deviations from some bildungsroman conventions: the
protagonist is well past adolescence, scientific information goads develop-
ment, and the redemptive outcomes of fitting climate knowledge to iden-
tity are not assured. Akin to the heroines in Susan Fraiman's study of the
women's bildungsroman, Kingsolver's protagonist, Dellarobia Turnbow,
"scal[es] . . . an intellectual summit" against strong headwinds of marital
domesticity. Her "struggle between rival life stories" begins after her mar-
riage plot is already fulfilled and leaves her wanting.[7] The means by which
Dellarobia reconciles the facts of environmental science with her rocky con-
jugal life drives the story of *Flight Behavior*. This reconciliation takes place
through Dellarobia's strategy of making analogies that expose tensions
between climate information and sociocultural and economic conditions.

Analogies stress that the epistemological value of plasticity is essential to addressing this tension within U.S. climate politics.

Kingsolver's novel is ostensibly about companion disruptions to home and ecosystem. The book's first sentences make a universalizing pronouncement redolent of the nineteenth-century novel: "A certain feeling comes from throwing your good life away, and it is one part rapture. Or so it seemed for now, to a woman with flame-colored hair who marched uphill to meet her demise."[8] Initially, personal rather than environmental conditions elicit this part-rapturous emotion. Dellarobia is a twenty-eight-year-old mother of two who is confined to a failing town and a failing marriage due to a teen pregnancy. She is "throwing [her] good life away" by meeting a potential lover at a shack in the woods her husband's family owns. En route to the tryst, a throbbing mass of color arrests her attention. A subsequent visit reveals the sight to be a colony of North American monarch butterflies hanging from the trees like a curtain that is as flame-colored as Dellarobia's hair. The colony is startling for its brilliance but also for being an anomaly: Dellarobia is witnessing a rare mismigration. The butterflies have traveled to Tennessee instead of their usual wintering grounds in central Mexico. In the five months the novel spans (November 2010 to March 2011), Dellarobia transforms from a drifting housewife and frazzled mother into a community college student and assistant to the biologists investigating the monarchs.

A paratextual "Author's Note" separates climatological fact from fiction. A 2010 flood in central Mexico mentioned in the story did occur, but the monarchs' errant migration to southern Appalachia is Kingsolver's invention (435). Or, at least, it's an invention for now. The mismigration is a bellwether of anthropogenic climate change and not a glitch in one population.[9] Ovid Byron, the visiting lepidopterist who studies the insects, offers three anthropogenic changes that could be causing the phenomenon: overexposure to the pesticides used to contain West Nile mosquito populations that have surged owing to rising temperatures; infection from a parasite that flourishes in heat; and "devastation in the 'spring range,' . . . a funnel-shaped area" running through Texas "ransacked by drought" (350). Settling in Tennessee, the monarchs herald climate dangers and endanger themselves. One hard freeze could kill the creatures before they reproduce. In addition to the monarchs' strange flight behavior, weird weather constitutes the

novel's environmental imaginary. Rains of biblical proportions and balmy December days make the news in Feathertown. If the monarchs incite awe and confusion, living in a world where "sensible seasons had come undone" incites melancholy and despair in local residents (49). To signal these emotions, the narrator medicalizes the season: "after a brief fling with coloration [the trees] dropped their tresses in clumps like a chemo patient losing her hair. A few maroon bouquets of blackberry leaves still hung on, but the blue asters had gone to white fluff and the world seemed drained" (49).[10] Kingsolver blends actual and invented environmental changes to create a cocktail of unsettling emotions and implies that today's fiction will soon be tomorrow's fact.

Analogy enables Dellarobia to make sense of these disruptions and align them with her religious, social, and economic circumstances in Feathertown. The device, which is at once rhetorical and epistemological, accommodates the outsized scale of climate crisis. The text answers historian Dipesh Chakrabarty's call for imaginative climate representations that "use the metaphoric capacity of human language" to fill the gap between the emotional and the geophysical. He treats simile as one mechanism for ground-truthing climate data, for moving from scientific explanation to humanistic, historical meaning.[11] In the charged atmosphere of climate politics, analogy enlivens deadening data. During the so-called climate filibuster of March 10–11, 2014, Massachusetts senator Edward Markey trotted out another medicalizing trope for climate disaster: Earth as sick human body. "The planet is running a fever," he insisted, "but there are no emergency rooms for planets. We have to engage in the [sic] preventative care so that we deploy the strategies that make it possible for our planet to avoid the worst, most catastrophic effects of climate change."[12] In Markey's analogy, mitigation is to prevention as adaptation is to emergency care; the first action is unquestionably preferable to the second. In this example of climate-altered Earth as fevered body, simile helps understanding by provoking emotion. Analogies provide answers to the question, "How does and could climate change feel if it proceeds unimpeded?" The rhetorical device aligns scientific information with the bodies of those affected by that information and introduces the ethical and embodied stakes of data. In Dellarobia's hands, analogy also reveals compatibilities between opposing identities and knowledge communities and affirms plasticity.

The trope of flight behavior provides an overarching analogy linking the novel's domestic and environmental plots. Dellarobia's flight behavior—hurtling toward sexual gratification at the expense of her family—is likened to the monarchs' migration northward to find mating partners that diversify the genetic makeup of the colony. Of greater interest to me here, however, is the work of analogy in the protagonist's climate coming-of-mind.

Along with strong emotion and vivid color, simile saturates the first pages of *Flight Behavior*. With the opening glimpse of the butterflies, Dellarobia abandons her adulterous meeting and takes in the dazzling scene. Her epistemological journey has begun. "These things were all over, dangling like giant bunches of grapes," she observes (12). The narrator, focalizing Dellarobia, tries on another figure for describing the curtain of orange as if the first didn't suffice: "*Fungus* was the word that came to mind" (12). The associative brain entertains other relations that domesticate the wild phenomenon: "Fungus brought to mind scrubbing the mildewed shower curtain with Mr. Clean" (12–13). This comparison is satisfying because it scales it down and brings it into the home, but it doesn't fully satisfy; the vision is too disruptive for Mr. Clean. Next, the trees "were like nothing she'd ever seen, their branches droopy and bulbous"; "unreal, like a sci-fi movie" (13). The housewife again assimilates the otherworldliness of the scene to her experience when she observes, "the trunks and boughs were speckled and scaly like trees covered with cornflakes" (13). As familiar as cereal and cleaning products, as disorienting as an alien, the anomalous migration provokes miniature thought experiments through analogy. The similes that fill the opening pages do not resolve into a single "x is like y" statement but instead skip between possibilities. The instability of the analogies is even more apparent as the chapter concludes. The monarch curtain "was no forest fire," Dellarobia thinks (15), but four pages later, fire is the best available simile: "Dellarobia wondered if she looked as she felt, like a woman fleeing a fire" (19).

Accumulating similes, *Flight Behavior* is a contemporary rejoinder to the Aristotelian theory of relation as moving from a stable idea to a new destination. Philosopher Jeffrey Brower explains that "Aristotle's preferred name for relations is just 'things toward something' (*ta pros ti*)."[13] Dellarobia's hopscotch through similes rejects the unidirectionality of this account of relation. Vehicles are not "applied" from one phenomenon to another.

Environmental apprehension here requires multidirectional thought. Her similes range across domains of experience—the household, pop culture, elements and objects in nature—and, because the analogizing process is so searching and protracted, they expose the limits of experience. With this use of analogy, *Flight Behavior* aligns more closely with Michel Foucault's *The Order of Things*, wherein the device has the power to "extend, from a single given point, to an endless number of relationships." It "makes possible the marvellous confrontation of resemblances across space; but it also speaks . . . of adjacencies, of bonds and joints." The most important point for Foucault and for my analysis of the device's epistemological and aesthetic functions is that the similarities that analogies reveal come from "visible marks" in the objects but are also grounded in "uncertain glimmer[s]" in nimble minds.[14]

Flight Behavior's analogies, displaying those glimmers and the "marvellous confrontation of resemblances," describe alterations to flora and fauna correlated to climate crisis, but they are also one of the literary pleasures the novel offers, as compelling on their own as its stories of environmental disruption and domestic discontent. The possibilities for analogy only expand further when Dellarobia becomes an apprentice scientist. Analogies then create an exchange between scientific discourse and more lyrical expressions of the colony's errant migration. When temperatures fall, Dellarobia and the lepidopterist Ovid head into the hills to survey the effects. Ovid has earlier explained that "large trees are protective; the trunks create a thermal environment like big water bottles. That's why you see [the butterflies] covering the trunks" when winter advances (226). The water bottle simile resurfaces when Dellarobia observes the butterflies sticking to their arboreal heat source: "She thought the words *thermal mass*, picturing the solid pelt of butterflies clinging to the great columnar trunks of the firs, which Ovid had described as giant water bottles" (249). She rolls the technical term "*thermal mass*" around in her mind. Terminology turns to picture with the help of the remembered analogy. This sentence, and the use of analogy more generally, equates "flight behavior" with entangled epistemologies: these mental flights travel from the specialized vocabulary of science to imagination, memory, and everyday experience.

While *Flight Behavior* advocates for the mental flights that are on display in this scene, the narrative also plants warnings about emotion-laden experience in nature supplanting other modes of understanding species

disruption. Specifically, it suggests that wonder can both expand environmental interest and misdirect it.[15] When she goes to see the enigmatic curtain of color a second time, before Ovid and his team arrive, the emotion reignites Dellarobia's latent inquisitiveness. As a child, she had irked lazy teachers who would rather be coaching basketball than answering a curious student's questions about physics. Yet wonder temporarily constrains the mind as well. She chastises herself for having failed to recognize what was always right under her nose. Fragmentary sentences emphasize the mind's struggle to admit inconvenient ideas:

Wings. The darts underfoot also were wings. *Butterflies.* How had she failed to see them? . . . She'd been willing to take in the run of emotions that stood up the hairs on her neck, the wonder, but had shuttered her eyes and looked without seeing. The density of the butterflies in the air now gave her a sense of being underwater. . . . Every tree on the far mountainside was covered with trembling flame, and that, of course, was butterflies. She had carried this vision inside herself for so many days in ignorance, like an unacknowledged pregnancy. (52–53)

The passage evokes the sublime, with Dellarobia's feeling of being submerged and overcome by the "unbounded, uncountable." As with the climate model visualizations studied in chapter 1, the feeling of sublimity leads not to a sense of human cognitive superiority but to a sense that perception and thought are easily hobbled. The upshot is that a powerful feeling like wonder can cloud sight and insight. The concluding simile renders Dellarobia's error more serious by equating this failure of sight with the failure of foresight that led to her first miscarried pregnancy. As she takes in more scientific information on climate impacts, she will craft analogies that bear feelings that sometimes aid and sometimes jam environmental understanding. This early scene models how analogy can integrate wonder, desire for scientific "truth," and lived, embodied experience.

As if in answer to Dellarobia's desire to both look and see, Ovid Byron, a Jamaican-born ecologist, appears at the Turnbow homestead to study the butterflies and becomes her tutor. Lepidopterists such as Ovid have long pursued the question of how monarchs seem to be born just knowing their colony's migration routes. The mismigration to Tennessee revises the question: Why did the creatures get it wrong this time? Ovid detects Dellarobia's interest in this question and, over time, invites her to learn the

methods of the field with his research team. *Flight Behavior* precisely details how she counts butterflies in demarcated regions of the forest and uses a centrifuge to measure the fat content of deceased monarchs. At home she and her five-year-old son, Preston, consult old encyclopedias, ask elders what they know about the local environment, and dip into "the river of all knowledge" that flows through Google and iPhones (425). Incorporating specialized and everyday modes of data collection, the novel provides fodder for one of its central points, here put by geographer Noel Castree: "What counts as 'evidence' and what passes for 'relevant knowledge' are necessarily *relative* to the diverse and debatable values and goals that different societies hold dear."[16] In conversational duets between Dellarobia and Ovid during their fieldwork, the novel reveals the diverse values and goals Castree stresses and, in the process, builds epistemological, environmental, and sexual tension.[17]

The scientist sets up temporary residence in a trailer behind the Turnbow house, just one of his stops as a cosmopolitan researcher. From Kingston, Jamaica, educated at Harvard, and professor at the University of New Mexico, the black scientist researches monarchs throughout the hemisphere and appears untethered to person or place. By contrast, the white, poor, female homemaker did not attend college, has never left the state, and rarely crosses the town line. Her life is defined by family, church, and lifelong friends, all of whom share her racial, religious, and socioeconomic positioning. Their scientific conversations are occasions when the protagonist's experiential horizons expand, and Dellarobia must make choices about how she will accommodate new information. Conversation is an occasion for scientific information and sociocultural difference to interact, triggering the coming-of-mind plot. As sociologist Kari Marie Norgaard shows, conversation "can help people understand their relationships to the larger world or obscure them. It can engage the sociological imagination, that 'quality of mind necessary to grasp the constant interplay between our private lives and the political [and environmental] world.' Conversation can also do the complete opposite."[18] Dellarobia comes to adopt Ovid's intellectual and emotional investments in environmental science, but, when her sociological imagination is engaged, she must pause because the friction can be too great. Analogies enter to show how she oscillates between the experts' understandings of climate crisis and the sociocultural meanings it holds for struggling Appalachians like her.

Dellarobia is an epistemological chameleon. As she learns about butterfly ethology and climate change, she is in dialogue with herself as much as she is in dialogue with Ovid and the scientific consensus he represents. Her mind shifts shapes in her encounters with scientific information, but she retains core aspects of her identity throughout. The first conflict with her extant values emerges when Ovid explains the butterflies' entwined migratory and mating habits. As the "'complicated system' began to take hold in her mind," she sees the creatures as "not just an orange passage across a continent, . . . not like marbles rolling from one end of a box to the other and back" (146). The negating similes that describe her mind's movements resolve into an affirmative but still disquieting comparison: "This was a living flow, like a pulse through veins. . . . The sudden vision filled her with strong emotions that embarrassed her. . . . How was that even normal, to cry over insects?" (146). Specialized information such as diapause (cessation of sexual maturation) and storm mortality (mass die-off in a cold snap) entangles with analogies based in the home and the body, which yield powerful but discomfiting emotions. *Flight Behavior* underscores the affectivity of Dellarobia's climate coming-of-mind through metaphors that hold devastation and beauty in tension, as when she observes, "If these butterflies were refugees of a horrible misfortune, there could be no beauty in them" (143). While collecting data in the field, Dellarobia realizes the butterflies are a dreadful splendor. This is just one of the moments when the narrative oscillates between declaring the species' "terminal" status and appreciating its "irresistible" allure (282). The epistemologically and emotionally dense analogies hold together these dual feelings of despair and delight. They subtly propose that ground-truthing data can be an aesthetic affair but not always an easy one. Dellarobia's scientific education is also an affective one; training in what it is appropriate to feel and for what.

"Intense emotions" do not, however, immediately bend Dellarobia to Ovid's conception of climate change. Encounters with butterflies and data about them goad her coming-of-mind plot, but this journey does not follow a linear path. The information-deficit—or "public understanding of science"—hypothesis does not hold. As anthropologist Candis Callison explains, these phrases capture "the sentiment that if the public only knew more facts, or 'all' the information, they would be compelled to act on the ramifications and potential impacts [of climate change]."[19] (I examine Ovid's adherence to this model below.) *Flight Behavior* dramatizes the

limits to this sentiment through Dellarobia's situated and circuitous coming-of-mind in which climate information is socially uncomfortable and difficult to assimilate. When Ovid utters the phrase "climate change," "she knew to be wary" and retreats to "the vision that moved her, an orange flow of rivulets reaching over a continent" (147). Wonder again serves as a diversion, here from the disruptive information Ovid bears. What Ursula Heise describes as "the clash between the cultural meanings of the butterflies' arrival—their aesthetic appeal, their suggestion of divine presence, their power to alter the course of human lives—and its ecological meanings—species loss, climate change" jams a simple model of environmental knowledge production in which information leads to awareness and action.[20] Personal and sociocultural factors can mute as well as amplify expert scientific information.

Those factors, however, also produce a different kind of expertise. Through Dellarobia and Ovid's tête-à-têtes, *Flight Behavior* undoes the dyad that positions Ovid as the environmental expert and the locals as vessels for knowledge. While Dellarobia starts out not knowing nature if it bit her, in her words (4), the labors that the other Turnbows perform—raising sheep, laying gravel, and dyeing yarn using local plants—are environmentally dependent. As sheep farmers, they take their cues for when to shear and mate the herd from the weather. They must replenish their supplies of gravel before heavy rains erode roads and driveways. Hester, Dellarobia's mother-in-law, has accumulated knowledge of the region's flora that accrues authority when Ovid's team is searching for flowers whose nectar can sustain the colony through a freeze. Ovid had "call[ed] this place 'poor in winter flower'" (341), but the Turnbow matriarch proves him wrong when she spots a flower named, appropriately, "harbinger" (347). Spotting one harbinger with Hester's assistance, Dellarobia's eyes open to the floral abundance in what had previously seemed barren woods.

And yet the novel proves that lived relations to one's environment do not necessarily or immediately turn environmental threats into priorities. In this respect *Flight Behavior* complements sociological and psychological theories for why a gap remains between climate data—and even environmental experience—and strong measures toward climate mitigation and resilience.[21] In fact, the novel is a quite deliberate repository of theories the audience for Kingsolver's best sellers might not encounter otherwise. Distraction is the most mundane obstruction to climate action. On no fewer

than eight occasions, the narrative mentions Dellarobia's husband's compulsive channel surfing to suggest that eroded attention spans account for the gap between climate research and public response.[22] Television is one source of distraction from ecological endangerment, but economic threats make more urgent demands on attention. If Ovid and his assistants lose sleep over the extinction of insects due to a weirding climate, locals lose sleep over unemployment and looming foreclosures. Other reasons for climate inaction are even knottier than stresses on attention. First among them is the difficulty of inhabiting multiple scales at once. Variations in spatial scale organize *Flight Behavior*'s chapters. The titles first rise—from "The Measure of *Man*" to "Talk of the *Town*" to "*Global* Exchange"—and then descend in a revised lexicon—from "Circumference of the *Earth*" to "Natural *State*" to "Perfect *Female*," traversing the scale of Bakhtin's "national-historical time" and spatial scales from the region to the planet. For Dellarobia, responsibilities that emerge at the smaller scale, those of being a mother, wife, friend, and daughter-in-law, outweigh existential threats that cross "town," "state," and "earth." She puts this sentiment succinctly when she exclaims to Ovid, "I'm not saying I *don't* believe you, I'm saying I *can't*." He responds, "For scientists, reality is not optional" (283). For the cosmopolitan male scientist, life in southern Appalachia is subordinate to data-based ecological realities, but Feathertown is a place where economic and ecological threats must share the spotlight. Lest readers assume only people in Dellarobia's circumstances fail to scale up their concerns, the novel reminds readers of humans' tendency toward presentism: "There's some kind of juice in our brains that makes us only care about what's in front of us right this minute" (428).[23] The monarch's wayward migration, though a bellwether of climate disturbance, does not endanger human survival in the near term and instead attracts tourist traffic and dollars. And here we have another obstruction to climate action: the argument that a warming world brings financial benefits, if only for some.

In addition to attention deficit and presentism, the novel alludes to cultural framing and cultural cognition to explain climate inaction. Dellarobia concisely defines the former theory: "People can only see things they already recognize. . . . They'll see it if they know it" (282). Feathertowners also cannot "recognize" climate change because of entrenched allegiances and cultural cognition, that is, the "disposition to conform one's beliefs about societal risks to one's preferences for how society should be

organized," which derive from identification with a group.[24] In *Flight Behavior* neighbors, conservative radio, Fox News, and Christian pastors articulate the community's normalized values. These theories constitute the *social* scientific infowhelm that Kingsolver embeds into the narrative as a companion to the cascade of natural scientific information. The novel thus heeds Callison's advice to attend to "the ways in which [climate] facts are produced and circulated and the vast networks and affiliations where individuals negotiate and determine positions, identity, and meaning, often in conjunction with a wider group process."[25]

Crucially, *Flight Behavior* does not merely rehearse and popularize the research on the social dimensions of climate action; it also contributes to it. Through one woman's coming-of-mind, it entertains analogies that bring climate information to the body and into the home; the analogies become a way to negotiate "positions, identity, and meaning" in a sociocultural milieu that initially rejects anthropogenic climate change. Rather than endorse the idea that, in the narrator's words, "there were two worlds here, behaving as if their own was all that mattered. With such reluctance to converse" (152), *Flight Behavior* instead forces conversation. Analogy amounts to mental experimentation that demonstrates the value of epistemological and social plasticity, of trying on positions that irritate internalized norms.

The experimental function of analogy manifests throughout the book, but it is particularly evident in an exchange between Dellarobia and Ovid over whether human intervention can solve the colony's increasingly desperate plight. A Feathertown resident has offered to truck the butterflies to Florida before a freeze decimates them. Dellarobia jumps at the offer, but Ovid dismisses the proposal condescendingly: "It's really quite touching, the good intentions" (316). She pushes him to explain. "An animal is the sum of its behaviors. . . . Its community dynamics. Not just the physical body" (317). Dellarobia glosses this statement: "What makes a monarch a monarch is what it does, you're saying" (317). Ovid goes on to explain that the butterflies migrate to mix their genetic material with conspecifics from other parts of the continent. In this conversation about genetic integration, conceptual and epistemological mixing takes place between the white Appalachian mother and the black cosmopolitan researcher. Dellarobia builds on Ovid's point but paints the creatures' behavioral patterns in colors she sources from her life: "I get that. . . . Like mostly swapping your

goods at the secondhand store in town, and then once a year doing the international-trade thing at the dollar store" (318). The dollar store analogy perches Dellarobia on the pivot between house-holder and biology student, between local knowledge and ecological infor-mation. It also brings economy and ecology under the same sign in a novel—and a national climate discourse—that is animated by these concerns. In *Flight Behavior* analogy also smuggles ethics into the scenes of scientific tutelage and defies the scientific value of neutrality. In the absence of other proposals for saving the butterflies, Dellarobia clings to the truck owner's offer. Ovid disavows the role of monarch messiah she would like him to fill. " 'It's not my call. . . . I'm not here to save monarchs. I'm trying to read what they are writing on our wall.' Dellarobia felt stung. 'If you're not, who is?' . . . 'That is a concern of conscience . . . Not of biology. Science doesn't tell us what we should do. It only tells us what *is*' " (320). Just as Dellarobia's sociocultural affinities can block climate acceptance, Ovid's allegiance to science glues him to the "public understanding of science" model: that "information is all we have" and that information refers to a verifiable "real-ity" free of economic, ideological, and domestic pressures (322, 283). If locals focus only on *that* the butterflies have descended on Feathertown and not the climatological reasons *why*, he focuses on *why* and not on *what* the event demands ethically, economically, and socially. Eventually Ovid dis-avows this cut-and-dried separation of science and "conscience." By that point, Dellarobia's coming-of-mind plot has beat him to the realization that facts have a "communal life,"[26] that culture, ethics, and needs entangle when ways of knowing confront ways of being.

Instead of marking a bright line between worlds, the characters' inter-actions place scientific, domestic, and regional cultures into conversation. They traverse what Callison terms "vernaculars," those "interpretive frame-works by which a term comes to gain meaning within a group and the work of translation that such a term must undergo in order to integrate it into a group's worldview, ideals, goals, perceptions, and motivations to act."[27] Dellarobia balks at the phrases *climate change* and *global warming* because they are vilified in her interpretive frameworks. The work of trans-lation required to fit them into her vernacular takes place through analo-gies in which ecological ignorance becomes an unwanted pregnancy, and monarch mating becomes thrift store shopping. Dellarobia is a human boundary object in these exchanges, one of those "scientific objects which

both inhabit several intersecting social worlds . . . and satisfy the informational requirements of each of them."[28] She brings the "social world" of research science into contact with the worlds she occupies as working-class Appalachian, mother, and churchgoer. Like the boundary objects Susan Star and James Griesemer describe, she remains "plastic enough to adapt to local needs . . . yet robust enough to maintain a common identity across sites."[29] Because all the social hats Dellarobia wears constrain in some way, she continually reshapes extant social worlds as she enters new ones. Moreover, in her data encounters, she articulates epistemologies associated with each group in terms of the others. She is the node where lepidoptery, climate crisis, weird weather, domestic discontent, and labor and socioeconomic precarity meet. Scientific information is not rigid and imperturbable, we learn; it reacts with the sociocultural and economic realities of working-class life in recession-era Appalachia.

Flight Behavior relays scientific information about climate impacts for their own sake but, crucially, also feeds that information through Dellarobia's mind to process. Information becomes raw material for analogy as an act of seeing-as that engenders epistemological plasticity. Just as the narrative takes the conventions of the bildungsroman as modifiable, adapting them for conditions of twenty-first-century environmental crisis, so too does it take the facts and methods of environmental science as adaptable to sociocultural, personal, and economic circumstances. While good similes alone cannot demolish divisions between climate deniers and climate hawks, *Flight Behavior* advocates their role in plasticity, an epistemological value requisite for bringing conflicting parties to the same table.

INTUITION ON THE ICE IN *THE WHALE AND THE SUPERCOMPUTER*

In Kingsolver's fictional Feathertown, expert scientific information integrates with local knowledge. Traversing the boundary between these knowledges, Dellarobia's similes register the epistemological and social plasticity that could make climate information meaningful and acceptable for varied communities. In *The Whale and the Supercomputer* (2004), author Charles Wohlforth stands as a participant-observer of the dance between expert and local knowledge of climate disturbance, a dance that is as relevant to the book's Arctic setting as it is to Kingsolver's Appalachia.

Wohlforth's science memoir details how communities of indigenous peoples, white Alaskans, and nonresident researchers produce environmental knowledge in one of the regions most endangered by climate disturbance.[30] A longtime resident of Alaska and nonfiction writer, Wohlforth documents the myriad methods and technologies for apprehending climate change in the U.S. Arctic. The sticking point in *The Whale and the Supercomputer* is not denialism or skepticism as it is in *Flight Behavior*; the protagonists have no doubts that anthropogenic climate change is well underway and harming human and more-than-human life in the North. The question is how to integrate the epistemologies operant in the region.

Most of the book's action transpires in and around Barrow (Utqiagvik in Iñupiaq, the language of the Iñupiat people), at the northern tip of Alaska, in May 2002. Wohlforth arrives at the "sharp boundary between the manageable terrestrial kingdom of dry land and the invisible wilderness of the sea" to shadow Iñupiat whale hunters.[31] The winter of 2001–2002 brought remarkably high temperatures and, with them, remarkable thinning and separation of shore ice.

The book eventually addresses these phenomena, but its opening scenes unfold a drama of environmental management that is also an epistemological drama. Controversy over the International Whaling Commission's decades-old moratorium on whale hunting is heating up along with the air and sea. The consensus among marine researchers holds that the bowhead whale population faces extinction, but indigenous hunters see things differently. Their experience on the ice indicates that bowhead numbers are robust, and they petition for hunting to resume. To settle the matter, the local Department of Wildlife Management has allocated millions of dollars for a whale count based in established positivist science. Researcher John Craighead ("Craig") George is tasked with cooperating with the Iñupiat, but he arrives "skeptical about the whalers' claim. . . . 'We frankly were taught we were scientists and we were doing stuff scientifically, carefully, and the other information was anecdotal' " (19). *Anecdotal*: a derisive term for this researcher who is accustomed to the scrutiny of funding agencies and peer reviewers. For the hunters, however, anecdote is an epistemological tool as valid as the databases scientists use to record the whale count. The intergenerational observations and narratives that *anecdote* captures triumph over quantification in this epistemological contest. To the Iñupiat the multiyear project "amounted to a lot of trouble (and $10 million) to find

out something they already knew" (22): bowhead are not at the edge of extinction. The count succeeded in reopening whaling as well as opening the Wyoming scientist's eyes to the need "to accept that there was another valid way of knowing complex facts about the environment" (22).

The Whale and the Supercomputer (hereafter, WS) opens with this anecdote about the importance of anecdote to present the entangled epistemologies of climate crisis. Knowledge of Arctic disturbance from global warming requires diverse sources, yet integrating these sources often produces friction. Anthropologist Kirsten Hastrup explains that this occurs because, among other reasons, "people act upon climate change within particular knowledge spaces" in which configurations of labor reinforce relations to physical space that have become naturalized within particular knowledge regimes.[32] Indigenous peoples, white Alaskans, and international researchers hold differing views on what counts as expertise, experiment, evidence, and even knowledge, but they all constitute the knowledge space of the U.S. Arctic. Wohlforth's book, like Kingsolver's, delivers specialized information on climate crisis but also uses that information as the material for a nonexpert's coming of mind through information encounters. The first-person narrative melds the modes of memoir, ethnography, and popular science writing, modes that figure prominently in the archive of creative climate writing.[33] This diversity of literary modes instantiates WS's claims for epistemological diversity.

The coming-of-mind mode in Wohlforth's text is less indebted to the bildungsroman tradition than it is in Flight Behavior, but WS shares that novel's task of assembling diverse knowledge communities and playing out tensions between them by way of an individual's epistemological journey. Values might diverge within the Arctic knowledge space, but easy dichotomies also do not hold. There are no villains here. Instead, Wohlforth emphasizes the interdependence of what might seem disparate "epistemic cultures," Karin Knorr Cetina's term for "those amalgams of arrangements and mechanisms—bonded through affinity, necessity, and historical coincidence—which, in a given field, make up how we know what we know."[34] The author-protagonist's coming-of-mind develops as he charts the traffic between these "amalgams" in a place where whales and supercomputers occupy the same waters.

The book strives throughout to coordinate traditional methods of knowledge production with those of Big Science. In the latter instance, we find

technologies such as climate models familiar from chapter 1 and positivist methods of data collection and analysis similar to those Ovid performs in *Flight Behavior*. In the former instance, we find methods of local knowledge production like those Hester demonstrated in Kingsolver's novel. Often referred to as traditional, indigenous, or traditional ecological knowledge (and abbreviated as TK, IK, or TEK, my usage below), this is "a cumulative body of knowledge, practice, and belief, evolving by adaptive processes and handed down through generations by cultural transmission, about the relationship of living beings (including humans) with one another and with their environment."[35] Methods of TEK are lively, based in embodied actions— whether for sustenance, profit, or cultural meaning—and integrate humans with more-than-human nature. Anthropologist Julie Cruikshank cautions that, as TEK is "gaining new visibility," we must be careful not to view it as "static, timeless, and hermetically sealed"; that is, as a kind of indigenous curiosity that gets treated "as an object for science rather than as intelligence that could inform science."[36] *WS* takes account of the ecological processes, physical labors, and social relations that constitute TEK as a form of "intelligence" as it comes into contact with Eurowestern scientific ways of knowing. In line with Callison, Chie Sakakibara, Kyle Powys Whyte, and others who examine interactions between TEK and positivist climate change studies, Wohlforth establishes that "the line between scientific and traditional knowledge is less stark" than strict categorizations would suggest.[37] This line dissolves in Wohlforth's book through a process of coming-of-mind in which TEK and positivist information become integrated knowledge systems.

The chapter entitled "The Supercomputer" is the center of gravity for Wohlforth's intellectual maturation. Though the book takes a catholic stance toward knowledge sources, computational modeling comes in for scrutiny because, as we saw in chapter 1, it drives current research on climate impacts and brews controversy. Examining the individuals and processes that make models run, Wohlforth defines the utility and limits of positivist epistemologies. He ultimately proposes an alternative to the computational model: model as a type of person, specifically a person conceived as an intuitive supercomputer embedded in human networks.

As chapter 1 demonstrated, models boggle in their complexity. To impress readers with just how overwhelming they are, Wohlforth enumerates their operations during a visit to NOAA's Climate Monitoring and Diagnostics

Laboratory (CMDL) in Barrow. This may be "an ordinary office" (141), but the text introduces it using dramatic, mysterious tones. The approach to the CMDL building is disorienting, an effect that is even more troubling given the enormity of CMDL's purpose.

> In failing light under a low overcast, the table-flat plain of snow faded into the sky as a single, colorless blue-gray, without features or depth, upon which this squat rectangular box of a building seemed to float out of context. . . . Humanity was in the process of deciding the future of all living things through its use of energy stored in hydrocarbons. How fitting it seemed that this outpost, where the information critical to that choice was gathered, balanced in a shapeless void on the edge of the world. (141)

The featurelessness of the facility corresponds to the uncertainty humanity faces as it hurtles toward a climate emergency. The blurriness of the scene also anticipates the author's eventual skepticism toward modeling. To build models that bring more precision to the climate picture, those working in the building "started at the beginning, with conservation laws of momentum, mass, and energy, the first of which could be found in Sir Isaac Newton's *Principia Mathematica*" (152). Wohlforth speaks here in the vernacular of Eurowestern science: in the beginning, there was Newton's grand synthesis. From this starting point of physical laws, thousands of lines of code incorporate "equations that reflected everything that affects the climate: radiative heating and cooling; convection; gas chemistry; energy absorption and transparency; atmospheric pressure; wind; turbulence near the ground; humidity; condensation; freezing; snow albedo; sea ice albedo"; and more (152). After enumerating all these data sources, Wohlforth repeats a commonplace we saw in the specialized literature on models: for how sophisticated they incontestably are, they cannot paint a mimetic picture of climate systems or predict futures.

His take on the practice is a bit more biting, though: computational methods are too insular and abstract. Though the author scrutinizes both indigenous knowledge and Big Science, he is particularly suspicious of the latter here because models seem to discount TEK and assume authority over Arctic climate knowledge. He laments that "rather than being dedicated to understanding the natural world in itself, a career spent studying a process in nature attained value for its potential to add lines of computer code to a

GCM [General Circulation Model]" (153). "The audacity of the enterprise" astounds Wohlforth; it does not adequately acknowledge the "fundamental knowability limit" that constrains comprehension of ice and other essential metrics of climate disturbance (152, 167). With the phrase "natural world in itself" quoted above, Wohlforth suggests that people can gain unmediated access to environmental processes, or at the very least have more direct contact with them. In practice, though, WS depicts the many forms of mediation that make the workings of nature accessible. For example, field scientists may use technological sensors to measure temperature and ice thickness while Iñupiat hunters may record these variations through the body, narrative, and mapping and render them meaningful by "reinforc[ing] their cultural relationship with the bowhead whale to better cope with an unpredictable future."[38] Modelers stand at the furthest remove from the environment since they remain in their cubicles, pursuing projects incomprehensible to all but a few specialists. A mathematical language supplants a verbal one because "the work was so abstract that words couldn't handle it" (163). Modelers thus cut off the discursive and communal ways of knowing that constitute climate knowledge. Suspiciously extralinguistic and eluding the grasp of a dedicated pupil—that is, Wohlforth himself—modeling prioritizes quantitative epistemologies at the expense of others.

Though elsewhere he details how computational and embodied ways of knowing intermesh, in "The Supercomputer" chapter he contrasts modeling's quantitative methods to knowledge derived out on the ice. What might seem like an inconsistency in fact reflects WS's coming-of-mind plot, which is concerned with how we can best perceive and comprehend changes to climate systems and not whether those changes are occurring. As in Callison's study of climate change, for Wohlforth "questions . . . morph from what it is to who can speak to/for/about climate change."[39] Against the insularity and hubris of modeling that Wohlforth finds at the CMDL, WS proposes inclusivity and receptivity.

Wohlforth uses the term "intuition" to capture this epistemological shift in climate knowledge. Intuition has demeaning associations that could minimize the epistemological depth and breadth of TEK and reinscribe the priority of Eurowestern science. This is because it has been called on to contrast negatively those epistemologies based in rationalist logic, measurement, objectivity, verifiability, and the like. Despite these negative associations, I retain the word that Wohlforth uses but clarify that it is not

opposed to positivist epistemologies. Rather, intuition encompasses and enlarges them. It includes the methods of indigenous knowledge that Whyte enumerates:

systems of monitoring, recording, communicating, and learning about the relationships among humans, nonhuman plants and animals, and ecosystems that are required for any society to survive and flourish in particular ecosystems which are subject to perturbations of various kinds. Indigenous knowledges range from how ecological information is encoded in words and grammars of Indigenous languages, to protocols of mentorship of elders and youth, to kin-based and spiritual relationships with plants and animals, to memories of environmental change used to draw lessons about how to adapt to similar changes in the future.[40]

The "instruments" sensing these changes may not be made of metal or silicon, but they sense nonetheless and yield so-called data that affords shareable accounts of environmental conditions and their disturbance. In Wohlforth's coming-of-mind plot, this knowledge joins up with fieldwork by climate scientists and computational modeling to produce what he terms intuition. Intuition thus names an Arctic knowledge space built from an amalgam of perceptual, embodied, and socially discursive information, as well as technological and positivist data. Recording a process of intellectual formation, WS disabuses readers of the idea that intuition is somehow innate and devoid of intelligence. It arises from those skills of "monitoring, recording, communicating, and learning" Whyte cites and thus must be cultivated through inquisitiveness, attention, calculation, and conversation across media and modalities.

Intuition is at once grounded and expansive. Grounded because it requires "sensual contact of our physical selves with the real world" (184) as well as intergenerational contact through language and story. Expansive because one acquires and exercises this capacity through unpredictable contact with humans and more-than-humans. The necessity for bodily contact presents a parallel between Wohlforth's and Dellarobia's coming-of-mind stories. However, in contrast to *Flight Behavior*, which is laden with similes to propose analogy as a crucial epistemological value, WS makes its case for intuition through ethnographic study of people working on the ice. Wohlforth relates the story of a whaling captain who "has to size up complex, changing ice conditions in a matter of seconds. He needs

to think faster and better about ice than any computer can" (191). As those who live and labor on the ice confront the information of nature, intuition takes precedence over measuring and calculating using the tools of technoscience. Wohlforth opposes this kind of judgment built on experience to "rigorous analysis" in this passage, explaining that it calls on one "to recognize a situation rather than figuring it out" (191). The author-protagonist missteps here in contrasting the methods of local and indigenous knowledge to "rigor." Though it may be true that the "real world" rarely allows sufficient time for measurement and calculation, these situations still call on "rigor" of another sort. It is the rigor of hours of learning ice conditions, currents and winds, and the effectiveness of responses while performing the work and listening to peers' and elders' narratives. When intuition guides climate knowledge, data collection, knowledge production, and decision making become integrated operations.

While intuition inheres in an individual—just as plasticity inhered in Dellarobia in *Flight Behavior*—this epistemological device is not an individualist one. The practice is refined among the Iñupiat based on "over a thousand years of subsisting from their environment. In a language perfectly suited to the problems it addressed, they held long talks in camp. . . . New ideas and technology were adopted when they worked, and old ideas were discarded when it was clear they didn't help" (192). As in *Flight Behavior*, conversation again emerges as a vital practice, one that integrates the person into a community of knowers. Housed in a person but arising through collective methods, "intuitive understanding of the ice was the product of many minds" in Utqiagvik (192). Such methods are essential to climate justice. As Whyte contends, they can generate strategies for addressing climate crisis in ways that "bring together Indigenous communities to strengthen *their own* self-determined planning for climate change" rather than subject communities to colonizing forms of climate adaptation.[41]

As the book develops, the antagonism between TEK and positivist science continues to turn to integration. Wohlforth's meeting with polar climatologist Jim Maslanik cements the idea that "both scientists *and* Native observers can effectively operate with *both types* of knowledge."[42] The "qualitative, intuitive, holistic . . . oral" and the "quantitative, rational, synchronic" are not as incompatible as they might appear.[43] WS introduces Maslanik as a specialist on the varieties of ice in the Alaskan Arctic who both listens to what "the ground tells us" and relies on technologies for

measuring elusive ice (199). He employs microwave sensors on NASA satellites, low-flying aircraft, and ice measurements and core samples that are then studied under microscopes, all instruments and methods familiar to positivist climate science. But observations from Warren Matumeak, an Iñupiat elder, stand on equal footing with this high-tech sensing equipment. At seventy-four years old, Matumeak has decades of experience whaling and hunting polar bear and served as the borough's planning director. He can tell that, in his words, Maslanik and his team have "got a long way to go" when it comes to detecting the subtleties and complexities of the "layers, movements, and changes" in ice over time (90). As in *Flight Behavior*, where Hester Turnbow guides the lepidopterists to the native flora that can sustain butterflies through an erratic winter, in *WS* longtime inhabitants of the region register climatic transformations that elude the instruments of technoscience.

By no means easy, the integrative, multimodal ice research that Matumeak and Maslanik perform redresses the narrowness of modeling. It also nudges Wohlforth's coming-of-mind because it salves the frictions between the cultures and epistemological frameworks that meet in the Alaska Arctic. The intuitive approach in which TEK and positivist research converse "recultures" climate, an effort climatologist Mike Hulme encourages for Eurowestern audiences in response to "the dominant articulation of climate . . . as a . . . reality revealed through enumeration and constructed through statistical and mathematical manipulation." When climate is *de*cultured, it "becomes removed from its imaginative, historical and cultural anchors, whilst offered in its place is a new category of climatic 'realities' emerging from abstracted weather statistics or from supercomputers."[44] In contrast to computation's unmooring effects, the integrative approach Wohlforth encounters in Utqiagvik culturally "anchors" climate study because it entangles the scientific epistemologies that require sensors, satellites, and supercomputers with indigenous epistemologies that require embodied observation, memory, story, and history. Climate researchers will not unplug their computers anytime soon—nor should they—but the most important processing units for apprehending climate change are "inside individual human beings, in their minds and in their bones" (278).

In Utqiagvik Wohlforth identifies an epistemological situation in which the totality of a person's experiences melds with community memory and practices to produce knowledge superior to the most sophisticated model.

This is the person as supercomputer. Or, more precisely, as an embodied computer wired into a wider network.

Craig, the whale researcher, first provides the computer metaphor that accrues significance after Wohlforth's visits with the various climate researchers and indigenous whalers in the region. Craig describes the Iñupiat community as "a giant machine gathering and crunching data. . . . 'There's conversation, conversation, conversation back and forth, and there's this statement that comes out: "We know this." They're taking in massive amounts of data' " (23). The "data" collected through subsistence fishing and cultural activities on the land is longitudinal and, as Callison notes, often strays from the timeline "interlopers" impose:[45] "Outdoors, communication among many observers—hunters and fishermen—created a continuous picture of a large area, an area far larger and for a duration far longer than the measurements taken by any scientific team going into the field for a few weeks at a time" (23). Individual relations with the land feed into a conversational knowledge exchange within the network of Utqiagvik residents. Experiential data from direct contact with the land enters community exchanges; a person becomes an information node in a social and ecological network within which knowledge and the meanings of climate change circulate. The trope of mind-as-computer is well grooved into popular Eurowestern imaginaries of the brain, but WS lends the trope extra poignancy by contrasting it to modeling as an enterprise that abstracts and disembodies knowledge about a culturally and environmentally complex place. Through profiles of individuals who exemplify intuition such as Warren Matumeak and the seventy-year-old Iñupiat hunter Thomas Itta, Sr. (278), WS's coming-of-mind plot arrives at personal computing of a peculiar sort: one where a person "runs" intuition composed of somatic experience integrated with a community of learners and the tools of technoscience.

Just as intuition requires consulting maps, model scenarios, and peer-reviewed papers as well as breathing in the warming air and palpating the shifting ice of a disrupted ecoregion, representing this process of intellectual formation requires a form that integrates scientific information on climate change with anecdote, memoir, travel writing, ethnographic reportage, and technological history. This diversity of modes formally instantiates the book's epistemological values. That is, as the coming-of-mind plot unfolds, the narrative becomes what that plot promotes: an amalgam of

inputs that both records and exemplifies the epistemological diversity required "over and above the weight of facts by themselves" in order to understand and plan for climate change.[46] There is undoubtedly a sticking point in Wohlforth's promoting the epistemological value of intuitive "personal computing": can one hone this tool only when on the ice in the Far North? What are the options for the reader who is strapped for cash or time, or who is averse to emitting CO_2 in order to see the impacts of overemitting CO_2? The book's memoiristic mode at least partially answers for this problem. The book trusts that the next best thing to somatic experience is reading the first-person account of an individual's data encounters. But with this point, we return to the preface and the paradoxical takeaway of Juliana Spahr's "Unnamed Dragonfly Species": for many of us, especially for internet users in the Global North, climate crisis is a highly mediated phenomenon, even when it is unfolding all around us. Both Spahr and Wohlforth suggest that those mediations still have the power to prompt journeys of intellectual formation in which epistemological values like intuition can take shape.

COMMON SENSE THRILLS IN CRICHTON

Kingsolver's and Wohlforth's climate narratives depict encounters with the climate infowhelm that produce friction between epistemologies and cultures. *Flight Behavior* and *WS* do not so much offer new theories explaining obstructions to climate action as employ literary devices—notably, analogy and generic hybridity—that promote epistemological values required for climate knowledge. The realist novel and scientific memoir I have studied here are certainly not the only literary genres devoted to climate representation. We might also look to farce (e.g., T. C. Boyle's *Terranauts*), graphic documentary (Philippe Squarzoni's *Climate Changed*), science fiction (Octavia Butler's *Parable* series), fantasy (N. K. Jemisin's *The Broken Earth* trilogy), speculative horror (Jeff VanderMeer's *Southern Reach* trilogy), or YA fiction (Saci Lloyd's *The Carbon Diaries* series).[47] To conclude, however, I briefly study how a best-selling novel within a popular genre—Michael Crichton's thriller *State of Fear* (2004)—turns protagonists into processors of the climate infowhelm. Denying the fact of anthropogenic climate change and its impacts, Crichton's novel attempts to debunk climatologists'

arguments and activists' calls for progressive policies. It contorts the epistemological values of plasticity and intuition toward common sense understood as an unimpeachable, individualist practice. *State of Fear* shows the exigency of studying literature of all genres for its representation of how epistemologies form, endure, and become susceptible to disturbance.

State of Fear "may well be the most important climate change novel yet written," according to literary critic Adam Trexler.[48] It has sold millions of copies worldwide, and climate denier and U.S. senator James Inhofe called Crichton to provide evidence against the scientific consensus on climate change to the Committee on Environment and Public Works in 2005.[49] The novel develops a coming-of-mind plot as the protagonist processes scientific data through Socratic dialogues with researchers and through visualizations embedded in the text, all of which aim to shake readers' trust in climate research and activism. Crichton plants characters that are clearly his mouthpieces, but a paratextual "Author's Message" eliminates any ambiguity about his convictions.[50] It also positions the novel as a coming-of-mind narrative. Crichton writes, "I have more respect for people who change their views after acquiring new information than for those who cling to views they held thirty years ago."[51] We should be clear that he acknowledges that "atmospheric carbon dioxide is increasing, and human activity is the probable cause" (676). He doesn't deviate from scientific consensus here. But the message goes on to say, "We are also in the midst of a natural warming trend that began about 1850, as we emerged from a four-hundred-year cold spell known as the 'Little Ice Age'" (676). Warming is moderate, he insists, and higher atmospheric CO_2 concentrations are not correlated to it. The next century might bring another Little Ice Age or, in the unlikely event that temperatures do rise (by at most 0.812436°C in Crichton's estimation [677]), the picture will be rosy: "I suspect that the people of 2100 will be much richer than we are, consume more energy, have a smaller global population, and enjoy more wilderness than we have today. I don't think we have to worry about them" (678).[52] Given this, the book asks, why is there a global warming panic? The answer is that the press and environmental organizations have joined forces to mount a "global warming sales campaign" that leverages fear for advertising dollars and bigger donations (291). Big Green nonprofits have corrupted environmental science by turning it

into a business and turning researchers into mercenaries who must deliver desirable, marketable results.[53] If a lesson of *Flight Behavior* and *WS* is that information is always "interested" in the sense that it is shaped by race, gender, culture, economics, and geography, *State of Fear* takes a different approach to "interest," claiming that it amounts to deliberate manipulation of data to serve the economic and professional goals of scientific, environmentalist, and media organizations. Promoting a version of common sense against such interestedness, Crichton correlates common sense to business-as-usual approaches to climate crisis. The novel sets up scenes in which individualist common sense prevails and denies that anthropogenic climate change requires a rethinking of dominant ways of life in the United States.

These claims thread through the two modes between which the novel oscillates: high-octane thriller and coming-of-mind story. A key player in both plots is Peter Evans, a lawyer for George Morton, the wealthy benefactor of the National Environmental Resource Fund (NERF). When Morton unexpectedly withdraws support for NERF and disappears in a car accident, Evans and Sarah Jones, Morton's personal assistant, set off to discover the reasons for his change of heart and suspicious death. They end up trailing a network of "eco-terrorists" who use military-grade technologies to induce extreme weather events meant to incite fear about climate change (302). Throughout this action drama, Evans receives a contrived education in global climate research that is meant to deny scientific consensus while promoting individualist common sense. Though *State of Fear*'s ecopolitical commitments diverge radically from Kingsolver's and Wohlforth's, the books converge in their use of scientific data and methods as resources for a narrative of intellection formation.

Dozens of graphs visualizing datasets from climate and meteorological agencies sprinkle the novel. The graphs are fodder for dialogues that set off Evans's epistemological journey and reveal *State of Fear*'s fallacious views on climate change. One hundred pages into the seven-hundred-page book, Evans plays the role of a potential juror in a pending lawsuit. NERF and a Pacific island nation, Vanutu, are suing the U.S. Environmental Protection Agency for failing to regulate greenhouse gases.[54] Jennifer Haynes, a graduate student working on the NERF lawsuit, wants to see how nonexperts like the jurors will interpret scientific visualizations that the defense might

introduce into court. Along the way, she undergoes a conversion to the climate denialism she is only meant to perform to build a stronger case for NERF.

The narrative first takes a wide-angle view of temperature change with four spiky line graphs depicting the annual and five-year temperature means for the United States and the world from 1880 to the early 2000s. One of the four graphs juxtaposes atmospheric CO_2 concentrations in parts per million (102); another extracts a slice of this same graph depicting the years 1940 to 1970 (103, figure 2.1). As Jennifer offers possible interpretations of the charts, the reader must recall that she in fact works for the NERF/Vanutu side and, at this point in the narrative, accepts the fact of anthropogenic climate change.

She first establishes Evans's trust in the authority of governmental agencies such as NASA: " 'So we can regard this graph as accurate? Unbiased? No monkey business?' 'Yes' " (101).[55] She then tries to dismantle his conviction that the data supports climatologists' argument that "as the carbon dioxide goes up, the temperature goes up" (102). Her next move is to show a graph that zooms in on the "Great Acceleration," "the phenomenal post-1950 surge in the human enterprise that emphatically stamped humanity as a global geophysical force."[56] Jennifer continues the interrogation:

FIGURE 2.1. Michael Crichton, "Global Temperature vs. CO_2 1940-1970," *State of Fear*. Reprinted by permission of HarperCollins Publishers Ltd. © Michael Crichton 2004. *Source:* giss.nasa.gov

" 'Was carbon dioxide rising during that period?' 'Yes.' 'So, if rising carbon dioxide is the cause of rising temperatures, why didn't it cause temperatures to rise from 1940 to 1970?' " (103).

With these questions, she continues to chip away at Evans's certainty about climate change processes until he feels "slightly uneasy. But only slightly" (106). Jennifer succeeds in planting this kernel of doubt without undermining the authority of "raw" data. In fact, *State of Fear* shows a consistent trust in the calculations themselves, which is surprising given its message that the research enterprise that performs those calculations is so easily tainted by political and financial interests. Somehow, data is impervious to this taint so long as it isn't put to some use. Jennifer lets the numbers stand and uses a Socratic method of questioning to build Evans's skepticism. Along with the interpretation of data graphs, this pedagogical method activates the coming-of-mind that promotes the epistemological value of common sense. The dialogues between Evans and Jennifer echo the conversations between Dellarobia and Ovid in *Flight Behavior*, but the key difference here is that the dialogue proceeds by targeted questioning that invites only yes-no responses and shuts down analogous thinking. The dialogues in *State of Fear* increase friction between climate information and experience rather than lubricate the analogous thinking that can integrate data and life.

Evans's slight discomfort increases in the next scene of graphical interpretation three hundred pages on. The narrative releases a fusillade of data: twenty charts that make the case that the postwar warming trend is *not* correlated to increased CO_2 emissions from human activity. Line graphs, some reaching back to the early nineteenth century, show almost no increase in the mean temperature of small-, medium-, and large-sized American cities (445, 446, figures 2.2 and 2.3). The nearly horizontal line showing this temperature stability flatlines the case that global warming is an unfolding crisis. Even in the face of these graphs, Evans is not yet ready to concede and offers counterarguments derived from climate science (447–58). Eventually, however, Jennifer bends Evans—and herself—toward denialism.

Evans reaches this endpoint in his coming-of-mind journey through the epistemological tool of common sense. Jennifer does not *tell* Evans what to think; instead, she establishes his confidence in the so-called raw data and invites seemingly unmediated interpretation of the graphs that requires only common sense. As the volley of questions and answers proceeds, the

New York, NY 1930–2000

FIGURE 2.2. Crichton, "New York, NY 1930-2000." Reprinted by permission of HarperCollins Publishers Ltd. © Michael Crichton 2004. *Source:* United States Historical Climatology Network (USHCN)

Albany, NY 1930–2000

FIGURE 2.3. Crichton, "Albany, NY 1930-2000." Reprinted by permission of HarperCollins Publishers Ltd. © Michael Crichton 2004. *Source:* United States Historical Climatology Network (USHCN)

lawyer's initial positions on climate change appear less substantiated because they are untraceable and violate common sense:

"I think the theory of global warming predicts that some places will get colder."
"Really? Why is that?" [Jennifer probes.]
"I'm not sure, but I read it somewhere."

"The Earth's entire atmosphere warms, and as a result some places get colder?"
"I believe so."
"As you think about it now, does that claim make sense to you?" (453)

Evans's climate knowledge is unmoored and thus cannot stand up to the simple interpretation of the data that any layperson can perform. Though the novel elsewhere portrays Americans as intellectually feeble because they are susceptible to the influence of media, lawyers, and public relations specialists,[57] the data encounters argue that individuals are reliable data processors if these influences are removed. What's more, to make its case for common sense in the coming-of-mind plot, the novel must contradict a message of the thriller plot: that "expectations determine outcome" (457), that is, that funders expect certain results from their investments, and this determines the outcome of research. The novel risks this and other inconsistencies to advocate for common sense as the epistemological device that best processes climate information.[58]

The dialogues between Jennifer and Evans both create and manage climate infowhelm. They create it by embedding dozens of charts visualizing climate data; they manage it by showing laypeople who use common sense to interpret those graphs in ways that minimize "fear, worry, danger, uncertainty, panic" (539). Scenes showing characters poring over literary texts are staples of the bildungsroman and other literary genres such as slave narratives. Less familiar to novel readers, however, are scenes of graphical interpretation such as those peppering *State of Fear*. In Crichton's novel, this literary device creates the conditions for promoting the epistemological value of common sense. In a scene of reading, a novel will rarely reproduce the entire work characters hold before them. In *State of Fear*, however, graphs can be embedded wholesale; the novel can thus show rather than tell. That is, readers have access to the same object that characters are interpreting and are invited to produce interpretations in tandem—if not always in alignment—with those characters. Put another way, readers can participate in a data encounter and a coming-of-mind through the same visual objects that instigate the characters'. Indeed, Crichton's hope is for mimesis, that readers will reproduce Evans's intellectual development and reject the connections among human activity, CO_2 increases, rising temperatures, and climate crisis. The fact that we are typically reading alone only underscores the individualistic approach to knowledge production that

State of Fear promotes. Whereas plasticity and intuition emerge from embodied, multisensory encounters with nonhuman nature and peoples in various sociocultural positions, common sense presents knowledge as an autonomous pursuit that creates friction. Socratic dialogues might fuel Evans's intellectual formation, but the mode is hardly conversational or collective in Crichton's novel. The goal is yes-or-no responses, not exchange. The data Jennifer presents is not "like" anything, nor does it become a component in an embodied, intuitive "supercomputer." In *State of Fear* individualism underpins both the formal strategies of graphical interpretation and Socratic dialogue and the epistemological value of common sense that these scenes activate.

The coming-of-mind plot, whether folded into a regional realist novel, a science memoir, or a best-selling thriller, cannot eliminate the phenomenon of climate infowhelm. Characters work through dilemmas that climate information presents, from the violation of cultural norms and economic exigencies to the varieties of knowledge pertaining to the climate crisis and the appeal of business-as-usual futures. These dilemmas enter the texts when scientific information becomes aesthetic. Wohlforth, Kingsolver, and Crichton use this information as the clay from which they mold their narratives of environmental disturbance and, in *State of Fear*, skepticism about it. Rather than soothe the strains of infowhelm, however, the data encounters provoke epistemological possibilities. Data and experience, measurement and memory, models and common sense, these all produce frictions that the narratives either alleviate or irritate. With divergent methods—and, in the case of *State of Fear*, goals—all three coming-of-mind narratives remind us that epistemology is integral to climate representation and politics. When considering how climate change comes to matter, we cannot ignore the matter of how human minds work. And considering these matters, we cannot ignore the data encounters that prod coming-of-mind plots, a crucial mode of creative climate writing today that uses storytelling to play out—and sometimes untangle—epistemological dilemmas.

PART 2
The New Natural History

PREFACE

In part 1, Juliana Spahr's "Unnamed Dragonfly Species" motivated questions about the experience of climate data under conditions of information abundance and contestation. In the prose poem, the names of threatened species punctuate the text to show how devastating data erupts into everyday life. The catalogue of extinction in "Unnamed" suggests a photo negative of the species catalogs and taxonomies that Eurowestern naturalists compiled with fervor in the seventeenth through nineteenth centuries.[1] Incorporating climate media and data with a species catalog, Spahr's poem affiliates climate crisis not only with its technologically sophisticated tools of computation and modeling but also with fields such as taxonomy and biodiversity studies that developed from Enlightenment natural history. Considered more broadly, her oeuvre directs us to the concerns of part 2, which argues that writers and visual artists are producing a new natural history in the cultural sphere to manage grief and propose epistemologies for a time of loss.

Spahr's "Things of Each Possible Relation" ("TEPR"), which precedes "Unnamed" in *well then there now* (2011), paves the way for thinking about natural history. Nearly all the poem's first twenty-five lines begin with "the": "the view from the sea / the constant motion of claiming, collecting, changing, and taking / the calmness of bays and the greenness of land caused by the freshness of things growing into."[2] Repetition—including

anaphora—and refrain are poetic devices that express the central idea of the poem: "what we know is like and unalike" (56). With this phrase, "TEPR" expresses a premise of new naturalist art: that knowledge arises from acts of sorting this from that based on the like and unalike. The poem mentions classificatory activities throughout: compartmentalizing, "forming diverse assemblies" (57), and establishing relations between part and whole. Midway through the poem, simile markers construct anaphoric lines that survey the relations that result from classification: "like the language of the human being and the hummingbird of/the language/like the hummingbird of the aspiration and the aspiration of the/butterfly/like the wings of the butterfly and the bird/like the part of the extremity of the bird and the part of the/extremity of the dolphin" (60). These lines suggest a speaker classifying animals and simultaneously present kinds of likeness and unlikeness. We have the relation of orthography: *human being* and *hummingbird* are alike in six of their nine letters. "The part of the extremity of the bird" suggests relations created through synecdoche. "Of" also signals the poem's organizing concern with relation, with the preposition indicating belonging or possession. Likeness and unlikeness, then, depend on making sense through practices of classification.

Classification intimately relates to another of the poem's refrains, "occidental concepts of government, commerce, money, and imposing" (56). The explanatory note identifies the source for this refrain in Isabella Aiona Abbott's writings: *"The introduction of exotic (alien) plants and animals as well as Western concepts of government, trade, money, and taxation began a series of large and extremely rapid changes"* on the islands (71). Studying ethnobotany teaches the poet *"the deeper history of contact"* embedded in species names and stories. This history frequently includes practices of producing knowledge through colonialist "imposition" in Hawai'i and elsewhere in the colonized world (70).

"TEPR" thus incorporates practices of natural history that serve colonialist exploitation and that also inspire the poem's making. Classificatory labors become a poetic resource for *"question[ing] the divisions between nature and culture"* because they are an origin point *for* those divisions (71). At the same time, these labors have their own history that entangles art and science rather than differentiating them. With this insight, the poet participates in the new natural history that the next chapters detail. Akin to

other artists working in this vein, she speaks in the same tongue as Enlightenment naturalists yet adapts naturalism for loss and depletion rather than exuberant abundance and expansion. In "TEPR" and the environmental art included in part 2, the naturalist languages of describing and classifying are ripe for interrogation in the face of mass extinction and land-use change. In Spahr's poem we find the animating concerns for a range of cultural works of new natural history: How do Enlightenment modes of knowledge production endure in the present? In what ways do those modes—in particular, natural history and its practices of classification—produce knowledge under conditions of environmental endangerment and in what ways do they obscure it? What epistemologies might emerge from natural history when artists turn it to present conditions of environmental loss? How does new naturalist invention entangle information and emotion?

Natural history provides both theme and method for novels by Cormac McCarthy, Verlyn Klinkenborg, and Reif Larsen in chapter 3 and visualizations by the Audubon Society, Bryan James, and Maya Lin; paintings by James Prosek; and bioart by The Tissue Culture & Art Project in chapter 4. Working in these varied media, new naturalist artists revive theories, practices, and forms of representation derived from natural history, the classificatory and descriptive arm of the biological sciences. Natural history emerged as a scientific discipline in its "classical" period of the eighteenth and nineteenth centuries in order "to group animals, plants, and minerals according to shared underlying features and to use rational, systematic methods to bring order to the otherwise overwhelming variation found in nature."[3] Luminaries from this period such as Maria Sibylla Merian (1647–1717), Linnaeus (1707–1778), Georges-Louis Leclerc, comte de Buffon (1707–1788), Charles Willson Peale (1741–1827), and John James Audubon (1785–1851) developed epistemological and representational tools for managing "overwhelming variation" and imagining humans' place within it. The herbarium, botanical illustration, species description, binomial nomenclature, and the curiosity cabinet: these methods and media have traveled far beyond the naturalist's greenhouse into the domains of art and curation. Producing these objects required a whole set of performed habits, among them, curiosity, attention, close observation, detailed annotation and/or visualization, and moving between scales of the small and large.[4] Flash forward over a century, and artists are

making naturalist modes of ordering and displaying environmental variety integral to their work. In doing so, they confront the positivist and imperialist legacies of an Enlightenment project while proposing alternative epistemologies based in emotion, failure, unknowing, and invention. They do so because natural history still underpins how we characterize the plenitude or loss of species as well as how we come to comprehend and respond to them.

If the long history of naturalism casts a long shadow on twenty-first-century artists, so too do recent environmental and technoscientific developments. Three concurrent conditions inform the new natural history. First, as this book examines, we are in a new moment of information explosion, and the new naturalists clearly feel this explosion both as media consumers and as participants in environmental representation. Second, genetic technologies and synthetic biology continue to stretch the concept of the natural. Every day brings reports of new "chimeras" that confound schemas for classifying animal, vegetable, and mineral; organic and inorganic. Once, so-called monsters presented classificatory conundrums for naturalists; now, engineered and designed creatures present similar challenges to classification schemas. A related development I pursue in chapter 4 is how biodiversity science and policy are pursuing "radical conservation" strategies that swerve away from the idea of an original or optimal ecological condition in favor of hybridity, invention, and experiment.[5]

Another crucial condition that inspires new naturalist artists is what I call an ecological economy of deficit. If classical Eurowestern naturalists perfected their techniques in response to an ecological economy of abundance as explorers and colonizers set out from the metropoles to collect organisms, the new natural history emerges at a time of anthropogenic extinction. Even accounting for recently identified species and huge gaps in the species record, the sixth mass extinction is underway.[6] And while extinction came to light through fossil discoveries in the classical period, the sense of ecological deficit in our era is qualitatively different because it is rapid and anthropogenic. The current deficit calls for updated classificatory methods and cultural forms that account for absence and uncertain futures. Working in this tradition of scientific information, artists record what is being lost and historicize present vanishings; they respond to entomologist Quentin Wheeler's call to "explore, describe, name and classify these [disappearing] species as the last possible evidence for a great deal of

evolutionary history."[7] But they also posit how individuals and communities experience loss and therefore account for emotions of grief. In short, the new naturalist arts manage environmental data to manage loss. Yet, as the next chapters insist, writers and visual artists revive natural history not out of nostalgic yearning or to unleash a zombie Enlightenment. Rather, they rework naturalist epistemologies and cultural forms to salvage a future out of the past; they produce ways of knowing that variously accommodate, contain, or diminish emotions of loss.

Before we delve into the artworks and these arguments, we should outline some features of classification, intellectual responses to it, and the epistemological problems it presents. It's tempting to make classification the provenance of specialized disciplines like taxonomy, geology, zoology, or information science. For better and worse, however, most mundane actions draw on classificatory schemes. Socks go in this drawer and not that one; you speak this way with this person but not that one. Information theorists Geoffrey Bowker and Susan Leigh Star underscore this ubiquity. They define a "classification system" capaciously as "a set of boxes (metaphorical or literal) into which things can be put to then do some kind of work." What most concerns Bowker and Star are the unexamined consequences of classification, in particular how individuals, communities, and institutions naturalize categories and thereby lose sight of the "material force of categories" and "the practical politics of classifying and standardizing." Values inhere in classificatory and descriptive methods. Bowker and Star encourage us to ask hard questions of our classifications in order to access and assess those values: "Who makes them, and who may change them? When and why do they become visible? How do they spread? What, for instance, is the relationship among locally generated categories . . . and the commodified, elaborate, expensive ones generated by" powerful, globalized entities?[8] Their questions chime with another that I paraphrase from Paul Farber's history of natural history: What responsibilities do our knowledge and our knowledge systems confer on us?[9]

The bulk of humanist scholarship on natural history tracks with Michel Foucault's account of how the discipline accorded humans a place of superiority. In *The Order of Things* (1966, English 1970), Foucault identifies classificatory labor as "not merely the discovery of a new object of curiosity; it covers a series of complex operations that introduce the possibility of a constant order into a totality of representations. It constitutes a whole domain

of empiricity as at the same time *describable* and *orderable*."[10] Naming, classifying, and describing nature, natural history imagines itself unveiling the universal systems of order encoded therein. With some exceptions, cultural studies of classical natural history accord with Foucault on its totalizing and appropriative aspects and affiliate the enterprise with imperialist domination. Spahr's "TEPR" supports this thesis, which is undoubtedly an alluring one. Just take as examples the totalizing ambitions expressed in titles like *Buffon's Natural History. Containing A Theory of the Earth, A General History of Man, of the Brute Creation, and of Vegetables, Minerals, &c. &c.* (1749–1788). Or Alexander von Humboldt's *Cosmos: A Sketch of the Physical Description of the Universe* (1845). In the decades following *The Order of Things*, researchers have fortified the links between imperialism and naturalism's totalizing quest for knowledge. Mary Louise Pratt's *Imperial Eyes* (1992) is a crucial hinge between the Foucauldian view and a postcolonial critique of this epistemology. As she argues, the alliance between European imperial expeditions and classical natural history molded "a global or 'planetary' consciousness" that we could see as a precursor to modern-day environmentalism. However, "the transformative, appropriative dimensions" of natural history also serve imperialism and its ecological predation.[11] Kathryn Yusoff forcefully presses this point when condemning how "White Geology's" conception of the Anthropocene erases the ways in which "imperialism and ongoing (settler) colonialism have been ending worlds for as long as they have been in existence." Through its acts of categorizing and racializing matter, geology "quickly established itself as an imperial science that both organized the extraction of the Americas and, in the continued context of Victorian colonialism, became a structuring priority in the colonial complex."[12] In this and its other guises, naturalism forced every new sight, no matter how unfamiliar, to fit within the colonizer's unifying and ordering epistemological systems and demoted or erased local knowledges.

Evidence for natural history's impulse to dominate and master certainly abounds. Take, for example, this bellicose exclamation from one of Linnaeus's disciples upon reading his books: "Furnished with these arms, I am preparing to make war upon the Vegetable kingdom, and to submit the lofty honours of the forests to the rule and authority of Botanic Science."[13] Classifying nature through nomination and description undoubtedly expressed an oppressive politics and planetary agenda. Still, other interpretations of

natural history circulate within humanist scholarship. Christoph Irmscher and Monique Allewaert nuance these accounts, without rejecting them, by proposing that U.S. naturalists such as Peale, Audubon, and William Bartram "char[t] the emergence of a Western self much less stable than such theories could comfortably accommodate."[14] Irmscher also demonstrates that U.S. naturalists held various positions on nationalism and imperialism, a point historian Aaron Sachs echoes in his study of Alexander von Humboldt.[15]

The works of new natural history I investigate share the ambivalence one finds in the scholarship on naturalism. They at once practice the methods of the discipline and emphasize the epistemological and ethical limitations of those methods. In this respect, new naturalist art honors the instabilities intrinsic to naturalist classification. Natural history has long debated practices of perceiving and partitioning the more-than-human world, asking questions such as, which nomenclatural systems should reign? What is the measure of accuracy in a description? What to do with aberrations and errors that bust systems of classification?[16] What such debates indicate is that a complex amalgam of values—environmental, aesthetic, ethical, and political—inheres in natural history's motivations, methods, and cultural forms.

The complexity of these values comes out not only in classical naturalists' debates but also, and thrillingly, in philosopher-artists' avant-garde experiments from the mid-twentieth century. As they play with tensions between order and disorder, completism and failure, and knowledge and uncertainty, they display the epistemological dilemmas that accompany classificatory projects. The contemporary literature and visual media I study in the coming chapters turn these tensions and dilemmas toward the problems of environmental devastation.

Daniel Spoerri's *An Anecdoted Topography of Chance* (*Topographie Anéc-dotée* du Hasard*, 1962, English 1966) drops us in a classificatory maelstrom. Spoerri's book-*qua*-art project stretches my descriptive capacities.[17] It inventories every item found on the Swiss artist's work table on October 17, 1961 at 3:47 P.M., in room "No. 13 on the fifth floor of the Hotel Carcassonne at 24 Rue Mouffetard [Paris], to the right of the entrance door, between the stove and the sink" (xv). Beginning with entry 1, "Piece of white bread," and ending with entry 80, "Cigarette burn," the "topography" in effect archives objects as a form of autobiography. But this object inventory does not

simply spark recollections à la Proust's madeleine. It also activates the con-
fusion inherent to order. The text is dense with footnotes, cross-references,
addenda, errata, illustrations, and reproductions of other texts. Though its
ambitions and contexts differ greatly from those of Linnaeus's *Philosophia
Botanica* (1751), Spoerri's project shares that tome's organizational complex-
ity. Linnaeus's *Philosophia*, where his system of binomial nomenclature
first appears in print, includes plates, notes, appendices, indices, defini-
tions, lists of plant names and features, a list of ancient and contemporary
naturalists, and numbered sections with multiple cross-references among
them. Likewise, *Topography* includes Spoerri's descriptive entries as well as
numerous supplements: appendices, a map of the table, the author's and
translators' "original notes," "additional notes" from both parties, cross-
references to other entries and their notes, an index of names with notes
(!), and, perhaps most peculiarly, an index of heights of the objects to give
readers a sense of "the relief features of this topography" (170). The title
page clues readers in to the completist impulse that eventually dissolves
into disorder: "*Daniel Spoerri* An Anecdoted Topography of Chance (Re-
Anecdoted Version) Done with the help of his very dear friend Robert Fil-
liou and Translated from the French, and further anecdoted at random by
their very dear friend Emmett Williams With One Hundred Reflective
Illustrations by Topor."

Created collaboratively and anecdoted (and annotated) and twice
reanecdoted, *Topography* demonstrates a desire to classify that finds no
satisfaction. At the bottom of Spoerri's rabbit hole, we do not arrive at a
coherent picture of a life, a room, a table, or a moment in a day. We arrive
instead at a blueprint for the classificatory quandaries that arise when order-
ing even the most familiar objects. And ultimately at Spoerri's act of liber-
ating objects through disorder in appendix 6: "order in effect condemns
the objects to a specific use, while disorder and chance free them, thanks to
the unusual rapprochements that stimulate the memory" (199). Disorder
frees objects to generate associative memories. This is the epistemological
device that makes meaning rather than a rigid, exogenous classification
scheme.[18] Spoerri travels through frustration and proliferation to arrive at
the generative potential of "negative knowledge"—that is, "knowledge of the
limits of knowing, mistakes in attempts to know, things that interfere with
knowing, and what people do not want to know."[19]

As I argue throughout part 2, the new natural history follows the classificatory impulse and its epistemological and representational traditions to unleash similarly productive failures. New naturalist artists test the limits of classification as the avant-gardists do but with an eye to three urgent matters: the status of species extinction and the exhaustion of the land, how natural history has participated in this ecological economy of deficit, and managing the emotions of loss that arise from it. New naturalist artists honor the knowledge-making that classification affords while foregrounding the knowledges it occludes by entangling emotion, speculation, invention, and unknowing.

CLASSIFICTIONS

Why is the murderous antagonist of Cormac McCarthy's *Blood Meridian* a "botanizer?"[1] Why does Reif Larsen route a narrative of grief through a precocious boy devoted to classifying the world? Why does Verlyn Klinkenborg rewrite eighteenth-century naturalism through the eyes of Gilbert White's tortoise? These writers are producing what I call *classifictions*, narratives that repurpose techniques of natural history, including quantification, description, taxonomy, and precise illustration. Classifictions employ these techniques to detail environmental conditions, whether they be strains on the land from overdevelopment or the flora of a British garden, while also detailing obstructions to environmental knowledge. The task of incorporating information produces these contradictory actions of making known and cutting off knowledge. McCarthy's *Blood Meridian, or, the Evening Redness in the West* (1985), Larsen's *The Selected Works of T. S. Spivet* (2009), and Klinkenborg's *Timothy; or, Notes of an Abject Reptile* (2006) hark back to the eighteenth and nineteenth centuries, that era of classical Eurowestern naturalism surveyed in the preface to part 2. A debt that their titles announce with their nods to classificatory choice and selection.[2] Today's ecological economy of deficit and state of land exhaustion push the narratives to consider the limits of Enlightenment epistemologies and to entangle them with ways of knowing rooted in emotion and uncertainty.

McCarthy, Larsen, and Klinkenborg are not alone among fiction writers producing new naturalist literature.[3] Indeed, a robust archive of nonfiction from the likes of Robert Macfarlane, Helen Macdonald, Ellen Meloy, George Monbiot, David Quammen, and Lauret Savoy, among others, operates in this mode. I focus on fiction for the ways it employs but also defamiliarizes naturalist techniques and vocabularies such as illustration, classification, technical naming, and species observation and description. These techniques and vocabularies have long been the stock-in-trade of nature and science writers and, while these genres are undoubtedly creative, their status as nonfiction aligns them too closely with the traditions of natural history for my purposes here. What can we detect in these techniques through their relocation into the aesthetic sphere of the novel? In making naturalism an aesthetic resource for narrating environmental change and loss, novelists also make aesthetic choices that reveal the workings of narrative that generate (or impede) ways of knowing, and they investigate affective templates for managing the infowhelm on loss. These aesthetic choices include "subjectless" third-person narration, hybrid verbal-visual storytelling, and first-person animal narration. Through these techniques, classifictions use naturalist modes of thought and representation to establish species value and either fortify or erode the drive to master more-than-human nature. Moreover, these novels perform environmental grief through temporalities, narrative positions, and grammatical forms that break out of standard molds for nostalgia and mourning.

"BOTANIZING" IN *BLOOD MERIDIAN*

In McCarthy's *Blood Meridian*, naturalist methods carry the mood of terror in the mid-nineteenth-century U.S. borderlands. There is perhaps no more chilling depiction of the naturalist impulse than what we find here. *Blood Meridian* ponders the stakes of epistemological mastery through dense descriptions and a character whose methods are as meticulous as they are murderous. As I will argue here, however, the novel's methods of presenting scientific information emphasize that, though mastery succeeds in its ends by reshaping the U.S. West, mastery also meets resistance in more-than-human narration.[4] *Blood Meridian*'s descriptions, the very device that sets out to order the world, install the limits to mastery. They achieve this dual action through detailed naturalist practices, the grammatical

positioning of human characters and more-than-human forces, and the extensive use of similes. Through these formal strategies, as well as its historical setting in the mid-1800s, the novel identifies naturalism with imperialist capitalism and the exhaustion of the land whose ravages are even more apparent when the novel appears on bookshelves in the 1980s.

Set along the Mexico-U.S. border from 1848 to 1850, with a concluding chapter set in 1878, the novel trails a picaro named only "the kid." At the age of fourteen, he journeys from Tennessee to Louisiana and then on to Texas, Mexico, Arizona, and California. These travels are propelled by the "outfits" he joins along the way: filibusters trying to capture territory from Mexico for the United States and, most notably, the historical Glanton Gang of scalp hunters that Mexican authorities hire to decimate the Apache population.[5] The barbarity that fills *Blood Meridian* is by now legendary. Native Americans and Mexicans are prey to all manner of death, but the narrative spares no creature, human or otherwise. The terrifying yet beguiling Judge Holden doles out the most poignant violence in the story as well as the philosophical justification for it. A preternaturally white, tall, and bald polymath, he espouses theories on geology, theodicy, the nature of evil, the succession of civilizations, and more. At times a moral relativist and at times an absolutist, the judge confounds classification even as he practices it using naturalist methods.

Critical and readerly attention bends easily toward the bloodshed and rape, which are undoubtedly unignorable. But what to make of the fact that the pulsing heart of this bloodshed is a naturalist? The novel presents numerous tableaux of Holden collecting, describing, illustrating, and classifying, practices it bundles under the verb "to botanize" (127). For instance:

The judge had taken to riding ahead with one of the Delawares and he carried his rifle loaded with the small hard seeds of the nopal fruit and in the evening he would dress expertly the colorful birds he'd shot, rubbing the skins with gunpowder and stuffing them with balls of dried grass and packing them away in his wallets. He pressed the leaves of trees and plants into his book and he stalked tiptoe the mountain butterflies with his shirt outheld in both hands, speaking to them in a low whisper, no curious study himself. Toadvine sat watching him as he made his notations in the ledger. (198)

Already in this scene, attentiveness, care, and even intimacy, as heard through that "low whisper," mingle with violence. The judge practices taxidermy on the fly, mixing the instruments of the animals' destruction—gunpowder—with the materials of its environs—dried grasses. He turns plants into ammunition but also preserves them for description and illustration.

Make no mistake, though. The judge's naturalism does not make him a treehugger *avant la lettre*. Where the gang finds threat in indigenous peoples, he also finds threat in more-than-human matter. Naturalism amounts to a salvo against nature's incursions on human sovereignty and superiority. He proffers this philosophy in an astounding declaration: "little or nothing in the world . . . the smallest crumb can devour us. Any smallest thing beneath yon rock out of men's knowing. Only nature can enslave man and only when the existence of each last entity is routed out and made to stand naked before him will he be properly suzerain of the earth" (198). The judge, of course, states a gross historical inaccuracy: humanity is long practiced in enslavement; but this elision serves the hyperbole about nature-as-enslaver. Natural history is a response to this victimhood. As a form of domination, the judge's methods are a metonym for the violent imperialism that the novel chronicles.[6] Support for this reading comes in other vignettes of naturalist description and rendering. On the Glanton Gang's trek, the judge collects artifacts of prior civilizations and records them in his ubiquitous "leather ledgerbook"; the narrator bestows on this "curious study" the same attention the judge bestows on his specimens: "He sketched with a practiced ease and there was no wrinkling of that bald brow or pursing of those oddly childish lips . . . and he put this into his book with nice shadings, an economy of pencil strokes. He is a draftsman as he is other things, well sufficient to the task" (140). The tone here strikingly contrasts the tone of anxiety, suspense, and horror that permeates much of the novel. Language indicating measure and calm—ease, nice, sufficient, economy—momentarily soothes the tension that builds through references to the arcane, to blood and redness, and to the expansiveness of time. The tranquil mood surrenders to destruction, however, when the judge demolishes the objects he has just represented. Glanton assesses the judge in the aftermath of this act: "and he seemed much satisfied with the world, as if his counsel had been sought at its creation" (140). We return to the

entanglement of classification and violence, of mastery and destruction. Though only a simile in the hypothetical mood ("as if"), the comparison positions the naturalist as preexisting and preceding creation and perhaps even as the commanding creator itself. The considered elegance of the judge's drawing counterweighs his bent for destruction, though the balance certainly tips more to the latter. Along with the judge's later statement that nature is the only "enslaver" of humanity (198), this episode demonstrates how the skillful naturalist uses his techniques as counterinsurgency against nature's dominance.

Blood Meridian's first pages describe the lands on which the plot will unfold as the staging ground for this counterinsurgency: "not again in all the world's turning will there be terrains so wild and barbarous to try whether the stuff of creation may be shaped to man's will or whether his own heart is not another kind of clay" (4–5). The novel offers the judge's naturalist practices as a necessary companion and analog to more overt battles in a perpetual war against the terrain that ramps up in the mid-nineteenth century, a war involving mining, logging, intensive agriculture, and dam and railroad construction. Similar to the "as if" in Glanton's description of the judge (140), the "or" in this opening description is pivotal and structures the novel's positions on mastery. Humanity's ability to remain "suzerain" is in doubt (198). One of the judge's sermons puts this doubt into relief. He professes, "that man who sets himself the task of singling out the thread of order from the tapestry will by the decision alone have taken charge of the world and it is only by such taking charge that he will effect a way to dictate the terms of his own fate" (199). If bygone natural theologians sought God's imprint in every herb and seed, the natural historian can take on a godly mantle by ordering the world.

Yet, in accordance with the novel's ping-pong philosophizing, other statements contradict this position and assert the futility of humans' quest for order and, further, knowledge. "The truth about the world, he said, is that anything is possible. Had you not seen it all from birth and thereby bled it of its strangeness it would appear to you for what it is, a hat trick in a medicine show, a fevered dream, a trance bepopulate with chimeras having neither analogue nor precedent" (245). Humans make the familiar strange by imposing an order on the incomprehensible, an order that does not correspond to nature's own. Ultimately, in an echo of *Hamlet* and an allusion to Ariadne and Theseus, the verdict lands that "even in this world

more things exist without our knowledge than with it and the order in creation which you see is that which you have put there, like a string in a maze, so that you shall not lose your way. For existence has its own order and that no man's mind can compass, that mind itself being but a fact among others" (245).[7] The methods of natural history—observing, describing, collecting, comparing, classifying—render nature naked but without conferring absolute control over the more-than-human. Humans' facticity—their being one entry among others in a catalog of beings—potentially deflates their epistemological and physical dominance. The judge thus articulates a central bootstrapping problem in natural history: How can people classify, describe, and dominate when they constitute the world like one "fact among others"?

The judge's sermon poses such limits to humans' ability to "compass" creation; *Blood Meridian*'s descriptive and narrative techniques offer additional examples. Specifically, the novel's grammatical choices perform failures in humans' mastery over their environments even as the narrative progresses through rapacious acts that, as I emphasize later in this section, anticipate the exhaustion of the land due to resource extraction and infrastructure development.

Blood Meridian sets expectations for exquisite detail from its cover. The book's subtitle—"The Evening Redness in the West"—sounds like the caption to a landscape painting, while its first line—"See the child" (3)—is a bardic directive that orients the ensuing narrative toward sight and description, a literary mediator of sight. The narrator frequently commands the reader to see the environmental features described and presents this world with a naturalist's knowledge that mimics the judge's own expertise. To take one example: "[The Glanton Gang] passed through a highland meadow carpeted with wildflowers, acres of golden groundsel and zinnia and deep purple gentian and wild vines of blue morninglory and a vast plain of varied small blooms reaching onward like a gingham print to . . . the adamantine ranges rising out of nothing like the backs of seabeasts in a devonian dawn" (187). The floral fabric spreads across a landscape evoking deep time, the Paleozoic era when life begins and moves from water to land.[8] This passage suggests reasons for the judge's disquiet about the sovereignty of the more-than-human realm. "Adamantine" references solidity and durability, a forceful contrast to the description of human will as malleable clay (5). The wildflowers are ostensibly delicate, even their common names suggest

as much, but they also give off a whiff of eternality that contrasts the precariousness of humans' existence.

Blood Meridian, like *All the Pretty Horses* (1992) and other McCarthy novels, continually activates this dyad of eternality and ephemerality. In the 1985 novel, this dyad manifests grammatically in the interplay between the vast landscapes that make geological time palpable and the precise and near time markers that introduce most of the novel's chapters. Chapter 2 opens with "Now" (15), and the book proceeds to "Five days later" (42), "With darkness" (55), "For the next two weeks" (151), "On the fifth of December" (204), "In the late winter of eighteen seventy-eight" (316), and finally "*In the dawn*" (337). These temporal markers and the narrator's frequent use of deictics like "here" and "now" model the attention to present conditions that naturalist description requires. At the same time, however, they confine humanity to narrow limits. The characters travel on the scale of human time and place while all other matter, even the tiniest wildflowers, seems to be unfettered and extensive. According to the judge's philosophy and ethos, natural history fights against nonhuman beings' capacity to crush humans, yet description and time markers humble human aspirations to control.

The text also confers control on the more-than-human through narratorial shifts that redirect attention from the objects the judge sees and describes, to the "curious" judge himself. *Blood Meridian* unfolds through third-person narration, with some moments focalized through characters. As the travelers observe playas, arroyos, and tempests, the environment visually consumes them in turn. An instance of this move appears when the kid enters that Puritan topography, the "howling wilderness": "Dawn saw them deployed in a long file over the plain, the dry wood wagons already moaning, horses snuffling" (42). Time and the journey continue apace, and the narrator notes, "They rode on. The white noon saw them through the waste like a ghost army, so pale they were with dust, like shades of figures erased upon a board. The wolves loped paler yet" (46). The judge's imperious sight is here reversed. The humans are visually consumed. Having already been erased from the tableau through the simile "like shades of figures," the traveling outfit is erased again when the word that describes them, "pale," ushers in other creatures that take their place. This is one example of the novel's penchant for generating comparisons between humanity and other creatures on a chain of being. Humans are at times the kin of animals—mice (73), apes (74), birds (118), cats (151), crabs (278)—and

at other times the kin of gods or other supernatural entities—deities (92), djinns (96), sprites (300), "some queer unruly god" (251).

The narrator can be explicit about the undoing of fixed classifications for beings. Observing a playa from above, Glanton's company takes in the landscape: "In the neuter austerity of that terrain all phenomena were bequeathed a strange equality and no one thing nor spider nor stone nor blade of grass could put forth claim to precedence" (247). The conditions of perception, this "optical democracy" in McCarthy's much-cited phrase (247), level the person to the stones his horse's hooves trample. This passage is the locus classicus for readings of *Blood Meridian* as "a critique of our culture's anthropocentrism."[9] There's a truth but also an inadequacy to this claim. I find the novel more interested in staging a battle—one that comes to a stalemate—between the anthropocentrism that natural history and Eurowestern imperialism have handed down and the beings and lands that have long been subject to epistemological, representational, and material forms of control. This is not to claim, as Georg Guillemin does, that "the narrative voice insinuates the existential equality of humans, domestic animals, wild animals, and inanimate nature," nor to position *Blood Meridian* strictly within what Mark McGurl terms "a new cultural geology" that theorizes "the blank indifference of geological nature to human cultural-political representation."[10] The novel does not precisely conform to these claims that emphasize a flattening of agency; rather, it enacts the conflict between, on the one hand, mastery over other beings through naturalist practices and other forms of imperious control and, on the other hand, humanity's submission to nature as "enslaver" (198).

Description stages this conflict in ways that the novel makes possible more readily than nonfiction nature or science writing. When chromatic time is the grammatical subject that does the seeing (e.g., "Dawn saw them," "The white noon saw them"), the descriptive labor shifts and becomes seemingly "subjectless" in a way that chimes with Ann Banfield's account of this narrative technique. She identifies moments when "a sense-datum given to no one" enters a sentence and offers an "impersonal subjectivity." The narrator is "no longer the transparent vehicle for an ego-centered expression which in speech subjectivises all that can be said."[11] That is, these statements do not originate from anything we might identify grammatically or narratively as a person or even an omniscient narrator.[12] Being exclusively literary in nature, they also offer unique ways of rendering observation.

When in *Blood Meridian* a time of day or a topographical feature relays sense-data, the text grammatically inscribes "the appearance of things not necessarily observered [*sic*]."[13] I argue that these moments of presenting perceptual data that cannot belong to a character or narrator substantiate the judge's fear that the matter of the world slips free from human control. Interestingly, this occurs in those very moments—moments of description— meant to bring the matter of the (fictional) world into being. *Blood Meridian*'s descriptive techniques establish the limits to humans' classificatory success in the fact that nature, that which is meant to be ordered and classified, has its own perceptual capacities.

A final locus for this slippage of human command appears in the text's ample and bewildering similes, another signature of McCarthy's writing. Just as readers can easily find pronouncements from the judge that contradict his earlier sermons, the similes frequently undo—or at least confound—themselves. In combination with the novel's abundant use of "and,"[14] ambiguous pronouns, and quick shifts in verb tenses and modes,[15] its metaphors and similes create a sense of infowhelm. Rarely do the similes place a scene or an object within a stable classificatory schema by detailing it. They do not so much conjure a possibly inhabitable or even visualizable reality as proliferate possibilities among which the reader must choose. Take, as just one example, this much-discussed description of a group of Apaches the filibusters encounter. The twenty-three-line sentence begins with an expression of racism that suffuses the novel: "A legion of horribles, hundreds in number, half naked or clad in costumes attic or biblical or wardrobed out of a fevered dream" (52). Should the collective of costumes be interpreted according to one of these metaphor templates: Athenian, biblical, or delirious? Does each costume fall into one of these categories? In this description the piling on of options makes the scene more diffuse, more chaotic, rather than more exact. The simile that concludes this lengthy sentence aggregates possibilities without the need for "or": "and all the horsemen's faces gaudy and grotesque with daubings like a company of mounted clowns, death hilarious, all howling in a barbarous tongue and riding down upon them like a horde from a hell more horrible yet than the brimstone land of christian reckoning, screeching and yammering and clothed in smoke like those vaporous beings in regions beyond right knowing where the eye wanders and the lip jerks and drools" (52–53). (When the sergeant exclaims, "Oh my god," in the next one-sentence

paragraph, the reader might easily think he's responding to this blast of description as much as the individuals being described.) The word "death" is the hinge that swings the layered simile from clowns to demons, just as "smoke" swings it from demon to ghost. This accumulation of beings to which the Apache riders compare renders them less, not more, visible. It makes them as "vaporous" as the ghosts on which the simile pivots. What's more, the similes place them in domains where comparison does not hold. They are "like" but "more horrible yet than." "Like" but "beyond right knowing." Similes scramble rather than solidify the descriptions in which they appear. In its own acts of putting forth, then, the novel shows the failure of epistemological and aesthetic devices for making sense of observations. These bewildering similes emphasize the judge's thought that "existence has its own order and that no man's mind can compass" (245). Naturalist description is a classificatory tool that attempts to compass existence by putting forth, making comparisons, and establishing hierarchies. *Blood Meridian*'s classificatory similes demonstrate the failure of humans' quest for order by performing the inexactitude of description. Similar to the avant-garde experiments by Daniel Spoerri examined in the preface to part 2, the text demonstrates the generative potential of classification even as it presents classification's undoing.

Blood Meridian's riotous descriptions ultimately produce conceptual disorder, if through stunning prose. They also indicate anxieties about the extractive industries and infrastructure projects shaping the Mexico-U.S. border region during exuberant expansion beginning in the nineteenth century and continuing into McCarthy's late twentieth-century moment. Description is not only a naturalist method affiliated with imperialism; it is also a device that expresses the pending fatigue of the land that results from that rapacious appropriation. The novel's environments seep violence and fear. The book's title announces this condition, as do early descriptions of the land the travelers cross: "They rode on and the sun in the east flushed pale streaks of light and then a deeper run of color like blood seeping up in sudden reaches flaring planewise and where the earth drained up into the sky at the edge of creation the top of the sun rose out of nothing like the head of a great red phallus until it cleared the unseen rim and sat squat and pulsing and malevolent behind them" (44–45).[16] The bloody demonstrations of masculinity that occur across the novel's pages find expression in this threatening masculine sun that alternately trails and precedes the

filibusters. The narrative endorses anthropogenic causes for an earth gone bad with malevolence: "as if in the transit of those riders were a thing so profoundly terrible as to register even to the uttermost granulation of reality" (247). McCarthy's West is exhausted even in its newness to the white men who have come to put it under their control. It is as if the very appearance of the settlers and exploiters has drained the land even before they have finished the deed of displacing and killing indigenous peoples and making way for extractive industries. This claim chimes with the judge's speech explaining the novel's title. He declares that humanity's "spirit is exhausted at the peak of its achievement. His meridian is at once his darkening and the evening of his day" (146–47). Again, we should not, as Dana Phillips also cautions, take the judge as a mouthpiece for the novel's views.[17] However, he offers here a template for understanding how the text presents westward expansion and exploitation entering an exhausted state "at the peak of its achievement" in appropriating lands for capitalist industry. The marauders in *Blood Meridian* are aware of the limits to expansion. "You wouldnt think that a man would run plumb out of country out here, would ye?" Toadvine asks (285), and yet that's precisely what the novel is anticipating.

The murder and rape that make way for development herald the beginning of the end that the novel's last pages describe. The mid-nineteenth century is the apogee—or, from another perspective, nadir—of violent conflict over the U.S. West. These wars play out among all parties involved: Mexico, the United States, and indigenous tribes such as the Comanche and Apache. The last chapter decorates the year 1878 with images of the "sunchalked bones of the vanished [buffalo] herds" and lanes of wagons layered out to the horizon (317). Here the plot arrives at that moment Toadvine finds imponderable: running plumb out of country.

The descriptions that precede the epilogue anticipate this endpoint as well. Descriptive surfeit attempts to offset the ecological deficit the kid witnesses in 1878 and McCarthy inhabits more fully in the 1970s and 1980s when writing *Blood Meridian*. Yet rather than compensate for humans' efforts to master and contain nature, this surfeit in fact exemplifies how nature slips free of mastery. The descriptions bear echoes of natural history as they are rife with obscure diction and detail derived from botany and geology. As these descriptions accumulate, often through those series of similes I examined above, linguistic excess announces other excesses that

will afflict the land. Overhunting, mining, and the decimation of indigenous tribes are just some of the injurious changes that opportunists bring to the U.S. West. McCarthy's formal strategies, especially within the domain of description, entangle positivist epistemologies centered in human mastery, and ways of knowing that minimize that dominance. This is not to say that art can crush the exhausting extractivism that readers glimpse in the book's epilogue but rather that aesthetic techniques of managing information play out the desires for and consequences of epistemological mastery.

MULTIMODAL MOURNING IN *T. S. SPIVET*

Blood Meridian inscribes the exhaustion of the land into the moment of westward expansion and its most violent achievements. This anticipatory posture appears in Judge Holden's lecture on how ignorance about our current actions matters little in the face of the history to which they contribute: "It is not necessary, he said, that the principals here be in possession of the facts concerning their case, for their acts will ultimately accommodate history with or without their understanding" (85). I read in this remark a wider comment on how human actions—whether crossing a meadow of groundsel or massacring a Mexican village—travel forward into a future that is outside the individual's knowing but also create others' present and future. This anticipatory move surfaces in Reif Larsen's classifiction, *The Selected Works of T. S. Spivet* (2009, hereafter *Spivet*). Incorporating naturalist methods into its narrative and its form, *Spivet* also amplifies loss as an inherent feature of natural history. It proposes that what seems to offer nostalgic escape from grief in fact digs up the roots of the very thing one is trying to escape. Larsen's novel is not quite a book with illustrations and not quite a graphic novel, but what we might call a visualized narrative. It uses a doubled representational approach that introduces multiple temporalities into the story. My reading will show that the blending of visual and verbal media and the temporalities it brings to the novel activate grief despite naturalism's staunch empiricism and putative exclusion of emotion.

Tonally and narratively, *Spivet* couldn't be further from *Blood Meridian*. Larsen's title introduces the novel's protagonist-narrator, Tecumseh Sparrow Spivet (a.k.a. T.S.): a twelve-year-old boy who is a naturalist prodigy.

His skills at classification, measurement, visualization, and cartography are so developed that, when his mentor submits his work for the Smithsonian's Baird Award for illustration, the institution assumes the artist is an accomplished adult and awards him the prize. In effect, a misclassification launches the plot of a novel riddled with classifications. The unexpected call from the Smithsonian and T.S.'s decision not to tell his family about the award launch the main story: the boy decides to hobo to Washington, D.C., from his home at Coppertop Ranch in Divide, Montana. He rides the rails eastward—reversing the trajectory of *Blood Meridian* and many another Western—and a picaresque bildungsroman is underway.

Larsen's picaresque is also picturesque. Filling the margins of the large-format book are charts, maps, diagrams, and botanical, zoological, and anatomical drawings from the notebooks T.S. keeps throughout his childhood and on his rail journey. The illustrations, which are sometimes accompanied by T.S.'s reflections, offer another path for the three plotlines within the novel to play out. The main plot is T.S.'s journeys and encounters in the present of the diegesis. The second is his coming to terms with the accidental killing of his brother Layton during one of T.S.'s classificatory experiments, a traumatic event that has quietly devastated his family. The third plot is his mother Dr. Clair Linneaker's writings about her great-grandmother-in-law, Emma Osterville Englethorpe, a trailblazing geologist from the late 1800s who abandoned her career "to marry an illiterate Finnish immigrant."[18] This uneducated Finn, Tecumseh Tearho Spivet, is T.S.'s namesake.

The family narrative by Dr. Clair cements the novel's stakes in the nineteenth century, which also appear through the sepia tone and nostalgia that infuse the narrative and illustrations. Dr. Clair's account is in a font resembling an old typewriter. The book's endleaves and the pages dividing its three parts are in a sepia tint, an early indication that the narrative's orientation is toward the past and its "feeling tone" toward nostalgia.[19] Additionally, nineteenth-century referents fill the novel: lithographs, parchment, citations of *Moby-Dick*, invocations of U.S. Manifest Destiny, and methods of natural history all position the story in another era. This orientation toward the past jars with the novel's forward-looking generic modes—the picaresque and the bildungsroman—but accords with the family's nostalgia. Both of T.S.'s parents are out of time. The boy has the sense they were

"born perhaps one hundred years too late" (11). Dr. Clair Linneaker is "a misguided coleopterist" on a quixotic search, inspired by her namesake Linnaeus, for the obscure tiger monk beetle, *Cicindela nosferatie* (11).[20] The boy's father, Tecumseh Elijah Sparrow, yearns for the Montana of yesteryear even as agribusiness and residential development are encroaching on their home on the Continental Divide. "The cinematic West of the trail drive" sends Tecumseh into what T.S. dubs the "Spiral of Nostalgic Unfulfillment" (84). Though participating in this nostalgia as well, T.S. is circumspect and wonders whether his nostalgia is as misguided as his parents' because it refers to "a world that had never even existed in the first place," one based in "*a falsified cultural memory*" (15).

Natural history in *Spivet* is one domain in which this falsification occurs, but, as we will see, it is also the means by which the novel transmutes nostalgia into grief for an imperiled land. Practices of classification and natural history introduce a tug between proximity and distance that also manifests in the text's multimodal and multitemporal storytelling. Through this tension, *Spivet* shows naturalism as a productively failed epistemological tool that has helped produce ecological deficit and loss but can also produce historical and emotional intelligence.

T.S.'s wanderings hinge on a misclassification—the Smithsonian taking a young savant for an established expert—and classificatory procedures litter the novel. Natural history is at once a habit, an ethic, and an epistemological disposition for *Spivet*'s characters. T.S. has several role models for his naturalism: his mother, his great-great-grandmother about whom his mother secretly writes, and Dr. Terrence Yorn, a professor who serves as a surrogate father and nominates him for the Baird Award. These models teach him methods for "unsquirreling the natural world" (49)—close observation, measurement, quantification, and faithful rendering—that are also, to cite Lorraine Daston and Peter Galison, "norms that are internalized and enforced by appeal to ethical values, as well as to pragmatic efficacy in securing knowledge."[21] T.S. asserts that the "number one rule of cartographia was that if you could not observe a phenomenon, you were not allowed to depict it on your parchment" (32). Positivism is the goal, invention is the nemesis, and these norms have a force apparent in the phrase "not allowed." The boy is a descendent of those "militant empiricists" from another Daston study who pursued the "heroic effort of observation fueled

by curiosity."[22] Excavating archives in Butte, T.S. encounters the values he holds dear at work. He idealizes the coffee-swilling cartographers who named the mountains of western Montana.

> They were conquerors in the most basic sense of the word, for over the course of the nineteenth century, they slowly transferred the vast unknown continent piece by piece into *the great machine of the known, of the mapped, of the witnessed*—out of the mythological and into the realm of empirical science. For me, *this* [original emphasis] transfer was the Old West: the inevitable growth of knowledge, the *resolute gridding* of the great Trans-Mississippi territory into a chart that could be placed alongside others. (16, emphasis mine)

Conquering dissolves myth into knowledge, empiricist knowledge that, Cartesian at its core, fits neatly on grids, maps, and charts. Along with the positivist language—"known," "mapped," "witnessed"—"machine" and "gridding" indicate the ways the rolling and ragged topography of the West is slotted into human-made and technologically managed ordering systems. The cartographers are heroes to T.S., but Larsen's diction hints at what and who are bulldozed over in this process. For nineteenth-century cartographers, conquering the territory requires conquering epistemological access to it. This can only be a completist project, an idea that those past participle adjectives indicate. A natural historian in Dr. Clair's embedded narrative of her ancestors endorses this idea: "We are in the great age of categorization. This world may be completely described in fifty years. Well . . . seventy years, perhaps. There are a lot of insects, and beetles in particular" (181, ellipsis in original).

To categorize, classify, and grid, however, explorers must exclude what already exists, including the names and epistemologies that exemplify indigenous peoples' relations to what eventually became the American West. The cartographers T.S. admires practice the kind of epistemological and linguistic imperialism that "promoted European global expansion and colonization" and contributed to the "process of the loss and rebuilding of cultural identities."[23] Excluding and disappearing other epistemologies, the known, the mapped, and the witnessed become new myths, that "*falsified cultural memory*" that T.S. at first associates with his father's nostalgia (15). Always incomplete because predicated on exclusion and illusion, classification is never purely empirical. Early hints of classification's limits appear

when T.S. is in the archives. He recognizes that even the great mappers violate the first rule of cartographia and "imagin[e] all sorts of false geographies in the territory just beyond the next mountain" (33).[24]

It's one thing for T.S. to find deviations from the rules among dusty map drawers; it's quite another for him to encounter them in his closest role model, his mother. The boy's most poignant memory of Dr. Clair has her in the posture of a taxonomist: "As I walked past the entrance to Dr. Clair's study, I saw her struggling with the weight of some huge taxonomic dictionary, using only one hand to hold the giant tome, as the other was still maintaining the pinned tiger beetle upright in the air. This was the kind of image I would remember my mother by when and if she ever passed on: balancing the delicate specimen against the weight of the system within which it belonged" (12). The hefty intellectual labors of classification are here made physical. Remaining faithful to the particulars of the individual object as well as the parameters of the taxonomic system presents as much of a burden as the weighty book. Yet the boy most admires this struggle because it shows his mother's accountability to observation, measurement, system, and precision. The shock that results when Dr. Clair deviates from the values of positivism counts as T.S.'s second emotional trauma, one less potent than his brother's death but one no less consequential. T.S. discovers the notebooks containing the story of his ancestor and realizes Dr. Clair has abandoned her search for the elusive beetle species. He confronts unthinkable possibilities: "Was this what she had been doing all these years? . . . Was my mother not a scientist but a *writer*?" (148). The fact that T.S. presents these vocations as mutually exclusive is just one of many signs that he is a classifier through and through. This is not that; this has more value than that. His mother is no longer a coleopterist but an apostate, a writer.

Discovering her narrative notebooks disrupts the categories into which T.S. has placed her: she is a fabulist, not an empiricist. At this point in the plot, T.S. has not learned that invention is inextricable from naturalism. Yet despite T.S.'s strict separation of science and writing, the novel elaborates many ways invention suffuses naturalist practices. In this respect, *Spivet* echoes Daston and Galison's insights from *Objectivity*. To attain objectivity in its purest form would require "blind sight," would require "aspir[ing] to knowledge that bears no trace of the knower—knowledge unmarked by prejudice or skill, fantasy or judgment." As they argue, however, "the

knower" is very much a part of the naturalist enterprise. "Nature seldom repeats itself, variability and individuality being the rule rather than the exception." Therefore, to produce standardized descriptions, naturalists created "a generality that transcended the species or even the genus to reflect a never seen but nonetheless real plant archetype: the reasoned image."[25] One object cannot represent every instance of its type, and the naturalist must supplement observation by aggregating and standardizing examples. Traces of the knower abound. Distinctions between classification and invention, therefore, are not so hard set as the boy—and other luminaries of natural history—might like to think. To T.S.'s mind, however, Dr. Clair has violated naturalism's proscription against imagining and has swerved not only from the scientific ethos but also from family tradition.

The boy had already begun to wonder how to "tempe[r] the impulse to invent rather than represent" when browsing the Butte archives and had developed a saccharine strategy: "Simple: every time I found my stylus wandering beyond the known boundaries of my data set, I instead took a sip from the Tab soda can on my drafting table" (33). The novel will ultimately depict the failure of T.S.'s efforts to resist invention by making invention inherent to naturalist knowledge production. In depicting the boy's dogged commitment to empirical classification and description and the slow erosion of that commitment, *Spivet* reinscribes—and reillustrates—classificatory practices. It offers a third way between, on the one hand, faithfulness to classification that occludes other forms of knowledge, especially emotion, and, on the other hand, rejecting classificatory methods because they are based in error and failure. In developing these epistemological paths, the novel places personal grief on a continuum with environmental loss. T.S.'s journey eastward becomes a journey toward understanding the mechanism of grief and its unexpected entanglement with a less rigid notion of classification.

In *Spivet* taxonomy, cartography, and other classificatory practices both make things known and cut off avenues to knowledge. One way it does the latter is by favoring one form of attention at the expense of another. In Dr. Clair's quest for the tiger monk beetle, she "see[s] the world only in parts, in tiny parts, in the tiniest of parts, in parts that perhaps didn't exist" (70). The father, meanwhile, is as farsighted as his wife is myopic, taking in the wide expanses of Big Sky country and missing what's right before his eyes. Tecumseh's admonition that his son needs to "open your eyes a little bit"

misses the fact that, often, T.S.'s eyes are open but to the point of distrac-
tion (56). For example, the boy's focus strays when talking on the phone
because "I was always visualizing what was going on at the other end, and
so I often forgot to speak" (17). As if tempting readers to succumb to the
same distraction, an illustration titled "A Short History of Our Phone Cord"
winds on and off the two-page spread narrating this scene. Too much in
the past, in the detail, and gazing toward the horizon, the Spivets have lit-
tle access to present realities even though they, in the case of the naturalist
mother and son, strive to "unsquirrel" the world, and, in the case of the
father, labor on the land.

T.S.'s lapses in attention are worrisome, but more worrisome are lapses
in emotion that are endemic to the ranch. T.S. uses naturalist methods to
displace his feelings on several occasions but most notably when he classi-
fies his father's disappointment in him. The boy dissects and illustrates his
father's displeased facial expressions based on Dr. Paul Ekman's "Facial
Action Coding System, which broke all facial expressions down into some
combination of forty-six basic action units. These forty-six units were the
essential building blocks of every human expression in existence. Using
Dr. Ekman's system, I could thus attempt to map at least the muscular gen-
esis of my father's expression, which I had dubbed the *This-Boy-Must'a-
Been-Switched-at-Birth Lonesome Ponder*" (43). T.S. systematizes the body
to fit emotion into a classificatory system that "maps" but does not appre-
hend affect. He grids embodied emotion according to the same procedures
he applies to measuring the length of his sister's chewing gum tape (35) or
the moves in their game of cat's cradle (115). Classifying the face makes it
available for combination but also supplants other conduits to knowledge
such as feeling emotion and conversing with his father. Describing "mus-
cular genesis" ultimately puts more distance between father and son. Emo-
tional distance then becomes physical in that T.S.'s inability to share an
emotional life with his family prompts his solo journey eastward. In this
respect *Spivet* uses the picaresque plot to show how devotion to classification
perpetuates emotional ignorance. As I show later in this section, however,
classification and emotion entangle to produce personal and environmen-
tal knowledge.

T.S.'s labors in classification have him attend closely to the nonhuman
realm, and he partially fills in emotional detachment by cathecting objects.
The affective orientations of things are more transparent to him than

humans'. He detects "mood and demeanor" in objects such as the Bitter-root Mountain range (122), and he converses with his porch (7), his Radio Flyer wagon (92), the train he rides, the Great White Lamp he covers with ink to halt a freight train (96), and the Winnebago (a.k.a., the "Cowboy Condo") that is among the train's cargo (114). In fact, in this first-person novel, T.S. just as often has objects as interlocutors as he has other people. In effect, the topography of the West and humanmade objects are overani-mated while the human world is underanimated.

When T.S. does acknowledge the emotions that arise from family expe-riences, he literally marginalizes them. It is telling that readers first learn of Layton's death when T.S. uses it as a temporal marker in an aside: "Soon after Layton died, the Blue Moon [Saloon] burned down" (5). It then takes almost three hundred pages for T.S. to narrate the events surrounding Lay-ton's accidental killing. In a marginal note labeled "Bathroom = Safety," readers learn that, when his brother shoots himself, T.S. alerts his father and then promptly hides in the bathroom and, in another retreat into a bygone era, "stare[s] at the black-and-white postcards of steamships that I had pasted onto the walls" (294). While none of the Spivets has sifted through the grief from Layton's death, T.S.'s predicament is more acute because Lay-ton shoots himself during an experiment aimed at classifying the sound of gun reports. Grief is pervasive and strong but rarely acknowledged outside the margins, as in an illustration of Layton's rocking horse, "silent" and standing next to "an empty gun rack" in the brothers' room (86), an image with the caption, "Oh. I miss him" (87).

T.S. shunts emotion and grief to the side through naturalist practices, but they also provide a means for addressing emotion. They are a medium for entangled epistemologies. The layered temporalities of his notebooks produce this entanglement. *Spivet* stages conflict between positivism and emotion and simultaneously demonstrates how these two epistemologies are bound together. To understand this, we need to delve further into emotions of loss as well as the temporalities at play in *Spivet*. As analyzed earlier, nostalgia is the book's pervasive tone. But does nostalgia also describe the loss associated with Layton's death? While it might be tempt-ing to answer yes, the novel confines nostalgia to events and objects asso-ciated with cultural memory. Tecumseh, Dr. Clair, and T.S. all mourn for a never-existing referent; in this respect their nostalgia accords with Susan Stewart's account of nostalgia as "a sadness without an object, a sadness

which creates a longing that of necessity is inauthentic because it does not take part in lived experience. Rather, it remains behind and before that experience. Nostalgia, like any form of narrative, is always ideological: the past it seeks has never existed except as narrative, and hence, always absent, that past continually threatens to reproduce itself as a felt lack."[26] Pondering his father's longing for an Old West that never existed as imagined, T.S. identifies the self-reproducing nature of the emotion in "The Spiral of Nostalgic Unfulfillment" (84). As a yearning for what has never been, nostalgia is as bottomless as one's narrative imagination.

The novel positions the grief for Layton against nostalgia through its multimodal form. The illustrations introduce a variety of temporalities into T.S.'s narrative of loss that bend the text toward melancholia, an emotion of grief through which "the past remains steadfastly alive in the present."[27] As a visualized narrative, *Spivet* uses a doubled representational strategy in which time unfolds in the main diegesis about T.S.'s eastward journey— which itself recollects the recent past—and past events "remain steadfastly alive" through T.S.'s notebooks and Dr. Clair's narrative of the boy's ancestors. Moreover, the text adds current commentary to the notebooks and makes past and present more proximate.

Visualizations render Layton's death visible to counterbalance the silence that otherwise surrounds the tragic event. T.S. incorporates classificatory objects such as the coroner's report that measures and authorizes the death and a drawing that demonstrates how Layton could physically have shot himself. While this visualization may displace emotion, others incorporate emotion into classificatory labors. T.S. illustrates the Radio Flyer wagon that he uses to transport his luggage to the rail yard. Dents in the wagon are evidence of the brothers' daredevil adventures; the divots in the metal give Layton a material presence through absence. T.S. is delighted to discover— and then to visualize—how these dents match the contours of his over-stuffed suitcase: "I liked the synchronicity of Layton's gravity antics somehow aligning on this dark and chilly morning with the exact sum of my inventory. It made me miss him" (91). T.S. uses temporal language— "synchronicity"—to describe a spatial congruity that elicits a rare outburst of grief. Past and present synchronize as the wagon and the suitcase physically embrace; T.S.'s present rides in his past. The main body text acknowledges this coincidence, but it appears in the narrative as astonishment about the physical world—"Amazingly, the suitcase fit perfectly inside the uneven

red walls—it was as though the dents perfectly matched the contours of the luggage" (91)—rather than as the loss T.S. expresses in the caption to the drawing.

In *Spivet* the space of the margins, in which T.S.'s measurements, illustrations, and classification projects appear, is the space of grief. *Spivet* represents grief using a hybrid visual-verbal vocabulary that scrolls out simultaneously in two spaces—the body text and the margins—but through multiple temporalities.[28] Through the interplay between body text and margins and between word and visualization, *Spivet* takes on the problems of representing the present liveliness of absence and loss. The novel simultaneously experiments with entangling positivist and affective epistemologies.

The next chapter will have more to say about how nostalgia coexists with forms of grief in new naturalist visual media. To continue with my reading of *Spivet*, however, I want to rethink the Spivets' historical entrapment not as "misguided" nostalgia (84) but as a way of extending grief outward to encompass the loss of a child as well as environmental damage. At the same time as the male Spivets mythologize and then mummify the "Old West," the text also details current environmental conditions. Landscape descriptions and T.S.'s remarks on development in the Rockies register an evolution in the epistemologies T.S. brings to bear on his environment and reveal the ongoing temporality of environmental grief. From the railcar, the boy describes Wyoming's Red Desert with a sense of awe that implies idealization:

The more I searched the landscape . . . the more I was surprised at the number of *different shades* of reds that were present in the rocks. They were beautifully striated across the topography, like layers of some grand geologic cake. Burgundies and cinnamons tinted the sawbucks at the higher elevations; on the banks of a dry riverbed that wove its way along the railroad line, pink-infused mustard limestone faded into salmon and then luminous magenta at its silty river bottom. (180)

T.S. brings his naturalist attention to the landscape, lingering on the color gradations that mark geological strata. Here, however, no map, chart, or table accompanies the description; his attention is purely sensual. Undulating sentences mimic the meandering of the desiccated river and the railroad tracks that parallel it. The red palette echoes *Blood Meridian* but

without the tenor of murderous violence. This is a savory landscape filled with "cake," "cinnamons," "mustard," "salmon." Earlier on his journey through Montana, he described a "landscape of olfaction" (110), and it's as if the lands of the western United States are synesthetic, made up of "deep, muckraking notes of silt and pollywogs and moss-covered rocks"; maple syrup and "the spiralic fumes of oil and grease and metal grinding and pulling" (110). Environmental features strike all the senses through color, scent, sound, and even taste.

The landscape descriptions are sumptuous and stand alongside, rather than efface, the histories that are embedded in the rocks and rivers of the West. "Dams, canals, irrigation systems, aqueducts, reservoirs—these were the real temples of the West, distributing water by an incredibly complex series of laws that no one really understood but on which everyone, including [T.S.'s] father, had an opinion" (44). The infrastructure of extraction and water management makes a new cathedral, to repurpose William Cronon's phrase.[29] But this is a cathedral with collateral damage, particularly to the water supplies that are so crucial to the Spivets' ranch. In the Butte archives, T.S.

had come to slowly understand one of Butte's great ironies: that even though the mining companies had been sucking the mountains of their minerals for over a hundred years, it was not some avalanche or widespread instability of the soil that threatened the town today but rather the *water*—the red, arsenic-laced water that was slowly flowing back into the great negative space of the Berkeley Mining Pit. Every year that crimson lake rose twelve feet, and in twenty-five years it would overtake the water table and run down Main Street. (45–46)

The red of toxic copper-mining runoff seeps from this early scene of information gathering into the reds of T.S.'s description of the Wyoming landscape a hundred pages on. Reading between these scenes, the flavorful reds of Wyoming's topography suggest contamination as much as geology. The environmental impacts of Butte's transformation from mining camp to boomtown are just some of the changes the narrative notes. In addition to the "temples" of water use, it describes the takeover of the land by McDonald's fast food "temples of convenience" (135). It remarks on collapses caused by the "fossil fuel crisis" (309) and a mountain pine beetle invasion killing

pine forests throughout the Rockies (110), a disaster tightly correlated to climate change.

T.S.'s rail journey provides new ways of accessing environmental knowledge, not only the tools of sight, measurement, and detachment that he employs as a naturalist but also the senses of taste and smell and the emotions of loss. As the boy's epistemological approaches entangle, the novel connects rationalist understandings of the land—those that make it "witnessed," "mapped," "gridded," and "known" (16)—with the transformations T.S. observes from the train window. In this respect, the knowledge practices of the so-called Old West are current loss *in potentia*. That is to say that the environmental changes detailed in landscape description are ongoing losses that are rooted in enduring epistemological methods that would seem to offer nostalgic escape. In this way, the novel puts its finger on a central problem of ecological grief: how "ambiguous" those losses can be. Environmental researchers define as ambiguous a "loss that goes on without answers or closure and leads to feelings of being frozen, halted, or stuck in the grief process, living with both the presence and the absence of what was lost."[30] *Spivet* engenders this ambiguity, which resonates with definitions of melancholy, by making the very past in which the main characters are stuck the source of the present conditions from which they seek to escape, whether through a rail journey, an ancestral narrative, myths of the Old West, or emotional repression. Similar to how McCarthy uses the nineteenth-century setting of *Blood Meridian* to emphasize that current exhaustion of the land has roots in capitalist expansion and imperialism, Larsen harks back to naturalism to suggest that poisoned waters, overdevelopment, and the crises of climate change can be traced to practices of making known through classification.

That is a harsh judgment of natural history and one that the novel both proposes and tempers by making classification a source for alternatives to positivist epistemologies. One of those alternatives is failure. Tim Lanzendörfer spotlights failure as key to *Spivet*, arguing that "the major realization that T.S. has in the course of his metafictional and metacartographical musings is that mapping's reduction of complexity produces something that is in itself fictional."[31] Cartography and other methods of rationalizing the world always fail to meet the strict rules for empiricism and mimesis to which the boy initially adheres. The novel begins with T.S. expounding these values and ends with him declaring that "Cartography

Is Useless" (351). The visualization bearing this title demonstrates T.S.'s skill for and embrace of invention. Having survived his adventures— though only barely—and having arrived at the Smithsonian to accept the Baird Award, he tells a rapt audience a false narrative about his parents' death before his family arrives as if through *deus ex machina*. He records this lie on a map that shows where he alleges his parents died in Montana. In his accompanying note, T.S. declares a new allegiance to inexactitude: "no map-truths were ever truth-truths. I was in a dead-end profession. I think I knew I was in a dead-end profession, and the dead-endedness was what made it so attractive. In my heart of hearts, there was a certain comfort in knowing that I was doomed to failure" (351). T.S. arrives at a perspective voiced by the avant-garde classifiers I presented in the preface to part 2: that what classification brings to the fore is its own limitations and failures; it occludes and invents as it strives for order.

But classification's failures are not useless as T.S. declares. Rather than relegating natural history to nostalgic mythologization, failure can create affective and historical (if subjective) knowledge. As we've seen, classification is also the space for grief in the novel. Classification provides the occasion for the novel's multimodal and multitemporal form, and this form mediates presence and absence. Natural history and cartography ultimately must accommodate observation and measurement as well as invention and feeling. The novel's entangled epistemologies show the continuity between positivism and present conditions of ecological loss; they stress that the toxification and exhaustion of the land T.S. witnesses on his journey have been in preparation for centuries with the aid of positivist epistemologies.[32]

WHEN THE DESCRIBED DESCRIBES

Grieving for an exhausted nature goes back even further than the nineteenth century in which McCarthy and Larsen set their classifications. Verlyn Klinkenborg's novel, *Timothy; or Notes of an Abject Reptile* (2006), reminds readers that, even before figures like Judge Holden were botanizing on the stolen lands of the U.S. West, naturalists in eighteenth-century Europe were collecting creatures and making them the object of their classificatory attentions. *Timothy* takes this scenario and makes the object subject. The creatures that in McCarthy's and Larsen's stories silently fall prey to

human projects of imperialism and extractivism assume powers of self-expression in Klinkenborg's book.

To the extent that the novel tells a story at all, it tells of the displacement of "a subspecies of tortoise" from its natal grounds in Turkey, along the Mediterranean Sea, to southern England.[33] Timothy, as the tortoise is eventually called, first arrives at Rebecca Snooke's home in the Sussex town of Ringmer and ultimately lands in the garden of Gilbert White in the nearby village of Selborne. In the history of natural history, Selborne's acclaim is outsized relative to its small footprint because White meticulously detailed the area's trees, tubers, owls, deer, and, yes, tortoises in *The Natural History of Selborne* (1788), a classic of the genre. Klinkenborg's novel of "notes" draws from White's original text but reverses the species relationships that structure eighteenth-century naturalism: the specimen becomes observer, describer, classifier, and evaluator.

Timothy fits within a subgenre of novels in which animals are narrators— Richard Adams's *Watership Down* (1972), Barbara Gowdy's *The White Bone* (1998), and Alain Mabanckou's *Memoirs of a Porcupine* (2012) are other examples—but it is notable among these for its unusual status as a historical fiction. Timothy the tortoise in fact inhabited White's garden beginning in 1780 and features in his writings on Selborne. Klinkenborg's fictionalization of this historical creature calls attention to the methods that earned White his reputation as a natural historian and proto-ecologist. In addition to delighting readers with its curious and perspicacious "reptile" narrator, *Timothy* cracks open the assumptions, motivations, and misapprehensions of natural history. Reversing the gaze of natural history, *Timothy* queries how the discipline assigns species value and how beings perceive the ways of knowing to which they are subject. It democratizes classificatory endeavors by giving a creature that is typically the object of the naturalist's gaze those same powers of observation and description. In studying how naturalist methods developed in the Renaissance, historian Brian Ogilvie concludes that natural history was "not merely a collection of books that the encyclopedists could arrange tidily in their imaginary libraries: it was a cultural form, situated above all in a specific community."[34] The communal aspect of naturalism is delimited by a number of factors that might come readily to mind—for example, gender, race, geography, class, literacy, and educational attainment. One factor that might come less readily to mind, however, is species. Does the community within which naturalism coalesces

include the creatures that naturalists study? What happens when the being typically described does the describing?

One result in *Timothy* is that a chain of being that had run vertically now runs laterally, as if justifying Judge Holden's anxieties about humans losing sovereignty to nature. Akin to McCarthy's novel, Klinkenborg's probes humans' positioning relative to the more-than-human through grammatical choices, including the use of fragments, prepositions, and absent subject pronouns. In the tortoise-narrator's acts of comparing its species to humans, *Timothy* shows description and evaluation to be handmaids that are predicated on spurious logics of comparison, logics that grammar might uncover and undo. The tortoise's forced migration from the Mediterranean to southern England sets comparison in motion. This scenario of displacement and exile amounts to biotic colonialism. Similar to *Blood Meridian* and *Spivet*, Klinkenborg's novel positions classical natural history as an origin point for understanding the manipulations of species and land that characterize the author's present. The knowledge practices of classical naturalism are current loss *in potentia*.

With a philosophical point of view and a narrative voice, the tortoise exhibits the inquisitiveness and close attention that specimens normally *receive* rather than *perform* in naturalist representation. In the book's first pages, Timothy narrates in a staccato style. While carried upside-down, the tortoise perceives its surroundings: "Ground breaks away. May wind shivers in my ears. My legs churn the sky on their own. I look down on beantops" (5). Sentences are often fragmentary and sound like notes filling a naturalist's notebook or captions accompanying a botanical illustration: for example, humans, "great warm two-legged beast. Stilt-gaited like the rest of their kind" (5). The novel's opening pages oscillate between fragments and complete sentences to coax the reader into a testudinal, or tortoise-like, rhythm: "Houses never by when [humans] need them. Even the humblest villagers live in ill-fitting houses. The greater the personage the worse the fit. Crescent of pale shell at the ends of their fingers" (7). The sentences convey at once the deliberate motions of an unhurried creature and her alacrity of thought, as if to say that slow of body does not mean slow of mind. (I use "her" henceforth because the paratextual note explains that White was wrong in designating Timothy a male [159].) These are just the first of Timothy's many commentaries on *Homo sapiens*, the species that uprooted her and now offers her so-called comforts. The luxuries of a spacious

garden and a constant supply of food are incommodious in her eyes and correspond to humans' enslavement to hunger and choice (60, 134). The novel is replete with such observations suggesting humans are inferior to other species because they are inelegant, incoherent, "uneconomic" (8), disproportionate to their purposes, naked to weather and calamity, and "virtuosos of despair and justification" (98).

Above all, though, they're just too damn fast. In addition to rushing through their days, humans give themselves only a short night's rest to slow their pace rather than the prolonged hibernations of the long-lived tortoise. Humanity's temporal nature makes it less suitable for the plodding attention required for naturalism. Slowness is a virtue in this and other respects. Timothy is in a privileged position to observe and describe because she is slow, durable, and low to the ground. She's the perfect specimen of naturalism not in the sense of being its object of study but in being its practitioner.

In evaluating humans relative to other species, Timothy makes discoveries that could be ripped from the pages of a naturalist's notebook: "I watch him watching me. Sometimes he even seems aware of being watched. . . . Look of consciousness crosses his face. Awareness of my awareness" (74). White's and Timothy's locked looks seem also to act as moments of knowledge transfer, as if Timothy has access to White's writings about her. She uses a vocabulary rich in demotic and Linnaean names for the plants and animals of Selborne: "Goatsucker, churn-owl, fern-owl, ever-jar, puckeridge" (22), hepaticas (37), Marvel of Peru (50), *Merops apiaster* (66), *Vallisneria* (97). (In this way, *Timothy* is akin to *Blood Meridian*, where knowledge of plant species names seems to be transferred from the Judge to the narrator.) The novel includes a glossary that explains such botanical and zoological terms as well as place names and historical personages, thus transferring knowledge from White to Timothy and on to readers (161–78). In one respect, then, *Timothy* elevates the status of a more-than-human being that possesses consciousness, discernment, curiosity, and emotional awareness. Further, it elevates her as the superior naturalist because she demonstrates the epistemic virtues of slowness, closeness, steadfastness, and self-containment. However, to illuminate distinctions and convergences between human and tortoise worldviews, the narrative must transfer human intelligences into that other being. This transference of knowledge occurs within sentences whose elliptical style undoes

humans' exclusive rights to narrative. The reader thus alternates between anthropocentric and zoocentric forms of knowledge production.

In this respect, *Timothy* both supports the argument that novels are inherently anthropocentric and reroutes that argument. The tortoise frequently comments on humanity, but the novel also features a nonhuman protagonist and attends to the variety of species being contained in even a small patch of garden. By frequently abandoning subject pronouns in its fragmentary sentences, the novel brings focus to how English grammar often insists on assigning agency.[35] In response to the desire to grammatically designate subjects, Timothy's descriptions invert the controlling anthropocentrism of traditional botanical and zoological observation by using her own attributes—above all, her shell—as the metric for assessing her caretakers' anatomy. With a tortoise as its naturalist-narrator, the novel does not neutralize the anthropocentric biases of narration; instead, it underscores the situatedness of knowledge and installs new hierarchies of being.

Timothy undoubtedly works to deanthropocentrize the novel genre. For our purposes, however, we can most usefully think of it as an aesthetic exploration of a matter central to naturalism: how the sciences of classification confer value on life through acts of positioning, describing, analyzing, and hierarchizing. The text underscores the first of these actions in the opening scene where Thomas, White's servant, discovers the "escaped" tortoise after her weeklong absence. Timothy, in response, considers her location: "The boy is mistaken. There is no *Out*! Humans believe the asparagus forest is *In*! Fruit wall, laurel hedge. . . . But I am always *Out*. Among the anemones. On the grass-plot. In the shade of the Dutch-currant trees. In the sainfoin just short of the Pound Field. Under young beans a week away. Under the rasp and green-rust smell of their leaves" (7). These prepositional fragments locate the tortoise spatially and, she implies, in classification systems that are not native to her own positionality and perception. The need to place Timothy grammatically—as "among," "just short of," "under," etc.—falls on a spectrum of acts of manipulating the more-than-human realm. "The world is [humans'] to arrange" (20), Timothy muses at one point and then revises this statement slightly several pages on: "All the world to be rearranged" (25). These coupled statements speak at once to White's status as a naturalist who solicits specimens from around the world and, having "rearranged" them—that is, displaced them—arranges them in his

collections and classificatory systems. Timothy's reflections on prepositions of placement and her remarks on arrangement thus also invoke the animal's displaced status. *From* a cliffside *on* the Mediterranean, she finds herself *in* the cold climes *of* southern England. Her modes of expression are displaced as well. To probe humans' need to arrange and rearrange, she must use the language of her captors. This is especially apparent when she employs Linnaean names that, to revisit Londa Schiebinger's study of "bioprospecting," constitute a kind of linguistic imperialism that threatens cultural—and, in *Timothy*'s case, biotic—identities.[36]

If the tortoise is denatured geographically and linguistically, she is also denatured biologically. White and others misclassify her as male because the cold environment renders her sterile, and she never lays eggs. "To and fro of this climate. It has unsprung my vitals. Stalls me for months on end. Some internal weather has gone awry" (113). The novel elaborates on the lived reproductive effects of her diasporic positioning. The climate wrenches Timothy not just from reproductive potential but also into knowledge of "failed fertility" (113). In the "Cilician scrub" of her homeland, she laid eggs but was ignorant of whether her progeny survived or expired because she "wandered off" from them (114, 113). Unfamiliar weather imposes the unwelcome knowledge of having no biological future. Timothy characterizes this knowledge in metaphors that underscore the creature's grief and the violence of colonialism and enslavement: "I am an abandoned city. Inhabitants stolen. Plagued. Driven off. Murdered" (113). Disease, dispossession, and even death register in her displaced body. *Timothy* employs the trope of the knowing exile and adds biological "discordance" as one of the consequences of this condition (114). The tortoise thus echoes the idea that naturalist practices are a close cousin to imperialism. The narrative adds animal flesh to Thomas Richards's observation that narratives of the British Empire are "full of fantasies about an empire united not by force but by information."[37] In *Timothy* information is obtained by forced dislocation of bodies that express displacement to inhospitable settings through dysfunctional biology and discomfiting knowledge. Timothy practices naturalism in the vein of her captor White, but she entangles these ways of knowing with the embodied experience of their effects on the creatures that come under observation. She shows that another reason natural history and grief are intimate bedfellows is that both indicate "fundamental assumptions about what we choose to value."[38]

Rearranged, misdescribed, with "unsprung vitals," Timothy gazes back at naturalist classification. In "conjuring with the separateness of their species. Separate creation. Special dominion. Embarrassed by signs of their animal nature" (141), naturalists, the novel suggests, have already failed in their endeavors. Not to see one's own animality and to see only separateness and specialness is to fail to observe and describe with the intimacy of creaturely being. When the tortoise arrives at Selborne, White treats her as "a mere quantum of tortoise. Experimental substance to be tried against certain hypotheses" (142). She is a unit of information, an entry on a list, or an instrument of science. With time White comes to see how Timothy shares humanity's searching condition. "His look at last suggests that we are both caught up in the same hypothesis. The same experiment" (143). Without the support of difference, the system erodes, and Timothy becomes "merely itself" (152). From a quantum, Timothy ends as "merely a fact in a world of facts" (157). Being a quantum and being a fact might seem equivalent in that they both suggest that an object has been reduced, instrumentalized, and quantified, but the narrative by this point has ascribed great value to the mere. (The word appears at least thirty times in the short book.) To be mere is to stand outside systems of analysis that confer more value on some beings than others. As "merely itself" and "merely a fact in a world of facts," Timothy stands in a position of similarity to human beings who would otherwise insist on their difference and superiority.

Timothy toys with an idealistic view of species equivalence but ultimately contends that it is impossible not to compare, not to succumb to the "fallacy of analogous reasoning" (66). The novel acts out both the inevitability and the inadequacy of comparing beings through the tortoise's reversal of naturalism's gaze, and it emphasizes this inadequacy with her final state of exhaustion. "I wish to be out of human reach. Out from under the constant stir. Laborious turmoil of this breed. Endless bother of humans. Toil inherent in their mere existence" (148). At the end of the novel, our narrator is reiterating the theses about humans she offered at the beginning. But there is a change here because repetition signals exhaustion. *Timothy* animates this condition by featuring a sensate, articulate being who has been displaced and subjected to human designs. She grieves for a lost home. Her grammar, specifically her use of present progressives, emphasizes this air of fatigue at the end of the novel. Ceaseless human labors capture everything in their ambit: "Plotting and measuring and planning. Cutting

vistas. . . . Trimming hedges. Amending this bit of earth and that bit. Mining chalk to spread on the fields" (148). The whimsy of *Timothy*'s new natural history gives way, in the end, to a sense that virtuosic classification is tinged with despair, to paraphrase the tortoise (98). It's as if the novel gives voice to those creatures that, in McCarthy's and Larsen's books, silently fall prey to human projects of imperialism and extractivism.

All of this industry—plotting, measuring, planning, mining—ultimately signals loss for Timothy; not only her lost home but more far-reaching losses that appear in her earlier exclamations on the violence of biotic colonialism: "stolen. Plagued. Driven off. Murdered" (113). Klinkenborg's novel positions the narrator-naturalist as both the object and subject of these losses, as a figure anticipating her place in twenty-first-century ecological deficit and as the calculator of this deficit. Reversing the gaze of the naturalist does not fully counter the anthropocentrism of natural history or deprivilege the human subject so much as signal the emotional core of naturalist practices: loss and grief. The novel presents knowledge of these emotions through the voice and altered body of a diasporic creature both like and unlike her captors. The cessation of ovulation results from naturalists' classificatory zeal, from the desire to collect and relocate and examine, but this change to Timothy's body also leads to the misclassification of her sex. This irony culminates the narrative's play with perspective through grammatical choices in that it shows not only that other epistemologies are possible but also that naturalism's ways of knowing often lead to its own failures.

For Walter Benjamin, feelings of loss are "a definitely historical problem related to the experience of modernity."[39] As Jonathan Flatley elaborates, these feelings indicate "the place where modernity touches down in our lives in the most intimate of ways" because they stir essential questions: "What social structures, discourses, institutions, processes have been at work in taking something valuable away from me? With whom do I share these losses or losses like them? What are the historical processes in which this moment of loss participates—in other words: how long has my misery been in preparation?"[40] Losses do not appear out of nowhere. They point to structural and discursive histories that are shared and that reach backward and forward in time.

The classifictions gathered in this chapter answer Flatley's final question by showing that the environmental injuries that are pervasive in the twenty-first century have "been in preparation" since at least the triumph of naturalist classification. The conditions for the currently growing ecological deficit bear the traces of and can be traced back to epistemological tools developed centuries prior. The more-than-human realm, however, exceeds the epistemologies that would confine it to the empirical, the rational, the orderable. *Blood Meridian, or, the Evening Redness in the West; The Selected Works of T. S. Spivet*; and *Timothy; or, Notes of an Abject Reptile* entangle other epistemologies with those positivist ones that guide natural history to show how loss and grief are constitutive of naturalism. The same scientific and representational practices that generate knowledge and that value or devalue creatures and biomes—practices of observation, measurement, taxonomy, naming, illustrating, mapping, etc.—contribute to the erasure of biotic potential. These practices also contribute to their own failure. In *Blood Meridian* this failure becomes apparent when nonhuman narration challenges the mastery that Judge Holden asserts through his naturalist practices; in *Spivet*, when epistemologies rooted in emotion and invention that have been marginalized from classification are seen as constitutive of it; and in *Timothy*, when the described object describes her world and exposes misclassification as a result of the colonizing acts of natural history. These literary works sow the seeds for the new natural history in visual media I explore in the subsequent chapter. As we will find, visualization techniques used to aesthetically mediate the data of species threat elaborate how grief structures natural history and the disciplines that have developed out of it.

VISUALIZING LOSS FOR
A "FRAGMENTED SURVIVAL"

Natural history museums are under fire, and the flames are approaching from all sides. From one side, environmentalists are attacking the institutions for their cozy partnerships with the fossil fuel industry. The activist organization The Natural History Museum (NHM) exemplifies this trend. It is a proscience nonprofit that promotes critical curation by museum experts and the public alike. The group exposes science museums that curry favor with fossil fuel industry donors and obscure the scientific consensus on climate change. NHM encourages individuals to become "museum anthropologists" who probe how these institutions mold "what we see, how we see, and what remains excluded from our seeing." Counting Nobel Peace laureate Eric Chivian, activist Naomi Klein, and indigenous organizer Judith LeBlanc among its advisors, NHM arranges exhibitions and expeditions that "demonstrat[e] principles fundamental to scientific inquiry, principles such as the commonality of knowledge and the unavoidability of the unknown."[1]

From the other side, the flames approach from scholarship and artworks on the enduring influence of imperialism on curation in natural history museums. Visual theorist Mieke Bal reads in institutions such as the American Museum of Natural History "the story of the changing but still vital complicity between domination and knowledge, possession and display,

stereotyping and realism, and between exhibition and the repression of history." In line with Susan Scott Parrish, Mary Louise Pratt, Londa Schiebinger, and Kathryn Yusoff, who appeared in the preface and chapter 3, Bal sees the classical age of natural history as an "era of scientific and colonial ambition" that endures into her late twentieth-century present. For Bal the natural history museum will become one of the dinosaurs it displays if it does not become a "metamuseum" that can reflect on the institutional consolidation of power and knowledge.[2]

NHM is not the only one to have picked up on Bal's call for critical curation; artists who use natural history as both theme and medium share the theorist's dismay. Painter Walton Ford is both a devotee and a critic of the institutions, describing them as "really nineteenth-century trophy rooms, displays of conquest," "plastic biodiversity exhibits" that deny their colonialist heritage.[3] Mark Dion, a like-minded artist who produces cabinets of wonder and parodic reproductions of naturalist expeditions (and who also sits on NHM's advisory board), views the institutions as containers for the ruins of life and lacking in vitality.[4]

Still, the very people fanning the flames engulfing the natural history museum are also rescuing it from them. Ford and Dion practice the arts of naturalism even as they scrutinize its legacy. Photographer Maria Whiteman champions the museum's role in inviting empathic encounters between humans and more-than-human creatures. These sites are "one of the few kinds of spaces in which members of the public come into contact with animal bodies and develop attitudes toward other living species."[5] For wildlife writer Richard Conniff, the museum's benefits are even more political: we should preserve them just as they preserve threatened and extinct species because they are on the front lines of biodiversity conservation and climate science. The best natural history museums turn toward the future and are hardly "moribund" vestiges of a colonially and environmentally troubled past.[6] These artists and the authors of classifictions we studied in chapter 3 prove that natural history and its institutions loom large in the contemporary environmental imagination.

The previous chapter ended with Reif Larsen's *The Selected Works of T. S. Spivet*, in which the practices of naturalist illustration and classification visually enact grief. The problems of representation central to loss yield affective epistemologies for the characters mourning a dead boy

and an altered landscape. *Spivet*'s insights usher us into this chapter's visual media: paintings, digital visualizations, and bioart that are fired up by natural history and also put its traditions under fire. At a moment when "shifts in the epistemology of nature" are underway owing to genetic analysis, synthetic biology, and environmental disturbance, the "principles of scientific inquiry" that have historically shaped Eurowestern relations to the more-than-human world also invite scrutiny.[7] Painter James Prosek; visualization designers Accurat (for Audubon), Bryan James, and Maya Lin; and bioartists The Tissue Culture & Art Project bring naturalist approaches to bear on the concurrent conditions outlined in the preface: ecological deficit, information surfeit, and emergent biotechnologies that get taken up in the conservation sciences. Their projects demonstrate that managing environmental information today is also a project in managing loss. They devise representational strategies that produce this intimacy between information and emotion. Poetry scholar Margaret Ronda argues that traditional aesthetic templates for mourning such as elegy fail to offer "abundant recompense" in the twenty-first century.[8] New naturalist visual artists see this failure as an opportunity to revive modes of scientific representation for the compensations against extinction and endangerment they might offer. They lobby answers to Ursula Heise's question for extinction narratives: "Is it possible to acknowledge the realities of large-scale species extinction and yet to move beyond mourning, melancholia, and nostalgia to a more affirmative vision of our biological futures?"[9] The answer is rarely a simple yes or no.

Environmental artists take up natural history in an interrogative mode. Naturalist techniques of illustration, collection, and display not only have representational utility but also open inquiry into the enduring influence of Enlightenment epistemologies on current environmental values and science. New naturalist artists expose the sutures in classificatory systems by using them to access ways of knowing built on speculation, uncertainty, and open-endedness. They negotiate the positivist tradition by promoting negative knowledge, which acknowledges limits on, obstacles to, and errors in knowing and turns them into a new aesthetic of thought. This art repurposes natural history's epistemologies and representational modes to salvage a future out of the past and to variously accommodate, contain, and diminish emotions of loss.

JAMES PROSEK'S ILLUSTRATIVE INVENTIONS

As a new naturalist, Prosek dwells in the representational idioms and methods of the dominant Eurowestern epistemologies of nature. In his paintings, neither nature nor ways of knowing it are ever fixed; environmental knowledge and emotions are clearly evolving in a "post-wild world."[10] Prosek is a painter, illustrator, and science writer who made his name with *Trout: An Illustrated History* (1996) at the precocious age of nineteen. His ventures as a fisherman-illustrator inspired his attention to how systems of classification, and especially taxonomy and nomenclature, become naturalized. While standing on the banks of rivers in the northeastern United States as a child, he came to challenge the givenness of names that entombed fish species in systems of classifications. For Prosek taxonomy fails in "exhaustively representing the world of natural things" because experiences with animals in the field and on the stream are more variable than taxonomy allows.[11] The artist continues to question taxonomic systems in the years after *Trout* when he "explore[s] the idea that naturalists named things because they wanted to create a legacy for themselves, or wished to be published more, or because of an innate human compulsion."[12] Ranging beyond his native New England, he continues to paint and write against the taxonomic impulse that, he claims, derives partly from careerism and egoism.

Yet naturalist methods remain compelling. Prosek's practice is deeply empiricist: he goes out into the field and observes, measures, illustrates, and even preserves animals. He does so, however, to explore the variety of perceptions of nature that give the lie to static species names. This travel- and labor-intensive process replicates classical naturalist methods and yields works that evoke John James Audubon's and Charles Willson Peale's paintings. Exhibitions such as "Un-Natural History" (2011), "Wondrous Strange" (2014), and "Field Guide: James Prosek's Un/Natural World" (2015) are born of critique, but Prosek's aesthetic is exuberant. The vibrancy and playfulness of the paintings counterbalance his disturbance with the naturalist traditions within which he works. The pieces composing "Un-Natural History," my focus here, combine the "innate human compulsion" for order with a proclivity for creative variation and disorder.[13] As my analysis goes on to show, this balance between order and variety in one sense reproduces Eurowestern classifiers' treatment of monstrous figures that

violate their systems, but it also breaks from this tradition by reveling in invention and uncertainty. Prosek's paintings show the sutures in classification practices and foreground naturalism's history of instrumentalizing and intervening in life. Exploring the inadequacies of taxonomy, they place viewers in turbulent epistemological waters where empiricism and invention mingle.

Prosek's works flicker between the empirical and the chimerical. The creatures he invents begin in language, in the curious common names for animals. He transforms the names *parrotfish*, *roosterfish*, and *kingfisher* into creatures blending avian and piscine features. He transforms *flying fox*, a name whose multiple referents—a kind of bat and a kind of fish—already scramble the brain, into a fox with wings. Let's take *Parrotfishe* (2009, figure 4.1). The name references an oceanwater fish from the Caribbean islands that eats coral reefs using a beak-like mouth. On Prosek's paper, the parrotfishe becomes "its name in protest of being named."[14] It becomes a

FIGURE 4.1. James Prosek, *Parrotfishe*, 2009. Courtesy of the artist.

fish-bird to align not only with its name but also with another manifestation of hybridity: its sexual hermaphroditism. The animal presents further classificatory conundrums that give it a contested status among taxonomists and systematists. The first line of the "Parrotfish" entry in Wikipedia announces these contests: "Parrotfishes are a group of about 95 species traditionally regarded as a family (Scaridae), but now often considered a subfamily (Scarinae) of the wrasses."[15] For a nonexpert, this taxonomic trouble hinges on just one letter: the change from "d" to "n" marks a step down in the classificatory scheme. As if to signal the difference a letter makes, Prosek appends an "e" to the parrotfish for his painting. The species evidences the ongoingness of classification processes that we might easily take as fixed in their Enlightenment origins.

Prosek places the fish-bird directly in the center of cream-colored paper as if in midflight or in midswim . . . certainly in-between. Though we know the media the artist uses—watercolor, gouache, colored pencil, graphite—we don't know the medium through which the parrotfishe travels. Like his antecedent, Audubon, Prosek does not always fill in the creature's environment. The vibrant reds, yellows, blues, and greens that distinguish parrots and this species of fish make up for the austerity of the background. As art historian Jill Deupi notes, Prosek creates "a visual *tour-de-force* that leaves no doubt about the artist's mastery of the intractable medium of watercolor."[16] The saturated colors become muted yet more textured as they move down to the scales and fins of the figure's fishy half. Prosek manipulates the unforgiving medium of watercolor to make the feathers and scales more tactile, to add a shimmer to the latter, and to produce an inquisitive expression in the animal's eyes.

With this expression and the parrotfishe's posture, Prosek's indebtedness to Audubon is plain. Though the parrotfishe might be midswim or midflight, this could also be a postmortem rendering. Audubon typically illustrated birds that had died by his own rifle and that were then stuffed or wired up.[17] Though this creature has no existence in nature, visual features hark back to Audubon's process of "destroy[ing] beauty to create beauty."[18] Just as Audubon placed his birds' heads in distorted poses to fit their life-sized features on the page and to show as many facets of the body as possible, this parrotfishe's head is cocked. Back and at an angle rather than in direct profile, the head displays more of its distinctive beak. Then again, the parrotfishe's angle could instead reference the stutter-stop head movements

parrots make when inspecting an intriguing object. Of course, neither the Audubon tradition nor parrot ethology can be explanatory here given that the creature is a figment of Prosek's critical-classificatory imagination. *Parrotfishe* is then chimerical in theme and in method. It fuses the piscine and the avian and fuses naturalist empiricism and fantastical chimericism.

Mingling observation and invention, Prosek cleaves to naturalism despite his dissatisfaction with the "myth of order" it propagates.[19] Naturalist idioms shout out from the paper. Mottled turquoise and beige eggs, labeled "egg 1" and "egge," display a feature of the parrotfishe's reproductive system but also suggest the presence of a collector. Other curiosities and faint, handwritten notes announce, "I was there." That is, they perform Timothy Morton's concept of "ecomimesis," a "rhetorical device [that] usually serves the purpose of coming clean about something 'really' occurring, definitively 'outside' the text, both authentic and authenticating."[20] The eggs and annotations authenticate the artist's presence at the scene, taking notes and collecting specimens. The complete text of the notes, which describe the creature's provenance and personality, emphasizes ecomimesis: "[Egg] found in the sand in the hot sun. Hermaphrodites, they appear to be beautiful and earnest. Agua Boa [River], Amazon, via the Branco and Negro. I said 'this fish that swims has a wicked bite.' From Andros Island, Bahamas to Amazonia. . . . Resident of blue holes. James Prosek, 2008, Rarely seen on plants. Encumbered by neither salt nor fresh. I am drawing on experience here!" The exclamatory, present-progressive assertion and slapdash, nonlinear quality of the notes place us in the moment. It's as if we were peeking over the illustrator's shoulder as he draws and writes in his field notebook. *Parrotfishe* makes explicit what natural history typically attempts to efface: that the subject always intrudes even though naturalists may "aspire to knowledge that bears no trace of the knower."[21] Prosek's painting thus corroborates ecocritic Christoph Irmscher's thesis that American natural history so often becomes "a form of autobiography" even as it strives for objectivity.[22] The signature, date stamp, and first-person annotations introduce the autobiographical as authenticating, yet the fact of invention runs counter to positivism, or at least muddies it. Prosek traffics in the zones of observation and invention and shows their continuities: on the one hand, observation never remains uncontaminated by the observer's interventions—here expressed as textual exclamations—while on the other hand, invention traffics in subjective witnessing.

Prosek's affinity with naturalism thus applies to his representational style as well as to how he participates in the field's history of negotiating the monstrous. Historian Harriet Ritvo argues that, for Enlightenment naturalists, "the existence of hybrids or mongrels or crosses . . . emphasized the existence of boundaries between groups and simultaneously obliterated them. The intensity of the aversion provoked by mixed creatures suggested the importance of the divisions thus called into question, whether they were zoological, political, agricultural or social."[23] Expressing attraction rather than aversion, Prosek engages in a project of both highlighting and effacing "boundaries between groups." In response to homogenizing classifications, he invents even greater biological variety.

Whereas *Parrotfishe* invents a chimera of actual animals, *Cockatool* (2008) invents a cyborg (figure 4.2). The tools found in a Swiss Army knife—scissors, ruler, bottle opener, drill bits—replace the feathers of the bird's crest.[24] The piece repeats the environmentalist refrain that humans have irrevocably shaped nature, even down to creatures' anatomy and physiology. Prosek's work includes the epistemological and representational methods of natural history among those shaping forces that can craft a cocka*tool* out of a cocka*too*. The painting situates the cockatool with a descriptive annotation below the figure: "cockatool or can-do-ca-too, efficient at most simple carpentry jobs, Barringtonia Asiatica painted from life The moonlight crumbled to degenerate forms. Pohnpei Island Micronesia March 2008. Bird sighted on Kosrae island, only known specimen." *Barringtonia asiatica* refers to the fish poison tree on which the bird perches with a nut in its claw. The tree contributes to the rich biodiversity for which the Pohnpei is renowned and, like the classification-busting parrotfish, places classificatory conundrums within the frame. Linnaeus initially designated this tree *Mammea asiatica* in his *Species Plantarum* (1753) based on a specimen collected on the island of Java. German botanist Wilhelm Kurz assigned the fish poison tree its currently accepted name of *Barringtonia asiatica* in the late nineteenth century. The tree bears the legacy of troubled nomenclature, a legacy Prosek introduces without underscoring, leaving it to curious viewers to research.

Taken together, the painted figure and the annotation are reminders that both tweezers and names are instruments of human ingenuity. *Cockatool* activates the dynamism of classification that arises from "the sheer density of the collisions of classification schemes in our lives."[25] Given that the

FIGURE 4.2. Prosek, *Cockatool*, 2008. Courtesy of the artist.

classification of a bird depends on aspects like its metabolic and reproduc-
tive systems, its heart and skeleton, the presence of beak and feathers, does
a change of feather into metal shunt the creature out of the class Aves and
into another yet-undetermined category? When "too" become "tool," does
the bird slip off the taxonomic hierarchy entirely? Even if we resolve these
questions about the creature's avian status, ethical quandaries surface. Most
of us know the cockatoo as a companion species whose value derives from
the pleasures it brings animal-lovers and the profits it brings vendors of

charismatic birds. Literally instrumentalized, the bird is now a *Cacatua habilis*, or tool-wielding bird, who is "efficient at most simple carpentry jobs." When the animal's utility increases in this sense, does its aesthetic and companionate values increase or diminish accordingly? In physically instrumentalizing the animal and spurring these questions of value, *Cockatool* features the ways humans intervene in and value life through colonialist exploration, classification, and appropriation.

A tree goes from *Mammea* to *Barringtonia*; a bird flickers between organic and inorganic; a painting shimmers between invention and empiricism. Key to this latter process, I argue, are the curiosity and quest for information that the painting encourages. Curiosity is the lifeblood of natural history (look no further than the curiosity cabinet). Prosek's paintings include enough specialized taxonomic and geographical information to prod research missions into the veracity of the places, fauna, and flora he notes. These inquiries naturalize the fictive in that they, at least for a moment, have viewers take as actual the imagined. However, because the lifeforms Prosek includes straddle the real and the invented, these questions may be doubly speculative: Do the cockatool and the fish poison tree share an ecosystem? Is *Barringtonia asiatica* as deadly to this cyborg species as it is to the actual fish? Are the instruments on the bird's crest forms of protection against such dangers? The painting has transported the viewer to a hypothetical world. In effect, Prosek's new natural history—his fusion not only of types of matter but also of mimesis and imagination—places viewers in strange epistemological territory. The questions above are nonsensical given the creature's fictive status, but they respect the *Cockatool*'s ontological conditions as established in the painting. Repurposing naturalist methods, Prosek invites us to hold in tension positivist and speculative ways of knowing the more-than-human.

"Painted from life," the cockatool scrambles the idea of observation, a foundation of empiricist epistemologies. In this respect and in his foregrounding of classification, Prosek takes scientific and artistic methods as his theme. Crucially, the painting is just as much about the processes of natural history as it is about the charismatic bird. Like the parrotfishe, the cyborg bird is "draw[n] from experience" but teaches that all "sightings" involve invention. The paintings evoke the dual meanings of vision: perception via sight but also imaginative projection. Prosek's work then exposes the sutures in classificatory procedures. When the annotation announces

the creature is the "only known specimen," it aligns the painting's hybrid empirical-invented status with naturalism's intertwining of the material and the conceptual. Lorraine Daston explores this epistemological mingling through the function of type specimens in botanical natural history. Type specimens are the "ur-specimens of the species" that are archived in herbaria for botanical study; they are the reference objects "to which the original description and name is [sic] anchored." Researchers consult them when settling disputes about species taxonomy. The type specimen, however, has a "paradoxical status as a concrete abstraction" that "represents but does not exemplify its species."[26] It is not some Platonic ideal of the species but rather the one most typical and most convenient for preservation. Incorporating the concepts of the specimen and of uniqueness through its annotation, *Cockatool* introduces the tools natural history uses to navigate the particular and the general, a process that involves straddling material objects and conceptual abstractions.

Prosek's paintings thematize the colonialist instrumentalism of natural history as well as its epistemological complexities. Rather than denigrate the tradition and throw it on the dust heap of scientific and artistic history, they recuperate naturalist ways of knowing. They foreground the epistemological paradoxes inherent to naturalist methods. The style and tone of Prosek's works are crucial to this recuperative work. The vibrancy of his palette and the wry, ebullient annotations stamp the occasion with joy. Precision can read as an effort at control—and that reading lingers here—but it also reads as exuberance when put to these "monstrous" figures. What's more, the detail of the paintings and the ecomimetic quality of the annotations bespeak intimacy between artist and animal; they suggest proximal encounter and sustained attention. Again, this can tip toward an imperialist, appropriative relation. The paintings do not foreclose this possibility and instead suspend it along with the other ontological and epistemological suspensions I have detailed here.[27] These suspensions come with a great degree of ecological uncertainty. Prosek's twenty-first-century context is one of deficit. The "only known specimen" announces scarcity, perhaps even the creature's imminent extinction, while the hybrid, invented aspect of the animals causes us to wonder if these are genetically modified beings compensating for the lost or threatened.

In an age of technoscientific intervention into bodies and ecologies, "all natural history is a history of disturbance."[28] With their modified,

hybridized figures, Prosek's paintings nod to this condition and invent within the parameters of naturalist precision. The techniques of the eye and the hand—observing, sketching, describing, preserving, collecting, illustrating—serve to depict an irreversibly altered more-than-human nature and to speculate on what evolves within it. *Cockatool* and *Parrotfishe* propose that precision can elude the "myth of order" to instead promote an epistemology and ethics of ambiguity that does not "settl[e] for one naturalized mode of interaction" with the creatures of the Earth.[29] In the aesthetic sphere, naturalist precision and other methods can be put to the uncertainties that classification has always had to negotiate.

DESIGNING DIGITAL ECOSYSTEMS

"Cast off from the certainties of Nature, how are past and present ecologies known? How might their futures be predicted? What should be conserved if multiple futures are possible?" These questions preoccupy geographer Jaime Lorimer in his project to understand animal conservation in the Anthropocene. His sweeping answer is that, given the current "hybrid and discordant ontology of wildlife," we need "speculative practices unsure of future outcomes" to produce ecological knowledge and save animals.[30] For Prosek, speculation begins with emulation. He adopts the methods of naturalists like Audubon but infuses them with inventions that muddy the epistemological waters in which his forebears swam. His works engage positivist epistemologies and push those into domains of speculation, hybridity, discord, and uncertainty. The data visualizations by Bryan James and Maya Lin that I turn to now engage in these speculative practices in ways that underscore both their debt to natural history and natural history's descendants, conservation and biodiversity science. James's and Lin's projects visualize loss in an ecological economy of deficit but offer recompense for absence by designing ecosystems. James shows the continuity between natural history and biodiversity sciences through their shared biopolitical cast, while Lin reproduces the infowhelm within biodiversity sciences and exhibits the complex temporalities and forms of grief inherent to twenty-first-century species study. To pivot toward these arguments, I begin with a visualization that shares with Prosek the Audubon tradition and shares with James and Lin digital modes of recording species in a time of deficit.

Audubon Annual Report 2013

John James Audubon and the society he inspired are familiar juggernauts of conservation environmentalism. The National Audubon Society, or simply "Audubon" as it is known today, has also attained an iconic status due to its visual imprint on environmentalism. The eponymous painter's legacy inspired Harriet Hemenway and Mina Hall to form the organization in 1896 to protect waterbirds in Massachusetts, and the group's conservation work in the ensuing 125 years has shaped U.S. environmental policy. The organization's ambit has expanded recently to include climate change policy among its concerns. With this more planetary scope has come the need for enhanced mapping and sensing techniques and bigger data. In 2011 Audubon announced a "multimillion-dollar strategic partnership . . . [that] creates network-wide GIS [Geographic Information System] mapping capability."[31] This ongoing initiative adds sensor technologies and data processing to Audubon's repertoire of conservation strategies. This shift is perhaps most visible in the annual Christmas Bird Count. Long an exemplar of citizen science, the count now involves "crowd-science."[32] *Audubon Annual Report 2013* announces that they are "putting the most powerful mapping and data visualization tools in the hands of conservation leaders from every corner of the Audubon network"; more everyday tech such as birdcams, smartphones, and social media are also helping "answer tough questions, democratize data, and create a culture of collaboration."[33] With these efforts, Audubon's Bird Count fuses observation through-the-binoculars with what media sociologist Jennifer Gabrys calls "citizen sensing": "computational and mobile practices of environmental monitoring involving smartphones and low-cost or mobile devices."[34] Audubon confirms Gabrys's argument that environmental sensing technology—whether in the hands of specialized researchers or crowd scientists—is rendering the planet computational and rendering computation planetary.[35]

A media shift accompanies this technological shift. Founded on Audubon's watercolor and pastel illustrations, the organization's representational investments move to photography in the twentieth century, thus aligning with transformations in the history of art. In the years prior to 2013, a striking photograph of a bird or flock greeted donors and other readers of the annual reports. As Audubon transitions to "21st Century Conservation" through global GIS and social media ventures, the visual rhetoric

transforms as well.[36] For *Annual Report 2013*, the organization tried data visualization. This move broadcasts Audubon's technological investments as well as its greater reliance on abstraction and aggregation. The charisma, strangeness, power, and/or vulnerability of birds, themes of the illustrations and photographs, take a back seat to quantification. The cover image introduces two tensions that run through new naturalist visualization as well as conservation and biodiversity sciences: between abstraction and specificity and between aggregation and uniqueness. Visualization not only veers toward abstraction and aggregation, as we will see; it does so on a greater scale than the representational media long associated with Audubon. Naturalist painting typically features a single specimen or at most a cluster; photography can fit a whole flock in the frame. Data visualization, however, can harbor thousands of creatures. This expansion marks an epistemological "shift in relation to information technology toward 'comparison, extrapolation and cumulative effect.'"[37] As my reading will establish, as charisma gives way to abstraction in *Audubon Annual Report 2013*, the emphasis on the human and on method increases.

The report's cover, created by Italian data design firm Accurat, uses a scatterplot display to depict the number of bird species tallied in the Christmas Bird Count from 1900 to 2013 and the change in that number over time. The bottom *x*-axis indicates the year of the count and the top *x*-axis the ordinal number for it; the *y*-axis shows the "number of participating field observers" (figure 4.3). V-shaped icons indicate the average number of bird species, where they were counted, and whether those numbers have increased (teal and marine blue) or decreased (yellow and red). Ask a child to draw a flock of birds crossing the sky, and she might very well produce a cluster of Vs similar to those here. So familiar and simplistic, these icons evoke birds through abstraction even before we take note of the Audubon name on the cover.

Accurat strategically lays out the *x*- and *y*-axes so that the avian avatars seem to be lifting off. Though the visualization suggests bird flight, *Homo sapiens* and not species of Aves are what lift off here. Given that *participation* in the count increases, the upward rise in Vs does not indicate whether more species were counted owing to the group's conservation efforts or only to more robust human involvement and use of sensing and other technologies. The visualization communicates not the successes of Audubon's conservation efforts so much as its success in mobilizing crowd-scientists.

FIGURE 4.3. Back and front covers of *Audubon Annual Report 2013*. Designers: Giorgia Lupi, Gabriele Rossi, Simone Quadri, Marco Bernardi, Michele Graffieti. © Accurat, 2013.

Borrowing visual theorist Johanna Drucker's basic definition of data visualization as "*metrics expressed as graphics*," the metric of value in Accurat's image is humans and their electronic devices.[38] In a sense, then, the visualization does not deliver the content one might expect from a conservation organization's annual report: that is, change in the status of bird populations over time. The visualization instead affirms the Audubon president and CEO's announcement that their latest mission is "to analyze our membership, understand our supporters, and find out what moves people to action."[39] As mapping, sensing, and communications technologies "revolutioniz[e] how Audubon works," what count most are the group's methods of counting. With the organization's methods prominently on display rather than the status of birds, the visualization manages information on threat and loss by diverting attention to a nonavian kind of abundance: of information, technology, and people. If anthropocentrism is the report's pervasive theme, quantification is its dominant epistemological and representational mode, not only on the cover but also throughout the document, which is festooned with data visualizations.

This epistemological mode serves a mood of optimism, a mood that conforms to the tone of the annual report genre. An annual report wants to champion successes, and the visualization's strategies of abstraction and aggregation promote this cheery outlook. In Accurat's piece, environmentalism's burgeoning commitments to citizen science, social media, and crowd-sourced Big Data inflect the representation of scientific information. Information and environment converge in a quantitative object that also does emotional work: it diminishes loss and dispels grief through its anthropocentric and technological focus.

Bryan James's *In Pieces*

Audubon's visual strategies inspire my turn now to the question of the status of loss in data visualizations repurposing natural history. Accurat's avian scatterplot falls within Drucker's category of visualizations that "are static in relation to what they show and reference." Reacting to an ecological economy of deficit, James's *In Pieces* (2015, originally titled *Species in Pieces*) falls into the category of "*knowledge generators*" that, following Drucker's schema, have "a dynamic, open-ended relation to what they can provoke."[40] *In Pieces* incorporates methods of selection, abstraction, and

fragmentation that are essential to the biopolitical program associated with natural history as well as its disciplinary descendants in the conservation sciences. Through digital invention, however, the project toys with reconstitution to offer invented ecosystems as creative recompense for loss.

While in the Audubon visualization feelings of grief diminish in proportion to the launching Vs' hopeful rise, *In Pieces*'s more dynamic portrayal foregrounds species extinction and the values of uniqueness and charisma that make species loss an occasion for grief. The opening splash page welcomes visitors to a "CSS [Cascading Styles Sheet]-based interactive exhibition celebrating evolutionary distinction."[41] As an "exhibition," *In Pieces* evokes natural history museums, now updated for digital platforms instead of those monumental destinations of school field trips. James describes the project as celebratory, but the accompanying music is doleful and reminds viewers that extermination is the occasion for this celebration. Accepting the invitation to "explore the exhibition," viewers come to Piece 1, a helmeted hornbill (*Rhinoplax vigil*, figure 4.4) and cycle through thirty species that "face a fragmented survival." At any point the user can abandon the project's sequential ordering and click to a menu of rotating white dots that correspond to the "30 unique species." Whether African penguin (*Spheniscus demersus*), diademed sifaka (*Propithecus diadema*), or Wallace's birdwing (*Ornithoptera croesus*), the same thirty triangular

FIGURE 4.4. Bryan James, "Helmeted Hornbill," *In Pieces*. Courtesy of the artist.

pieces compose the image of the animal. Only the pieces' orientation and color vary.

On each animal page, a link to "What's the Threat" puts us in mind of the captions and educational labels on museum displays. The link takes users to open-source data on the creature's scientific name, geographical range, unique characteristics, and sources of threat, and beyond that to videos, photographs, and relevant conservation projects. As an "exhibition" with informational displays, *In Pieces* evokes the natural history museum, here updated for digital platforms. In addition to these nods to practices of collecting and presenting species, what particularly interests me are the subtler ways the project brings the methods of natural history to the screen. Specifically, the methods of selection, abstraction, fragmentation, and reconstitution.

James curates a deliberately narrow subset of critical and endangered animals: only thirty species-pieces. (The project may have been inspired by the fact that these words are near-anagrams.) Selection is thus at the heart of his method. But how would one choose from among the twenty-eight thousand threatened species currently appearing in the IUCN Red List database?[42] James's governing metric for selection is distinctiveness, a metric he derives from the EDGE of Existence program at the Zoological Society of London. The program funds conservation projects for one hundred species from among the thousands of threatened mammals, corals, amphibians, reptiles, sharks, rays, and birds. To receive conservation priority in the EDGE program, a creature must be "evolutionarily distinct and globally endangered."[43] The adjectives "unique," "wonderful," "unusual," "irreplaceable," and "interesting" dominate EDGE's lexicon. These descriptors reference more than just the creatures' staggering visual features. Importantly, "distinctiveness" refers to genetic and behavioral uniqueness, such as having few close relatives on a phylogenetic tree. As Ursula Heise notes in her study of extinction narratives, these characteristics are vital to biodiversity policy "because the questions of how closely related the species are and what ecological functions they fulfill need to be considered" along with the number of extant specimens.[44] The "interest" of a species, then, is subjective, ecological, and quantitative.

Scholarship on natural history and biodiversity science confirms the interplay among these aspects of "interest" as well as aesthetic and affective qualities. Information theorist Geoffrey Bowker, among others, shows that

taxonomists and biodiversity scientists tend to investigate the exotic, the cool, the easy-to-study, "what has already been studied," and what humans can use or profit from. These rationales for selection initiate a feedback loop "whereby things that cannot be described easily and well get ignored, and so receive an ever-decreasing amount of attention."[45] Attention begets attention; neglect begets neglect.[46]

The concept of charisma offers another way of understanding the factors shaping species interest and protection. Look around at environmentalist campaigns, and a menagerie of "charismatic megafauna" meets your eyes. Conservation and climate change organizations, among others, typically spotlight lions, leopards, elephants, African buffalos, and rhinos (the so-called Big Five African species) as well as polar bears, jaguars, and whales because they stimulate the imagination and sympathy and spur tourism and fundraising. Charisma might feel like a nebulous category of the "I-know-it-when-I-see-it" sort, but scholars have added contour to its meanings within conservation discourse. Jaime Lorimer distinguishes ecological charisma, or "the material properties of an organism," from aesthetic and corporeal charisma, respectively, "the visual appearance of a species in print, on film, or in the spectacular encounters of ecotourism" and "the feelings engendered in proximal, multisensory encounters" with an organism.[47] Frédéric Ducarme, Gloria Luque, and Franck Courchamp survey studies within the conservation field and add to Lorimer's list of factors determining charisma: "'detectability and distinctiveness' (i.e., fame), 'socioeconomic biases' (the way societies see each animal and its reputation), . . . and 'potential to generate satisfaction' (which represents its interest for scientists, intellectuals and curious people)."[48] James selects animals that are more obscure than the charismatic megafauna of environmentalist campaigns, but his menagerie still reproduces the largely anthropocentric values that determine species charisma, values such as aesthetic interest and satisfying feelings of curiosity and surprise. In a digital visualization, animal encounters are not "proximal," as Lorimer describes, but they are "multisensory" and even interactive, as I go on to explain.

Propagating the values of charisma for a new natural history, James brings out the biopolitical cast of both "old" natural history and "new" conservation. In its most basic sense, biopolitics involves setting aside some life for continuation and other life for degradation, about making live and

letting die. Lorimer's study identifies selection and attention as biopolitical tools that the conservation sciences employ and defines these tools as "late-modern ways of securing life at the scale of the population (or other aggregations of individuals)."[49] Along with the EDGE program, *In Pieces* places nonhuman—and not just human—life within a "biopolitical frame."[50] Selection is essential to "taking charge of life," to use Foucault's phrase,[51] but, for biopolitics to operate at the level of the population rather than the individual specimen, it also requires abstraction, standardization, and, frequently, fragmentation. To design and present the striking animals he selects, James must abstract them. Though not as abstract as the Vs that sweep across the Audubon visualization, the figures in *In Pieces* are more outline than detail. (Just flip back to Prosek's paintings for a vivid comparison.) Having abstracted the animals' shapes, the designer then fragments them into thirty standardized pieces. The creatures are "bodies in parts," though the parts here are geometrical and code-based rather than anatomical and genetic.[52] Once abstracted, standardized, and fragmented, the species are, in James's words, available to "being morphed, moved and toyed with."[53] The pieces standing in for species undergo manipulations that echo the anthropogenic ecological changes—the "toying with"—that have produced species endangerment in the first place. James's phrase places his digital "tinkering" on a continuum with intervening in ecosystems.

The biopolitical bent of *In Pieces* does not end at selection and digital conservation of abstracted creatures. Its interactive features also perform a fantasy of reconstitution. Click the "What's the Threat" link next to a species-piece and the animal's thirty triangular fragments break apart then explode into smaller shards (figure 4.5). These shards rotate around the informational text and data on the subsequent screen. Exit this view and the small shards reconstitute into the thirty pieces that compose the schematic rendering of the animal (figure 4.6). The project encodes the logics of abstraction, standardization, and fragmentation underlying natural history and biodiversity science. And yet the interactivity of *In Pieces* performs the action of making fragmented life whole again. Creatures whose environments and futures now lie in pieces due to pollution, climate change, and habitat destruction, "unite together . . . in an interactive exhibition," as the opening screen announces. Within a digital domain, *In Pieces* designs

FIGURE 4.5. James, "Pygmy 3-Toed Sloth," after clicking on "What's the Threat," *In Pieces*. Courtesy of the artist.

FIGURE 4.6. James, "Pygmy 3-Toed Sloth," reconstituting when returning to main view, *In Pieces*. Courtesy of the artist.

an ecosystem to shelter the threatened. This is an ecosystem that levels geographical and ecosystemic distinction even as it extols the creatures' distinctiveness.

One argument we could make about this project is that it's a form of wish fulfillment that diverts attention away from the messy work of biodiversity

conservation. This argument is compelling, but I instead want to approach reconstitution as a kind of ecological invention akin to so-called radical conservation. Lorimer, Jonathan Adams, Emma Marris, and Ben Minteer, among others, detail future-oriented, speculative forms of conservation for a "post-wild world."[54] In this world, bringing ecosystems back to a fixed baseline is an obsolete ideal. "Restoring the complex ecosystems we have destroyed may be, at the moment, just too hard," Marris admits. "We don't know enough about what they looked like or how they worked. . . . We can't get the magic back. The alternative . . . is not to restore to some notional and incompletely apprehended past but to design or engineer for specific, measurable goals."[55] Unable to "get the magic back," *In Pieces* designs an interactive digital habitat that showcases uniqueness but that is predicated on similarity. The conditions causing endangerment, the sites of that endangerment, and creatures' ways of responding to it may vary, but precarity at the level of the species is as invariable as the thirty pieces James manipulates. As the splash screen for *In Pieces* announces, diverse beings "share their struggles, and unite together" around endangerment in this new media menagerie.

The visualization creates a community of difference organized by threat to elicit feelings of loss. The aesthetic strategy of fragmentation augments those feelings, yet the strategy of reconstitution contains them. The project promotes curiosity about more-than-human beings, but, with restoration an obsolete ideal, the outlet for that curiosity is a "designed" community that coalesces around distinctiveness *and* similarity. *In Pieces* offers one of those encounters with environmental data that, to return to Juliana Spahr's "Unnamed Dragonfly Species," are "easier than ever before to acquire" thanks to online media.[56] We can fault *In Pieces* for carrying viewers too far from the sources and scenes of species endangerment, an outcome of the Audubon visualization as well. My argument, however, stresses that the project's aesthetic strategies bring to light the biopolitical knowledge practices of natural history and its biodiversity sciences. This digital ecosystem delivers information about threats to the thirty species in its menagerie, but perhaps more important, it restages methods central to naturalism and biodiversity and thereby shows the epistemologies and values that have guided the animal sciences for centuries. Even as species exhibitions move from the natural history museum to the online exhibition, these new media carry imprints of the methods by which, and idioms within which, we have long come to environmental knowledge.

Radical conservation may, as Heise argues, represent "a new environ-mentalist orientation . . . toward celebration rather than mourning, and a new sense that humans are able to transform the planet . . . following delib-erate choices," an orientation Accurat's Audubon visualization shares by muting loss.[57] However, artists such as James who address conservation through new naturalist media are more ambivalent. *In Pieces* and Maya Lin's *What Is Missing?*, which I address next, lean toward mourning by incorporating the data of species threat and lean away from it by designing alternative ecosystems.

Maya Lin's *What Is Missing?*

Like James, renowned land artist Maya Lin visualizes absence by design-ing a virtual world out of a damaged one. *What Is Missing?* (2010–, hereaf-ter *WIM*) uses new naturalist methods in new media, but its searching title already indicates that this project operates in an overtly interrogative and mournful mode. Lin, best known for the Vietnam Veterans Memorial in Washington, D.C., describes the online project as a "global memorial to the planet," the last memorial she will ever design.[58] *WIM* launched online in 2010 and, as of 2019, has been significantly redesigned three times. *WIM*'s purview is vast and virtual; it compasses the planet to collect the species, cultures, and environmental experiences that anthropogenic changes are threatening or have already annihilated. *WIM* opens with splash screens announcing that it memorializes the disappearing and the disappeared through multiple media: sound, video, photographs, textual narrative, his-torical maps, and scientific data and explanations. To manage this com-plexity, Lin enlists a team of researchers, web designers, and video artists, a contrast to James's solo design venture. The project aspires to provide "something both personal and close to home" by collecting "experiences we each have had with nature (the visibility of the stars at night, the sounds of songbirds) that gets [*sic*] us to think of just how much we are losing of the natural world and how it affects us emotionally."[59] Promoting intergen-erational memory, the project invites users to "add their own memories" in image and narrative. With this call to participate, as well as other fea-tures we'll study, *WIM* heralds not only the intimacy of information and emotion but also the communality of both. Though it's certainly false that "*we* each have had" the variety of experiences *WIM* collects and displays,

FIGURE 4.7. Maya Lin, "View in Place," *What Is Missing?*, 2010–. http://whatismissing.net. Courtesy of the artist.

the idea is to use the collection to forge a community around grief spanning past, present, and future. My interest is in how it does so through the methods of naturalist display and the data intensity of the biodiversity sciences. WIM performs that quintessentially naturalist act of collecting in ways that layer media types as well as temporalities. These layerings inscribe the multiplicity of data sources in biodiversity sciences as well as place the memorial in multiple temporalities that hold two emotions of loss— melancholy and nostalgia—in tension.

I cannot canvass all the project's myriad features here. Instead I focus, as with *In Pieces*, on the ways *WIM* constitutes a "memory practice" made up of "act[s] of committing to record . . . embedded within a range of practices (technical, formal, social)" that have endured since natural history's Enlightenment heyday.[60] Lin and her collaborators designed the site to allow for multiple means of accessing content, but the default setting is a Mercator-projected world map (figure 4.7). While the splash screens load and introduce the project's aim to memorialize the disappearing and the disappeared, the map slowly populates with colorful icons in the shape of compasses, spirals, and filled and outlined dots of different sizes. The icons shimmer as they lure users to click, discover, maybe even contribute with their cherished memories or persistent anxieties about the missing. The icons correspond to the memorial's nodes—timeline, video, stories, conservation, and disaster—which a legend at the bottom of the page explains.

Clicking on one of the spirals ("Timeline") opens a sequence of vertically arranged circles, each referring to a moment on a timeline of extinctions that have occurred at that place. Compass-shaped icons ("Conservation") open onto key moments in conservation history, the more hopeful of the project's nodes. Small dots ("Stories") access historical and user-generated narratives of loss (figure 4.8); large dots ("Video") play brief films that explain the causes of ecological endangerment and, in some cases, prescriptions for "what you can do";[61] and outlined dots ("Disaster") open windows onto environmental collapses ranging in scale from the Asian carp "invasion" of the Great Lakes to climate change and the bombings of Hiroshima and Nagasaki.

For example, a spiral icon in the Indian Ocean leads to a three-centuries-deep history of ecological losses affecting the island nation of Mauritius, beginning with the well-chronicled dodo (1662) and ending with the round island burrowing boa that went missing in 1975.[62] With the world map still visible if faded in the background while we explore, it is as if we have lifted off the ground and out of time. This collection of images, recordings, landscape photographs, natural history exhibits, historical maps, and more is perhaps the best instantiation of "information as a form of memorialization." It draws from the same kinds of sources that fill *In Pieces*—e.g., the IUCN Red List—but also, in line with Rita Raley's claims about tactical media, "counter[s] the statistical abstraction" of such databases.[63]

FIGURE 4.8. Lin, "Parrots by Debashree Turel," *What Is Missing?* http://whatismissing.net/memory/parrots. Courtesy of the artist.

Though the world map is the default view for all these gateways onto biotic, geophysical, and phenomenological loss, *WIM* travelers can also experience them temporally through the "View in Time" option (figure 4.9). The aesthetic of reconstitution that we saw in James's species-pieces appears here in the transition between "View in Place" and "View in Time." Click on the link to the latter and the icons disperse and, over the course of a minute (a glacial pace by web standards), rest in their place on a timeline spanning from 2000 B.C. to the current year. As they relocate in an erratic pattern across the screen, the icons resemble stars, motes of dust, or undersea plankton. With its gentler pace and "twilit" scheme, to borrow Sarah Chihaya's description,[64] *WIM* shares James's aesthetic strategy of dispersal and reconstitution for depicting incalculable ecological deficits.

The aesthetic strategy of reconstitution also manifests in one of the precursors to *WIM* that is now embedded within it: *Unchopping a Tree* (2009). Lin and her team collaborated with RadicalMedia to produce this short film for the United Nations Climate Change Conference (COP15) in Copenhagen in 2009.[65] The video's title alludes to poet W. S. Merwin's eponymous essay and opens with a score by Brian Eno playing against footage of the world's most famous urban parks. Text fades in and out, overlaying the images: "Central Park New York City, USA Destroyed in 9 minutes," "Ueno Park Tokyo, Japan Destroyed in 2 minutes," "Ørsted Park Copenhagen,

FIGURE 4.9. Lin, "View in Time," *What Is Missing?* http://whatismissing.net. Courtesy of the artist.

Denmark Destroyed in 1 minute." Without the title, we might suspect that these time-to-destruction statistics refer to a hypothetical bombing. With this allusion, the times-to-destruction put deforestation on par with military annihilation. They refer to the rate at which the parks would disappear if the trees were chopped down given then-current rates of global deforestation. Keeping with Lin's objectives to bring environmental loss home and incite response, *Unchopping a Tree* asks, what would you do "if deforestation were happening in your city? How quickly would you work to stop it?"[66]

These questions hail the viewer into the activist position. From there, the film moves to a grove of trees that is unpeopled but undoubtedly touched by humans. The viewer feels as if they're in a depression in the humic ground because the camera is level with the fresh stump of an evergreen in the center foreground. Needles and twigs begin to rise from the forest floor as if conjured by an unseen magician or stirred up by an approaching tornado. Twenty seconds into this sequence, the viewer realizes that the tree is reconstituting itself. The treetop lifts off the ground. As if a dancing figurine in a jewelry box, the trunk rotates until the base of the truncated tree aligns with the stump. *Unchopping a Tree* defies expectations again when the scene stops before the tree fully reconstitutes (figure 4.10). The conifer never attains the stately position we assume it once had, and the video concludes

FIGURE 4.10. Lin, still from *Unchopping a Tree*, 2009. Produced by RadicalMedia. vimeo.com/8128504. Courtesy of the artist.

with the reminder, "We can't unchop a tree. But we can **not** chop it down in the first place. Or we can plant a new tree **sustainably**."

Unchopping a Tree presents a fantasy of reconstitution similar to the one that plays out in *In Pieces*. However, Lin steps back from wish fulfillment, and the rewind on deforestation never completes. The work of *depicting* loss and the work of *reversing* it are not equivalent here. The space that remains between the stump and the trunk visualizes this gap that *WIM* tries to fill by collecting what has been lost and recommending actions such as reforestation through the conservation and sustainable living modules.[67]

The reconstitution trope that drives *Unchopping a Tree* appears in more muted form as the dispersal and reconstitution of the icons when transitioning between the time and place views within *WIM*. This transition effect evokes another type of gap by suggesting the state of infowhelm within the biodiversity sciences. The floating, shimmering, dispersing, and coalescing icons visualize the data profusion, or what Bowker calls "datadiversity,"[68] that is part and parcel of the "technologically mediated memory" on which biodiversity and conservation work depends.[69] Databases of extinct and endangered species are vital memory practices for conservation, much as herbaria and taxonomies are for natural history. They suggest comprehensiveness but can never fulfill the "panoptical dreams" of "mapping the biosphere." Bowker's concept of datadiversity gets at how this dream dissolves in the face of overwhelming and incomplete data on species status. It refers to the diverse, often incommensurable datasets that proliferate across the disciplines involved in biodiversity study and policy. Myriad partially overlapping datasets accumulate but cannot be integrated, often because they do not share a common standard of measurement such as timescales for dating specimens or field sample size. Datadiversity produces a situation in which "it's triangulation [of data] all the way down."[70]

Datadiversity is frustrating in the field and the lab but generative for Lin's visualization aesthetic. One of *WIM*'s central paradoxes is that, in seeking comprehensiveness by layering media and crowdsourcing information, it underscores the inherent incompleteness of cataloging and representing extinction. It proves Heise's point that these archives "have . . . incompletion hardwired into their basic structure."[71] In the face of datadiversity, Lin's visualization incorporates quantitative, affective, phenomenological, and cultural "data sets." Communications scholar Lauren Kolodziejski rightfully worries that *WIM*, with its panoply of "visual, aural, and textual

elements with interactive features," "may fail to have the impact [Lin] hopes" because users bear responsibility for integrating the variety of media.[72] What Kolodziejski overlooks, however, is how the piece thereby reproduces the incompleteness of classification systems. Lin's project both addresses infowhelm and reproduces it. It thereby shares Prosek's project of showing the inevitable sutures that seam scientific practices of assembling, cataloging, and displaying information about biodiversity and its loss.

The very title of Lin's project, with its interrogative punctuation, prepares users for this experience of incompleteness. Along with the title's present progressive tense and the word "missing," the question mark calls out the multiple temporalities in which *WIM* dwells. These temporalities are crucial to understanding the emotional signatures of a project that is at once a messy memory practice, a performance of grief, and, like *In Pieces*, a designed ecosystem that collects creatures and things. As a memory practice that draws on recent biodiversity databases and evokes natural history collections, *WIM* "permit[s] both the creation of a continuous, useful past and the transmission sub rosa of information, stories, and practices from our wild, discontinuous, ever-changing past."[73] In the cases Bowker studies, the past is changing both because there are gaps in the data record and because access to that past is highly mediated by technology and media. Lin's memorial emphasizes both factors by calling on users to fill in the gaps with experiential "data" and by multiplying the forms of mediation it employs to reconstitute the past.

Now, this is not to say that the starry skies and dodo birds that *WIM* memorializes are figments of the imagination, or that the sixth mass extinction is a hoax perpetrated by greedy environmentalists. By no means. Rather, I liken this invention of the past to Susan Stewart's account of objects of longing.[74] Akin to the curiosity cabinets in Stewart's study, Lin's memorial accumulates environmental artifacts in response to longing. *WIM* gathers up "both the minimum and the complete number of elements necessary for an autonomous world" and "seeks a form of self-enclosure which is possible because of its ahistoricism. The collection replaces history with *classification*, with order beyond the realm of temporality."[75] It collects information from myriad sources to design a hermetically complete, but never totalizing, domain in which disparate creatures and experiences can coexist despite differences in time, geography, biology, and

culture. Lin's work both invents a past and transmits a past. The eclectic assemblage offers imagined tableaux of what was in the act of preserving.

Given this, we might call *WIM* a nostalgic piece. In Stewart's account, nostalgia refers to "a past [that] has never existed except as narrative. . . . Longing for an impossibly pure context of lived experience at a place of origin, nostalgia wears a distinctly utopian face, a face that turns toward . . . a past which has only ideological reality."[76] We saw a version of this nostalgia in the previous chapter with the Spivets's longing for "*a falsified cultural memory*" of the nineteenth-century U.S. West.[77] Just as the temporalities of *Spivet* are more complex than they at first appear, *WIM*'s tenses are intricate. The past is constantly developing because it "has only ideological reality" or, in Bowker's terms, is "wild, discontinuous." Timothy Morton helps us elaborate on the unfixed position of the past through his account of environmental elegy. Representations of environmental loss "as[k] us to mourn for something that has not completely passed, that perhaps has not even passed yet. . . . It weeps for that which *will have passed* given a continuation of the current state of affairs."[78] With these accounts of longing and mourning, we can better understand the project's temporalities and how the title signals them. As an elegiac environmental collection, *WIM* sets its sights on the evolving past (the "missing") and on the uncertain "*will have passed*" (the question mark) that results from what is happening now (the present progressive).[79]

With temporal complexity comes emotional complexity. *WIM* bends not only toward nostalgia but also toward melancholy. Or, rather, it holds the two emotions in suspension. Theories of loss tend to differentiate these two emotions. For example, Catriona Mortimer-Sandilands's reading of "melancholy natures" diagnoses the prevalent response to environmental grief as "nature-nostalgia," which appears in ecotourism, spectatorship, and campaigns to save an individual species or place. Nature-nostalgia, she contends, too easily "incorporate[s] environmental destruction into the ongoing workings of commodity capitalism." Loss is packaged and consumed and ultimately displaced, never truly grieved. Mortimer-Sandilands recovers grief for its political potential; grieving the "very real but psychically 'ungrievable'" acknowledges the more-than-human entities and processes that too often seem inappropriate subjects for such profound emotion. What pervasive toxicity, the sixth mass extinction, and ocean acidification

demand is "a politicized melancholic sensibility," an ongoing mourning that requires everyday remembrance rather than isolated spectacle.[80] *WIM* holds nostalgia and melancholy in suspension, if not by design then certainly through design. On the one hand, it promotes intimate but virtual species encounters that could just be "nature-nostalgic" if the designers had a profit motive. However, its fluid, participatory form also insists that environmental loss is ongoing, in reality and in representation. The project is oriented toward a changing past but also toward an evolving, uncertain future. As the conditions of extinction change, so too does this digital memorial. Working on *WIM* to write this book made its unfinished quality abundantly clear. The *WIM* team has significantly relaunched the site three times since it first appeared in Chinese in 2010. The site I consult as I write in 2019 is not the same as the one I first viewed in 2012, nor even the same as the one Kolodziejski examined for her 2015 article. Features and components drop out, and others take their place; new icons and stories appear; new initiatives spin off. In this respect, *WIM* resembles a piece of software or an operating system that receives continual updates and upgrades, and an asymmetry between content and medium emerges: the site evolves in the digital realm as it records species that may cease to do so on land and in the seas and sky.

The visualization's proliferation of media and dual impulses to collect and revise belie a simple nostalgic purpose and introduce melancholy into the affective mix. Recall that, in the Freudian lineage, the "work of mourning" reaches no end in melancholy; instead, "the complex of melancholia behaves like an open wound."[81] There may well be identifiable sources for the feeling, but the full extent of the loss is unknown. Melancholic loss therefore requires constant care. *WIM* holds in suspension two emotions of grief: nostalgia, with its orientation to an imagined past, and melancholy, with its ongoing, speculative futures. In this respect, it activates the many temporalities of loss and inscribes them in a visualization built from the memory practices of both classical natural history and modern biodiversity science. Aesthetic strategies of collaboration, multiplication, layering, and ongoingness also show the inherent incompleteness, even the leakiness, of the containers and categories that naturalism has offered as epistemological tools.

In visualizing the data of extinction, James and Lin create "an autonomous world" out of a worsening one.[82] These projects are Janus-faced. One

face looks back to adapt epistemological methods of naturalist science, and another looks forward to invent digital ecosystems for uncertain futures of ecological deficit. While the Audubon visualization expressed optimism with the forward and upward sweep of avian icons indicating human and technological abundance, *In Pieces* and *What Is Missing?* offer complex temporalities and emotions of grief through strategies of collection, fragmentation, reconstitution, and open-endedness. They create species interactions that make two propositions for our current age of species threat: that designed ecosystems may be the only viable response to extinction and that the future is only salvageable by refracting old epistemologies through new media.

NOARK AND NEGATIVE KNOWLEDGE

Prosek's paintings and James's and Lin's visualizations toggle between then and now, between now and what may come. They capture the still-unfolding histories of life by inventing creatures, pasts, and digital ecosystems within the traditions of Eurowestern science. To conclude this study of new naturalist visual media, I explore the lengths to which invention can go while remaining within the bounds of this epistemological tradition. I then broaden out to consider motifs that have run through part 2: uncertainty and ignorance.

The Tissue Culture & Art Project (TCA)'s *NoArk* (2007–2011) takes invention to ends permitted by synthetic biology. It creates "life in the age of biotechnology" but adopts representational practices from the age of natural history.[83] Oron Catts and Ionat Zurr are the Australia-based artists behind TCA.[84] They first exhibited *NoArk* in 2007 and relaunched it several times between then and 2011. For this installation-*qua*-experiment, TCA created a bioreactor that cultivates an invented organism: a "chimerical 'blob' made out of modified living fragments of a number of different organisms, living, in a techno-scientific body" (figure 4.11). This growing blob sits adjacent to taxidermized animals, including a rabbit, mouse, crow, and donkey (figure 4.12). For the synthetic lifeform, the artists acquired plant and human and nonhuman animal cells from "tissue banks, laboratories, museums and other collections."[85] This method is exemplary of bioart, a term coined by Eduardo Kac in 1997 to "describe the diverse practices of visual artists, avant-garde writers and tactical media groups who experiment

FIGURE 4.11. The Tissue Culture & Art Project (Oron Catts & Ionat Zurr), *NoArk II*, 2008. Developed at SymbioticA, School of Human Sciences at the University of Western Australia. Courtesy of the artists.

FIGURE 4.12. The Tissue Culture & Art Project (Oron Catts & Ionat Zurr), *NoArk II*, 2008. Developed at SymbioticA, School of Human Sciences at the University of Western Australia. Courtesy of the artists.

with . . . the 'soft technologies' of biology."[86] In contrast to Prosek, who seeks species encounters in the field, and James and Lin, who collect them digitally, TCA mines centers of scientific commerce and research for their biomaterials. Like their fellow new naturalist artists, however, TCA places these radical experiments in a lineage of taxonomy and display derived from classical natural history.

The *NoArk* installation resembles the dioramas on display at natural history museums and the curiosity cabinets that are the antecedents of these museums. The allusions to naturalism bring an indispensable historical perspective to the emergent sciences of engineered life. The red and blue hues bathing *NoArk*'s vessels containing impassive creatures and tangles of tubes may position the project in a more modern—and perhaps more sinister— laboratory context, but TCA's debt to naturalism is obvious from their statements on the piece. The artists declare they "are making a unified collection of unclassifiable sub-organisms." As the aggregation of cells grows into an organism, a "taxonomical crisis" ensues, a crisis familiar to naturalism but updated for twenty-first-century genetic engineering and synthetic biology.[87] This new naturalist invention compels categorization at the same time as it violates descriptive schemas. Not quite living, the "sub-life" or "neo-organism . . . is orphaned, bereft of parentage or kinship, abandoned by the Linnaean classification system that depends on organismic coherence." The bioreactor rotates on a platform, and this movement stages the "novel dynamic system" to which the organism contributes.[88] Though their media radically differ, Prosek and TCA create "neo-organisms" that stretch the idea of "coherence" and put classificatory systems to the test. The growing cells and preserved animal specimens of *NoArk* reside in physically separate boxes that suggest the conceptual boxes into which Eurowestern science slots lifeforms whose dynamism defies such constraint. The juxtaposition of the dead and the living-yet-synthetic stages classificatory collisions that make the idea of order itself fantastical.

These collisions become all the more striking when viewers consider the future orientation and uncertainties of biological synthesis. Akin to art-experiments by Critical Art Ensemble and Beatriz da Costa in which synthetic organisms enter existing ecosystems, *NoArk* "blur[s] the distinction between the 'new wild,' a realm populated by creatures that have emerged amid regimes of biological control, and the 'old wild,' where . . . feral animals have long roamed free."[89] TCA and kindred bioartists take the raw

materials and byproducts of scientific experimentation and bioengineer them into potential contributions to Earth's biota. This invented "nature" shares space with dead nature in *NoArk* to emphasize that, while the methods of natural history might appear to be passive acts of environmental description to our twenty-first-century eyes, they too are active "regimes for managing and producing life."[90] Whereas environmental invention takes place on paper for Prosek and in the digital realm for James and Lin, invention here takes place with living genetic material. Common questions in debates over genetically modified and engineered organisms pertain to TCA's new naturalist art: Can "sub-life" reproduce and evolve? Will the organism become lively or remain as inert as the preserved specimens in the adjacent containers? How might a designed organism alter existing ecosystems? These questions are germane despite the artists' promise that their experiment is fully contained; TCA explains that "we use a cell bag that has enough nutrient media for two weeks. We do the preparation in a laboratory near the gallery and at the end of the exhibition, we take it back to the lab and kill the solution with bleach."[91] *NoArk* invents environments and beings that may—or may not—come to be and make contact. The project's potential for interaction and alteration stages the unknown futures of a planet under constant change from anthropogenic activities.

Taking up natural history in the interrogative mode and orienting it toward invention in multiple temporalities, the artists in this chapter hold epistemological allegiances with positivist science and with "negative knowledge." In one respect, works by Prosek, James, Lin, and TCA participate in the tradition of classifying and displaying flora and fauna and thus revive Enlightenment epistemologies. But through invention, uncertainty, and open-endedness, new naturalist visual art approaches what Karin Knorr Cetina calls negative knowledge. This "is not nonknowledge, but knowledge of the limits of knowing, of the mistakes we make in trying to know, of the things that interfere with our knowing, of what we are not interested in and do not really want to know."[92] Knorr Cetina's negative knowledge shares features with Roy Dilley's "nescience" and Robert Proctor and Londa Schiebinger's "agnotology," all epistemological states that have intrigued twenty-first-century science studies.[93] These thinkers recuperate ignorance at the same time as they acknowledge the nefarious ends to which it can be put, including antiscience denialism and doubt-mongering around toxicity, vaccination, and climate crisis. In its more

productive sense, ignorance is "a *resource*, or at least a spur or challenge or prompt . . . to feed the insatiable appetite of science"; we don't want to eliminate ignorance of this sort lest we throw the baby of potential knowledge out with the bathwater of partisan nonknowing.[94]

New naturalist artists entangle negative knowledge with positivist science to capture epistemological conditions surrounding today's crises of extinction, pollution, climate change, and land use change. The artworks studied in part 2 all speak in the same tongue as Eurowestern natural history but tell a story of ecological deficit. They critique naturalist values of mastery, control, and containment as imperialist, appropriative, and inadequate to environmental transformation and endangerment. However, in promoting negative knowledge as a vital environmental epistemology, they do not also discard positivist methodologies. The new natural history does not harbor some Futurist mandate to "destroy the museums, libraries, academies of every kind";[95] it instead proposes that the future is salvageable only by refracting the past through new literary and media forms. These artists want to understand how the scientific information and idioms that emerged centuries ago endure and can be remade to capture the precarious present and the uncertain futures that those same epistemologies helped create. If "ignorance . . . is really about the future," as neuroscientist Stuart Firestein opines, it just might be the epistemological mode we need now.[96]

New naturalist art, which foregrounds epistemological traditions and entangles positivism, emotion, embodiment, invention, and uncertainty, reminds us that the expectation that science is orderly, masterful, and fixed not only is inaccurate but also undermines science's potential for invention. This art reminds us of a point Anahid Nersessian makes when meditating on the stakes of "literary agnotology," that a scientific field— whether it be biodiversity or climatology—"that contradicts itself over time or at a time is a field obligated to its own disorder, metaphysical or otherwise. The point is not to eliminate that disorder but to give it its place in a theory."[97] The new natural history, I argue, is producing that theory through art and out of the very traditions so long synonymous with order. It repurposes those traditions for the contradictions of environmental loss in which we live today: positivism and speculation, mimesis and invention, fragmentation and reconstitution, melancholy and nostalgia, certainty and uncertainty.

PART 3
Aerial Environmentalisms

PREFACE

"We arrived. / We arrived by air, by 747 and DC10 and L1011."[1] We enter Juliana Spahr's "Sonnets" from above. A reminder that, in the twenty-first century, the air is the space from which millions access new places and perspectives on the planet. Turn the page of "Sonnets" and arrival announcements give way to data lists: "white blood cells at 4.2 thousand per cubic millimeter / red blood cells at 3.88 million per cubic millimeter / hemoglobin at 14.1 grams per decaliter / hematocrit at 42.6%" (20). This transit from air to body occurs by way of a walk: "We arrived and then walked into this green" (19). Flight is grounded as the speaker records the feeling of humidity on the skin, yet this scene of embodiment is shot through with quantitative data that depersonalizes the body and associates it with those alphanumeric machines, 747, DC10, L1011. Readers are especially attentive to these aerial moments and their quantitative trappings because Spahr prefaces each poem in *well then there now* (2011) with an aerial silhouette of the place where she wrote the poem (O'ahu, New York City, or California) and the geographical coordinates that pinpoint the precise location (for example, N 40° 41' 5" W 73° 58' 8"). The journey of "Sonnets" from air to ground and into body via technoscientific data anticipates paths on the epistemological journey detailed in chapters 5 and 6. Spahr's work confirms what much environmental art proposes: the aerial is a vital optic for environmental thought. This optic is not crystal clear, however. It is muddied, productively

so, by epistemological tensions that emerge in "Sonnets," tensions between data and embodiment, between quantification and subjectivity, between evidence from the skies and evidence on the ground. When visual and literary artists use aerial techniques to gain purchase on environmental damage, they exploit these tensions in ways that uncover the histories of the aerial as an epistemological tool and the potential it holds for endangered futures.

The knowledge potential of the aerial is both vast and limited. This is even more apparent when aerial technologies get an upgrade from plane to satellite in Spahr's "Unnamed Dragonfly Species." Recall from the preface to part 1 that this poem features a third-person-plural speaker stuck in patterns of information gathering, guilt, and denial. News reports about climate change lead them to watch animations of disintegrating Antarctic glaciers that are "really just a series of six or so satellite photographs" (77). Information from the satellite sequence ignites a desire that "Sonnets" fulfills: to go from seeing above to being on the ground so that they may feel "what it was like to be there on the piece that was breaking off" (77). As in "Sonnets," transit out of the sky passes through quantitative data, primarily about glacial melt rates over time: "melting about three feet a year . . . lost as much as seven and a half miles in a sixty day period . . . at a rate of as much as ten miles in ten years . . . retreating by five hundred feet per year" (78). The satellite imagery is meant to yield knowledge of climate collapse by offering expansive views of typically inaccessible places. However, as we saw in the preface to part 1, it yields instead bleary eyes, tight shoulders, and a state of stuckness. Aerial media is not the knowledge-delivery system they hoped it would be. They might be able to see, but what does all this seeing add up to?

This question motivates the next two chapters and the artists they feature. Undoubtedly, aerial photographs, satellite imagery, and the verbal descriptions that rely on them yield valuable environmental information. Comparing a satellite view of the Antarctic from 2000 to one from 2020 provides evidence for the effects of rising surface and ocean temperatures as well as a sense of their scale and rapidity. Yet there are so many things Spahr's speakers still cannot figure out from these images: everything from what a penguin's experience of warming might be to who will accept blame for the local and global consequences of geophysical collapse.

This tension between knowledge and ignorance is at the heart of what I call the *epistemology of the aftermath* that environmental artists engage when they employ the aerial. Chapters 5 and 6 detail how artworks use aerial technomedia to gain understanding of the aftermaths of environmental degradation. In doing so they rely on the positivist epistemological values that have long been associated with the aerial: transparency, objectivity, universality, and mastery. Like the new naturalist artists of part 2, however, aerial artists contaminate those values with mediation, materiality, not-seeing, and positional multiplicity. Visual media from nonprofit SkyTruth and artists Laura Kurgan and Fazal Sheikh and novels by Kim Stanley Robinson, Indra Sinha, Jeff VanderMeer, and Claire Vaye Watkins propose that the messy conditions of aftermath, while often made accessible through aerial technomedia, exceed the epistemologies that traditionally attach to those views. Through aesthetic techniques such as obliquity, "telescoping," self-reflexivity, and temporal complexity, their works depict the processes and consequences of environmental change while also telling histories of the aerial that open alternative ways of knowing.

I use *technomedia* to emphasize a point prevalent in this art: that aerial representation becomes available through developments in technology and media that are inextricable from each other. When we refer to the aerial perspective, we are always also referring to the technologies and media that give access to those views. To produce alternative epistemologies through the aerial, artists call on the conditions and histories of technomediation. A key claim of part 3 is that these conditions and histories inflect aerial vision at all turns and that artist-activists embrace this fact rather than shy away from it. Akin to new naturalist artists, they tactically rework an instrument of imperialist and capitalist epistemologies coming out of the Enlightenment.

Before elaborating on imperial-capitalist-extractivist narratives of aerial technomedia, we must note that these forces do not "own" the aerial perspective. For example, ancient geoglyphs made by the Nazca people in the eponymous Peruvian desert assume a god's view from above.[2] More recently, as geographers Margaret Wickens Pearce and Renee Pualani Louis note, the use of digital maps, satellite images, global positioning systems, and geographic information systems (GIS) "has proven to be a critical step for protecting cultural sovereignty by communicating the importance of

178

AERIAL ENVIRONMENTALISMS

Indigenous cultural knowledge to people outside the community."[3] At the same time as Pearce and Louis explain how aerial and satellite cartography can serve indigenous rights, they extend a decades-long conversation about the misuses of these technomedia. When GIS and geographical data-sharing became more widely available in the 1990s, geographer Robert Rundstrom expressed concern with "the effects of GIS on the epistemological diversity still manifest among the indigenous peoples of the Americas," particularly with how Eurowestern authorities could use these technologies as "tool[s] of epistemological assimilation."[4] Debates about indigenous uses of cartographic technomedia underscore two points on which I expound in the coming chapters. The first comes to the fore in Rundstrom's analysis: that cartographic technomedia encode epistemological values as well as lived ways of relating to the environment. As he writes, "in technosciences, technologies modify and transform the worlds that are revealed through them; the instruments deliver 'realities.' "[5] Too often, in doing so, they erase other realities and epistemologies, for example, "the ubiquity of relatedness, the value of nonempirical experience, the need to control access to levels of geographical knowledge, and the value of ambiguity over binary thought."[6] The second point follows from these: that, while the view from above is not proprietary to any one epistemological stance, there is an enduring link between the aerial and Eurowestern values of objectivity, mastery, empiricism, and human domination of the more-than-human. The chapters to come identify ways that other "realities" emerge from the aerial when artists use it both to identify and to disturb the "dominant semiotic regime" that surrounds it.[7]

It's this regime that has prompted scholarship on the aerial by thinkers such as Caren Kaplan, Mary Louise Pratt, Paul Saint-Amour, and Paul Virilio.[8] This humanist discourse has conferred on the aerial myriad capacities and monikers: bird's-eye, God's-eye, Apollonian, promontory, zenithal, bombsight, view from nowhere; telepresence, indirect or eyeless vision; observer epistemology, peephole metaphysics.[9] For many commentators on the aerial, it coincides with Enlightenment modernity as such, an exemplary instrument of rationalism, imperialism, and/or militarism. Plenty of evidence belies this argument—from ancient Hopi and Pueblo glyphs at Chaco Canyon to contemporary uses of satellite GIS for "countermapping"[10]—yet influential narratives of the view from above often align with geographer Denis Cosgrove's story of the "Apollonian eye." This is a

vantage that, either in imagination or in fact, comes from a "viewpoint above the earth, proclaiming disinterested and rationally objective consideration across its surface."[11] This is the view of God surveying all he has made, of a bird without political interests, of an eyewitness observer with unimpeachable purchase on knowledge. This is often also, by extension, the inscription of vision as the most reliable and rational of the senses.[12]

Cosgrove offers a genealogy of global aerial imaginaries in the West that stretches back to ancient Greece and Rome. Along with the examples from indigenous cultures noted above, his archive serves as a reminder that the aerial did not hatch from the same egg as modern travel and communications technologies. In this vein, Pratt examines a precursor to aerial sight obtained from planes, spacecraft, satellites, and drones, what she calls "the promontory view." A "heroic perspective" achieved by climbing to great heights, the promontory view recorded in eighteenth- and nineteenth-century European travel writing positions the spectator as "the monarch-of-all-I-survey."[13] "Monarch" indicates the advantages that accrue to this viewer. He stands above it all, detached; universal truths are his to access and command. As historian Jenifer Van Vleck relates, "this lofty vantage point could foster a sense of aloofness and superiority." One can gather valuable information while remaining insulated from "messy on-the-ground realities."[14]

Lofty vantage points multiply and become more spectacular when technologies of flight and of image reproduction come online in the nineteenth century. Air balloons might have first served military agendas, but they soon became the vehicles for Frenchman Nadar's first urban aerial photographs in the 1850s.[15] Balloons gave way to planes as the military aircraft of choice in the twentieth century. Before commercial air travel was widespread, servicepeople accessed the "bombsight perspective" on the Earth's surface in the First and Second World Wars. On perusing aerial photographs from this period of military aviation, Bruce Robbins asks, "What does it mean to take your slant on things from a B-17?" and answers that it "seemed to promise power, superiority, mobility, security" even from within the vulnerable conditions of war.[16] Robbins's question finds a similar answer in Virilio's account of modern Western perception as "a conjunction between the power of the modern *war* machine, the aeroplane, and the new technical performance of the *observation* machine."[17] Elizabeth DeLoughrey extends this vein of analysis to consider the simultaneous arrival of

satellite technology and of global environmental endangerment. With this convergence, the aerial is recruited into "empire's use of narratives of technological progress to expand toward the 'ends of the earth' in ways that naturalize dominance over the global commons such as the high seas and outer space."[18] Again, the aerial does not only serve Eurowestern military and imperial ambitions for domination. It may also serve spiritual purposes or be a medium for subjective, embodied experience of place. Yet, as we see from this critical conversation, an influential narrative in the humanistic study of aerial vision tags it as a technology of imperialism and militarism that instantiates Enlightenment values.

As we saw with natural history, this narrative becomes the basis for environmental artists and advocates to take up the aerial in an interrogative mode. Thus even though not all uses of the aerial express Enlightenment values, I dwell on this strain of scholarship because these values *constitute* the repurposing of aerial technomedia in recent environmental culture, a claim that accords with Kaplan's observation of "a tension between those who assumed that aerial views produced an improved vantage point on the 'real' and those who found the same view to be confounding, disturbing, or overwhelming."[19] The repurposing of the aerial for art and activism becomes possible with decisive technomedia developments in the late twentieth century that make these views more accessible, more pervasive, and more manipulable. These developments are, in philosopher Peter Sloterdijk's estimation, nothing less than world-shattering. "The view from a satellite makes possible a Copernican revolution in outlook," he pronounces. "Ever since the early sixties an inverted astronomy has thus come into being, looking down from space onto the earth rather than from the ground up into the skies."[20] In twenty-first-century minds, "looking down from space" likely conjures iconic orbital imagery that first appeared in the Space Age of the 1960s and 1970s. The first U.S. reconnaissance satellites entered orbit in 1964 under the banner of the Central Intelligence Agency (CIA)'s Corona surveillance program. Corona phased out when Landsat, its successor at the U.S. National Aeronautics and Space Administration (NASA), launched in 1972 to offer "the first public remote-sensing satellite . . . which took unclassified pictures of the earth for use in natural resource management."[21] Where the first satellites put CIA eyes on communist enemy territory (especially the USSR and China) as part of the Cold War, Landsat afforded views of lands and waters desirable for extraction

and development, supporting geographer John Pickles's point that "one consequence of this way of making the earth visible is that nature, earth and space are rendered as a resource, as a source of information and value."[22] We must not forget, however, that "making the earth visible" can promote endeavors other than state surveillance and extraction. Satellite technomedia aided environmental plunder but also pictured damage from it and provided some of the earliest evidence of climate change in the 1980s.

The satellite age spurred innovation in geographical technologies in subsequent decades, and these inventions have infiltrated the lives of wealthy consumers today. As artist Laura Kurgan details, 1973 inaugurated the research phase of the U.S. Department of Defense–developed Global Positioning System (GPS), which "is now not only a household word, but a ubiquitous technology."[23] When GPS was operationalized in the 1990s, the range of its applications expanded remarkably. Today we can count among those uses navigation by foot, car, bike, and public transit; online dating; health care and fitness monitoring; sociological risk analysis; and deforestation mapping. When Google Maps and then Google Earth came online as web applications in the early 2000s, advanced geovisualization was at the fingertips of millions. Geographical technomedia flowed through multiple pipelines and into numerous domains, including the military, commerce, extraction, entertainment, and environmental and scientific research.[24]

Accompanying these shifts was an explosion of art that embeds aerial and satellite imagery or employs GIS and GPS technologies.[25] The fascination with these newer technomedia builds on the hold that the aerial has long had on artists and their audiences.[26] What captivates the artists I study shortly is not the beauty and wonder such views afford—though these play a role, too—but their potential to adjust the frameworks through which we apprehend environmental aftermaths in the twenty-first century. What becomes of aerial data when it is the raw material for art? As an optic that finds a home in art as readily as it does in the extraction industry, what does the aerial tell us about environmental knowledge production and its histories? How do aerial technomedia "modify and transform the worlds that are revealed through them"?[27]

The answers to these questions will vary across the next two chapters depending on the object we interpret: from a visualization by an environmental watchdog group to a speculative description in a postapocalyptic

novel, from conceptual visual art to a hallucinatory dream in a picaresque eco-fiction. Across this range, however, we will find these works pose a situated, uncertain epistemology of the aftermath against the rationalist epistemology of aerial universality and transparency. Environmental culture elaborates on aerial technomedia's associations with forms of mastery, often going so far as to make them components of the work itself. Yet they also decouple the aerial from those associations. As with the new natural history, aerial art honors the device's potential to deliver information about environmental conditions but also foregrounds the knowledges it occludes. It displays feedbacks between data production and aesthetic production: infowhelm so frequently calls on aerial representations to get a handle on stunning alterations to the planet, and yet these representations so often produce infowhelm in turn. Developing epistemologies of the aftermath, the work of SkyTruth, Kurgan, and Sheikh in the visual sphere and Robinson, Sinha, VanderMeer, and Watkins in the literary sphere confers on the aerial not mastery but indeterminacy, not totality but multiplicity, not universality but partiality, not before-and-after but in-between, not transparency but reflexivity. Their aerial innovations powerfully express the mediatedness of environmental knowledge by making mediation— whether by machine, history, time, dust, data, or drugs—the very material of their creations.

Chapter Five

ENVIRONMENTAL AFTERMATHS
FROM THE SKY

The spring and summer of 2010. Computer, smartphone, and television screens were full of views from above and murky images from below. On April 20, 2010, BP's Deepwater Horizon drilling platform blew out in the Gulf of Mexico off Louisiana, and an uncontrollable gusher of oil started spewing out from a well 5,000 feet underwater. The slick made its way to the surface and spread out to suffocate fish, birds, and less visible marine life. As Stephanie LeMenager observes, this was an environmental assault that generated "a plethora of visible data."[1] This data came from the depths and from heights: How many gallons were seeping out per minute, per hour, per day? How much sea surface did the oil cover when measured from the sky? How much did the gush slow and the slick retard when the dispersant Corexit was applied? How many billions of dollars were lost owing to gutted fisheries? And on and on. Much was and remains unknown about the "long dyings" the BP spill set in motion, but you might not have guessed the extent of the ignorance from the amount of information the event generated.[2] That much of the data was gathered from above and from below—via satellite imagery and BP's underwater "spillcam"—emphasizes that "ultradeep" oil extraction is "an extension of the once space-age ambition" to travel as far as human technologies will reach and to send back images from those extreme zones.[3]

Environmental watchdog SkyTruth has its sights set on these images, inspired by the idea that, "as we know, seeing is believing" and "IF YOU CAN SEE IT, YOU CAN **CHANGE** IT."[4] The group's mottos are not subtle. They announce that the visual imprint of a disaster like the Deepwater Horizon spill must be seen to be known and to be redressed. SkyTruth attempts to out environmental destruction by taking satellite technomedia in hand. To follow through on its mission to effect change through sight, the organization's founder, John Amos, and his team employ satellite imaging, remote-sensing technologies, and Big Data analytics to produce "radical transparency."[5] *Radical* because of aerial imagery's potential to disrupt damaging extraction, and *radical* because of their combined use of sophisticated technologies and the human capital of everyday activists.

If you followed the U.S. news in that spring and summer of 2010, you likely saw SkyTruth's work. Following the Deepwater Horizon blowout, the group collaborated with University of Florida scientists to monitor satellite and remote-sensing imagery of the Gulf. Essentially reading the oil on the water, it gave the lie to official corporate and government estimates of the rate of the leak (figure 5.1). Amos and his team became minor celebrities of tech-driven activism and have since extended their monitoring to include illegal practices of deforestation, mining, and fishing, as well as the "normal accidents" of legal extraction.[6]

SkyTruth is one of several projects of aerial activism I study in this chapter to extend my claims about the aesthetic forms environmental information takes in contemporary technomedia. The BP aftermath is just one of many incidents that prove the aerial remains an invaluable environmental optic. We saw in the preface that humanist scholarship typically interprets aerial technologies and media as tools of imperialist, positivist epistemologies, and I begin this chapter with a strain of aerial environmentalism that exemplifies these epistemologies. Yet, much as new naturalist artists repurpose the tools of Enlightenment science for conditions of ecological loss, aerial artist-activists repurpose the aerial for nonpositivist epistemologies in the face of environmental aftermaths. SkyTruth and artists Laura Kurgan and Fazal Sheikh make tactical use of aerial technomedia such as satellites, planes, cameras, and digital data. I use "tactical" in the sense media theorist Rita Raley develops, as "forms of critical intervention, dissent, and

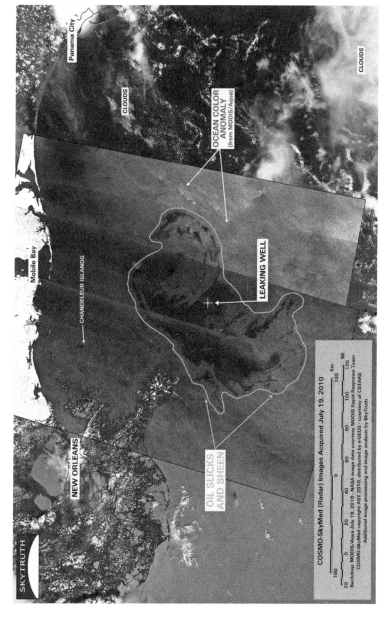

FIGURE 5.1. SkyTruth, "Deepwater Horizon Oil Spill—COSMO-SkyMed (CSK) Images, July19, 2010," flic.kr/p/8kmhsN. NASA image data courtesy MODIS Rapid Response Team. COSMO-SkyMed. Copyright AST 2010, distributed by e-GEOS courtesy of C-STARS. Additional image processing and image analysis by SkyTruth. Courtesy of SkyTruth.

resistance"; "the intervention and disruption of a dominant semiotic regime, the temporary creation of a situation in which signs, messages, and narratives are set into play and critical thinking becomes possible."[7] Raley's definition and my endeavor in this chapter chime with Lisa Parks's analysis that, while satellite vision aids Eurowestern imperial, military, and corporate control, we must examine how we can "wrestle the satellite out of the orbit of its 'real agencies' so that it can be opened to a wider range of social, cultural, artistic, and activist practices."[8]

In this chapter that "wider range" expands by examining the *epistemology of the aftermath* in aerial activist media. I propose this phrase to capture a way of seeing and knowing the environment rooted in the aesthetics of technomedia. The epistemology of the aftermath relies on positivist epistemologies, especially the comparison of before-and-after images that feed the idea that "if you can see it, you can change it." However, it also emphasizes materiality, mediation, self-reflexivity, and temporal complexity in ways that counter mastery, transparency, and universality. I share common cause with Caren Kaplan, who argues that "the history of aerial views . . . troubles [the] conventional divide between power and resistance in the storyline of visual culture in modernity." She defines the "spectacular aftermath" as "a hegemonic discourse that deploys imagery to reinforce the division between war and peace, suggesting that state violence is rational, predictable, and confined to a proscribed space and duration." Her sphere of concern is war and terrorism while mine is extraction and climate crisis, but we both look to the aftermath as a temporality that suggests a tidy linearity but instead delivers "multiple worlds that a singular worldview cannot accommodate."[9] I approach this disjunction between the discourse of rationality and mastery that surrounds the aerial and its messy layerings and temporalities through the technological self-awareness that aerial activists bring to their projects. SkyTruth, Kurgan, and Sheikh produce aerial countermedia that do not purify the aerial of its associations with Enlightenment values, just as the artists in part 2 do not purify their work of the traditions of natural history. Nor do they wish to. Instead these aerial projects contaminate those origins to highlight the mediated epistemologies of environmental knowledge that fulfill the aims of Kaplan's aerial analysis: "to let go of the desire for totalized vision that requires a singular world, always already legible."[10]

TAKING THE OVERVIEW

Satellite technology breeds media, and the values those media express are not deterministic. We cannot overlook this point. Satellite media at once fix views of land and water and are reproducible in ways that make them more accessible than the physical technologies. Perhaps no other artifact confirms this point better than *Blue Marble*. At the same time as satellites were first scanning the surface of the Earth, NASA was sending orbiters and humans into space, resulting in the first photographic views of the whole planet. The Latin *somnium*—"the sense of imaginative dreaming long associated with rising over the earth"—was a dream no longer.[11] The first Earth-from-space image was taken from a camera on a V-2 missile in 1946, establishing the tight alliance between these views and military apparatuses. This was followed by an image from an unpeopled Lunar Orbiter 1 in 1966, by *Earthrise* in 1968, and by *Blue Marble* in 1972, the latter two taken by the crew of Apollo missions (figures 5.2–5.4). I, like many, would be hard pressed to say precisely when I first saw these images. As a child in the 1990s—which saw the relaunch of Earth Day after events such as the

FIGURE 5.2. White Sands Missile Range/Applied Physics Laboratory, first image of Earth from space, taken by a camera on V-2 missile 13 launched October 24, 1946. Courtesy of U.S. Army/White Sands Missile Range/Applied Physics Laboratory.

FIGURE 5.3. NASA, *Earthrise*, 1968. Mission-Roll-Frame AS08-14-2383HR, http://eol.jsc.nasa.gov.
Courtesy of the Earth Science and Remote Sensing Unit, NASA Johnson Space Center.

Chernobyl explosion in 1986, the Montreal Protocol of 1987 to reverse
ozone depletion, and the Exxon Valdez oil spill in 1989—the icon was so
ubiquitous it had even detached from its origins in space exploration. It
felt as if humans had always had access to this impossible vantage.

But of course, military and then space flight are its origins, and it was
due to influencers like Stewart Brand that the orbital view was both natu-
ralized and mobilized for environmentalism. Brand's *Whole Earth Cata-
log* (1968) most blatantly logoized *Blue Marble* to peddle products, books,
and ideologies based on the conviction that "We are as gods and might as

FIGURE 5.4. NASA, *Blue Marble*, 1972. Mission-Roll-Frame AS17-148-22727, http://eol.jsc.nasa.gov.
Courtesy of the Earth Science and Remote Sensing Unit, NASA Johnson Space Center.

well get used to it."[12] Brand took to heart the idea of the "god's-eye view" and conferred on humans the enormous powers of planetary manipulation that environmental thinkers debate now under the coinage *Anthropocene*. The combination of universalizing, aggrandizing hubris and anxious vulnerability that makes the Anthropocene both a compelling and a contentious concept is already apparent in Brand's logoization of *Blue Marble*.

Claims that space views spurred a revolution in planetary consciousness are thick on the ground, and I won't repeat them here.[13] Instead I turn to

one source, the Overview Institute, that shows the enduring tendency to use views from above to spur environmental consciousness. The institute is compelling for my analysis because its discourse blatantly promotes epistemological values of transparency and universality. Its use of aerial media provides a point of contrast to the artist-activists I study in subsequent sections who emphasize the form and materiality of aerial data and the technological history that makes space views available.

Inspired by astronauts' reports of viewing Earth from space, Frank White became an evangelist for the perspective. His enthusiasm found expression in *The Overview Effect: Space Exploration and Human Evolution* (1987), and he now promotes the overview through an eponymous institute that counts the likes of Virgin Galactic's Sir Richard Branson and George Whitesides among its eclectic members. The Overview Institute contends that seeing the planet from space provokes a universal feeling of connectedness with all humanity and the desire to preserve the life that the planet sustains. As in Brand's *Whole Earth Catalog*, we can detect notes of both authority and vulnerability in the group's "Declaration of Vision and Principles": " 'The Overview Effect' . . . refers to the experience of seeing firsthand the reality of the Earth in space, which is immediately understood to be a tiny, fragile ball of life, hanging in the void, shielded and nourished by a paper-thin atmosphere. From space . . . national boundaries vanish, the conflicts that divide us become less important and the need to create a planetary society with the united will to protect this 'pale blue dot' becomes both obvious and imperative."[14] The declaration promotes immediacy in three senses: "firsthand" witnessing of "reality," a sense of urgency, and the quick arousal of that urgency. The overview is alchemical in that it takes passive witnesses and transmutes them into engaged advocates. Echoing the data visualization rhetoric we examined in chapter 1, the thesis here is that seeing Earth from above produces an instantaneous and transparent sense of connection that yields understanding and prods action. Immediacy and transparency go along with universality. The description of Earth in the passage insists on its vulnerability and ephemerality: "fragile," "pale," "dot," "paper-thin," "void." "Shielded and nourished" as if at battle or at a mother's breast. At the same time, it extols humanity's ability to compass the globe, erase difference for the better, and thereby address this imperiled condition. Overviewers embrace human essentialism as the path to planetary survival. A universalized human condition can save the day when supported

by the technologies of space exploration and inhabitation. With this con-
viction, the institute lobbies for greater financial investment in space tech-
nologies that would allow for tourism to and even colonization of other
planets.

Overview's commitment to values of immediacy, transparency, and tech-
nomastery is unwavering. They may be an idiosyncratic bunch, but these
values and aerial adoration are evident outside the institute's membership.
They are apparent in the *Guardian* newspaper's long-running monthly
series "Satellite Eye on Earth," and in the frequent use of the aerial in report-
ing on environmental disasters and violent conflicts. They are apparent in
the success of photographer Yann Arthus-Bertrand's "Earth from Above"
series of books and of Benjamin Grant's Daily Overview media company,
which is directly inspired by the Overview Effect and includes a blog, cof-
fee table book, and an Instagram account with 767,000 followers (as of
November 2019).

Like Grant's followers and the *Guardian*'s readers, I find aerial images
captivating. What interests me is how artist-activists play on this allure to
draw out what is occluded in the rhetoric of transparency, universality,
and environmental "goodness" surrounding the aerial. Highlighting the
technological structures and imperial histories that make aerial media
available as well as the aesthetic form that aerial data takes, SkyTruth, Laura
Kurgan, and Fazal Sheikh promote epistemological values of situated-
ness, uncertainty, materiality, and mediation. They turn these values to a
technological environmental ethics that does not simply propagate that
technology's militaristic and colonialist origins.

SKYTRUTHING EXTRACTION

Claims for transparency and universality obscure the sources of the tech-
nomedia through which many of us come to environmental knowledge.
With this point I take a page from Donna Haraway, in particular her famous
espousal of "situated knowledges" and the "partial perspective." This per-
spective contrasts the "god trick" of disembodied, authoritative knowledge
acquired from "seeing everything from nowhere," a trick so long associated
with Big Science and the visual media it generates. These media may include
"the camera eye of a spy satellite or the digitally transmitted signals of space
probe-perceived differences 'near' Jupiter that have been transformed into

coffee table color photographs." By contrast, the partial perspective "turns out to be about particular and specific embodiment and definitely not about false vision promising transcendence of all limits and responsibility." Even when transcendence serves some version of environmental responsibility, as it does in the Overview project, the "god trick" (and god's-eye view) denies both embodiment and technological mediation, key conditions of situated knowledges. Striving for such knowledge is an effort "to have *simultaneously* an account of radical historical contingency of all knowledge claims and knowing subjects, a critical practice for recognizing our own 'semiotic technologies' of making meanings, *and* a no-nonsense commitment to faithful accounts of a 'real' world."[15] Accounting for the real world and attempting to better it for all species and oppressed peoples requires the partial perspective that is excluded from values of transcendence, transparency, mastery, and universality.

Inspired by Haraway's partial perspective, I now want to situate— historically and materially—the technomedia that deliver the aerial perspective to publics in the twenty-first century. It is precisely this situatedness and partiality that aerial artist-activists deploy in developing an epistemology of the aftermath. Let's circle back to the satellite media that we might find in a coffee table book such as Grant's *Overview* (2016). Grant did not launch his own satellite mounted with a digital camera or remote-sensing device to obtain the images that appear in his book. His media enterprise is built on images acquired from others. Glance at the source credits for these images and the name DigitalGlobe comes up again and again. Once, the technologies of remote sight were the province of state militaries. Now, satellite visuals depend on corporate-government partnerships such as DigitalGlobe. The corporation owns "the most agile and sophisticated constellation of high-resolution commercial Earth imaging satellites" and "believe[s] the answers to some of the world's most pressing problems are within reach if we elevate our perspective and see things more objectively, more holistically—from space." All this is captured in their slogan: See a better world®. The company's suite of satellites surveils on a vast scale and iterative timeline: it collects "well over one billion square kilometers of quality imagery per year and offers intraday revisits around the globe."[16] Some of this imagery is freely available in a publicly accessible, searchable archive.[17] Much, however, comes at a price that varies based on the resolution of the imagery and whether the satellite was "tasked" to

acquire the data; tasking "involves the expensive navigation of a satellite over a specific location."[18] The publicly traded company has cornered the market in satellite aerials. When you toggle to the satellite view mode in Google, Apple, or Bing mapping applications, you will likely access proprietary views from DigitalGlobe. In addition to such Silicon Valley clients, it counts defense, intelligence, resource extraction, environmental monitoring, urban planning, and real estate development among its target industries.

The privatization of satellite imagery is a twenty-first-century phenomenon, though technologically aided aerial vision has long been in the hands of wealthy Eurowestern nations. When we consider the structural conditions that give access to these views, there is nothing transparent, immediate, or universal about aerial production in the digital age. Even when Eurowestern mapmaking moves from the codex to the computer server, legacies of control by the state, military, and corporations cloud the aerial.

Architecture theorists Ines and Eyal Weizman help elaborate this point in their reflections on before-and-after imagery of human rights disasters. DigitalGlobe and its French competition, Satellites pour l'Observation de la Terre (SPOT), serve groups involved in disaster prediction and recovery as well as technology companies such as Apple and Google. The Weizmans explain, "When crisis occurs, or is expected, commercial image satellites align their orbits to cover 'regions of interest' or 'areas at risk' in the hope of selling their images to organisations interested in the events below."[19] They engage in proleptic acts of collecting image data that might be saleable on the disaster market. (I'll have more to say about the proleptic temporality of satellite aerials in the pages to come.) Disparities in access readily surface under these circumstances. There are disparities not only in the ability to purchase "before" images but also in the ability to task satellites to retrieve images after a disaster occurs on the ground. The Weizmans explain the significance of discrepant access: "Generally [human rights and environmental groups] can only afford to interpret satellite images of those places that are already being monitored by well-funded state institutions or corporations. It thus makes it harder for private organisations and NGOs to set their own agenda, and makes them dependent on the tangled interests of militaries, states and large international organisations."[20] When dependent on satellite technologies, interpretation of aerial media carries the imprint of the very corporate and state

entities with which an NGO might be in conflict as it renders humani-
tarian aid or redresses environmental wrongs. These discrepancies that
inhere in the history of the technomedia wrest satellite visuals from the
epistemological values of transparency and universality.

Capitulation is not the only response to this situation. Media theorist
Jennifer Gabrys puts it well when she encourages users and scholars "not
to fix technology into conditions of inequality and the programmatic but
instead to open it into encounters . . . with technocultural creativity and
responsibility" and "to consider how environmental computational prac-
tices open into experimentation, expanded experiences, and speculative
adventures."[21] Reformulating this invitation for the concerns of this chap-
ter, how might environmentalism work within—and even with—the lega-
cies of discrepant access to experiment with and expand epistemological
values?

Analyzing SkyTruth's work delivers an answer to this question. As I cited
earlier, the nonprofit's slogans expound the "radical transparency" of orbital
aerials; it would seem it and aerial utopians like the Overview Institute are
close bedfellows. What's more, the group analyzes and renders images col-
lected from sources such as NASA Landsat, Google Earth, and Planet Lab's
RapidEye satellites; the so-called raw material for their data mining and
analytics, therefore, carries the imprint of corporate and state power that we
have been outlining. However, SkyTruth's participatory environmental
monitoring differentiates it from these sources of power precisely because
it calls on them. Moreover, its attention to the complex temporalities of
environmental violence places its visual media at a slant to the conditions
that structure it.

"Consistent vigilance."[22] This is SkyTruth's promise to the extractive
industries it works to expose. To those wary of the surveillance state and
surveillance capitalism, this language raises red flags. SkyTruth's premise
is that the only way to hold fossil fuel corporations, commercial fishing
fleets, and illegal loggers accountable is to counter their use of the latest sat-
ellite and detection technologies through relentless observation. The
watchdog's instruments of countersurveillance—satellite data and media—
are the very technologies extractive companies employ to find their com-
modities, but SkyTruth adds activist human capital to this equation. It
invites concerned individuals to "consistently" monitor satellite data of
areas under threat so they can find oil spills, chemical leaks, illegal fishing

and logging, and other harmful activities that SkyTruth can then bring to the attention of the press and state regulators. The aim is to return the gaze of bad actors by taking into hand the aerial technomedia so often controlled by the states and companies supporting extraction.

The biggest coup in this effort was undoubtedly exposing disinformation about the Deepwater Horizon catastrophe in 2010. More recently, SkyTruth has created tools for engaging citizen activists not just as data monitors but also as "ground-truthers" whose "detailed, on-the-ground observations provide a way to corroborate more distantly gathered data, and so these views from the ground are seen to offer a truth, or a 'truing,' of more abstract observations."[23] The sequence of devastating storms that struck the U.S. Gulf Coast and Caribbean in 2017 set SkyTruth and its citizen monitors to this task of ground-truthing. Hurricane Harvey, whose record rainfalls ravaged Houston and the Texas coast in August 2017, especially attracted their attention because it struck a hotbed of petroleum and petrochemical production. The stretch of land from Houston/Galveston to Beaumont/Port Arthur hosts refineries that process 14 percent of U.S. crude oil production and petrochemical plants that make plastics such as polyethylene and polyvinyl chloride. Economic impacts were immediate and obvious when nearly 20 percent of this refining capacity halted and plants went offline abruptly. The environmental and public health impacts were also rapid. Within two weeks of the storm, benzene, ammonia, xylene, carbon monoxide, and other pollutants—totaling 5.8 million pounds—had contaminated the air; 568,000 gallons of crude oil, gasoline, saltwater, and other pollutants entered the water system and soil.[24] Sky-truthing and ground-truthing complemented each other in the organization's approach to monitoring this toxic situation.

SkyTruth workers comb the news for reports of petroleum spills, chemical leaks, and other toxic releases, especially at sites of petroleum infrastructure such as well pads, fluid impoundments, and oil storage tanks. They then solicit stories from people on the ground to document their experiences. In SkyTruth's epistemology of the aftermath, before-and-after satellite aerials meet narrative and the human sensorium, which includes not only vision but also smell and taste. In the aftermath of hurricanes Harvey and Irma, which both hit in September 2017, SkyTruth created a "Spill Tracker" mapping tool to crowdsource these reports and make them publicly available.[25] "Flaring of Nitrogen Oxide" in Port

Arthur, Texas. "100 Gallons of Waste Water Containing Unknown Chemicals" near the Federal Corrections Complex on the road between Port Arthur and Beaumont. "Hazardous Air Emissions" layering the refinery megacomplexes of Baytown just southeast of Houston. These reports from people living and working in the affected communities spur more intensive aerial monitoring, creating a feedback loop of inputs between sky and ground, between remote-sensing satellite and near-sensing body. The immediacy SkyTruth introduces into its environmental epistemology is not the immediacy of "seeing firsthand the reality of the Earth in space" that the Overview Institute propounds but the immediacy of ammonia burning in the nostrils and of the unwelcome taste of saline in tap water.[26]

Hooking human witnessing and embodied experience up with orbital vision, SkyTruth takes account of the discrepancies in access to aerial technomedia. It cannot entirely circumvent these discrepancies, but it can self-reflexively point a finger at them. This act is particularly apparent in how it engages the temporalities of aerial media. As we will discover, SkyTruth places in time media that seem to be temporally static, and it draws distinctions between natural change, attritional damage, and catastrophic destruction through this temporal awareness. Radical transparency becomes cloudier—and deliberately so—than the motto suggests.

Brazil is one of many places where the boom-to-spill narrative of oil exploration plays out with consequences that attracted SkyTruth's aerial attention. Nineteen oil and gas reserves were discovered off the Brazilian coast in 2011 and drew petro-investment. Soon, evidence of an oil and natural gas leak was reported at Chevron's Frade field 230 miles (370 kilometers) off the coast of Rio de Janeiro in the Campos Basin (figure 5.5).[27] Following a Reuters report of a leak on November 8, 2011, SkyTruth analyzed satellite imagery, and John Amos estimated that 47,000 gallons—or about sixty barrels—of oil were coating the Atlantic Ocean within a 180-square-kilometer (69-square-mile) area.[28] The key question was, what were they seeing? The answer to that question hinged on time. Were they seeing a natural seep from the seafloor that would happen even if extraction were not taking place? The everyday leakage from extraction that is unavoidable when drilling takes place? A major spill event? The demarcation between the everyday and the spectacular is in the eyes and the bottom lines of the beholder. The viscous, glittering sheen on the ocean visible from above flickers between these states. Chevron's PR machine first

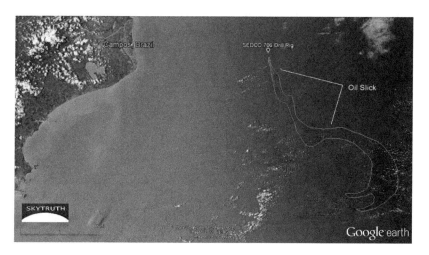

FIGURE 5.5. SkyTruth, "MODIS/Aqua satellite image shows growing oil slick in the deepwater Campos Basin off Brazil. Image taken around midday on November 12, 2011," https://skytruth.org/wp-content /uploads/2011/11/SkyTruth-Campos-oilspill-MODIS_Aqua_12nov2011-1.jpg. Courtesy of SkyTruth.

declared this sheen was evidence of normal geophysical forces. It then became a minor leak, one that a nation profiting from extraction should accept as a minor cost against financial benefits. In SkyTruth's analysis, the sheen registered as an ecological and economic disaster born of lax safety regulation and poor monitoring. Such discrepancies are not unique to the Frade fail; in any hotbed for extraction, on what basis do we distinguish between natural seepage, everyday attrition, and catastrophe? The passage of time helped clarify answers to these initial questions. In the days following the leak report, SkyTruth watched the slick spread and the 47,000-gallon figure mount to 157,000 gallons (3,700 barrels) *per day*—as compared to corporate estimates of 8,400 to 13,860 gallons (200–330 barrels). At this point, all claims to natural seepage were shattered.

Adjudicating among the natural, the attritional, and the catastrophic involves a temporal awareness that is often dampened by claims to the immediacy of a satellite image. Reading the oil on the water at the Frade spill, SkyTruth draws out the complex temporalities embedded in the media that, as this chapter goes on to show, are so crucial to aerial art's epistemology of the aftermath. Ines and Eyal Weizman get at this encoding of time in aerials when they provocatively muse, "It seems that almost

any photograph taken today has the potential to become a 'before' to a devastating 'after' yet to come"; this in a context in which, as they solemnly propose, "history is increasingly presented as a series of catastrophes."[29] The Weizmans suggest that, as satellites acquire data on their routinized orbits around the planet, they are engaging in forensic activities *avant la lettre*. This forensic knowledge is potential rather than kinetic when it is first captured. Lisa Parks helps elaborate this point: "The satellite image is encoded with time coordinates that index the moment of its acquisition, but since most satellite image data is simply archived in huge supercomputers, its *tense is one of latency*. . . . Much of what they register is never seen or known. The satellite image is not really produced, then, until it is sorted, rendered, and put into circulation." Parks characterizes the accumulation of this latent potential as *"diachronic omniscience—*vision through time—because [satellite images] enable views of the past (and future, with computer modeling) to be generated in the present that have never been known to exist at all, much less seen."[30] That is to say that "witnessing" happens only long after the fact and, we should recall, when an interested party requests the data for a project or in response to an incident.

In the face of damage in the Gulf, the Atlantic, or at any of the thousands of extraction sites around the globe, remote vision vivifies the past. It is not apparent from Parks's statement above, but she elsewhere attenuates the idea of omniscience. Chiming with Haraway's notion of the partial perspective, she insists on the partiality of this knowledge against claims to satellite imagery's totalizing knowledge.[31] When we examine aerials in their technological contexts, then, partiality and latency come to the fore. Aerial data is a kind of Schrödinger's cat in a state of epistemological suspension until activated by scientific researchers, developers, activists, and other aerial analysts. Even once activated, as at the Frade Field spill, the image is also suspended between the natural, the attritional, and the catastrophic until interpretations that attend to time can take place.

Just as latency is an essential technological and epistemological feature of aerial data, the before-and-after is an essential feature of aerial media, especially in states of aftermath. The gap between the before and the after is the space for historicity that SkyTruth exploits toward activist ends. Degradation, decline, crisis, remediation, adaptation, mitigation, resilience. A host of environmental actions imply a practice of contrasting a before state to an after state. Before-and-afters play such a central role in apprehending

disaster that they have become naturalized for many viewers. The techno-media conditions that make those views available are rarely considered. Aerial images generally—and satellite images in particular—often come to us as static. They bear a time stamp and may be composites, as I address shortly, but they *appear* as snapshots of a condition. The epistemological procedure one undergoes to interpret before-and-afters involves time-dependent comparison of images rendered temporally static. What's more, this procedure takes place with incomplete information. Ines and Eyal Weizman emphasize that, when apprehending aftermaths, viewers are forced to fill in what's missing. In the before-and-after images that register environmental and/or humanitarian injuries, "the event—whether natural, man-made or an entanglement of them both—is missing. Instead, it is captured in the transformation of space. . . . This spatial interpretation is called upon to fill the gap between the two images with a narrative, but that job is never straightforward."[32] Of course, the conditions present in the before and in the after matter, but also at stake is this missing in-between. Latency and suspension characterize aerials when they figure in analysis of aftermaths.

Let's bring this process of filling-in to bear on Chevron's negligence at Frade Field. What were the actions that created the befoulment apparent in the after image? Was its source deep in the geological crust or in the machines and human labor of extraction? These questions are written onto the canvas of feelings that before-and-afters produce. Feelings that may include surprise, sadness, shock, confusion, dissonance, horror, or even nostalgia. The casual ubiquity of these images mutes the complex emotional states and epistemological work that aftermaths induce. In addition to requiring an epistemology built on suspension and complex temporalities, the aftermath captured in before-after images also requires "a reservoir of imagined images and possible histories."[33] That is, the gap the Weizmans theorize is a space of speculation and interpretation as much as it is one of detection and verification.

This epistemological messiness, which is fodder for the aesthetic work of artist-activists I turn to shortly, becomes clear when we account for the technologies that structure the media through which we access aerial data. SkyTruth's seeing is not a view from nowhere, despite its rhetoric of radical transparency. I have lingered on how the group's citizen aerial activism contrasts the rhetoric and desires that circulate around aerial cultural

production to establish terms for understanding the artistic work of the next sections. An epistemology of the aftermath accounts for how technological and media histories condition the knowledge that aerials produce. This includes the terms of access to satellite technologies and their entanglement in imperial and extractive enterprises; temporal attributes of the media including latency and suspension; and epistemological procedures dependent on speculation, uncertainty, and temporal and spatial situatedness. Inspired by the technology and media theorists I have cited thus far—Raley, Haraway, Parks, and Gabrys—the question now is, how can aerial users acknowledge and then repurpose these legacies within environmental culture so as "not to fix technology into conditions of inequality"?[34]

LAURA KURGAN'S "PARA-EMPIRICAL" ART

Laura Kurgan's art is about the interplay between the technological conditions enabling the aerial and the formal attributes of art that embeds it. We might call her aerial art "uncreative" in line with Kenneth Goldsmith's coinage for poetry that does not strive to "make it new" but instead creates texts out of "found" information, from songs, others' poems, and the mediasphere.[35] The found material in Kurgan's *Monochrome Landscapes* series (2004) comes from satellite image repositories, notably DigitalGlobe's database. She shares SkyTruth's and the Weizmans' interest in the uncertainties that aerials produce in contrast to the transparent knowledge frequently conferred on aerial sight in Eurowestern discourse.

Kurgan's artbook-*qua*-manifesto, *Close Up at a Distance* (2013), features *Monochrome Landscapes* but opens with the iconic *Blue Marble* that has galvanized utopian dreams of planetary connectedness. Unlike *Earthrise* and the original *Blue Marble* image, which astronauts shot with cameras on Apollo spacecraft, more recent iterations such as *Blue Marble Next Generation* (2015) are captured by unpeopled spacecraft (figure 5.6). They offer "eyeless vision" of the planet and thus evoke the military origins of Earth-from-space imagery (see figure 5.2).[36] In addition to being eyeless and digital, this sight is also composite. Kurgan underscores the distinction: NASA's next generation of remote "eyes" on Earth

are composites of massive quantities of remotely sensed data collected by satellite-borne sensors. The difference between the generations of *Blue Marbles* sums up a

FIGURE 5.6. NASA, *Blue Marble Next Generation*, April 9, 2015. Data from six orbits of the Suomi-NPP satellite, created by Norman Kuring. Courtesy of NASA/NOAA/GSFC/Suomi NPP/VIIRS/Norman Kuring.

shift in ways of thinking about images, what they represent, and how we are to interpret them. So, where you might think you're looking at image number AS17-148-22727 [the 2012 *Blue Marble Next Generation*], handcrafted witness to earthly totality, in fact what you're seeing is a patchwork of satellite data, artificially assembled—albeit with great skill and an enormous amount of labor. . . . It's an image of something no human could see with his or her own eye.[37]

Kurgan adds media specificity to Parks's and the Weizmans' accounts of the latency of aerial data. In the twenty-first century only naïve or untutored viewers expect the imagery that surrounds them—in advertisements,

in GIFs, on Instagram—to be "handcrafted," untouched by photo-editing software and filters. The same awareness of mediation should also hold for views-from-above. What appears as a single image, a snapshot of one moment in time, is in fact an assemblage that requires further manipulation beyond the technologies that captured and archived the data. Studying Blue Marbles as composites, Kurgan resonates with geographer John Pickles on cartographic *bricolage*. Pickles uses this phrase to describe "mapping as a social practice [that] is also a historical process of accretion and reworking: . . . a palimpsest of epistemological commitments."[38] Epistemological commitments to mediation, situatedness, and interpretation layer onto commitments to transparency and universality when Blue Marbles enter the next digital and composite generation. Yet the fact that Kurgan must make this point underscores how the enduring iconicity of Earth-from-space gives these images the allure of immediacy. In viewing the Next Generation, we are still viewing myths of representation that encrust the original *Blue Marble* and the ideas of utopian planetarity that it energized. As Kurgan reflects, these images continue to circulate in the "public sphere [as] a way of viewing things close up at a distance in which there is no absolute scale, no anchor, no center" (24). They are views from nowhere.

When that epistemology of the aerial becomes the content of aerial art, however, aerials yield epistemological values rooted in technological mediation. Calling attention to the composite form of satellite aerials, Kurgan's art toggles between "precision and ambiguity" (12) in ways that chime with the work of the new naturalist artists of chapter 4. For the panels of *Monochrome Landscapes*, which she features in *Close Up at a Distance*, Kurgan acquired images from DigitalGlobe and Space Imaging (a company eventually absorbed into DigitalGlobe through a series of acquisitions) and also tasked satellites to acquire specific image data.[39] The criteria for Kurgan's selection of images were twofold: contested territories of extraction, war, or commerce, and a seemingly monochrome palette. The latter criterion made abstraction a central aesthetic feature of the project. In dialogue with Ellsworth Kelly's monochromatic *Four Panels* (1970–1971) and in line with the conceptual art tradition, Kurgan sought "pictures of places on Earth primarily characterized by one of four basic colors: white, blue, green, and yellow. The rules were simple, and generically, there were not many choices: snow, water, trees, and sand" (155). Blue: best found at the point of zero longitude and zero latitude in the middle of the Atlantic Ocean. White: in the

snowy expanse of area 1002 in Alaska's Arctic National Wildlife Refuge (ANWR), around which a contest over oil and gas extraction continues to rage. Yellow: in the Southern Desert of Iraq in the weeks after President George W. Bush launched Operation Iraqi Freedom. Green: in an old-growth tropical rainforest in Cameroon that's monitored by Global Forest Watch due to evidence of illegal logging (figure 5.7). Images at these locations appeared smooth, unruffled by human intervention. But that only made them ripe for Kurgan's roughing up following her premise that "embedded in the very structure of the techno-scientific, militarized, 'objective' image is something more disorienting, an 'emptiness and abstraction' that resists sovereign control and opens itself to other sorts of interpretation" (30).

Monochrome Landscapes opens "other sorts of interpretation" by smuggling in historical awareness and the conditions of technological mediation and human intervention. For example, the "Blue" panel introduces the history of cartography and the enduring dominance of the grid. The international grid of latitude and longitude fixes coordinates for navigation and timekeeping. It has been a standardized "tool of legibility" since 1884 and endures in the digital age of ubiquitous GPS.[40] Though the zero-zero point is an actual location on the globe and enables localization, we rarely conceive of it as a place. At most it is passed through in transoceanic flights or sea voyages between eastern South America and western Africa. Presenting it as an aerial image gives a physical place to something that seems abstract and that functions in "the administrative ordering of nature and society."[41] The other images in Monochrome Landscapes put less focus on cartographic history and more on the mediations of technology and the form of aerial imagery. The smoothness of this imagery becomes splintered, ragged, and contested. Kurgan performs this work on the white, green, and yellow panels through juxtaposition and zoom. The four panels first appear abutting one another and are zoomed out far enough that details melt into the chromatic surface. Those details reemerge when moving close to the photograph in the gallery space or when viewing the zooms that Kurgan includes in the book. When the zoom is tight enough, pattern, texture, and identifiable objects reassume their contours. A road cuts through the seemingly isolated Cameroonian wilderness in "Green" and becomes forensic evidence for illicit logging (figure 5.7). Two helicopters cross the Iraqi desert, evidence of sorties that DigitalGlobe had tried to suppress by not granting Kurgan access to the images she had requested (figure 5.8). Censoring

FIGURE 5.7. Laura Kurgan, GREEN [zoom 3—detail from *Monochrome Landscapes* (2004)]. Old-growth tropical lowland rain forest, Cameroon, about 100 km west of Yokadouma and 70 km east of the Dja reserve. Acquired December 4, 2001, 09:48 GMT. Upper left coordinates: 3°13'9.804" N, 14°12'27.72" E. Ikonos satellite, 1.0m per pixel. Includes material copyright © 2001 Space Imaging LLC. All rights reserved. Courtesy of the artist.

FIGURE 5.8. Kurgan. YELLOW [zoom 3, detail from *Monochrome Landscapes* (2004)]. Southern Desert, southeastern Iraq, between Al Busayyah and An Nasiriyah. Acquired March 30, 2003, 07:32:10 GMT. Center coordinates: 30°18'48.96" N, 46°22'25.68" E. QuickBird satellite, 0.61m per pixel. Includes material copyright © 2003 DigitalGlobe. All rights reserved. Courtesy of the artist.

the images was not an act of government "shutter control," as restricting satellite data is often called, but was voluntary and thus evidence of how DigitalGlobe maintains state interests. In "White" fissures appear in the frosting-smooth surface of ANWR, but what initially seems an inviolable space becomes a canvas for the ruptures in indigenous lifeways, bird migration, and caribou reproduction that occur when the area is opened to fossil fuel extraction.

"Green," "Yellow," and "White" populate the satellite image. They call attention to the smoothing over that occurs when the view is so far above that the particularities and uses of a space dissolve into the accumulation of pixels. The juxtaposition of panels and the ability to zoom unveil the human and more-than-human populations affected by extraction and military incursions. Animal bodies and military machines deflate the "aloofness" of aerial abstractions.[42]

Taken alone, the zooms and the bodies they unearth might suggest that Kurgan's aerial art is a ringing endorsement for the "radical transparency" of satellite imagery. It is true that, in a first move, *Monochrome Landscapes* tempts viewers to believe that, if we just zoom in close enough, the unknown and obscured will resolve into knowledge. In a next move, however, the project underscores the technological mediations of satellite vision that limit access to what remains at a distance even when it is brought close up. As with the tradition of conceptual art to which *Monochrome Landscapes* nods, the documentation surrounding the images opens this epistemological possibility. Kurgan's captions for each unzoomed panel are rich in data. For example, "Green":

Old-growth lowland rain forest, Cameroon, about 100km west of Yokadouma and
 70km east of the Dja reserve
Acquired: December 4, 2001,
09:48 GMT
Upper left coordinates: 3°13'9.804" N, 14°12'27.72" E
Ikonos satellite,
1.0M per pixel
INCLUDES MATERIAL
©2001 SPACE IMAGING LLC.
ALL RIGHTS RESERVED (152)

Similar data accompanies the other panels, though the pixel size goes down to 0.61m per pixel for "White," "Blue," and "Yellow" and the source is DigitalGlobe rather than Space Imaging. This infowhelm brings aesthetic abstraction into the realm of technological mediation. Again reminding us of the cartographic grid, each caption also reminds viewers of the proprietary nature of satellite data—copyright dates and provenance—and its position in space and time.

The pixel size opens onto additional aspects of technological mediation. For decades, a U.S. legal regulation restricted the resolution of publicly available satellite imagery to 0.5m per pixel; other nations, notably Israel, set the limit even higher at 1.0m per pixel. The rationale behind the former limit is that 0.5m per pixel is equivalent to the area the human body takes up when seen from satellite heights. Therefore the purported reason for setting this "threshold of detectability," to borrow Eyal Weizman's phrase, is to preserve individuals' privacy.[43] Yet this threshold also protects national security and can occlude state- or corporate-inflicted violence. DigitalGlobe prohibits access to the specific regions of Iraq that Kurgan initially requests so as not to release military intelligence during the 2003 invasion of Iraq, but the latency of satellite data, the fact that "much of what [satellites] register is never seen or known,"[44] meant that she was still able to catch sight of a military helicopter through a more randomized request. I propose that these captions and the other text in *Close Up at a Distance* underscore that satellite aerials are also a form of not-seeing. They are heavily regulated artifacts, and the views they offer are as much products of mediation as the supposedly "wild" and uniform territories they capture are products of human intervention. Even though the pixel restriction was moved to 0.25m in 2014, following DigitalGlobe's request to the U.S. Commerce Department, control over the aerial continues to make these views instruments of not-seeing as much as instruments of sight.

The toggling between seeing and not-seeing that *Monochrome Landscapes* performs is one of the "infinity of sets of twos" that aerial rhetoric sets in opposition but that aerial art-activism puts into interdependent orbits. In Kurgan's aerial art, "we sense something (or somethings)—ghostly, multiple, past, future, simultaneous" as viewers gain access to the aerial's technomedia and political histories. Kurgan and her fellow critical aerial artists smudge the "conventional divide between power and resistance . . .

between 'seen and seeing objects' to consider the possible presence of the unseen or unsensed."[45]

Kurgan's art-activism emphasizes mediation and situatedness through infowhelm, aesthetic and technomedia history, and abstraction turned into inhabited but contested place. In these ways it demystifies what philosopher Nelson Goodman terms "the myths of the innocent eye" that enrobe the aerial.[46] The aspects of SkyTruth's environmental advocacy we examined earlier—both self-reflexively pointing a finger at the technological and corporate mediations of aerial views and ground-truthing in ways that reinstall the epistemological importance of bodies—take aesthetic form here. Conceptual art's abstractions and reliance on textual accompaniment situate Kurgan's aerial activism in the aesthetic sphere; data acquires a dual status as technological and representational. Making the smooth ragged, the static temporal, the proprietary accidental, the up-close still unseen, Kurgan adds another dimension to the epistemology of the aftermath that SkyTruth promotes: "para-empiricism." She offers this "modest" concept to acknowledge that, "when working with data, things are not as obvious as they seem" (34). Data is "auxiliary, almost, not quite, functional but not really a substitute" for "the concrete facts of the world" (35). Or, I would add, for ways of knowing the world in its varied states of beautiful abstraction and situated degradation. Kurgan infuses aerial epistemologies with not-seeing by rendering the conditions of aerial access into conceptual, "uncreative" art.

SHEIKH'S OBLIQUE ON THE AERIAL

Photographer Fazal Sheikh's aerial practice elaborates on seeing and not-seeing and other "sets of twos" as interdependent practices that constitute the epistemology of the aftermath. Conditions of colonialism, and how those conditions produce environmental degradation, explicitly motivate the art-activism he pursues in collaboration with Eyal Weizman. Sheikh and Weizman directly evoke the humanist critiques of aerial technomedia I discussed earlier while demonstrating the urgent stakes of the aerial for marginalized populations and ecosystems today. The stakes run deep in *The Conflict Shoreline: Colonization as Climate Change in the Negev Desert* (2015), which developed out of Sheikh's photographic project *The Erasure Trilogy* (2015). Between 2010 and 2015 Sheikh, a Guggenheim and

MacArthur award-winning photographer, traveled in Israel and Palestine
to investigate the territorial and cultural displacements that have taken
place in the region, with special attention to the erasures of community and
memory that have resulted from Israeli settlement of Palestinian and Bed-
ouin lands. *Desert Bloom*, the final volume of the trilogy, contains aerial
photos of the Negev/Naqab desert in southern Israel (figure 5.9).[47] Sheikh

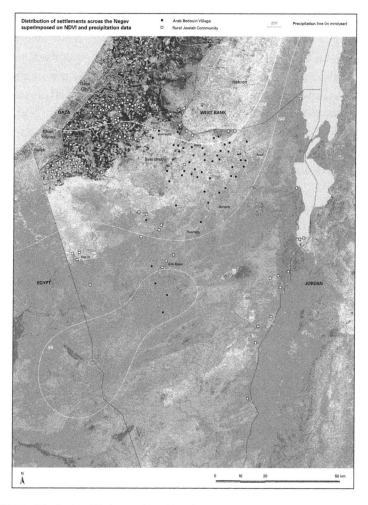

FIGURE 5.9. "Distribution of [Bedouin and Jewish] settlements across the Negev superimposed on NDVI
[Normalized Difference Vegetation Index] and precipitation data." Map by Jamon Van Den Hoek; analysis
by Van Den Hoek and Forensic Architecture, 2014. From Fazal Sheikh and Eyal Weizman, *The Conflict
Shoreline: Colonization as Climate Change in the Negev Desert*, Steidl Publishers, 2015. Courtesy of Fazal Sheikh.

took the aerials from 2000-feet above the ground in a small Cessna plane piloted by an Israeli. He then collaborated with aerial analysts such as Eli Atzmon to interpret the images and published them in *The Erasure Trilogy*. *Desert Bloom* contains no text—a separate volume collects the explanatory notes—and there are no borders around the images. One is fully immersed in the photographs when paging through the book, and fanning the pages produces impressions of both layering and incompleteness, effects that will be relevant later in my readings. Many of the photographs from *Desert Bloom* also appear in *The Conflict Shoreline* in a smaller format. For this study, Weizman traveled with Sheikh through the Negev and composed an essay investigating the environmental and cultural injuries to the region. As the book's subtitle indicates, the essay is an argument for "colonization as climate change," that is, for how climatic manipulation serves state interests in a region that has been home to Arab Bedouin populations for thousands of years. The displacement and marginalization of Palestinian communities is likely more familiar to many living in North America and Europe. Less well known is the displacement and marginalization of Bedouin peoples through state-sanctioned settlements and industrial and security installations. Sheikh and Weizman take the town of al-'Araqīb, just north of Beersheba, as their focus for studying the harms of these acts of dispossession. Israeli police forces have serially demolished this settlement and refused to recognize its legitimacy as a site of Bedouin inhabitation.[48] A work of aerial activism enmeshed in a campaign for Bedouin rights, *Conflict Shoreline* elaborates an epistemology of the aftermath through aesthetic means. Like SkyTruth and Kurgan, Sheikh and Weizman advance this epistemology through self-reflexivity about the technological mediations of aerial data. Using the oblique angle, they draw out the materialities, temporalities, and mediations that structure aerial imagery, especially in contested territories.

To gain purchase on the oblique, let's consider the epistemological power of its contrasting vantage within the field of aerial imaging: the vertical. Aerial views orient spatial relations away from contiguity on a horizontal plane toward distance on a vertical plane. As aerial photographer William Fox explains, when viewed on a vertical axis, space appears flat, representable, mappable.[49] In *Before and After*, Ines and Eyal Weizman underscore the vertical's association with objectivity by telling the history of forensics. They relate the invention of the *plongeur* by French investigator Alphonse

Bertillon in the nineteenth century. This device "consisted of a horizontally-facing camera that photographed the mouth of a periscope-like-structure [sic], which directed the camera's gaze up to the top of a high tripod and then down again, affording a bird's-eye view of the crime scene." Bertillon invented a device offering this line of sight because verticality "avoided any of the preconceptions of subjectivity or positioning."[50] This is the dream of the view from nowhere but with the aim of objectively spotting details that tell a tale of violence. In addition to objectivity, the vertical enhances the ability to order space, a phenomenon we saw in Kurgan's evocation of the cartographic grid in the "Blue" panel of *Monochrome Landscapes*. Political theorist James Scott asserts that "certain forms of knowledge and control require a narrowing of vision"; he points to cadastral mapping—the parceling out and administering of land for forestry, agriculture, and other purposes—as one instance of a narrowing of vision that enables states to impose order. Like the "state fictions" he analyzes, the vertical perspective from above offers "an overall, aggregate, synoptic view of a selective reality . . . making possible a high degree of schematic knowledge, control and manipulation."[51] It suggests all-seeing because it affords a vantage and sense of space hard to acquire through relations of horizontal contiguity. Yet, to Scott's point, this vantage can narrow and simplify. In the Israeli context Sheikh and Weizman investigate, verticality has aided efforts to establish boundaries that are both political and environmental and that abet manipulations of peoples and climate.

Such environmental ordering is essential to the process of erasure that inspired Sheikh's *Trilogy*. For *Conflict Shoreline* he and Weizman draw attention to how strategic manipulation of the 200mm annual isohyet promotes erasure. An isohyet is a line connecting regions of the globe that share the same average annual rainfall (see figure 5.9). Two hundred mm/year designates the threshold of aridity for the desert designation. The rainfall data and the boundary line that derives from it create political realities on the ground. Weizman reflects, "to follow this line on its journey east and west is . . . to point to an ongoing historical process by which political developments have violently interacted with changing climatic conditions along this seam."[52] The legacy of this process runs deep, at least back to Ottoman imperial dominion in the Middle East in the nineteenth century. Weizman refers here not only to the forced relocations of Bedouin groups reaching back to this period but also to the coincidence that drone strikes by U.S.

and Western European military forces tend to cluster along this line where it cuts through Yemen, Somalia, Mali, Iraq, Libya, and Gaza. *Conflict Shoreline* begins with the 200mm isohyet to emphasize that climate is a tool of enduring imperialism, in Israel and throughout the Middle East. Climate change is "an unintended consequence of industrialization," he writes, but has also "always been a project for colonial powers, which have continuously acted to engineer it" (12).

In the Negev, climate engineering serves Zionist territorial expansion. Sheikh's collection of aerials in *Desert Bloom* takes its name from David Ben-Gurion's promise to Zionists in the 1930s to "make the desert bloom," that is, to place agricultural settlements in desert zones that are not obviously arable. Greening the desert, Zionists expanded into regions that previously had accommodated only small-scale agriculture and animal grazing by the seminomadic Bedouins. Afforestation was and remains a key ingredient in this greening—and subsequent resettling—of the desert. As Weizman reports, starting in the early twentieth century, botanists saw afforestation as a means of intentional climate change: "[Forester Otto Warburg] suggested that forests could change the country's climate into a more European one, reduce temperature, and increase rainfall" (24).[53] The Jewish National Fund (JNF) continues to lead efforts to plant forests and adjust the aridity line; it pursues climatic experimentation with the goal of territorial appropriation.

Not surprisingly, things have not quite worked out as ecologically planned. The intensive irrigation required for settlement and large-scale agriculture has contributed, along with rising temperatures, to the Dead Sea losing water at a rate of one meter per year since the 1960s. Ecological complexity has been reduced, and cycles of drought and flooding have become more violent. While ecologically damaging, climate change has been an effective pretext for colonization in a regime "that uses ecology as a political tool" (30). The parallels to the dispossession and marginalization of indigenous peoples in the United States are notable. In the Negev as in the desert Southwest of the United States, a two-stage process unfolds in which denigrating the land and its peoples enables expropriation and development for nationalist and capitalist projects. First, against all evidence of millennia-long inhabitation and cultivation of the land by indigenous peoples, the territory is deemed uninhabitable and not arable because it receives relatively little rainfall. Once the land is deemed *terra nullius* and

indigenous communities have been dispossessed, it becomes available for the development of toxic military bases, carceral installations, or "revival" development by white settlers (52). The "dead Negev doctrine" rests on the concept of the aridity line—which, recall, is a designation based solely on rainfall data (51). This line becomes "not only a tool of dispossession but . . . an act of denial that dispossession has taken place" because, according to the tautology, the desert is free of human habitation (51).

Lines of demarcation are lines of power. The state, in effect, employs the isohyet to justify terraforming and the cultural and ecological erasures that go with it. Evidence of Bedouin agricultural practices is forested over in order to deny land claims. If the existence of Bedouin farming and animal grazing had already been erased *conceptually and rhetorically* through the people's association with desert nomadism, it is now erased *materially* to eliminate evidence that would support territorial claims and the right of return. This process is effective because it recruits environmental data that "simultaneously naturalizes dispossession and obfuscates its effects" (52). A meteorological line thus attains colonial, juridical, and cultural force.

In the face of the tentacular powers of the line—the vertical from above and the isohyet encircling the globe—Sheikh takes a slant. His oblique line of sight responds to how aerial verticality and linear demarcations on the ground have served Israeli domination. It yields textures and questions that require an epistemology of the aftermath based in time, materiality, and uncertain interpretation, thus attenuating the aerial's ready association with visibility, immediacy, and transparency.

Let's turn to an image of afforestation to get purchase on these entanglements of aerial form, history, technology, and epistemology (figure 5.10).[54] When taking his photographs, Sheikh chose times that are propitious for what Weizman terms "aerial archaeology" (13): for this environment, the start of the rainy season in October and November when downpours clear the air of dust and harvests leave "the surface of the earth appear[ing] continuous and almost translucent" (14), and weekends when military exercises pause.[55] In *Desert Bloom (Notes)*, the photograph title includes a latitude and longitude designation—31°18'50" N / 34°40'58" E—and a lengthy descriptive caption. The caption provided in *Conflict Shoreline* does not include geographical coordinates but adds a title: *Earthworks in Preparation for Planting of the Ambassador Forest, along the al-'Araqīb Stream, 200 MM RPA [rainfall per annum]*. We are directly over the desert isohyet. The

FIGURE 5.10. Fazal Sheikh, *LATITUDE: 31°18'50"N / LONGITUDE: 34°40'58"E. Earthworks in preparation for planting of the Ambassador Forest, October 4, 2011,* from *The Conflict Shoreline* (28–29) and *Desert Bloom* (plate 35). Courtesy of the artist.

subject of "Earthworks" is savannization, a precursor to afforestation in which foresters plant acacia and eucalyptus intermixed with other small plants so that the coming saplings can absorb more water during the rainy season. Savannization eases the transition from desert to forest at the threshold. The image also features remnants of the village of "Abu 'Abudūn, of the Tiyāha tribe. It was abandoned and destroyed after 1948" (30).

The eye likely begins with the pattern of curves occupying the center of "Earthworks," which is the area of plantings within the frame. This soft undulation contributes to the sense that afforestation is harmless.[56] Unlike the site of an oil spill, a bombing, or a drone strike, afforestation seems benign, even ecologically salutary, rather than catastrophic. Yet the pattern also resembles a fingerprint, as if to symbolize possession, in this case, occupation of the land. The undulating pattern opens other interpretative avenues because it is so sensorily dynamic. The image suggests tempera-ture. The contrasts of light and dark become the contrasts of heat and cold. The tan colors radiate heat, while the shadows introduce coolness.

Returning to the visual senses, the eye traces over the central pattern, but we might also want to rub our fingers across the grain. Even lay our thumb over it and see if their shapes match. But of course, that scale is all wrong. The tactile quality of the image that comes into relief thanks to the oblique aerial would disappear if we were there on the ground.

These felt relations to the image create a sensory atmosphere against which other aesthetic features emerge. The dark bands within the parabolic curve also suggest the sweep of erasure, as if a broom or a brush had passed over the land to make way for the new. Just as the image was taken at an oblique angle, more on which shortly, the lines within the image run on the bias and bring obliquity directly into the composition. These diagonal lines add yet more texture to the central pattern of plantings, but they also announce that this is a space that is entered, run through, and run over. The association between afforestation and the fingerprint, between afforestation and possession, becomes stronger through these oblique lines of intervention. The caption explains this detail: "The path, accompanied by a shallow fence that runs diagonally from lower left to top right through the center of the image, coincides with the planned route of a railway line" (30). *Desert Bloom (Notes)* adds that construction on this route began in 2012, the year after Sheikh took the photo, and that "the forested area has since been overridden." Machines are entering this would-be garden over and over. The agricultural practices of the Bedouin Tiyāha are bulldozed in serial efforts to "maximize the desert's potential."[57] The preparations for the railroad that are apparent in the aerial photograph are a prelude to the destruction of the forest, which was itself an attempt to erase a people's history of inhabitation to make way for another's future.

The oblique opens angles of interpretation onto the biophysical, social, and political histories of the land. But how do we know "Earthworks" was taken on the oblique unless we read all the text accompanying the image, text that isn't even included in the main volume of *Desert Bloom*? At first the central pattern might appear to be shot on a vertical. We know Sheikh approached at an oblique when the eye ranges to the upper left-hand quadrant. The façade of the electrical transmission pole is too visible to be taken from the vertical. We can see the entire plane of the pole as well as its long shadow. The vertical would only reveal the top of the structure, at most a bit of its side plane. Sheikh confirms this interpretation in his account of his process. Without the oblique angle, the fence poles mentioned in the

caption, which are still faint to the point of straining the eye, would have easily escaped notice as well.

Through the oblique, the photograph announces that it is not a view from nowhere. A person, a plane, a camera, and the sun all mediate the image; the knowledge it produces is situated and is also, as Haraway emphasizes, partial. The oblique is a self-reflexive angle: it announces itself and the aerial technomedia that produce it. The oblique refuses to mystify the methods by which the image came to be. Rather than immediacy and transparency, the images of *Desert Bloom* encourage slowness and suggest opacity. Aware of the oblique because of the pole's shadow, the viewer returns to the planting pattern at the center and reassesses the textures and contrasts that initially invited the eye. The dark shadings cannot be shadows because they are not facing the same direction as the shadow the pole casts. A new pattern of plantation work emerges: these are irrigation terraces that collect rainwater to keep the acacia and eucalyptus alive. This is the darkness of moisture rather than of shade. Other imprints and their textures surface as well: the traces of earthmoving equipment on the bottom left-hand terraces; Bedouin feet tamping down the soil on repeated trips to collect wheat, evidence of which is visible as "small spots within the field"; agricultural "scratching," a method of shallow plowing the tribe practiced before Israelis moved into the area (30). These agricultural patterns as well as the remnants of ancient water collection and wheat storage systems prove the arability of land that the state had deemed uncultivated because of its aridity.

If aerials are often records of aftermaths, Sheikh's images record serial aftermaths. One "after" follows another, from the destruction of the village, to plantings for afforestation, to bulldozing for transportation infrastructure. Temporal layering takes material form through the textures within the composition and the sensory outputs I cataloged earlier. The layering of aftermaths adds complexity to understanding before-and-afters. Recall Ines and Eyal Weizman's argument that, in before-and-after compositions, "the event—whether natural, man-made or an entanglement of them both—is missing. Instead, it is captured in the transformation of space. . . . This spatial interpretation is called upon to fill the gap between the two images with a narrative, but that job is never straightforward."[58] In *Earthworks* the space shows layers of transformation that suggest multiple injuries that entwine the histories of people, ecology, infrastructure, and state colonization. Reflecting the entanglements of time and space in the

Weizmans' account, *Earthworks* encodes time through texture, palimpsest, a sense of movement. As in Kurgan's work, temporality and self-reflexivity are perceptible through materiality and mediation, all of which constitute the epistemology of the aftermath. Yet, as Caren Kaplan states so clearly about Sheikh and Weizman's forensics, "when something is sensed remotely and therefore can be recorded, it moves into perceptibility but does not lose all of its properties of imperceptibility."[59] We can understand the importance of materiality and mediation to this toggling between perceptibility and imperceptibility through Weizman's concept of the "threshold of detectability" (77). This is the point at which objects in an aerial image—whether a tent, a cistern, or a fence, all key elements in his forensic work—match the size of the grain in the lines that make up the photograph's resolution. Over this threshold, objects tend to be visible. Under it, they will be invisible or at most appear as perturbations.[60] This resolution is not absolute, however. Atmospheric humidity and particulate matter alter the "effective resolution of the film" (70). The multiple forms of mediation that compose the image make interpreting damage to communities, the environment, and individual bodies itself an oblique affair. Accounting for what is visible and invisible—or merely suggested—requires attention to the limits of technomedia as well as the material conditions under which the image was produced.

Such self-reflexivity about technomedia only increases the domains in which interpretation takes place and dilates the time it requires:

In this condition the materiality of the objects represented . . . and the materiality of the surface representing it—the photographic negative—must simultaneously both be examined. Just like a film, the surface of the earth is a recording device. Just like the terrain, the image has a distinct material topography. Photographs are not an unmediated copy of the world, they are a relation between material objects— one of celluloid . . . and the other of stone, earth, and vegetation—mediated by the climate between them. (77)

Thus far in this chapter I have focused on several forms of mediation in aerial imagery: access to technologies, political and epistemological traditions, and the tenses of latency and suspension. Sheikh and Weizman's collaboration adds to these a set of material mediations: of celluloid, atmosphere, and soil. The publication history of Sheikh's photographs

introduces the textual to these already complex forms of mediation and materiality. The aerial photographs appear in three volumes—*Desert Bloom*, *Desert Bloom (Notes)*, and *Conflict Shoreline*—and have two sets of captions—nearly identical but not quite—that appear in the latter two books. The long captions incorporate data such as geographical coordinates and rainfall amounts as well as historical narratives about displacement and destruction of Bedouin peoples. Without the captions, the viewer would remain aesthetically delighted and intrigued but largely unmoored given that *Desert Bloom* provides no text to accompany its borderless images. And still the captions are only explanatory to a point. It takes great effort to spot the features the captions call out, and some of these features, to my eyes at least, still remain unidentifiable. Sheikh took to the air out of frustration with his "inability to fully visualize the situation on the ground."[61] When he returns to the earth with Weizman and publishes an elaborate interpretation of the aerials, the picture remains incomplete.

Sheikh and Weizman's project produces a mangle of text and image that has no pretense to epistemological mastery. Aerial apprehension is always oblique, always incomplete and undecidable, but most especially under the conditions of erasure and obfuscation that shape the Negev. The artist and architect reimagine the evidentiary power of the aerial without upholding the epistemological values of transparency, immediacy, and universality that suffuse the history of aerial technomedia. They underscore the mediations and situatedness—which are at once technological, topographical, climatological, and political—that shape aerial production and its related epistemologies. However, they still value the aerial as an environmental optic whose aesthetic form can be made tactical. Just as the new naturalists do not shun natural history because of its positivist epistemologies but instead bend natural history toward uncertainty, feeling, and embodiment, Sheikh and Weizman retain the aerial as a form of countersurveillance whose aesthetic features bend it away from transparency and objectivity toward not-seeing, sensation, and mediation.

Kurgan's *Close Up at a Distance* ends with extreme zooms onto her artworks that get so "close up" that the features of the composition blur while the materiality of the picture comes to the fore. *Conflict Shoreline* similarly ends with an act of "whiting out." Sheikh and Weizman zoom in on a cemetery

for the al-Tūri community that was photographed by the British Royal Air Force during a 1945 aerial survey of Palestine. The cemetery is central evidence in Bedouin claims to rights to the land, claims that the Supreme Court of Jerusalem has repeatedly rejected. Weizman explains the significance of whiting out: "When colonial cartographers left white spots on their maps, they acted as means of erasure: 'whiting outs' that led to the wiping out of entire native cultures. But supposedly objective and neutral aerial photographs do not undo the potential for erasure. They could also be used . . . to remove, white out, or read people and things out of representation" (83). Enlarging the area of the cemetery twenty-six times, Weizman tries to read these people and things back in. He finds within the blur "a pattern of lighter and darker shades in higher contrast than its surroundings" (83). Like the human body whose presence perturbs the image when it is below the "threshold of detectability," the cemetery exists here as contrast and disturbance (77). When judges deny a Bedouin group's claims to the land, they give priority to the intrusive terraforming, transformation, and pollution that settlement and development produce. "Mobilized against the claimants was the fact that Bedouin life leaves only gentle marks on the territory, and the inability of the film to render these marks clearly" (77). The blur in Weizman's white-out evokes this soft imprint in contrast to the brazen fingerprint pattern of *Earthworks* that correlates to possession and intervention. The blur also evokes the two forms of not-seeing explored in SkyTruth's, Kurgan's, and Sheikh and Weizman's aerial activism: there is the not-seeing that results from erasure, obfuscation, government and corporate control of technomedia, and dominant epistemological values of universality and transparency. Then there are the forms of not-seeing associated with the epistemology of the aftermath as engendered in aerial data: latency, suspension, mediation, materiality, layering, and self-reflexivity.

THE AFTERLIVES OF INFORMATION
IN SPECULATIVE FICTION

What happens to information in environmental aftermaths? In recent spec-
ulative fiction, processing information of ruined pasts joins the repertoire
of required activities following environmental collapse. In these novels, info
processing makes the reasons for collapse accessible but also obstructs
knowledge and response. Colson Whitehead's *Zone One* (2011) demon-
strates these functions of information in the aftermath. Though climate
crisis is not this zombie narrative's central catastrophe, the novel associ-
ates the plague that has zombified humans with "that other, less flamboy-
ant, more deliberate ruination altering the planet's climate [that] had been
under way for more than a hundred years, squeezing milder winters into
the Northeast."[1] The iconography of climate disaster also comes to hand for
describing the end stage of the viral apocalypse, when waves of zombies
inundate Broadway in New York City: "The ocean had overtaken the streets,
as if the news programs' global warming simulations had finally come to
pass and the computer-generated swells mounted to drown the great
metropolis. Except it was not water that flooded the grid but the dead" (302).
In this description and the asides about climate crisis, the zombie tale
becomes allegory for Americans' inertia on climate action and our status
as the walking dead in a warming world.

In Whitehead's near-future scenario, information processing is an attri-
bute of zombification and is also crucial to understanding and stopping it.

Or so headquarters assumes. When the plague strikes someone, the victim becomes either an arrested or an overactive information processing unit. "Stragglers" fit the former category: these zombies are stuck in a moment from their past they must continually relive, haunting a party store in gorilla costume or gripping a judge's gavel in a courtroom (64, 90). Stragglers expose humans as captive to programming, that is, the routines or moments that define a life. By comparison, "skels" present the more typical features of the plague, "feeding off their own bodies. Buffalo[, New York,] will tell you that the plague converts the human body into the perfect vehicle for spreading copies of itself" (120). The plague converts skels' flesh into data to be duplicated, a biopolitical dream turned nightmare. Skels are both undead and "the undead of information";[2] human agency and futurity are eviscerated. While arrested and overactive info processing are constitutive of the plague, data gathering is an inevitable if ineffective response to it. Expert analysts housed at headquarters in Buffalo oversee a massive mission to gather information about zombie-infested New York City. "2.4 stragglers per floor in this type of structure and .05 there. Numbers permitted Buffalo to extrapolate the whole city from Zone One, speculate about how long it will take X amount of three-man sweeper units to clear the island zone by zone, north to south and river to river" (42). In the aftermath of climate and contagion, the survivors turn to epistemological tools familiar to positivist science: standardization—gridding the city into "zones"—and quantification—counting the undead and counting down to completion.

Kate Marshall places *Zone One* among those "novels of the Anthropocene" that bring readers to a geological conception of time while remaining situated in our present. In her argument, the book is an Anthropocene novel to "the degree to which it requires thinking proleptically, or registering a future point of view in which the material stratum of the human is no longer that which is the most recent. This is a future point of view that by its very constitution must be nonhuman, or at least postterrestrial."[3] A future point of view enters *Zone One* through a large-scale sculpture that Marshall describes as "postterrestrial" but that, more simply, depends on the aerial. A zombie sweeper named the Quiet Storm has been arranging cars abandoned on a highway into an invented alphabet whose "grammar lurked in the numbers and colors, the meaning encoded in the spaces between the vehicular syllables, half a mile, quarter mile" (289). The Quiet Storm "writes" her message against the highway grid "reified by urban

planners" and uses a quantitative idiom—distance between cars, number of cars—perceptible only from the air (289). The perspective of the Anthropocene is a view from above that enters Whitehead's novel as an alternative mode of information management. While quantitative, the sweeper's sculpture requires a nonpositivist—and, to take Marshall's angle, postterrestrial—epistemology based in speculation.

Zone One constellates the concerns of this chapter, which I pursue through a suite of novels that depict environmental aftermaths: Kim Stanley Robinson's *New York 2140* (2017), Claire Vaye Watkins's *Gold Fame Citrus* (2015), Jeff VanderMeer's *The Strange Bird* (2017), and Indra Sinha's *Animal's People* (2007). In these books, as in Whitehead's, information processing provides access to the conditions that have produced crisis but also becomes an epistemological hindrance. In response to infowhelm, these narratives take to the skies, offering aerial perspectives to find the meaning of the aftermaths of climate crisis and toxic emergencies. This vantage only lands back on infowhelm, however, especially as the novels recruit information management techniques familiar from parts 1 and 2 of *Infowhelm*—specifically, data visualization and naturalist classification—to wrestle with aftermath. Though the aerial exacerbates information overload rather than minimizing it, the novels offer other compensations through the multiplicity of positions and ontological indeterminacy aerial techniques produce. These techniques include alternating between the aerial as setting, as point-of-view, and as movement; and telescoping, that is, shuttling between the aerial and the subterranean or subaqueous. Within speculative climate fiction, these functions of the aerial mediate infowhelm, positional multiplicity, and ontological messiness. With the literary aerial, this suite of novels reorients the device away from its origins in a desire to see the whole story, an affordance commonly ascribed to the aerial, and toward the epistemological and ontological uncertainties of environmental crisis.

PROSPECTS ON INFOWHELM IN *NEW YORK 2140*

A past dream for the aerial future makes a cameo in the early chapters of Robinson's *New York 2140*. In Harry M. Pettit's illustration for Moses King's *Views: New York, 1908–1909*, "the future city is imagined as clusters of tall buildings, linked here and there by aerial walkways, with dirigibles

casting off from mooring masts, and planes and balloons floating low over-head. The point of view is from above and to the south of the city."[4] In King's day New York is booming thanks to Gilded Age wealth and indus-trialization. Combined with innovations in aviation, those conditions buoy an urban imaginary of the future that reaches for the clouds. Pet-tit's frontispiece depicts aerial technologies as well as the vantages they afford. In an empirical rather than speculative vein, the novel also intro-duces Hermann Bollmann's 1960s map of Manhattan, a hand-drawn oblique aerial of every building present in midtown in the 1950s, which was produced based on 17,000 aerial and 50,000 ground-level photo-graphs. What happens to aerial dreams of the city such as King's and Boll-mann's when it is under water? Robinson's aerial references introduce this question into a science fiction tale of inundation. The next two sections of this chapter demonstrate that those dreams still endure, especially given the infowhelm of climate change. Yet the aerial combines with other posi-tions and perspectives to expand the domains of a dream like King's.

Almost two hundred years after Bollmann's rendering, New York in 2140 is an "aquatropolis" (4420). After calamitous sea-level rise, the High Line is an oyster bed, lower Manhattan a "SuperVenice," midtown an "intertidal" zone, and Chelsea "drowned" (823, 861, 2451, 1711). As the everyman narra-tor dubbed "the citizen" relates, "The floods inundated New York harbor and every other coastal city around the world, mainly in two big surges that shoved the ocean up fifty feet, and in that flooding lower Manhattan went under, and upper Manhattan did not. Incredible that this could happen! So much ice off Antarctica and Greenland!" (592–94). Incredible and yet predictable. *New York 2140* plays out the results of world leaders'—and espe-cially American leaders'—folly in not addressing the climate emergencies anticipated by models in the late twentieth and early twenty-first centu-ries. The novel uses science fiction (sf) as a scrim for realities unfolding in Robinson's present. Within the sf genre, this is a tried and true device for toggling between alienation and identification, for showing our present as the past to a future whose outcomes may be dystopian, utopian, or, in this novel's case, a mélange of both.[5]

Climate catastrophe is an inevitability. *New York 2140* focuses less on mitigation—the deed is done—and more on the synergies between mas-sive sea-level rise and finance capitalism. A cast of characters Dickensian in their variety offer their perspectives on this synergy. Specifically, nine

characters take turns focalizing their exploits in the new New York while a tenth narrator, the citizen, wryly and cantankerously relays heaps of information—about geology, hydrology, economics, architecture, literature, and urban history—that situate readers in 2140. As the futures trader Franklin Garr explains in his first-person-narrated chapters, "sea level got bet on, sure. . . . It joined all the other commodities and derivatives that got indexed and bet on" (369–71). Though climate change scenarios may have failed to significantly alter business-as-usual capitalism, capitalism knows how to get rich on the crises those scenarios portend.

This is not to say that deprivation, despair, and death do not accompany inundation in the world of 2140. In two "pulses" occurring in the late twenty-first and early twenty-second centuries, economic collapse and climate disturbance intersect to calamitous effect. They extinguish species, wreck cities, erode civil rights, destroy food and energy systems, and produce a refugee crisis measuring "fifty katrinas" and "ten thousand katrinas," the new metric for community disintegration (2195, 2281). Rather than lead to the collapse of capitalism as we know it, the First and Second Pulses inspire the 1 percent to treat climate change as merely the next "act of creative destruction" (2221). They pronounce triumphantly, "On we go with the show! Humans are so tough!" (2223). In some respects, little in this science fiction is unfamiliar, perhaps aside from the hydrophilic technologies and financial instruments that emerge in post-Pulse cities and markets.

After ignoring the scientific information on climate crisis, Americans turn to manipulating data in its serial aftermaths. Data manipulation is essential not only to the suspense plot of *New York 2140* but also to how the novel entangles environmental and economic futures. Computational data enters the narrative with its first line: "Whoever writes the code creates the value" (133–34). The character who speaks these words is immediately contradicted by his companion, but the opening lines still position readers to follow the data. Mutt and Jeff, the comedic characters who exchange these words, have been kidnapped and are imprisoned in an underwater cell after hacking into financial systems so they can rewrite "the sixteen laws [of capitalism] running the whole world" (176–77). Because these laws come down to data that "exist[s] in computers and the cloud" (176), Mutt and Jeff can hack them to reverse course on the current phase of disaster capitalism.[6] Their antics not only set off the detective plot embedded in the novel; they also lay out the novel's utopian trajectory. Mutt and Jeff's hacks provide the

template for the concluding hack on the financial system that a ragtag group of neighbors—a do-gooding social worker, a greed-is-good futures trader, a pair of wayward orphans, and others—commit. *New York 2140* is, then, a narrative about wrangling and redirecting the data that drives the financial system at a moment when ignoring the data on climate change has produced watery consequences.

Where there's data, however, there's also ignorance. The reigning epistemological position in *New York 2140* is ignorance in Nancy Tuana's sense of "a particular pattern of localized and global cognitive dysfunctions (which are psychologically and socially functional)."[7] The devastations of the First and Second Pulses, in which sea levels first rose "by ten feet in ten years" and then by fifty feet a few decades later, only briefly disrupt this ignorance (2189–90). High-octane finance capitalism resumes following the Pulses, now organized around real estate futures on the flooded coasts. Enduring stratifications among the 1 percent and the 99 percent suggest that the U.S. system slips back into ignorant business-as-usual all too easily. Climate change denial may no longer be a viable option, and advances in agricultural and materials science as well as cooperative living may make resilience more feasible for some. But the pattern of "wait out the storm, wait till other people get the ball rolling, and then . . . start gambling all over again" still rules the economic sector (8475). The narrative insists these gambles are built on marshy ground. The citizen admonishes, "If you think you know how the world works, think again. You are deceived. You don't know; you can't see it, and the whole story has never been told to you. Sorry. Just the way it is. But if you then think furthermore that the bankers and financiers of this world know more than you do—wrong again. No one knows this system" (4867–70).

Franklin, as a member of the finance industry, affirms the citizen's unforgiving assessment. Infowhelm and ignorance are key pillars of his "Intertidal Property Pricing Index," in which "simple sea level itself served as the index, and you could say it got invested in or hedged against, you could say gone long or short on, but what it came down to was making a bet. Rise, hold steady, or fall. Simple stuff, but that was just the start" (374, 369–70). The market for tidal property futures yields riches, and its potential is vast, as Franklin's chapters explore. Yet the metaphorical bedrock for the index is not so solid. Earlier in this chapter, Franklin explains, "Numbers often fill my head" (319), but what those numbers add up to is elusive.

It wasn't really possible to understand at a single glance the many graphs, spread-sheets, crawl lines, video boxes, chat lines, sidebars, and marginalia displayed on the screen, much as some of my colleagues would like to pretend that it is. If they tried they would just miss things, and in fact a lot of them do miss things, think-ing they are great gestalters. Expert overconfidence, that's called. No, one can glance at the totality, sure, but then it's important to slow down and take in the data part by part. (353–56)

Franklin goes on to compare this slow, piecemeal dissection of data to a genre hopscotch. He leaps between "haiku and epics, personal essays and mathematical equations, Bildungsroman and Götterdämmerung [a story of the gods' downfall], statistics and gossip" (357–59). This scene dismantles any rigid barriers separating data and literature and concurs with Kather-ine Hayles's verdict that, "because database can construct relational juxta-positions but is helpless to interpret or explain them, it needs narrative to make its results meaningful."[8] As people generate more forms of data for "seeing the world in terms that the computer can understand,"[9] the ques-tion becomes, how can that understanding cohere into Franklin's desired "totality"?

Only this range of narratives can hope to bring meaning to the multis-calar and multidisciplinary data that streams across Franklin's screens. And yet these narratives remain in the language of data; Franklin's list is meta-phorical, and meaning is still hard to find. Ultimately, traditional data genres eclipse narrative and poetic ones: "At pride of place in the center of [Franklin's] screen was a Planet Labs map of the world with sea levels indicated to the millimeter by real-time satellite laser altimetry. . . . This perpetual rise and fall now got measured to an obsessive-compulsive degree, understandable given the traumas of the last century and the dis-tinct possibility of future traumas" (363–367). Trauma inspires this con-stant, real-time act of quantification and visualization, but the data does not produce understanding of those traumas or prevent the next ones. The temporal cues in this passage—"real-time," "last century," and "future"—indicate how data might become narrative; storytelling is required to fill in the gaps between these time positions. But data dominates despite Franklin's and the citizen's caution that ignorance lurks in the gaps of info gathering, processing, and monitoring.

The aerial enters the narrative as a counterpoint to Franklin's screen-based data analytics. Rather than just stare at the virtual map of the world, *New York 2140* tests whether a view from the skies might bring knowledge of a planet climate change has remade. Akin to *King's Dream*, the novel envisions both aerial vantages and the technologies that provide that vantage. Innovations in construction produce "three-hundred-story super-scrapers, needling far up into the clouds, such that when you are in their uppermost floors, on one of the nosebleed terraces trying to conquer your altitude sickness and looking south, downtown looks like a kid's train set left behind in a flooded basement" (611–13). This description underscores the distinctions elites draw between Upper and Lower Manhattan: Upper is higher in income and in topography and includes "nosebleed" technologies, while Lower is lower in altitude and is home to the socioeconomically lowly whom this passage infantilizes. In a climate-ravaged world, people populate the air in skyscrapers as well as skyvillages. "After the coastlines had drowned, people had taken to the skies like dandelion seeds and recongregated in the clouds" (1566–67). Of course, by 2140 the air had been a human space for centuries, but now it has become a space for long-term inhabitation and even for agricultural production.

Amelia Black, an aviator and sexy social media celebrity, is the narrative's primary air-dweller though she eschews skyvillages for a personal dirigible named *Assisted Migration*. The vessel's name reflects her mission of moving imperiled animals to new homes when their habitats and migratory corridors are either lost entirely or severely fragmented owing to climate change and overdevelopment. Her missions, streamed from the clouds to the digital cloud, produce images one would expect in a *Planet Earth* documentary—megafauna cavorting, terrain seamed only by herds of animals—as well as video of Amelia's aerial, often nude, acrobatics. Crisscrossing the North American continent, she "flew over wildlife habitat and sky ag[riculture] corridors, and if she kept to a low enough altitude, which she did, there were hardly any signs of people. . . . That wasn't even remotely true, and when she reached her destination she would be reminded of the real state of affairs in a big way, but for the four days of her voyage, the continent looked like wilderness" (646–49, 652–53). This aerial perspective offers Amelia and her online followers a sense that land is abundant even as her assisted migration mission dashes that dream. As we saw in

chapter 5, the aerial here makes visible but also occludes realities on the ground. Amelia's missions earn her critics among traditional conservationists, those for whom assisted migration is as much of an ecological disruption as other human activities.[10] Though she defends her actions against her detractors, her thought that the aerial provides a false sense of wilderness concedes some of the point. Just as Franklin admits "it wasn't really possible to understand [the data] at a single glance" (353), Amelia's aerial views admit to their own limitations. They seem to promise a perspective that is more totalizing than Franklin's data hopscotch, yet her missions also produce a messy information situation. Her environmentalist critics "never tired of pointing out that she was just one more charismatic megafauna, . . . flying over the essential groundwork of lichen and fungi and bacteria and the BLM, all the complicated work of photosynthesis and eminent domain, where things were ever so much more complicated than she ever deigned to notice" (697–99). The acrobatic aviator objects to this evaluation, but it accords with Franklin's predicament of infowhelm. Containing the micro (bacteria), the meso (lichen and megafauna), and the macro (BLM), ecosystems on the ground cannot be compassed even from the air. Amelia mutes environmentalists' concerns about assisted migration because, well, what are the alternatives given the statistics on species threat and extinction? *New York 2140* uses the aerial to play out tensions within environmentalism I explored in chapters 4 and 5—between traditional and radical conservation and between sky-truth and ground-truth—and adds the tensions between the tactics of social media celebrity and of ecological science.

Through Amelia and technologies from skyvillages to superscrapers, Robinson's novel shows the aerial to be a tempting device for responding to climate calamities and getting purchase on them. Yet it recodes the device in terms familiar from chapter 5: as offering incomplete knowledge and perspectives that serve capitalist structures—in this case, literal structures— of power. With its depictions of data wrangling and aerial innovation, *New York 2140* joins *Zone One* in depicting information management as a way to access the underpinnings of calamity but also as an epistemological hindrance. But Robinson's novel does not merely dwell in quantitative and aerial domains. Amelia's adventures, along with air-aspiring inventions like superscrapers, do not only point up; they also bring the narrative down. They introduce a subterranean and subaqueous perspective that brings

the action of telescoping into the story. To the aerial's functions as perspective (the view from above) and as technology (dirigibles, superscrapers, skyvillages, and skyag), this adds another function to the literary aerial: as a form of motion. While neither constant real-time data nor the aerial might satisfy the desire to see the whole story, Robinson's, VanderMeer's, and Watkins's speculative stories of eco-collapse incorporate the aerial device of telescoping to explore a multiplicity of positions that expand the epistemological repertoire for aftermath.

TELESCOPING THROUGH SKY, SEA, AND SAND

New York in 2140 has seen advances in the sub- as well as the super-. While in Upper Manhattan composite building materials make superscrapers viable, in Midtown and Lower Manhattan the latest subaqueous technologies make buildings resilient to rising seas. Post-Pulse NYC still has millions of residents, and architecture and infrastructure are still in high demand. Engineers and designers therefore must drill down as they go high, reminding us that verticality travels in both directions and that, as Roland Barthes observed, "New York is in fact a deep city, not a high one."[11]

Vlade Marovich is the reader's guide to the subterranean and subaqueous strata that complement the aerial in *New York 2140*. A former diver whose skills will come in handy late in the novel, he is the superintendent for the Met Life Tower cooperative that all the main characters inhabit.[12] Vlade's responsibilities have expanded along with the building's functions: the tower is now submerged in water and contains a basement fishery along with a rooftop farm for food security, and the farm hosts the less fortunate in "hotellos," or portable abodes. In Vlade's chapters, Robinson geeks out on the rapidly improving infrastructure for a submerged future. The Met Life is composed of basements and subbasements that are built into the bedrock of the island below the waterline. In addition to maintaining the latest "graphenated composites" on the interior of the subbasement to prevent seepage, the super approaches building maintenance from the watery exterior: "Vlade was currently working with the team from the local waterproofing association that had caissoned the Madison Square side of the building to reseal the building's wall and the old sidewalk. The aquaculture cages covering the floor of the bacino had to be avoided, making for a tight squeeze, but the latest Dutch equipment could be angled and

accordioned in a way that gave them room to work" (500–503).[13] The latest construction equipment and materials are not the only innovations focused downward. Franklin's "intertidal raft housing" venture, which rounds out his speculative financial portfolio, would infill Manhattan with city-block-sized rafts anchored to bedrock on which low-profile buildings would rest. A real estate experiment in adaptation, "all the blocks would ... float up and down on the tides and currents together. Underwater framing to keep the canals between them open and navigable" (6343–44).

Through its world building, *New York 2140* carries readers from airy heights to submarine depths and, in some cases, makes the former dependent on the latter. Where questions of scale have consistently preoccupied environmental humanists studying climate representation, Robinson's novel and the other novels I turn to shortly expand our epistemological repertoires to include the traversal of depths.[14] Rather than only traversing time or zooming from macro to meso to micro, readers occupy multiple positions through the texts' settings and technologies, through their shifts in narrative point of view, and through the actions characters perform. These novels propose the aerial as one technique for getting a handle on infowhelm and combatting ignorance. As that technique cannot fully deliver, however, they multiply positions and ontologies not as a solution to ignorance but as a pathway to art and invention.

Jeff VanderMeer's *The Strange Bird* (2017) employs the telescoping device in a narrative entwining the emotional life of biological engineering with the futures of information. The titular creature has been spliced from electronic technologies such as GPS and from the DNA of cephalopods, birds, and humans. The novella stands alone but is a companion to VanderMeer's *Borne* (2017). For those unfamiliar with *Borne*, the ravaged environment and society of *The Strange Bird* take some time to resolve. Through descriptions of "fire-washed laborator[ies]" and "swollen, polluted river[s]," the setting emerges as a patchwork of aftermaths.[15] Climate change has combined with wars spawned by the biotechnology "Company" to ravage the planet. New synthetic organisms such as the Strange Bird and Mord, a flying bear that terrorizes the survivors in this dystopia, populate VanderMeer's world. The Strange Bird comes to consciousness in an underground laboratory. Memories of her compassionate keeper, Sanji, appear in dreams, but their meaning and the bird's purpose are unclear to her. She

remembers the contrition of the bioengineers as they whispered "'forgive me' or 'I am sorry' before doing something irrevocable to the animals in their cages. Because they felt they had the right. Because the situation was extreme and the world was dying" (58). This memory confirms that, while compassion still glimmers in humans even as civilization comes to an end, they cannot halt the destruction they wreak and continue to heed an insane logic of "doing the same things that had destroyed the world, to save it" (58).

The Strange Bird's fellow survivors in this ruined world either wield bio-tech or are products of it. Over the course of the novella, she is first cap-tured by an Old Man who has suffered his own traumas and who holds her in a cell in a building under sand. Eventually she falls into the hands of the Magician who creates ferocious synthetic beings as weapons in an ongoing war for dominance against Mord. The Magician doles out elaborate tor-tures to reengineer the Strange Bird into a kind of invisibility cloak that takes advantage of the creature's powers of camouflage. She remains sen-tient while "the Magician took her wings from her, broke her spine, removed her bones one by one" (63). "In the aftermath of atrocity," the reconfigured Strange Bird continues to suffer until the Magician is set upon by Mord's proxy army and is either "cast out or dead" (92). Rachel and Wick, protag-onists of *Borne*, find the bird in a slashed and barely surviving condition and attempt to understand the creature and then to reverse-engineer her back into her original form. Wick's efforts to rebird her reveal one of the Strange Bird's purposes: she is a life dissemination system. "It would have been reseeding the world as it flew. Microscopic organisms," Wick discov-ers (95); this explains her avian and geolocation components. She holds another purpose as well: to follow a "genetic imperative, buried deep" in her by Sanji to rejoin a companion, a mirror image who is also a surrogate for Sanji's lover. The bird is, then, a love letter from the aftermath. Through this reunion, the Strange Bird's wishes that she expresses in the novella's first pages—for "purpose," "kindness," "home," and "love for every animal" (6–7)—find fulfillment despite suffering and devastation.

Along the way, however, the bird has encounters that underscore both her purposes as a bio- and data technology and her difference from similar inventions. These encounters also investigate the question with which we began this chapter: What are the afterlives of information in the aftermath? When she first escapes from the Company building, she meets threatening

objects she calls "the dark wings." Even more than the Strange Bird whose propulsive signal guides her in a direction and with a purpose that is opaque to her, these surveillance devices are like Wendy Hui Kyong Chun's "undead of information," performing "the banal running of something 'in memory.'"[16] Their data processing has entered a state not so different from both the zombie stragglers and the living sweepers of Whitehead's *Zone One*. "Like living satellites, [the dark wings] had been circling the world for a vast amount of time, so many years she could barely hold them in her head. She saw that they were tasked with watching from above and transmitting information to a country that no longer existed, the receiving station destroyed long ago, for a war that had been over for even longer" (9). They collect, process, transmit, repeat; all with no real destination or purpose. That is, until the Strange Bird flies along and becomes the first being in years to "interpret" their data. In *The Strange Bird* as in *Zone One* and *New York 2140*, information gathering is a technique for producing knowledge about a calamitous world, but dark wings, sweepers, and futures traders find knowledge elusive no matter how much data they accumulate.

The Strange Bird analogizes the aftermath of information to socioenvironmental aftermaths when the bird encounters these drones.

In their defenselessness, performing their old tasks, keeping data until full to bursting, erasing some of it, to begin again, the Strange Bird gleaned a view of the world that had been, saw cities cave in on themselves or explode outward like passionflower blooms opening, a tumbling and an expansion that was, at its heart, the same thing. Until there was just what observed from above, in the light and the dark, sentinel-silent and impartial, not inclined to judgment . . . for what would the judgment be? (10, ellipsis in original)

The surveillance technologies have a built-in response to infowhelm: just erase the data and begin again. Yet residues remain, and the Strange Bird is their receiver. The surviving surveillance devices are data archives through which she can glimpse the past of the ruins she is navigating: cities caving in and exploding. This information situation accords with the postapocalyptic conditions on the ground. Most aspects of human existence have been erased, but the new world still bears remainders: the Strange Bird, Mord, and other synthetic creatures as well as a few bioengineer creators populate the land. The dark wings take on aspects of those bioengineers

when they perpetrate the first of the many violations the Strange Bird suf-
fers: electronically probing her to suss out her origins, code, and intent. She
baffles them, however. Communicating through signals she intercepts, the
dark wings can understand her only in negative terms: "*Un*stable mélange.
>>Mission critical *un*certain; synapse control override *in*consistent with
blueprint of original design. . . . *Un*known origin and intent. >>Action:
Avoid a *void* a *void* a *void!*" (11, my italics).

Though the Strange Bird wrestles with the unknowns and voids in her
memory, her experiences of flight are ebullient and differentiate her from
the dark wings' zombie aerial surveillance and unrelenting programming.
Flying brings her immense joy, even when it comes to her only in synthetic
memories, as when she first comes online (3), or in actual memories, as
when she is enslaved as the Magician's cloak (89). For how skybound *The
Strange Bird* is, however, it also tunnels underground through the telescop-
ing technique. The creature soars even when her mobility is curtailed by
imprisonment or reengineering. Her first flights are subterranean—"For a
long time the Strange Bird did not know what sky really was as she flew
down underground corridors" (3)—and her imprisonments and tortures
typically take place underground: from the subterranean lab of her manu-
facture to the Old Man's cell and finally to "the depths of the Company
building. Down, down, down" during the Magician's last stand (88). Like
Robinson, VanderMeer complements aerial vantages and spaces with sub-
terranean ones; the novella even nests the former within the latter when
flight occurs underground.

In a scene that pivots from the Strange Bird's imprisonment in the Old
Man's den to the Magician's lair, the aerial device of telescoping becomes
even more pronounced. The Old Man falls into a trapdoor that contains the
Magician's bat-faced minion. This is the bird's opportunity to break out of
his clutches and take to the air. Finally, if temporarily, free, she views the
scene from above: "There came a great tug from beneath the earth, and the
Old Man vanished into the trapdoor maw up to his chest. . . . From the air,
the Old Man looked as if he had never been anything but a head, a neck,
and a chest jutting out of the ground. Waving one hand, staring up at her
as she climbed, shouting the name that was not her name [i.e., Isadora].
While the bat-faced man worked on him from below. . . . As she rose she
could feel the name *Isadora* falling away from her" (47–48). Aerial and sub-
terranean settings share the scene. The narrator emphasizes both their

contrast and their interdependency when the bird and Old Man swap conditions of free and captive while simultaneously moving, respectively, higher and lower. As bird and man keep their gazes fixed on each other, the telescoping device acquires a kind of accordion or Slinky effect: the characters are still connected by sight and sound, but they are pulling in opposite directions. The sound of "*Isadora*" falling away while the Strange Bird lifts off complements the opposed physical movements the man and bird perform and the opposed spaces they occupy. Through this scene's telescoping device, the aerial's functions as setting, point of view, and medium for movement (as well as sound) coincide.

The Strange Bird, like *New York 2140*, expresses the epistemological challenges of aftermath not only in terms of scale (vast, minute) but also in terms of positional multiplicity. The novella's shuttling between aerial and subterranean spaces is a formal and topographical device that complements another key condition of the aftermath: shuttling between destruction and hope for renewal. Allison Carruth argues that *The Strange Bird* proposes biotech as "a basis for not only repairing ecosystems but also rebuilding social collectivity."[17] Carruth attends to the life dissemination program that is the Strange Bird's primary directive, but we also see the flipside of the biotech coin in the bird's ruminations. In her encounter with the dark wings, she thinks, "perversely, the laboratory had functioned as sanctuary . . . just not for the animals kept there" (10). The lab is at once torture chamber and refuge just as the Strange Bird at once embodies violent manipulations of life and regenerates life by "reseeding the world" (95). The suspended effects of devastation and survival recur in the novella's final lines when she has joined the companion to which her beacon has long directed her. The narrator reflects, "So much was leaving her, but of the winnowing, the Strange Bird sang for joy. . . . Not because she had not suffered or been reduced. But because she was finally free and the world could not be saved, but nor would it be destroyed. . . . And the two birds sang one to the other, the dead communicating to the dead in that intimate language" (108–9). A song of loss and endurance in an unfolding crisis, the creatures' calls announce that we—human, more-than-human, organic, synthetic—may be the living dead but can experience intimacy through art nonetheless.

To return briefly to *New York 2140*, the ambivalence of VanderMeer's ending accords with that novel's conclusion suspended between "classless

235

THE AFTERLIVES OF INFORMATION IN SPECULATIVE FICTION

anticapitalist utopia," as Gerry Canavan puts it, and business-as-usual capitalism.[18] Just as biotech is instrument of both devastation and renewal, digital financial trading is instrument of equalization and stratification in Robinson's sf. *New York 2140* ends with an unexpected alliance between the piebald cast of characters—rich and poor, young and old, trader and social worker, criminal and police inspector—who use the tools of finance to hack capitalism and "nationalize finance" to the benefit of all (9116). The citizen tempers the utopian account of the hack's results with this caution: "there was no guarantee of permanence to anything they did, and the pushback was ferocious as always, because people are crazy and history never ends" (9137). Speculative fictions of aftermath, therefore, do not only shuttle between multiple physical positions (aerial and subterranean/-aqueous) and multiple epistemological conditions (infowhelm and ignorance); they also shuttle between multiple affective positions: ruin and renewal.

To conclude this section and expand on this series of multiplicities, I look to Claire Vaye Watkins's *Gold Fame Citrus* (2015), which incorporates techniques of classification we studied in part 2 as well as the satellite aerial viewpoints of chapter 5. Watkins's novel depicts a desiccated and desertified California that is being consumed by a sand landform that earns a new toponym: "dune sea. The Amargosa."[19] This spectacular force merits this name because the first terrain it consumes is in the Amargosa Valley straddling the California-Nevada border. As the dune sea cleaves its way eastward into Nevada, the narrator chronicles the defeated efforts of communities to "deter the steady intrusion of sand" (116). "Steady" is an understatement; it moves so rapidly it defies all precedent. A process of geological transformation that "ought to have taken five hundred thousand years had happened in fifty" (117). *Gold Fame Citrus* places blame for worldrending drought and desertification not on God but on government bureaucracies from the municipal to the federal: "If this was God he went by new names: Los Angeles City Council, Los Angeles Department of Water and Power, City of San Diego, City of Phoenix, Arizona Water and Power, New Mexico Water Commission, Las Vegas Housing and Water Authority, Bureau of Land Management, United States Department of Interior" (120). Against the forces of the unrelenting dune sea and of bureaucracies kowtowing to the needs of developers, agribusiness, and corporations, the efforts of stalwart communities stand no chance.

Into this landscape enters Luz Cortez Dunn, a hapless ex-model who, after thinking she has lost her lover in the sand ruin, stumbles on one of these communities: a colony-cult that follows leader Levi Zabriskie and his theories about the Amargosa's mystical properties. As in the other sf we have studied, Watkins's book presents environmental crisis as an occasion for information gathering, processing, and overwhelm. On the one hand, archeologists and geologists follow in the Amargosa's wake as it carves the land and exposes evidence of the recent and deep past. On the other hand, the dune sea spurs the growth of false information. One reason for this misinformation is the Amargosa's unprecedented form. The narrator experiments with various metaphors to capture this uniqueness and attempts to medicalize it. The Amargosa is composed of "the sloughed off skin of the Sierra, the Rockies, so on. . . . A vast tooth-colored superdune" (114). Its vastness "expresses itself mostly in the bowels" (114); it is "a disease: a cancer, a malignancy, a tumor" (120). The Amargosa is "unhealed yet scar-tissue white, a wound yawning latitudinal . . . a sutureless gash" (113). These medicalizing images suggest the entanglement of body and earth and the somatic impacts of geophysical mutation.[20] The narrative tries out additional registers for depicting its elusiveness; *Gold Fame Citrus* incorporates a satellite perspective and layered forms of mediation to coordinate the scope of the dune sea: "From space it seems a canyon. . . . In the pixel promises of satellites it could be the Grand Canyon, its awesome chasms and spires, its photogenic strata, our great empty, where so many of us once stood feeling so compressed against all that vastness, so dense, wondering if there wasn't a way to breathe some room between the bits of us" (113). The narrator assumes an alien aspect Kate Marshall describes as "a nonhuman narrative sentience" that participates in a "decentering [of the human that] has as its goal the broader repositioning of the human within systems that are environmental, social, or material."[21] Not quite of the Earth but positioning itself as part of the human collective, the narrator evokes a historical moment when satellite technomedia carried optimism for the future. Thinking back to our study of aerial discourse in chapter 5, "pixel promises" announces both the techno-optimism of the Space Age and the tense of latency that satellite data occupies.[22] In all events, the dune sea is an utterly mediated phenomenon as "pixels," "photogenic," "compression," and, later in the passage, "silver chloride" and "promiscuous postcards" make clear (114).

Mediation intensifies when the narrator muses that, even when standing at "the sanctioned rim of the real deal," viewers cannot but see a painting before them. This topography is so overrepresented it can appear only as its reproductions in "motel art" (113). Even the people standing before this imagined canyon are like digital image files; they seek space "between the bits of us" in response to "feeling so compressed" (113). Bodies and data fuse through this satellite vantage. The emphasis on mediation and simulation reminds readers of the hypothetical mood of the passage: this is a *possible* view of a *not*-Grand Canyon that evokes feelings one *might* have while at the canyon's rim. To conclude this description, the narrator assumes a bardic voice and reasserts the aerial perspective: "See now from our imagined sky-perch. See through blurs of sand and waterless cloud and obfuscating energy" (125).

In addition to fusing reality and representation and body and data, this satellite view also shows how the landform produces positional multiplicity. The "mind lurches vertiginous" as the dune sea alternates between vertical depths and vertical heights through the literary device of telescoping: "The vast bleached gash we once took for chasm protrudes; the formation pops from canyon to mountain" (114). The landscape is a kind of duck-rabbit, shifting between concavity and convexity. This multiplicity does have a material explanation in the case of the Amargosa: sand. Sand is a solid substance, each grain of which has a shape, but in the aggregate those grains produce new forms that can then morph and even disperse. With these attributes, sand is a commonplace for impermanence and transformation. At the end of the satellite view of the Amargosa, the narrator traffics in these meanings: "Closer and the eyebrain swoons again: these mountains move as if alive, pulsing, ebbing, throbbing, their summits squirming, their valleys filling and emptying of themselves. Mountains not mountains. Not rock, or no longer" (114). This statement puts a fine point on how climate crisis strains epistemological and ontological faculties. *Gold Fame Citrus* increases this strain by using watery metaphors to characterize the sands. A newspaper headline compares the Amargosa to "INTERNATIONAL WATERS" (121), and a description refers to "the stoss-side base of the dune sea, glittering" (125), with "stoss" a geological term for "the side of any object that faces a flow of ice or water."[23] Ontological confusion meets irony in Watkins's metaphors for the climate-ravaged West: water, water (metaphorically) everywhere; nor any drop to drink.

The "eyebrain," an organ fusing perception and cognition, doesn't know what to do with this thing that both is and is not itself, just as Franklin cannot see the totality of the data in *New York 2140* and the dark wings are stumped by the Strange Bird's composition and programming. These climate fictions propose telescoping as a compelling aerial narrative device for apprehending these epistemological (how can I understand what I'm seeing?) and ontological (what is it and what am I?) puzzles that emerge in the aftermath and in the infowhelm.

INDETERMINATE BEING IN THE AFTERMATH

A prime example of misinformation in *Gold Fame Citrus* is Levi's catalog of neo-biodiversity that Luz cherishes until she learns of its falsity. This catalog leads us into the ontological puzzles of the aftermath that concern this section. Set off by grid-lined and grayed pages, "Neo-Fauna of the Amargosa Dune Sea: A Primer by Levi Zabriskie" appears about midway through the novel and is meant to correct scientific researchers' accounts of the megadesert as "a wasteland. Inhospitable" (192). Levi rebuts this assessment with a bestiary of novel species using systems of classification and display common to the new natural history I examined in part 2. Levi's illustrated primer presents information on the "Lilliputian Rattler," "Mojave Ghost Crab," and "Ouroboros Rattler," among other creatures ([197]). Until the hoax is revealed, the catalog appears to provide animal evidence corroborating the Amargosa's ontological strangeness. When Levi's bestiary emerges as a fiction, it instead resembles those "figments of the classifying imagination" that historian Harriet Ritvo examines. Such "unusual animals called into question systematic flexibility . . . , undermining the very categories that could not be stretched to accommodate them, as well as the principles on which those categories were based."[24] If so-called experts denigrate the Amargosa's vitality based on traditional epistemological categories, Levi will defy both them and their methods by repurposing classificatory systems for his own ends. The bestiary adopts positivist tropes one expects from a naturalist tome: scientific names; statistics about size and speed; descriptive phrases such as "is characterized by," "classified as," and "easily identifiable by"; and assertions that the naturalist was present as witness ([194–95]). Despite these markers of certainty, the creatures are ontological oddities similar to mermaids and unicorns. Previously noncarnivorous

plants start eating gnats, moths, and even "micro-owls" ([194]); other imagined creatures include a bioluminescent bat, a kangaroo rat that can jump up to fifty feet, and a tortoise with legs like stilts and a neck like a giraffe ([196–97, 199]).

The neo-fauna, while as imaginary as the mermaids of sailors' visions, demonstrates that inventing creatures that violate ontological categories is an epistemological resource when *terra* becomes *incognita*. Undoubtedly a sign of Levi's deceptions as a cult leader, the bestiary complements the satellite narrator's description of the Amargosa Dune Sea as "mountains and not mountains. Not rock, or no longer" (114). If the so-solid rock can become "no longer," why can't a grackle, needing to hydrate itself, grow a "sharp, proboscis-like beak . . . to extract the blood" of other neo-fauna ([200])? Until proven otherwise—and who will do the proving when the Amargosa is either consuming communities entire or rendering experts who visit it "nearly insane" (121)?—the bestiary offers a way to contemplate the aftermath of desertification when infowhelm and ignorance are rampant. At the same time, "Neo-Fauna" indexes hope that the dominant narrative of the Amargosa as "wasteland. Inhospitable . . . Barren. Bleak. Empty" is incorrect (192), and that there are more things in heaven and earth than are dreamt of in ecologists' inventories. In this respect, the bestiary chimes with *New York 2140*'s and *The Strange Bird*'s endings that suspend environmental ruin and renewal through acts of hacking, love, and song.

The multiple affective trajectories of these novels correspond to the positional multiplicity and ontological indeterminacy their aerial devices produce. Indra Sinha's *Animal's People* (2007) deepens understanding of this confluence of multiplicity and indeterminacy through speculations about environmental aftermaths. While the bestiary is only a short detour in Watkins's novel, strange species being is at the heart of Sinha's narrative. *Animal's People* may not wear the mantle of speculative fiction as comfortably as *New York 2140*, *The Strange Bird*, or *Gold Fame Citrus*, but it rounds out this cluster of novels because, in depicting one of the twentieth century's enduring environmental aftermaths, it marshals positional and ontological multiplicity as instruments in the battle over knowledge.

Animal's People fictionalizes the aftermath of the 1984 chemical explosion and toxic leak at a Union Carbide pesticide ingredients factory in Bhopal, India. Sinha renames the city "Khaufpur"—meaning "terror city" in Urdu[25]—and Union Carbide the "Kampani" (3), but the narrative refers to

historical events throughout. Hundreds of thousands of people in the chemical cloud were affected by the leak, with between 3,000 and 10,000 people dying in the immediate aftermath. The wide range of that tally indicates the contested information situation of Bhopal. Accurate data on death and injury is elusive not only because of the chaos the event unleashed but also because government and corporate estimates conflict with others' accounts. The long-term contamination of water and the injuries that appear in generations born subsequently—not to mention the untallied damage to plants and more-than-human animals—make Bhopal a paradigmatic case for Rob Nixon's study of slow violence.[26] Animal, the novel's protagonist and first-person narrator, was a newborn on "that night" when disaster strikes (5). Now nineteen years old, he roams Bhopal's slums with his canine companion, Jara, getting into scrapes, falling into reveries, and participating in politics, music, religious rituals, and medical studies, despite his skepticism toward them all.[27] Animal flouts all norms, from common strictures on vulgarity to unspoken rules about not eating skin torn from your calloused foot (13). Most important, because irremediable damage to his spine forces him to walk on hands and feet, Animal defies the norm that he act like and treat himself as a human person. Ontology follows morphology and physiology according to this logic. If he is shaped like his chum Jara, shares Jara's quadrupedal mode of movement, and is treated as less-than-human by Khaufpuris and the Kampani that caused his injuries, why not embrace his animality?

Ontologically unstable—and proudly so—Animal frequently enters into conflict with those who want to pin humanity on him. For the young man, this instability brings him pleasure and freedom at the same time as it displays the debilitating and dehumanizing effects of cruel multinational corporations and those who kowtow to them. Because of his refusal of humanity, the boy presents, in Nixon's analysis, a "disturbing, porous ambiguity, a figure whose leakiness confounds the borders between the human and the nonhuman as well as the borders between the national and the foreign."[28] The boy's ambiguity comes from the forms of multiplicity he exhibits. Animal does not only inhabit the conditions of human and more-than-human animal; he also traverses the borders, especially strict in Indian society, between the impoverished and the professional classes of doctors, teachers, and political organizers. Moreover, his narrative voice

is multiple: polyglot, musical, oral, bawdy, poetic, streetwise, and halluci-
natory by turns. Pablo Mukherjee defines Animal's ambiguity and multi-
plicity as "transpersonality." The transpersonal figure "can experience
the objective existence of his entire environment of Khaufpur as a net-
work composed of related subjects, including himself."[29] In Mukherjee's
reading, a collectivity forms around Animal despite his ambivalence
toward the human species; "a politics of belonging" coheres around "a
network composed of agents who must share labor and information in
order to survive" the morbid effects of multinational capitalism.[30]

Nixon and Mukherjee lay the groundwork for understanding how *Ani-
mal's People* generates ontological indeterminacy through a fiction of eco-
aftermath. For scholars of Sinha's novel, indeterminacy results from the
slow time of toxification, from Animal's hybrid narrative voice, from his
shuttling between high and low, and from his unique embodiment. Endors-
ing these readings, I add the aerial as another device that generates onto-
logical indeterminacy. Rather than shutting down indeterminacy under
conditions where information about the aftermath is abundant yet con-
tested, the aerial promotes indeterminacy and its aesthetic and philosoph-
ical potential.

Though *Animal's People* is replete with scenes of drug-induced halluci-
nation and ecstasies of the body in pain, one of the most disorienting scenes
has none of these causes. The strangeness begins with the start of a new tape
(the book is organized into oral stories Animal speaks into a tape recorder):
"I wake with head's singing. Still dark it's but can't sleep. I get up, step out-
side. Outrageous things are going on in my skull" (133). Animal climbs to
the top of the tower on the shuttered but still toxic chemical factory in which
he makes his "lair" (29). He has earlier explained that one gets the best view
of Khaufpur and its snarled streets from this height. In this scene, those
heights increase when Animal spies a bird and then becomes absorbed into
its body and consciousness. "I see a bird circling above, wonder what it's
seeing below. Up high and early, my eye dreams the start of this Khaufpuri
day. . . . So high I'm, the earth curves away from me, the upper air's full of
brilliance. I see the world spread like a map. . . . Bird that I am sees all" (133).
The narrative associates the aerial with a totalizing prospect even as it
describes the setting as "still dark" and therefore partially obscured. First
seeing a bird and then becoming bird, Animal's essence is as airy as the

medium he imagines flying through. Darkness soon "resolves to the innu-merable roofs of the very poor" in the "Nutcracker" area of the city where the factory and Animal reside (133).

This view from above is so totalizing that it even encompasses the seer. "Far below," the narrator continues, "an animal is moving slowly along a lane. What kind of creature is this, arse canted steeply into the air? drom-edary? centaur? Short way behind a smaller, also non-human being strolls" (133). Animal's identification as bird dissociates and distances him from his own body and perspective. He sees himself as a camel or even centaur, one of those real or fictive creatures that so captivated naturalist's imaginations in the eighteenth and nineteenth centuries. He has become alien to him-self and has assumed another species identity—bird—to go with those he already occupies—human and dog. Thinking back to my reading of *Gold Fame Citrus*, we could also say he has morphed into one of Marshall's alien narrators. For Mukherjee, Animal's liftoff expresses the boy's transpersonal capacities. The critic argues "that he is the location where [human and non-human personhood] meet, and as such, his very existence is an argument for their continuity and their ontological equality. Animal is able to medi-ate not merely between humans of various kinds, but also between non-humans and humans."[31] But it's important to note that continuity and equality do not amount to knowledge. Animal-as-bird observes himself walking with Jara through the Nutcracker, but he has ontological questions about this other version of himself: "What kind of creature is this, arse canted steeply into the air?" (133).

The verb tenses throughout this passage contribute to the multiplicity and ambiguity of Animal's position. The boy is first firmly planted in the present—"I wake"—but he soon enters the present progressive tense—"with head's singing." This tense of ongoingness appears throughout the novel as one of Animal's linguistic tics that indicates he speaks English inflected by the other languages in his repertoire: Urdu, Hindi, Farsi, and even French. However, when "an animal is moving slowly" appears later in the passage, the present progressive becomes more deliberate and contrasts Animal-bird's observation of Elli, a doctor and central character in the novel, going about her day: "Ellie, dressed in shalwar kameez, *will be giving* her last-minute instructions. . . . *will be going* to the doors. Light *will come gleam-ing* through cracks in the wood. . . . She*'ll take* a deep breath, *throw* open her doors" (134, my italics). Immediately following these words, a section

break terminates Animal's reverie, and we reenter the regular flow of Elli's plot about opening a free clinic serving the poor of Khaufpur: "Elli steps out smiling" (134). Future progressive, simple future, present: all these temporal positions coexist as Animal adopts another species form and perspective and steps outside a body that is already ontologically unstable.

This multiplicity and indeterminacy also surface in Animal's epistemological situation. The aerial reverie dissociates Animal from his knowledge. The first paragraph of the tape ends, "I'm curious," but goes on to relate what Animal knows better than anyone else: the quotidian happenings of the Nutcracker dwellers. He is likely not curious about what is occurring below since he knows it so intimately but is instead curious about this other species perspective. A change in ontology has offered a new epistemological position rather than new information. I agree with Mukherjee's interpretation that Animal's imagined lift-off networks him with the other beings that populate Khaufpur. Harder to support, however, is his claim that Animal "experience[s] the objective existence of his entire environment."[32] Mukherjee might only be using "objective" as an amplifier here, but, unfortunately, it calls up the long history of associating the aerial with objectivity and an imperial gaze that we studied in chapter 5. Rather than displaying the epistemological value of objectivity, Sinha's aerial comes couched in Animal's inimitable subjectivity. This subjectivity shines through in his "eye dreams," in explanations like "outrageous things are going on in my skull," and through ribald similes such as "like a bee's banana" or "like stale breath round the mouth of a drunk" (133). Sinha scrambles the legacy of objectivity associated with the aerial through the picaro's radical and multiple ontology.

What's more, Sinha's use of the aerial as a literary device alters the meaning of detachment, another keyword in the history of aerial technomedia. Animal detaches as much from his own self as he does from the surface of the Earth he observes in his assumed avian form. While the aerial has conventionally been used in the Eurowest "to distance the know-ing subject from everybody and everything in the interests of unfettered power" and has solidified the subject position of the seer,[33] the aerial in *Animal's People* erodes that subject position. Employed here, the literary device offers an epistemological vantage that is at once embodied and dissociated, and this vantage affirms ontological multiplicity. The city's status as environmental aftermath, also embodied by Animal, inspires these instabilities.

Khaufpur/Bhopal, like Animal himself, is unsettled, uncertain, and ongoing because full of "invisible poisons [that] remain dynamic, industrious, and alive."[34]

Animal's People renames the source of the living poisons with an allegorical moniker—"the Kampani"—while the true criminal—Union Carbide—remains as invisible as the poisons. The absenteeism of the U.S. corporation abets its risky operations and negligence when risk becomes reality. Zafar, a local activist, seeks redress for his fellow Khaufpuris and fights against this invisibility. Animal both admires and mocks him for this. But preeminent in the teenager's mind—and groin—is his sexual jealousy as he lusts after Zafar's comrade and love interest, Nisha. In one of the novel's picaresque scenarios, Animal poisons Zafar with Datura, a venomous plant Animal hopes will destroy his frenemy's libido. It instead destroys his intestines and produces hallucinatory visions. Just as Animal's "singing" head sends him up into the air (133), Zafar's delirium prompts the aerial. And, again, birds follow. In Zafar's dream, "he's flying above Khaufpur sitting on a plant stalk, and while he is high over the clouds a crow comes along" (227). Though never becoming bird, Zafar undergoes a process of dissociation similar to Animal's when he "looks down and sees himself, a small figure standing alone on the shores of a sea" that alludes to the daunting fight for environmental justice (228). Zafar asks the crow to grant a wish, "that simple natural justice should prevail" (227–28). The crow scoffs and dismisses the wish as foolish.

If the aerial journey cannot satisfy Zafar's desire for justice, what does it offer? From Zafar's ecstatic viewpoint, he sees the innards of Kampani headquarters as well as the tentacular reach of its toxic industry. Poisons and "bunkers full of atomic bombs," medical research, engineering ventures, public relations ploys, and accounting and legal schemes, the Kampani has a hand in it all (229). However, what appears to be a totalizing vision available only from above dissolves into incompleteness: "Says he, 'This is not my wish. I wish to see my enemy's face.' 'Third time impossible,' says the crow. 'The Kampani has no face'" (229). Zafar has experienced a version of Bruce Robbins's "sweatshop sublime," in which "there is a moment of insight accompanied by a surge of power. In thought, at least, you are launched . . . to the outer reaches of a world economic system of notoriously inconceivable magnitude and interdependence . . . Yet at the same time this insight is also strangely powerless. Your sudden, heady access to the global scale is

not access to a commensurate power of action on the global scale."[35] You return to "your everyday smallness,"[36] or, in Zafar's case, you "fall from the sky" (229). Seeing it all does not yield complete knowledge and power; what you realize you have is a partial perspective and no way to "see [your] enemy's face."

Animal's People, however, offers a trope that produces a different outcome from Robbins's sublime: "the invincible, undefeatable power of zero" (299). That is, the power of the poor, the poisoned, and the picaresque to take on colossal Kampanis. When Zafar evokes the power of zero while flying through the skies, he sees "the patterns of the land dissolve to designs such as are woven into carpets by the Yar-yilaqis and others from Kabul to Kurdistan" (230). He associates the power of zero with an aesthetic perspective. In other words, while the supposedly totalizing, even x-ray, perspective of the aerial fails to satisfy Zafar's desires for justice and deflates him, an aesthetic rendering via the aerial yields confidence that Goliaths might fall to the blows of Davids.

Sinha joins his fellow writers of aftermath in relying on the aerial to access information about catastrophe in a condition of infowhelm while also wresting the aerial from its associations with objectivity, universality, and totality. The aerial in *Animal's People* opens onto aesthetic—and hallucinatory—visions of the might-be rather than the positivist is. The device not only produces positional multiplicity but also opens onto the ontological indeterminacies that greet us in the serial aftermaths of toxic pollution and climate crisis.

CODA: PORTMANTEAUING THE POSSIBLE

To exit this chapter, I want to bank to the left and tour two essays on the aerial that draw out some of the keywords that have lurked in this analysis: embodiment, dissociation, and imagination or invention. Connecting these dots, these essays elaborate on the aerial as a powerful device for coupling epistemological and artistic innovation.

Virginia Woolf's "Flying Over London" (1928) describes a first experience of flight that travels from embodiment into nothingness. The narrator observes that, as the passenger becomes immersed in sky and the details of the earth blur, "one becomes conscious of being a little mammal, hotblooded, hard boned, with a clot of red blood in one's body, trespassing up

here in a fine air; repugnant to it, unclean, antipathetic. Vertebrae, ribs, entrails, and red blood belong to the earth."[37] The descriptors for this body in parts—hot, hard, red, clotted—are too rough and heavy and do not belong to the "fine air." The narrator, however, soon changes her mind. She finds within the body the stuff that surrounds it, and the image pivots. "*And in spite of our vertebrae, ribs, and entrails*, we are also vapour and air, and shall be united" (186). In the unity of gauzy and gross matter, death lurks. As Flight-Lieutenant Hopgood, the pilot entrusted with this journey, takes the narrator over England's green earth, the passenger does not feel limitlessness but "renunciation"; "it was the idea of death that now suggested itself; not being received and welcomed; not immortality but extinction" (188). That word—"extinction"—becomes the essay's drumbeat. "And our death was a fire; brandished at the summit of life, many tongued, blood red, visible over land and sea. Extinction!" the narrator cries out, "The word is consummation" (189).

Woolf draws out the death-drive inherent in a technology that also seems engineered to defy and escape death.[38] Aerial technology puts one in the body and dissociates one from it; inscribes death and defies it; carries one into "nothingness" and into "all the colours of pounded plums and dolphins and blankets and seas and rain clouds crushed together" (190).

After the narrator takes the reader into and out of the body through aerial maneuvers, the vision collapses into a mundane, mechanical failure. The aerial journey has happened only in her imagination. "As a matter of fact, the flight had not begun; for when Flight-Lieutenant Hopgood stooped and made the engine roar, he found a defect of some sort in the machine" (192). The ending of the essay gives to airy nothing by never having taken to the air. The adventure travels through kinds of matter, states of being, and even time. The hardy substance of bone, the relentless fluid of blood, evanescent vapor, and finally the River Thames traveling back in time "as the Romans saw it, as paleolithic man saw it, . . . with the rhinoceros digging his horn into the roots of rhododendrons" (187). It's as if the Rolls-Royces of wealthy Londoners have morphed into the foraging animals of prehistoric times. In condensed form, Woolf's essay uses the functions of the aerial— as setting, as technology, as point of view, as kind of movement—to think through embodiment, dissociation, and indeterminacy. Akin to twenty-first-century speculative novelists, she launches the literary aerial not for

objectivity and totality but for its ability to multiply positions and states of being.

Paul Saint-Amour's essay "Over Assemblage: *Ulysses* and the *Boîte-en-Valise* from Above" introduced me to Woolf's wondrous "Flying Over London." Her essay performs a "vivisection," according to Saint-Amour; it "enabl[es] the viewer to peer down into the occulted innards of the machine. Thus the fresh intimacy of esoteric data compensates for the physical distance required by data-gathering."[39] Saint-Amour takes the sights that the narrator imagines as forms of data that require collecting and processing. Intimacy is as available as distance when we're in the aerial, but only when the aerial is aided by imagination rather than empirical data.

Citing the aerial as a source for positional multiplicity, "Over Assemblage" chimes with my understanding of the aerial's work in speculative environmental fiction. Saint-Amour arrives at Woolf's essay via Joyce's *Ulysses* and its ability to occupy the positions of interiority and exteriority and the scales of "paramecium" and city (28). He argues that Joyce's experiments with position and scale ought to be credited to the "look-down view" within popular advertising of the 1910s and 1920s (23). This multiplicity finds formal expression in Joyce's abundant use of portmanteau words in *Ulysses* and *Finnegans Wake*, an innovation that, I argue, carries over into twenty-first-century environmental fictions.

Saint-Amour explains that a portmanteau word "collaps[es] two lexical systems within a single linguistic space—or, if you prefer, map[s] the vocabulary of one language onto the syntactic domain of another" (42–43). We saw versions of this in Robinson's and Watkins's penchant for mapping water onto air and sand in their descriptions. It's also apparent in *Animal's* "collapsing" of vocabularies through polyglossic series such as "Ous raat, cette nuit, that night, always that fucking night"; phoneticisms such as "jarnalis" for journalist and "Kampani" for company; and the phrase "Khaufpur," a neologism that attaches terror to a place.[40] Circling back to Saint-Amour's points about Woolf's aerial essay, these are the "linguistic supercontainer[s]" that render intimate what might otherwise be distant (43). Chimerical portmanteaux are abundant in *Gold Fame Citrus* and *New York 2140*. Watkins's topographic protagonist is not only a dune sea (itself a term that smuggles one concept into another) but a "sandalanche," which stows a watery substance in a dry one.[41] Robinson's city is a breeding ground

for the words. Neologisms like "gehryglory" for the new architectural won-
ders uptown and "pynchonpoetry" for an effect of water show the writer's
debt to his predecessor, John Dos Passos, but they are not only literary gen-
uflecting.[42] These and other portmanteaux in *New York 2140* propose that
the twenty-second-century city is made of cultural building blocks that
require a new lexicon as well as new supermaterials. The "melvillemood of
the Narrows at night," the "onset of lethemlucidity," the "thoreautheater"
of an estuary, a "delanyden" of iniquity: these "supercontainers" evoke clas-
sic writers of place to express the moods and effects of the climate-changed
metropolis (1864, 4179, 4380, 2878). Meanwhile, portmanteaux such as
"amphibiguity" and "heterogeneticity" (3251) reflect the epistemological
rewiring that's required when massive flooding mucks up categories of
being. This wordplay contributes to the playfulness of Robinson's novel, and,
as important, it immerses the reader in that relay between infowhelm, posi-
tional multiplicity, and ontological messiness that, in my argument, the
aerial mediates within speculative fiction. Urban ecology, always complex
and never singular, is in such flux between states that single-concept words
cannot suffice. The prevalence of portmanteau forms—which can be lin-
guistic, embodied, epistemological, and/or ontological—manifests the
experience of infowhelm in ongoing aftermaths. The data on this new world
is still being processed; meanwhile, the portmanteau captures the push and
shove between air and earth, between super- and sub-, between knowledge
and ignorance, between reality and invention, between human, animal, and
biotech.

Constellating speculative fiction through its aerial devices has carried us
back through the chapters of *Infowhelm*. Abundant yet contested informa-
tion provides access to the conditions of crisis and yet is just as easily an
obstacle to knowledge. In contemporary novels of aftermath, this informa-
tion situation goads experiments with the aerial along with other episte-
mological tools we have analyzed throughout this book: data processing,
data visualization, the naturalist catalog, and remote imaging. Novels by
Robinson, VanderMeer, Watkins, and Sinha are crucibles for epistemolog-
ical devices that do not so much tell the whole story of climate collapse as
inhabit the many positions from which climate stories must be told.

EPILOGUE
Can Thinking Make It So?

Someday, perhaps not long from now, the inhabitants of a hotter, more dangerous and biologically diminished planet than the one on which I lived may wonder what you and I were thinking, or whether we thought at all.

—WILLIAM T. VOLLMANN (2018)

It's never a question of whether we thought but of what we were thinking. Our present selves, examined by scornful future inhabitants of Earth, may be thinking only of today or tomorrow, of financial gain, of the unpaid bills that have piled up, of the next vacation or doctor's appointment. These are all valid interpretations of our present from that perch of a "hotter, more dangerous and biologically diminished planet" the wealthiest humans are currently creating. *Infowhelm: Environmental Art and Literature in an Age of Data* has taken a wider view of what constitutes thinking in the age of environmental crisis. It explains how contemporary literature and visual culture experiment with environmental epistemologies that became dominant under the sway of positivist science by entangling scientific information with speculation, emotion, uncertainty, ambiguity, invention, and embodied experience.

I have read the infowhelm as a catalyst for this new aesthetic of thought within the environmental arts. The explosion of information about environmental processes and their threats has certainly led some to take decisive action against climate crisis, mass extinction, and land exhaustion, but it mostly has not. Inaction undoubtedly has something to do with that other facet of infowhelm: how information becomes contested, dismissed, and distorted by those in power. But that is only one small reason Eurowestern

societies have not halted our course toward the direst climate scenarios. David Wallace-Wells catalogs many others. These are

so half-formed they might better be called impulses. We chose not to discuss a world warmed beyond two degrees out of decency, perhaps; or simple fear; or fear of fearmongering; or technocratic faith, which is really market faith; or deference to partisan debates or even partisan priorities; or skepticism about the environmental Left of the kind I'd always had; or disinterest in the fates of distant ecosystems like I'd also always had. We felt confusion about the science and its many technical terms and hard-to-parse numbers, or at least an intuition that others would be easily confused about the science and its many technical terms and hard-to-parse numbers.[1]

We might add to his litany the lack of political will, bold leadership, global governance, eco-consciousness, farsightedness, compassion, selflessness, realism, time, money, attention, even love.

Along with the scientific information, many of these reasons become part of the aesthetic repertoire of environmental arts of the infowhelm. Decency and fear motivate characters in Barbara Kingsolver's *Flight Behavior* (chapter 2), technocratic faith underpins climate visualizations (chapter 1), Juliana Spahr's speakers wrestle with scientific confusion and lack of attention (prefaces), market faith goads a faction of characters in Kim Stanley Robinson's speculative New York (chapter 6), skepticism toward the Left turns Michael Crichton's characters toward climate denialism (chapter 2), combatting disinterest in the fates of distant ecosystems inspires Bryan James's and Maya Lin's digital projects (chapter 4). Yet these artists and the others *Infowhelm* has featured do not stop at rehearsing these reasons, important as they are to understand. They instead share a conviction that has motivated me in writing this book: radical environmental change requires an epistemological overhaul. At the heart of all these reasons or, "impulses," lie ways of thinking that are so entrenched as to feel natural or at least so culturally rooted that to eradicate them risks one's identity and way of life. For example, to divest from technocratic solutions as the primary answer to climate crisis is akin to divesting from mechanistic, linear modes of thought. Deference to partisan priorities about the environment suggests an embrace of top-down problem solving. Environmental positions are linked to ways of thinking that run deep. In this respect,

thinking most certainly makes it—that is, planetary conditions—so. Epistemology, therefore, is at the center of all environmental discourse.

Shoring up this realization has been a satisfying but daunting aspect of writing *Infowhelm*. The book began with an interest in what artists are doing with the profusion of environmental information available today. Its ambit expanded with my discovery that responses to environmental crises either take off or fall flat based on the patterns of thought they reinforce or threaten in a given cultural context. The sociology and psychology of climate action have focused on the interpretive frameworks into which the facts and management of environmental threats fit, on "the spaces of ethics, morality, and other community-specific rationales for actions," as Candis Callison puts it.[2] They have focused on the "double reality" individuals enter when they acknowledge planetary endangerment but also "collectively distance themselves from information because of norms of emotion, conversation, and attention."[3] In some cases these studies address norms governing ways of thinking, as when Callison identifies "civic epistemology" as the "mix of ways in which knowledge is presented, tested, verified, and put to use in public arenas."[4] But epistemology as a distinct aspect of individual and collective environmental life often gets short shrift. Just as ethics, morality, emotion, conversation, and attention are normalized elements of our realities, so too are patterns of thought. Studying the ways information takes on new meaning when it enters art becomes a way of unpacking this integral element of environmental identity.

Focusing on thought does not discount the importance of belief, emotion, and values but rather demonstrates how the former entangle with the latter. To turn back to the introduction to *Infowhelm*, Paul Schrader's film *First Reformed* (2017) offers a powerful example of how climate information entangles with belief (in the case of protagonist Ernst Toller, Christianity), values (deference to authority, small-town New England stoicism), and emotion (grief, doubt, sexual desire) to produce eco-radicalism. The climate data and visualizations Michael shares with Toller do not triumph over Christianity in some simplistic epistemological battle between science and religion. Instead, this scientific information scales up Toller's grief from the personal to the planetary and turns his religious doubt into the conviction that he could become a Christological martyr, saving the environment and the soul of a community by blowing up the industrial capitalists who have sullied both. (Spoiler: Toller doesn't go through with

it.) I contend that the environmental arts—film in this case and the novel, memoir, poetry, painting, photography, bioart, and data visualization in the preceding pages of *Infowhelm*—are crucibles for this alchemical mingling of thought, belief, values, and emotion.

Artists stage encounters with scientific data and methods for the characters within their stories, as in Reif Larsen's *The Selected Works of T. S. Spivet* (chapter 3), and for the audiences who come to their works, as with Carbon Visuals' climate data visualizations (chapter 1). These encounters allow audiences to examine how minds respond to this information and to identify how these responses become naturalized in particular contexts. As Charles Wohlforth's *The Whale and the Supercomputer* demonstrates, Iñupiat perceptions of climate change are just as normalized within their Arctic context as those of the climate modelers working in NOAA's Climate Monitoring and Diagnostics Laboratory (chapter 2). In showing how minds work when confronting scientific information and how those workings of the mind become normalized, the environmental arts also demonstrate what's at stake in visual and textual mediation. In how conventions of language, symbol, color, time, genre, perspective, and more affirm dominant modes of thought or direct audiences toward other possibilities that neither deny nor pay excess deference to the claims of Eurowestern science. Arts of the infowhelm, thereby, also remind audiences of the persistence of interpretation. Not only do we need to bring the tools of humanistic interpretation to bear on so-called raw data and the media that "cook" them, as scholars have well established; we must also apply those tools to thinking itself. The cultural works analyzed in *Infowhelm* treat information as an aesthetic resource in its own right and turn it into a space of interpretive activity. They offer their own understandings of how epistemologies form, endure, yield emotion, and become susceptible to disturbance. But interpretive activity does not stop there; these environmental artworks create their own encounters with scientific information for audiences who must grapple with the constructedness of all knowledge.

Enthusiasm for entangled epistemologies is as palpable in environmental activism, law, and the humanities as it is in the environmental literature and visual culture I have studied here. We find it in forays into multispecies ethnography, design, and justice by Julie Cruikshank, Elaine Gan, Donna Haraway, Eben Kirksey, Kate Orff, and Anna Tsing, among others. We find it in governance models built on the Rights of Nature such

as the sumac kawsay/buen vivir mandate inscribed in Ecuador's constitution of 2008 and New Zealand's recognition of the Whanganui River's legal personhood in 2017. We find it in the "indigenous cosmopolitical" activism that fueled these legal victories.[5] We find epistemologies entangling in indigenous climate studies guided by the voices of Chie Sakakibara, Chief Vyacheslav Shadrin, and Kyle Powys Whyte, and in the indigenous-led digital media design of Elizabeth LaPensée. We find it in creative climate journalism by Brentin Mock, Elizabeth Rush, and Earl Swift that place local knowledge of environmental disturbance on the same footing as the research coming out of national labs. The environmental humanities haven't fully acknowledged these trends in scholarship, activism, and creativity as performances of entangled epistemologies. My hope is that *Infowhelm* will help us draw out the shift in thought that all these efforts exemplify. We can then use them as tools for identifying the many knowledges required to make decisions about environmental emergencies and to learn from and collaborate with communities making those decisions every day, as many of the thinkers mentioned above already are, rather than using them only as tools for cultural analysis or political critique.

The experiments with entangled epistemologies practiced by environmental actors also offer the opportunity to undiscipline the academy. They explicitly or tacitly question whether existing disciplinary frameworks and academic genres remain relevant to addressing the moral, cultural, and political dilemmas of the twenty-first century.[6] What if we approached intellectual, creative, and political environmentalism not in terms of "inter-" or "transdisciplinarity" but in terms of inter- or transepistemology? Admittedly, this is inelegant jargon, but this shift in vocabulary captures a need to grapple with modes of thought broadly—rather than disciplines specifically—as environmental thinkers envision the radical change required to address eco-crises. "Inter-" and "transdisciplinarity" already assign priority to the academic framing of a problem and its solutions. Entangling modes of thought invites more people to the table from the outset, and not only after the academy has crafted its takes on and solutions to a problem. This is not to say that colleges and universities should not convene trans-epistemological ventures and be active players in them. Rather, a reorientation around the trans-epistemological, in line with the entangled epistemologies *Infowhelm* has detailed, affords opportunities to bring multiple species, elements, histories, stories, speculations, inventions,

emotional amalgams, forms of embodiment, and even uncertainties to the same table.

In closing, I want to spotlight Kate Orff and her design firm, SCAPE, who exemplify this approach as they reshape public spaces for ecological remediation and resilience. They prioritize "ecological infrastructure and its protective value" and "design with mud," oysters, mussels, eelgrass, and other elements and creatures to repair environmental degradation and build resilience against climate crises.[7] SCAPE creates "oyster-tecture" for the New York City harbor and other cities, like Houston and New Orleans, whose natural buffers against the violent storm surge of hurricanes have been eroded by urbanization and industry. In response to a call from the U.S. federal government for designs to rebuild after Hurricane Sandy devastated New York and New Jersey in 2012, SCAPE proposed "Living Breakwaters." The plan is based in New York City's history as a hotbed for oystering—among the Lenape people and the settlers who followed—before pollution and industrialization destroyed the food source and the economies that built up around it. These human relations to oysters have largely been lost, and so too have the ecological functions these mollusks serve: reducing coastal erosion, slowing down waters, breaking up waves before they pummel the shore, providing habitat for other creatures. Aware of these histories and ecologies, SCAPE is building "a necklace of offshore breakwaters out of large rocks and stones, and seed[ing] them with oysters so they grow into reefs. . . . Rather than trying to hold the line and battle the ocean, the designers want to slow the water down and let it through—creating a buffer zone of cleaner, calmer water along the shore."[8]

We might call this project transdisciplinary, as it recruits bivalves, city residents (including schoolchildren who grow oysters to seed the project), historians of place, urban planners, marine biologists, watershed conservationists, landscape architects, and governmental and nonprofit funders into a shared vision for climate resilience and marine restoration. But approaching such projects as trans-epistemological, we can better appreciate the ways of thinking that make them possible: from indigenous ways of life with land and sea to children's ways of sensing and exploring their environments; from an engineering firm's idea of what constitutes a sea barrier to the historian's use of archives and narrative to reconstruct the shifts in an urban shoreline over time. SCAPE joins the artists that *Infowhelm* has studied to demonstrate that thinking *can* make it so. This making-so may

be piecemeal, and it may not be enough soon enough, especially for the most vulnerable, but when epistemologies entangle, "another relationship to nature besides reification, possession, appropriation, and nostalgia" takes shape.[9] Galvanized by the creativity of poets, novelists, journalists, painters, architects, visualizers, bioartists, and more, these relationships mingle fact with uncertainty, ambition with humility, exploration with limitation, exuberance with restraint, history with futurity, pragmatism with speculation.

ACKNOWLEDGMENTS

Without an outfit of brilliant, generous friends who have offered love, encouragement, insight, distraction, and necessary skepticism, *Infowhelm* would not be. My profound thanks to Joel Burges for being on the other end of the line as a listener, thinker, and carer, and to C. J. Alvarez, Harris Feinsod, Deena Kalai, Sam Pinto, Ashley Hunter, Neville Hoad, Michael Hoyer, and Lindsay Reckson. Matt Cohen, Nick Howe, and Jeremy Rosen read sections of the manuscript at crucial times. Mark Miller introduced me to the wonders of scientific data visualization years before this book was even a possibility. I wrote significant portions of *Infowhelm* on Hank Avenue; thank you, Stephen Breaux, for making that space. Above all, I am indebted to Allison Carruth, who is my closest fellow traveler in the environmental humanities and my beloved friend.

Thank you to all my students and "fr-olleagues" in the Department of English at The University of Texas at Austin, especially Betsy Berry, Doug Bruster, Ann Cvetkovich, Dylan Davidson, Reid Echols, Alan Friedman, Don Graham (may he rest in peace), Cole Hutchison, Martin Kevorkian, Allen MacDuffie, Julie Minich, Lisa Moore, Lisa Olstein, Alejandro Omidsalar, Wayne Rebhorn, Adena Rivera-Dundas, Emily Roehl, Liz Scala, Anne Stewart (whose visualization sleuthing skills were invaluable), Hannah Wojciehowski, and Jorie Woods. I am grateful for the responses I received at the English Department Collation in 2014, when I'd just set out on this

journey, and at the Words & Process Workshop in 2018, when I was enter-
ing the final bend. Conversations with colleagues and partners in the Planet
Texas 2050 grand challenge at UT have made the urgency of these ques-
tions visceral in our years of collaboration. Liz Cullingford was my chair
at UT Austin from my hiring in 2011 until the completion of this manu-
script in August 2019. She remains a stalwart supporter, sharp reader, and
sure-footed walking partner.

Philip Leventhal has been an attentive editor since I proposed *Ecosick-
ness* to Columbia University Press in 2012. I'm honored to continue collab-
orating with him and the CUP team. As the editors of CUP's "Literature
Now" series, Matthew Hart, David James, and Rebecca Walkowitz are fos-
tering the best of contemporary literary study from scholars of all career
stages. I'm especially grateful to David for his close reading of the McCar-
thy material and for continued opportunities to exchange work. Thank
you to the rest of CUP team, including Monique Briones, Noah Arlow,
Zack Friedman, Lisa Hamm, Anita O'Brien, and Susan Pensak, and to the
indexers at Arc Indexing. I am indebted to Amy Elias and to the anony-
mous reviewer for their feedback at two crucial stages in the gestation of
Infowhelm.

After writing her own study of contemporary environmental media,
Delia Byrnes came on as my research assistant and made the final stages of
piecing together the book less onerous and more pleasurable. Thank you.

My gratitude to those who invited me to present these ideas as they were
developing. Organizers and audiences at these institutions offered invalu-
able perspectives that enlarged and/or honed my thinking: Alice Kaplan
Institute for the Humanities at Northwestern University, American Acad-
emy of Arts & Sciences, Digital Matters Lab at the University of Utah, Ghent
University, Humanities Center at the University of Pittsburgh, Humanities
Institute Faculty Fellows Program at UT Austin, Post45 Symposium at the
University of North Carolina–Chapel Hill, Stanford University, Tanner
Humanities Center at the University of Utah, Texas Ecocritics Network,
UCLA Mellon Sawyer Seminar, University of Michigan, University of Texas
at Arlington, and Western Humanities Alliance Conference at Arizona
State University.

Infowhelm has received financial and leave support from The University
of Texas at Austin through the following awards: College Research Fellow-
ship (2014), Special Research Grant (2015), Summer Research Assignment

(2015), Humanities Research Award (2016–2019), Book Subvention Grant (2019), and Faculty Research Assignment (received 2019).

I wrote the first words of this book in April 2014 as a visiting scholar at the American Academy of Arts & Sciences in Cambridge, Massachusetts. The camaraderie among the early-career fellows—above all, Kornel Chang and dear friends Jillian Hess and Ju Yon Kim—and the guidance of Pat Spacks and Mary Dunn (may she rest in peace) gave me the confidence to consider my inchoate ideas book-worthy. I completed the first full draft of the manuscript in 2018–2019 as a visiting research fellow at the Tanner Humanities Center at the University of Utah in Salt Lake City. My gratitude to Bob Goldberg for leading the program and to the other fellows, above all Dima Hurlbut, for their feedback and companionship.

Scholars are always fortunate to study artists and organizations who make their creative works available for reproduction, as many have for this project. My thanks to the following presses and editors for allowing me to include my writing that appeared in their publications, often in quite different form. Portions of chapter 4 in "Scatterplots and Designer Ecosystems: Visualizing Loss in New Naturalist Media," *ELN: English Language Notes* 55, no. 1–2 (2017): 101–12. Early ideas for chapter 1 and portions thereof in the following: "Human/Planetary," in *Time: A Vocabulary of the Present*, ed. Joel Burges and Amy J. Elias (New York: NYU Press, 2016), 144–60; "Climate Visualizations as Cultural Objects," in *Teaching Climate Change in the Humanities*, ed. Stephen Siperstein, Shane Hall, and Stephanie LeMenager (New York: Routledge), 131–45, © Stephen Siperstein, Shane Hall, and Stephanie LeMenager, 2017, reproduced with permission of The Licensor through PLSclear; and "Climate Visualizations: Making Data Experiential," in *The Routledge Companion to the Environmental Humanities*, ed. Ursula K. Heise, Jon Christensen, and Michelle Niemann (New York: Routledge), 358–68, © Ursula K. Heise, Jon Christensen, and Michelle Niemann, 2017, reproduced with permission of The Licensor through PLSclear. I'm also grateful for rights to reproduce lines from *well then there now* by Juliana Spahr, copyright © Juliana Spahr, 2011.

Bette, Garrett, Mary, Abby, Connor, and Nathan stand by me even when we're far apart. My family's love has always made it all possible.

NOTES

INTRODUCTION

1. I began using the term *infowhelm* in 2014 before realizing it already had some currency. See Heather Houser, "Managing Information and Materiality in *Infinite Jest* and Running the Numbers," *American Literary History* 26, no. 4 (2014): 742–64. With no references in the *Oxford English Dictionary* or other standard dictionaries, the origins of the term are difficult to pin down. It appears in studies of information literacy in the field of education beginning in the 2000s to refer to information overload in the digital age. It entered the environmental humanities through my own writing as well as Rob Nixon, *Slow Violence and the Environmentalism of the Poor* (Cambridge, Mass.: Harvard University Press, 2011), 12, and Derek Woods, "Accelerated Reading: Fossil Fuels, Infowhelm, and Archival Life," in *Anthropocene Reading: Literary History in Geologic Times*, ed. Tobias Menely and Jesse Oak Taylor (University Park: Pennsylvania State University Press, 2017), 202–19.

2. You could make a word stew out of terms capturing the glut of information in the digital age: information overload, fatigue, or overflow; "infotopia"; "Total Noise." The latter two terms are attributable to Cass Sunstein, *Infotopia: How Many Minds Produce Knowledge* (New York: Oxford University Press, 2006); David Foster Wallace, "Introduction: Deciderization 2007—Special Report," in *The Best American Essays 2007*, ed. David Foster Wallace (Boston: Houghton Mifflin 2007), xiv.

3. For histories of information, see Ann M. Blair, *Too Much to Know: Managing Scholarly Information Before the Modern Age* (New Haven, Conn.: Yale University Press, 2010); Luciana Floridi, *Information: A Very Short Introduction* (Oxford: Oxford University Press, 2010); James Gleick, *The Information: A History, a Theory, a Flood* (New York: Vintage, 2011); Alex Wright, *Glut: Mastering Information Through the Ages* (Washington, D.C.: Joseph Henry, 2007).

4. Donna J. Haraway, "Otherworldly Conversations, Terran Topics, Local Terms," in *Material Feminisms*, ed. Susan J. Hekman and Stacy Alaimo (Bloomington: Indiana University Press, 2008), 158.

5. *First Reformed*, directed by Paul Schrader (New York: A24, 2017), https://www.amazon.com/First-Reformed-Ethan-Hawke/dp/B07D6V7MRJ.

6. The scene begins approximately ten minutes into the film. A24 did not grant permission to reproduce images from the film, but the scene appears briefly in the official trailer at 1:00, available at https://youtu.be/hCF5Y8dQpR4.

7. Michael shows Toller photos of men and women who have been "killed trying to protect the environment" in the Amazon. Rob Nixon terms these activists "environmental martyrs" in "Environmental Martyrdom and Defenders of the Forest" (lecture, The University of Texas at Austin, October 21, 2016).

8. Heather Houser, *Ecosickness in Contemporary U.S. Fiction: Environment and Affect* (New York: Columbia University Press, 2014).

9. Lorraine Code, *Ecological Thinking: The Politics of Epistemic Location* (New York: Oxford University Press, 2006), 4. Code's concept of "epistemologies of mastery" is indebted to Haraway's feminist science studies.

10. Instances of this knowledge defamation are too numerous to list. Focusing on the erosion of the Environmental Protection Agency (EPA) in 2018 alone, we find the Trump administration removing climate change references from government websites (January); dissolving the Office of the Science Advisor that counsels the EPA administrator (March); requiring that, in order to be considered in agency recommendations, scientific research must make all "raw" data public, an impossibility given human subjects privacy laws (September); and disbanding a pollution science panel (October).

11. Code, *Ecological Thinking*, 21.

12. Nicole Seymour, *Bad Environmentalism: Irony and Irreverence in the Ecological Age* (Minneapolis: University of Minnesota Press, 2018), 46.

13. Karin Knorr Cetina, *Epistemic Cultures: How the Sciences Make Knowledge* (Cambridge, Mass.: Harvard University Press, 1999), 1.

14. Seymour also makes this point, referring to success-fail verdicts within ecocriticism as "instrumentalist scholarly approaches," in *Bad Environmentalism*, 27–28.

15. I borrow "fate of knowledge" from Helen Longino's study of conflicts that arise around sociocultural approaches to scientific knowledge in *The Fate of Knowledge* (Princeton, N.J.: Princeton University Press, 2002).

16. Crucial studies in this effort include the essays in Jeffrey Jerome Cohen and Stephanie LeMenager's special section of *PMLA*, "Assembling the Ecological Digital Humanities," *PMLA* 131, no. 2 (2016): 340–409; Sean Cubitt, *Finite Media: Environmental Implications of Digital Technologies* (Durham, N.C.: Duke University Press, 2017); Ursula K. Heise, *Imagining Extinction: The Cultural Meanings of Endangered Species* (Chicago: University of Chicago Press, 2016); Stephanie LeMenager, *Living Oil: Petroleum Culture in the American Century* (New York: Oxford University Press, 2014); Timothy Morton, *Ecology Without Nature: Rethinking Environmental Aesthetics* (Cambridge, Mass.: Harvard University Press, 2007); Stephen Rust, Salma Monani, and Sean Cubitt, eds., *Ecomedia: Key Issues* (New York: Routledge, 2016); Seymour, *Bad Environmentalism*.

17. See Lev Manovich, "Data Visualization as New Abstraction and as Anti-Sublime," in *Small Tech: The Culture of Digital Tools*, ed. David Hawk, David M. Rieder, and Ollie Oviedo (Minneapolis: University of Minnesota Press, 2008), 3–9; "Database as Symbolic Form," in *Database Aesthetics: Art in the Age of Information Overflow*, ed. Victorian Vesna (Minneapolis: University of Minnesota Press, 2007), 39–60.

18. Johanna Drucker, *Graphesis: Visual Forms of Knowledge Production* (Cambridge, Mass.: Harvard University Press, 2014), 17.

19. Drucker, 126, 128–29. Drucker sets out this idea and others fundamental to *Graphesis* in an earlier article, "Humanities Approaches to Graphical Display," *DHQ: Digital Humanities Quarterly* 5, no. 1 (2011), www.digitalhumanities.org/dhq/vol/5/1 /000091/000091.html.

20. Drucker, *Graphesis*, 4.

21. Sean Cubitt has brought data visualization analysis into the interpretation of eco-cinema with "Everybody Knows This Is Nowhere: Data Visualization and Eco-criticism," in *Ecocinema Theory and Practice*, ed. Stephen Rust, Salma Monani, and Sean Cubitt (New York: Routledge/American Film Institute, 2013), 279–96.

22. The following works either are foundational to these fields or usefully explain those foundational sources: Gregory Bateson, *Steps to an Ecology of Mind* (1972; Chicago: University of Chicago Press, 2000); Gleick, *The Information*; N. Katherine Hayles, *How We Became Posthuman: Virtual Bodies in Cybernetics, Literature, and Informatics* (Chicago: University of Chicago Press, 1999); Peter Janich, *What Is Information?*, trans. Eric Hayot and Lea Pao (Minneapolis: University of Minnesota Press, 2018); John Durham Peters, "Information: Notes Toward a Critical History," *Journal of Communication Inquiry* 12, no. 2 (1988): 9–23; Claude E. Shannon and Warren Weaver, *The Mathematical Theory of Communication* (Urbana: University of Illinois Press, 1971).

23. This definition is akin to Lauren Klein and Miriam Posner's in "Editor's Introduction: Data as Media," *Feminist Media Histories* 3, no. 3 (2017): 1.

24. Klein and Posner, 1–8.

25. Jennifer Gabrys, Katherine Hayles, and Birgit Schneider are fellow travelers in this endeavor, and I reflect on their ideas in subsequent chapters. Studies of information and art typically focus on 1. the convergence of media; 2. the devices and platforms (smartphones, virtual reality, Facebook, etc.) influencing arts practice; and/or 3. art-science collaboration more generally. See David Hawk, David M. Rieder, and Ollie Oviedo, eds., *Small Tech: The Culture of Digital Tools* (Minneapolis: University of Minnesota Press, 2008); Margot Lovejoy, Christiane Paul, and Victoria Vesna, eds., *Context Providers: Conditions of Meaning in Media Arts* (Bristol, UK: Intellect, 2011); Lev Manovich, *The Language of New Media* (Cambridge, Mass.: MIT Press, 2001); Robert Mitchell and Philip Thurtle, eds., *Data Made Flesh: Embodying Information* (New York: Routledge, 2004); Victoria Vesna, ed., *Database Aesthetics: Art in the Age of Information Overflow* (Minneapolis: University of Minnesota Press, 2007); Stephen Wilson, *Information Arts: Intersections of Art, Science, and Technology* (Cambridge, Mass.: MIT Press, 2002). Recent studies of information in literature include Sebastian Groes, "Information Overload in Literature," *Textual Practice* 31, no. 7 (2017): 1481–1508; Maurice S. Lee, *Overwhelmed: Literature, Aesthetics, and the Nineteenth-Century Information Revolution* (Princeton, N.J.:

INTRODUCTION

Princeton University Press, 2019); Paul Stephens, *The Poetics of Information Over-load: From Gertrude Stein to Conceptual Writing* (Minneapolis: University of Minnesota Press, 2015).

26. Lisa Parks, *Cultures in Orbit: Satellites and the Televisual* (Durham, N.C.: Duke University Press, 2005), 14; Barbara Herrnstein Smith, *Scandalous Knowledge: Science, Truth, and the Human* (Durham, N.C.: Duke University Press, 2005), 47.

27. On this particular example, see David Turnbull and Helen Watson, *Maps Are Territories: Science Is an Atlas* (Chicago: University of Chicago Press, 1993), and the online companion at http://territories.indigenousknowledge.org.

28. David Turnbull, *Masons, Tricksters and Cartographers: Comparative Studies in the Sociology of Scientific and Indigenous Knowledge* (Amsterdam: Harwood Academic, 2000), 4.

29. Kyle Whyte, "Indigenous Climate Change Studies: Indigenizing Futures, Decolonizing the Anthropocene," *English Language Notes* 55, no. 1–2 (2017): 157.

30. Donna Haraway, "Situated Knowledges: The Science Question in Feminism and the Privilege of Partial Perspective," *Feminist Studies* 14, no. 3 (1988): 590, 583.

31. Herrnstein Smith, *Scandalous*; Longino, *Fate of Knowledge*; Londa Schiebinger, *Plants and Empire: Colonial Bioprospecting in the Atlantic World* (Cambridge, Mass.: Harvard University Press, 2004).

32. Knorr Cetina, *Epistemic Cultures*, 64.

33. Code, *Ecological Thinking*, 19.

34. Code, 35.

35. Michel Foucault, *The History of Sexuality*, vol. 1: *An Introduction*, trans. Robert Hurley (New York: Pantheon, 1978; Vintage, 1990); Foucault, *The Order of Things: An Archaeology of the Human Sciences* (1966; New York: Vintage, 1994); Bruno Latour, "Drawing Things Together," in *Representation in Scientific Practice*, ed. Michael Lynch and Steve Woolgar (Cambridge, Mass.: MIT Press, 1990), 19–68; Carolyn Merchant, *The Death of Nature: Women, Ecology, and the Scientific Revolution* (San Francisco: Harper & Row, 1980); Val Plumwood, *Feminism and the Mastery of Nature* (New York: Routledge, 1993); James C. Scott, *Seeing Like a State: How Certain Schemes to Improve the Human Condition Have Failed* (New Haven, Conn.: Yale University Press, 1998).

36. I use the phrases *more-than-human animals* or *more-than-human others* throughout this book. My preferred gloss on this concept comes from Ursula Heise: "the realm of nonhuman species, but also that of connectedness with both animate and inanimate networks of influence and exchange." Heise, *Sense of Place and Sense of Planet: The Environmental Imagination of the Global* (New York: Oxford University Press, 2008), 61.

37. Mary Poovey, *A History of the Modern Fact: Problems of Knowledge in the Sciences of Wealth and Society* (Chicago: University of Chicago Press, 1998), xv.

38. Daniel Bell, "Axial Age of Technology: Foreword 1999," in *The Coming of Post-Industrial Society: A Venture in Social Forecasting* (New York: Basic Books), lxiii.

39. Schiebinger, *Plants and Empire*, 5.

40. Code, *Ecological Thinking*, 23.

41. See Knorr Cetina, *Epistemic Cultures*; Karen Barad, *Meeting the Universe Halfway: Quantum Physics and the Entanglement of Matter and Meaning* (Durham, N.C.: Duke University Press, 2007); Andrew Pickering, *The Mangle of Practice: Time, Agency, and Science* (Chicago: University of Chicago Press, 1995).

265

42. Lorraine Daston and Peter Galison's magisterial book, *Objectivity* (2007), informs
these insights and my readings throughout *Infowhelm*. They demonstrate that objec-
tivity "is a way of being as well as a way of knowing" and reconfigure epistemology
within the sciences "as the repository of multiple virtues and visions of the good,
not all simultaneously tenable (or at least simultaneously maximizable), each orig-
inally the product of distinct historical circumstances, even if their moral claims
have outlived the contexts that gave them birth." Daston and Galison, *Objectivity*
(New York: Zone Books, 2007), 4, 33. This perspective gives purchase on how ratio-
nality, mastery, universality, and the correspondence theory endure even as other
values ascend in importance within scientific practice. Their study reveals that
"pure" enactments of an epistemology are rare and, even if possible, often
inefficacious.
43. Susan L. Mizruchi, *The Science of Sacrifice: American Realism and Modern Social
Theory* (Princeton, N.J.: Princeton University Press, 1998), 4.
44. David Wallace-Wells, *The Uninhabitable Earth: Life After Warming* (New York: Tim
Duggan Books, 2019), 3. Kindle.
45. I owe many of these points to Delia Byrnes.
46. Peters, "Information," 12.

PREFACE, PART 1

1. Walter Benjamin, "On Some Motifs in Baudelaire," in *Illuminations: Essays and
Reflections*, ed. Hannah Arendt, trans. Harry Zohn (1968; reprint, New York:
Schocken, 2007), 159.
2. Anne McClintock, "Too Big to See with the Naked Eye," *Guernica*, December 20,
2012, http://www.guernicamag.com/daily/anne-mcclintock-too-big-to-see-with-the
-naked-eye.
3. Noel Castree, "Global Change Research and the 'People Disciplines': Toward a New
Dispensation," *South Atlantic Quarterly* 116 (January 2017): 57.
4. Michael Segal, "The Missing Climate Change Narrative," *South Atlantic Quarterly*
116 (January 2017): 121–28; Michael Ziser and Julie Sze, "Climate Change, Environ-
mental Aesthetics, and Global Environmental Justice Cultural Studies," *Discourse*
29 (Spring & Fall 2007): 404. Adam Trexler describes dozens of post-1970s climate
change novels and their successes and failures in capturing the complex dynamics
of the crisis in *Anthropocene Fictions: The Novel in a Time of Climate Change* (Char-
lottesville: University of Virginia Press, 2015).
5. See, for example, Candis Callison, *How Climate Change Comes to Matter: The Com-
munal Life of Facts* (Durham, N.C.: Duke University Press, 2014).
6. Paul Slovic and Scott Slovic, eds., *Numbers and Nerves: Information, Emotion, and
Meaning in a World of Data* (Corvallis: Oregon State University Press, 2015).
7. Juliana Spahr's readership extends beyond the United States, but *well then there now*,
and especially "Unnamed Dragonfly Species," hails an American audience.
8. Juliana Spahr, *well then there now* (Boston: Black Sparrow, 2011), [6–7], 75, 93. Here-
after cited parenthetically.
9. The running "red list" of threatened species anticipates my study of what I call, in
part 2, the new natural history.

10. A nod to Rebecca Solnit, *The Faraway Nearby* (New York: Penguin, 2013).
11. Benjamin, "On Some Motifs," 159.
12. My thanks to Nicolas Howe for drawing this point out from my analysis.
13. Sean Cubitt, "Everybody Knows This Is Nowhere: Data Visualization and Ecocriticism," in *Ecocinema Theory and Practice*, ed. Stephen Rust, Salma Monani, and Sean Cubitt (New York: Routledge/American Film Institute, 2013), 282.

1. MAKING DATA EXPERIENTIAL

1. Joel Sternfeld, "Artist's Statement: *When It Changed*," Prix Pictet, accessed August 14, 2019, http://www.prixpictet.com/portfolios/power-shortlist/joel-sternfeld/statement/.
2. The *When It Changed* art book underscores infowhelm and data encounter. Sternfeld chops up sentences from climate conference reports and news items and festoons the book's cover and endleaves with these often indecipherable letters and mathematical symbols. Joel Sternfeld, *When It Changed* (Göttingen, Ger.: Steidl, 2008).
3. Lucy R. Lippard et al., *Weather Report: Art and Climate Change* (Boulder, Colo.: Boulder Museum of Contemporary Arts, 2007), 108.
4. Bill McKibben, "Global Warming's Terrifying New Math," *Rolling Stone*, July 19, 2012, http://www.rollingstone.com/politics/news/global-warmings-terrifying-new-math-20120719. Throughout this book, I use either the metric or the imperial system of units in accordance with my sources' usage. In cases where the source itself alternates between the two systems, I provide measurements in both.
5. Finis Dunaway, "Seeing Global Warming: Contemporary Art and the Fate of the Planet," *Environmental History* 14, no. 1 (2009): 10.
6. This notorious graph, which has undergone several revisions, depicts mean temperature anomalies in the Northern Hemisphere between A.D. 1000 and A.D. 2000. See Michael Mann, Raymond S. Bradley, and Malcolm K. Hughes, "Northern Hemisphere Temperatures During the Past Millennium: Inferences, Uncertainties, and Limitations," *Geophysical Research Letters* 26 (1999): 759–62. For a cultural analysis of the graph, see Birgit Schneider, "Image Politics: Picturing Uncertainty. The Role of Images in Climatology and Climate Policy," in *Climate Change and Policy: The Calculability of Climate Change and the Challenge of Uncertainty*, ed. Gabriele Gramelsberger and Johann Feichter (Berlin: Springer-Verlag, 2011), 191–209.
7. Schneider, "Image Politics," 206.
8. Mary Poovey, *A History of the Modern Fact: Problems of Knowledge in the Sciences of Wealth and Society* (Chicago: University of Chicago Press, 1998), 13, 12, xix, 4. See also Johanna Drucker, *Graphesis: Visual Forms of Knowledge Production* (Cambridge, Mass.: Harvard University Press, 2014); Lisa Gitelman, ed., *"Raw Data" Is an Oxymoron* (Cambridge, Mass.: MIT Press, 2013).
9. Helen E. Longino, *The Fate of Knowledge* (Princeton, N.J.: Princeton University Press, 2002), 11.
10. Longino, 118.
11. Schneider, "Image Politics," 191–92.
12. Noel Castree, "Global Change Research and the 'People Disciplines': Toward a New Dispensation," *South Atlantic Quarterly* 116, no. 1 (2017): 55.

13. My understanding of modeling largely comes from Paul Edwards's marvelous account of its history in *A Vast Machine: Computer Models, Climate Data, and the Politics of Global Warming* (Cambridge, Mass.: MIT Press, 2010). Other useful resources include Amy Dahan Dalmedico, "Models and Simulations in Climate Change: Historical, Epistemological, Anthropological, and Political Aspects," in *Science Without Laws: Model Systems, Cases, Exemplary Narratives*, ed. Angela N. H. Creager, Elizabeth Lunbeck, and M. Norton Wise (Durham, N.C.: Duke University Press, 2007), 125–56; Joshua P. Howe, *Behind the Curve: Science and the Politics of Global Warming* (Seattle: University of Washington Press, 2014); Clark A. Miller and Paul N. Edwards, eds., *Changing the Atmosphere: Expert Knowledge and Environmental Governance* (Cambridge, Mass.: MIT Press, 2001); Spencer R. Weart, *The Discovery of Global Warming* (Cambridge, Mass.: Harvard University Press, 2008); Weart, "The Development of General Circulation Models of Climate," *Studies in History and Philosophy of Modern Physics* 41, no. 3 (2010): 208–17.

14. As if grasping the nomenclature of modeling were not challenging enough, GCM can also abbreviate "global climate model," but the two terms are effectively synonymous in practice.

15. Barbara Herrnstein Smith, *Scandalous Knowledge: Science, Truth, and the Human* (Durham, N.C.: Duke University Press, 2005), 75.

16. Andrew Pickering, *The Mangle of Practice: Time, Agency, and Science* (Chicago: University of Chicago Press, 1995), 181.

17. Simon Shackley, "Epistemic Lifestyles in Climate Change Modeling," in *Changing the Atmosphere: Expert Knowledge and Environmental Governance*, ed. Clark A. Miller and Paul N. Edwards (Cambridge, Mass.: MIT Press, 2001), 118.

18. Edwards, *Vast Machine*, 21, 338.

19. Quoted in Myanna Lahsen, "Seductive Simulations?: Uncertainty Distribution Around Climate Models," *Social Studies of Science* 35, no. 6 (2005): 898.

20. Mary S. Morgan and Margaret Morrison, "Models as Mediating Instruments," in *Models as Mediators: Perspectives on Natural and Social Science*, ed. Mary S. Morgan and Margaret Morrison (New York: Cambridge University Press, 1999), 32.

21. A climate research group might also create ensembles of models to address skepticism about their output. See, for example, Naomi Oreskes, "The Scientific Consensus on Climate Change: How Do We Know We're Not Wrong?," in *Climate Change: What It Means for Us, Our Children, and Our Grandchildren*, ed. Joseph F. C. DiMento and Pamela Doughman (Cambridge, Mass.: MIT Press, 2007), 65–99.

22. IPCC, "Annex I: Glossary," in *Global Warming of 1.5°C. An IPCC Special Report on the Impacts of Global Warming of 1.5°C Above Pre-industrial Levels and Related Global Greenhouse Gas Emission Pathways, in the Context of Strengthening the Global Response to the Threat of Climate Change, Sustainable Development, and Efforts to Eradicate Poverty*, ed. V. Masson-Delmotte et al. (Geneva: IPCC, 2018), 557, https://www.ipcc.ch/site/assets/uploads/sites/2/2019/06/SR15_AnnexI_Glossary .pdf.

23. Noah S. Diffenbaugh and Christopher B. Field, "Changes in Ecologically Critical Terrestrial Climate Conditions," *Science* 341, no. 6145 (2013): 486. On the heuristic versus predictive functions of models, see Mike Hulme, "How Climate Models Gain and Exercise Authority," in *The Social Life of Climate Change Models: Anticipating*

Nature, ed. Kirsten Hastrup and Martin Skrydstrup (New York: Routledge, 2013), 30–44.

24. Paul N. Edwards, "Representing the Global Atmosphere: Computer Models, Data, and Knowledge About Climate Change," in *Changing the Atmosphere: Expert Knowledge and Environmental Governance*, ed. Clark A. Miller and Paul N. Edwards (Cambridge, Mass.: MIT Press, 2001), 62.

25. The Goddard suite is available at https://svs.gsfc.nasa.gov/13142. See Antti Lipponen's Flickr photostream at https://www.flickr.com/photos/150411108@N06/ and Twitter account at https://twitter.com/anttilip/.

26. Geophysical Fluid Dynamics Laboratory, "About GFDL," National Oceanic and Atmospheric Administration, https://www.gfdl.noaa.gov/about/.

27. Edwards, *Vast Machine*, 154–55.

28. On increasing specialization in the modeling enterprise, see Lahsen, "Seductive Simulations."

29. Hulme, "How Climate," 33.

30. The animation is available at https://www.gfdl.noaa.gov/html5-video/?vid=kd&width =940=&height=704&title=Surface%20Air%20Temperature%20Anomalies.

31. Hulme, "How Climate," 39.

32. Rita Raley, *Tactical Media* (Minneapolis: University of Minnesota Press, 2009), 2.

33. Lorraine Daston and Peter Galison, *Objectivity* (New York: Zone, 2007), 17.

34. This is known as the "hue-heat hypothesis": "colours toward the red end of the spectrum (red, orange, yellow) are perceived as warm, while those toward the blue end (blue or green) are perceived as cool." Thomas C. Greene and Paul A. Bell, "Additional Considerations Concerning the Effects of 'Warm' and 'Cool' Wall Colours on Energy Conservation," *Ergonomics* (1980): 949. For critiques of the rainbow and heat colormap defaults in visualization, see Bernice E. Rogowitz and Lloyd A. Treinish, "Data Visualization: The End of the Rainbow," *IEEE Spectrum* 35, no. 12 (1998): 52–59; Francesca Samsel et al., "Colormaps That Improve Perception of High-Resolution Ocean Data," *Proceedings of the 33rd Annual ACM Conference Extended Abstracts on Human Factors in Computing Systems* (2015): 703–10.

35. Kirsten Hastrup, "Anticipating Nature: The Productive Uncertainty of Climate Models," in *The Social Life of Climate Change Models: Anticipating Nature*, ed. Kirsten Hastrup and Martin Skrydstrup (New York: Routledge, 2013), 12.

36. Victoria Finlay neatly captures the emotional and symbolic range of red: "For many cultures red is both death and life—a beautiful and terrible paradox. In our modern language of metaphors, red is anger, it is fire, it is the stormy feelings of the heart, it is love, it is the god of war, and it is power." Finlay, *Color: A Natural History of the Palette* (New York: Random House, 2002), 142.

37. On the emotional properties of color in visualization, see Lyn Bartram, Abhisekh Patra, and Maureen Stone, "Affective Color in Visualization," *Proceedings of the 2017 CHI Conference on Human Factors in Computing Systems* (New York: ACM, 2017), 1364–74.

38. The authors eventually published the diagram separately in Joel B. Smith et al., "Assessing Dangerous Climate Change Through an Update of the Intergovernmental Panel on Climate Change (IPCC) 'Reasons for Concern,'" *Proceedings of the National Academy of Sciences Early Edition* (2009): 1–5. A tempered version of the

diagram appears in IPCC, "Summary for Policymakers," in *Global Warming of 1.5°C,* 11, https://www.ipcc.ch/site/assets/uploads/sites/2/2019/05/SR15_SPM_version_report_LR.pdf. The 2018 version crucially differs from the 2009 version in that the former diagram does not quantify risk and relies only on a color-coded range from "undetectable" (white) to "very high" (purple) risk.

39. Quoted in Birgit Schneider, "Burning Worlds of Cartography: A Critical Approach to Climate Cosmograms of the Anthropocene," *Geo: Geography and Environment* 3, no. 2 (2016): 2.

40. This is one of the main claims of Denis Cosgrove, *Apollo's Eye: A Cartographic Genealogy of the Earth in the Western Imagination* (Baltimore: Johns Hopkins University Press, 2001). I'll have more to say about the aerial in part 3.

41. Lahsen, "Seductive Simulations," 899.

42. "Anomalies" uses a Mollweide projection in which the area, not shape, of continents is accurate. On cartographic projection in modeling, see Birgit Schneider, "Climate Model Simulation Visualization from a Visual Studies Perspective," *Wiley Interdisciplinary Reviews: Climate Change* 2 (2012): 187.

43. Thomas Nocke, "Images for Data Analysis: The Role of Visualization in Climate Research Processes," in *Image Politics of Climate Change: Visualizations, Imaginations, Documentations,* ed. Thomas Nocke and Birgit Schneider (New York: Columbia University Press, 2014), 59.

44. Barbara Maria Stafford, *Good Looking: Essays on the Virtue of Images* (Cambridge, Mass.: MIT Press, 1996), 77.

45. Edwards, *Vast Machine,* xx.

46. Schneider makes a kindred point about how model visualization veers from control to chaos in "Burning Worlds," 13.

47. Hastrup, "Anticipating Nature," 6.

48. Bruno Latour, *Politics of Nature: How to Bring the Sciences into Democracy,* trans. Catherine Porter (Cambridge, Mass.: Harvard University Press, 2004), 246.

49. Juliana Spahr, *well then there now* (Boston: Black Sparrow, 2011), 93.

50. Of course, wealthy nations and communities will construct refuges within climate-ravaged areas, a phenomenon already visible in processes of so-called climate or eco-apartheid.

51. See also Allan Stoekl, "'After the Sublime,' After the Apocalypse: Two Versions of Sustainability in Light of Climate Change," *Diacritics* 41, no. 3 (2013): 40–57.

52. For this account, see especially §27–29 of Immanuel Kant's *The Critique of Judgment* (1790).

53. Sianne Ngai, *Ugly Feelings* (Cambridge, Mass.: Harvard University Press, 2005), 266.

54. See §28 of Kant's *Critique of Judgment.*

55. On this point, see Sianne Ngai, *Our Aesthetic Categories: Zany, Cute, Interesting* (Cambridge, Mass.: Harvard University Press, 2012), 253–54n80.

56. Ngai, *Ugly Feelings,* 271.

57. Ngai, 284.

58. "Visualising Your Carbon Emissions," CarbonSense, accessed February 7, 2017, http://carbonsense.com/carbonvisibility.

59. "What We Do," Carbon Visuals, accessed February 7, 2017, http://www.carbonvisuals.com/what-we-do/. Carbon Visuals was absorbed into the Real World Visuals company in 2016, and the website has since undergone revisions.

270

60. "What We Do," Carbon Visuals, accessed May 29, 2019.
61. *Insight* is a crucial term in visualization practice referring to "the act or outcome of grasping the inward or hidden nature of things or of perceiving in an intuitive manner." Enrico Bertini and Denis Lalanne, "Surveying the Complementary Role of Automatic Data Analysis and Visualization in Knowledge Discovery," in *Proceedings of the ACM SIGKDD Workshop on Visual Analytics and Knowledge Discovery: Integrating Automated Analysis with Interactive Exploration* (New York: ACM, 2009), 13. I discuss insight in Heather Houser, "The Aesthetics of Environmental Visualizations: More than Information Ecstasy?," *Public Culture* 26, no. 2 (2014): 319–37.
62. "New York's Carbon Emissions—in Real Time," Carbon Visuals, June 1, 2014, http://www.carbonvisuals.com/projects/new-yorks-carbon-emissions-in-real-time. Animation available at youtu.be/DtqSIplGXOA/.
63. "New York's Carbon Emissions."
64. Philip Smith and Nicolas Howe, *Climate Change as Social Drama: Global Warming in the Public Sphere* (New York: Cambridge University Press, 2015), 3.
65. See Jonathan Dickinson and Andrea Tenorio, eds., *Inventory of New York City Greenhouse Gas Emissions, September 2011* (New York: Mayor's Office of Long-Term Planning and Sustainability, 2011), https://www1.nyc.gov/assets/sustainability/downloads/pdf/publications/GHG%20Inventory%20Report%20Emission%20Year%202010.pdf.
66. On medicalization, see Heather Houser, *Ecosickness in Contemporary U.S. Fiction: Environment and Affect* (New York: Columbia University Press, 2014).
67. For the forms this trope takes, see Greg Garrard, "Worlds Without Us: Some Types of Disanthropy," *SubStance* 41, no. 1 (2012): 40–60.
68. Raley, *Tactical Media*, 142.
69. Lev Manovich, "Data Visualization as New Abstraction and as Anti-Sublime," in *Small Tech: The Culture of Digital Tools*, ed. David Hawk, David M. Rieder, and Ollie Oviedo (Minneapolis: University of Minnesota Press, 2008), 9.
70. These devices are known variously as carbon footprint, carbon dioxide, and, simply, carbon calculators.
71. James Morton Turner, "Counting Carbon: The Politics of Carbon Footprints and Climate Governance from the Individual to the Global," *Global Environmental Politics* 14, no. 1 (2014): 59–78.
72. The calculators referenced are available from the U.S. Environmental Protection Agency, https://www.epa.gov/ghgemissions/household-carbon-footprint-calculator/; Nature Conservancy, https://www.nature.org/en-us/get-involved/how-to-help/consider-your-impact/carbon-calculator/; and BP Educational Service, https://bpes.bp.com/carbon-footprint-toolkit/.
73. Alessandro Galli et al., "Integrating Ecological, Carbon and Water Footprint Into a 'Footprint Family' of Indicators: Definition and Role in Tracking Human Pressure on the Planet," *Ecological Indicators* 16 (May 2012): 102.
74. Galli et al., 102.
75. Thomas Wiedmann and Jan Minx, "A Definition of 'Carbon Footprint,'" in *Ecological Economics Research Trends*, ed. Carolyn C. Pertsova (New York: Nova Science, 2007), 5. For more detailed explanation of carbon calculator methodologies, see Turner, "Counting Carbon," 65.

76. See Divya Pandey, Madhoolika Agrawal, and Jai Shanker Pandey, "Carbon Footprint: Current Methods of Estimation," *Environmental Monitoring and Assessment* 178, no. 1–4 (2011): 135–60.

77. Available from CoolClimate, https://coolclimate.org/calculator.

78. Turner, "Counting Carbon," 66.

79. Turner, 66.

80. See Paul C. Adams and Astrid Gynnild, "Environmental Messages in Online Media: The Role of Place," *Environmental Communication* 7, no. 1 (2013): 113–30; Galli et al., "Integrating Ecological"; Pandey, Agrawal, and Pandey, "Carbon Footprint."

81. Global Footprint Network, "Media Backgrounder," https://www.footprintnetwork .org/content/images/uploads/Media_Backgrounder_GFN.pdf.

82. Quoted in Wiedmann and Minx, "A Definition of 'Carbon Footprint,'" 4–5, ellipsis and brackets in original.

83. The current calculator is available through the GFN at http://www.footprintcalculator .org/.

84. Turner, "Counting Carbon," 65.

85. Data available at Global Footprint Network, http://data.footprintnetwork.org/# /countryTrends?cn=231&type=earth.

86. For a study of responses to the GFN calculator results, see Adams and Gynnild, "Environmental Messages."

87. Barbara Maria Stafford, *Artful Science: Enlightenment Entertainment and the Eclipse of Visual Education* (Cambridge, Mass.: MIT Press, 1994), 47, xxi.

88. Businesses and governments that partner with carbon consultants are also participating in self-improvement, burnishing their reputations for investment and accolades.

89. David Archer, *The Long Thaw: How Humans Are Changing the Next 100,000 Years of Earth's Climate* (Princeton, N.J.: Princeton University Press, 2009), 113.

2. COMING-OF-MIND IN CLIMATE NARRATIVES

1. Juliana Spahr, *well then there now* (Boston: Black Sparrow, 2011), 82, 92.

2. Adam Trexler dedicates a whole study to the genre: *Anthropocene Fictions: The Novel in a Time of Climate Change* (Charlottesville: University of Virginia Press, 2015). Dan Bloom is credited with coining "cli-fi" and is an avid promoter of the genre.

3. Douglas Mao, *Fateful Beauty: Aesthetic Environments, Juvenile Development, and Literature, 1860–1960* (Princeton, N.J.: Princeton University Press, 2008), 6.

4. Franco Moretti, *The Way of the World: The Bildungsroman in European Culture* (New York: Verso, 1987), 4, 8.

5. Patricia Meyer Spacks, *The Adolescent Idea: Myths of Youth and the Adult Imagination* (New York: Basic Books, 1981), 236. See also Susan Fraiman, *Unbecoming Women: British Women Writers and the Novel of Development* (New York: Columbia University Press, 1993).

6. M. M. Bakhtin, "The *Bildungsroman* and Its Significance in the History of Realism (Toward a Historical Typology of the Novel)," in *Speech Genres and Other Late Essays*, ed. Caryl Emerson and Michael Holquist (Austin: The University of Texas Press, 1986), 21.

7. Fraiman, *Unbecoming Women*, 11, 10.

8. Barbara Kingsolver, *Flight Behavior* (New York: Harper Perennial, 2012), 1. Hereafter cited parenthetically.

9. Over a decade ago Elizabeth Kolbert documented that thirty-five migratory butterfly species in Britain have crept northward, in *Field Notes from a Catastrophe* (New York: Bloomsbury, 2009), 68.

10. On medicalization in environmental fiction, see Heather Houser, *Ecosickness in Contemporary U.S. Fiction: Environment and Affect* (New York: Columbia University Press, 2014).

11. Dipesh Chakrabarty, "Postcolonial Studies and the Challenge of Climate Change," *New Literary History* 43, no. 1 (2012): 11, 12.

12. Quoted in "Senate Dems Stage Landmark Filibuster for Climate Action; Scant Mention of Keystone Decision," *Democracy Now*, March 11, 2014, http://www.democracynow.org/2014/3/11/headlines/senate_dems_stage_landmark_filibuster_for_climate_action_scant_mention_for_keystone_decision.

13. Jeffrey Brower, "Medieval Theories of Relations," *Stanford Encyclopedia of Philosophy*, last revised December 19, 2018, https://plato.stanford.edu/archives/win2018/entries/relations-medieval.

14. Michel Foucault, *The Order of Things: An Archaeology of the Human Sciences* (1966; New York: Vintage, 1994), 21, 26.

15. I study the unexpected outcomes of wonder in chapter 3 of Houser, *Ecosickness*.

16. Noel Castree, "Global Change Research and the 'People Disciplines': Toward a New Dispensation," *South Atlantic Quarterly* 116 (January 2017): 65.

17. Dellarobia's sexual thoughts about Ovid frequently surface in their scientific discourse. See, for example, 317–18.

18. Kari Marie Norgaard, *Living in Denial: Climate Change, Emotions, and Everyday Life* (Cambridge, Mass.: MIT Press, 2011), 53.

19. Candis Callison, *How Climate Change Comes to Matter: The Communal Life of Facts* (Durham, N.C.: Duke University Press, 2014), 20.

20. Ursula Heise, "Encounters with the Thing Formerly Known as Nature," *Public Books*, September 9, 2013, http://www.publicbooks.org/multigenre/encounters-with-the-thing-formerly-known-as-nature.

21. The literature expounding these theories is vast; see Callison, *How Climate*; Susanne C. Moser and Lisa Dilling, eds., *Creating a Climate for Change: Communicating Climate Change and Facilitating Social Change* (Cambridge: Cambridge University Press, 2007); Norgaard, *Living in Denial*; Philip Smith and Nicolas Howe, *Climate Change as Social Drama: Global Warming in the Public Sphere* (New York: Cambridge University Press, 2015).

22. See *Flight Behavior*, 40, 65, 88, 113, 158, 162, 182, 391.

23. Smith and Howe put this predicament thus: "Climate change looks to be a chronic rather than an acute condition" and "people tend to discount future discomfort against current pleasure." *Climate Change*, 3.

24. Dan M. Kahan et al., "The Second National Risk and Culture Study: Making Sense of—and Making Progress in—the American Culture War of Fact," *GWU Legal Studies Research Paper*, no. 370, last updated April 16, 2013, http://dx.doi.org/10.2139/ssrn.1017189.

25. Callison, *How Climate*, 20.

26. Callison, title.
27. Callison, 13.
28. Susan Leigh Star and James R. Griesemer, "Institutional Ecology, 'Translations' and Boundary Objects: Amateurs and Professionals in Berkeley's Museum of Vertebrate Zoology, 1907–39," *Social Studies of Science* 19, no. 3 (1989): 393.
29. Star and Griesemer, 393.
30. For a recent assessment of this danger, see IPCC, *Global Warming of 1.5°C. An IPCC Special Report on the Impacts of Global Warming of 1.5°C Above Pre-industrial Levels and Related Global Greenhouse Gas Emission Pathways, in the Context of Strengthening the Global Response to the Threat of Climate Change, Sustainable Development, and Efforts to Eradicate Poverty*, ed. V. Masson-Delmotte et al. (Geneva: IPCC, 2018).
31. Charles Wohlforth, *The Whale and the Supercomputer: On the Northern Front of Climate Change* (New York: North Point, 2004), 15. Hereafter cited parenthetically.
32. Kirsten Hastrup, "Anticipation on Thin Ice: Diagrammatic Reasoning in the High Arctic," in *The Social Life of Climate Change Models: Anticipating Nature*, ed. Kirsten Hastrup and Martin Skrydstrup (New York: Routledge, 2013), 77–78.
33. See, for example, books by Naomi Klein, Elizabeth Kolbert, Bill McKibben, Rebecca Solnit, and Naomi Oreskes and Erik Conway.
34. Karin Knorr Cetina, *Epistemic Cultures: How the Sciences Make Knowledge* (Cambridge, Mass.: Harvard University Press, 1999), 1.
35. Fikret Berkes quoted in Clarence Alexander et al., "Linking Indigenous and Scientific Knowledge of Climate Change," *BioScience* 61, no. 6 (2011): 477.
36. Julie Cruikshank, *Do Glaciers Listen?: Local Knowledge, Colonial Encounters, and Social Imagination* (Vancouver: UBC Press, 2005), 10, 257.
37. Callison, *How Climate*, 56. See Alexander et al., "Linking Indigenous"; Chie Sakakibara, "People of the Whales: Climate Change and Cultural Resilience Among Iñupiat of Arctic Alaska," *Geographical Review* 107, no. 1 (2017): 159–84; Kyle Whyte, "Indigenous Climate Change Studies: Indigenizing Futures, Decolonizing the Anthropocene," *English Language Notes* 55, no. 1–2 (2017): 153–62.
38. Sakakibara, "People of the Whales," 160.
39. Callison, *How Climate*, 30.
40. Whyte, "Indigenous Climate Change," 157.
41. Whyte, 154.
42. Report of the Marine Mammal Commission on the Impacts of Changes in Sea Ice and Other Environmental Parameters in the Arctic, quoted in Callison, *How Climate*, 61. See also Alexander et al., "Linking Indigenous," 483, on how indigenous narratives complement peer-reviewed climate studies and geographical information technologies to "promote an expanded and multidimensional picture of the impacts of climate change."
43. Callison, *How Climate*, 56.
44. Mike Hulme, "'Telling a Different Tale': Literary, Historical and Meteorological Readings of a Norfolk Heatwave," *Climatic Change* 113, no. 1 (2012): 6.
45. Callison, *How Climate*, 62.
46. Callison, 139.
47. For a comprehensive description of climate change fiction of the past several decades, see Trexler, *Anthropocene*.

48. Trexler, 35.
49. Jamie Wilson, "Novel Take on Global Warming," *Guardian*, September 29, 2005, https://www.theguardian.com/environment/2005/sep/29/comment.bookscomment.
50. Author's notes appear in Spahr, Kingsolver, and Crichton, among other works, and would appear to be an essential paratext of creative climate writing. It's as if the climate infowhelm floods the text and pushes beyond its bounds.
51. Michael Crichton, *State of Fear* (London: HarperCollins, 2004), 678. Hereafter cited parenthetically.
52. I won't refute Crichton here because others have ably done so; see Brenda Ekwurzel, "Crichton Thriller *State of Fear*," Union of Concerned Scientists, 2005, http://www.ucsusa.org/global_warming/solutions/fight-misinformation/crichton-thriller-state-of.html; David B. Sandalow, "Michael Crichton and Global Warming," Brookings Institution, January 28, 2005, http://www.brookings.edu/research/opinions/2005/01/28energy-sandalow; Gavin Schmidt, "Michael Crichton's State of Confusion," RealClimate, December 13, 2004, http://www.realclimate.org/index.php?p=74.
53. The irony here is that this is precisely what the petroleum industry has done in the interest of climate denial, as Naomi Oreskes and Erik Conway show in *Merchants of Doubt: How a Handful of Scientists Obscured the Truth on Issues from Tobacco Smoke to Global Warming* (New York: Bloomsbury, 2010).
54. "Vanutu" may be an invented place or a misspelling of the real Pacific island nation of Vanuatu.
55. Scott Slovic analyzes how *State of Fear* builds trust in deniers and undermines trust in science, in "Science, Eloquence, and the Asymmetry of Trust: What's at Stake in Climate Change," in *Numbers and Nerves: Information, Emotion, and Meaning in a World of Data*, ed. Paul Slovic and Scott Slovic (Corvallis: Oregon State University Press, 2015), 115–35.
56. Libby Robin and William Steffen, "History for the Anthropocene," *History Compass* 5, no. 5 (2007): 1710.
57. Crichton states a kind of liar's paradox in the "Author's Message": "Everybody has an agenda. Except me" (680).
58. On *State of Fear*'s inconsistencies, see Trexler, *Anthropocene*, 38–40.

PREFACE, PART 2

1. The most famous among these is Carl Linnaeus's *Species Plantarum* (1753).
2. Juliana Spahr, *well then there now* (Boston: Black Sparrow, 2011), 55. Hereafter cited parenthetically. In a long note Spahr explains she ran drafts of the poem "*through the altavista translation machine . . . and translated my English words between the languages that came to the Pacific from somewhere else: French, Spanish, German and Portuguese*" (71). Following this digital manipulation, Spahr weaves the snippets of text together.
3. Paul Lawrence Farber, *Finding Order in Nature: The Naturalist Tradition from Linnaeus to E. O. Wilson* (Baltimore: Johns Hopkins University Press, 2000), 1–2.
4. I have more to say about these epistemological habits in the ensuing chapters.
5. An early, influential monograph in the field is Jonathan S. Adams, *The Future of the Wild: Radical Conservation for a Crowded World* (Boston: Beacon, 2006).

6. To take just one recent study, which also references classical naturalism: "research-
ers found that about 1,234 species had been reported extinct since the publication
of Carl Linnaeus's compendium of plant species, *Species Plantarum*, in 1753. But
more than half of those species were either rediscovered or reclassified as another
living species, meaning 571 are still presumed extinct." Heidi Ledford, "World's
Largest Plant Survey Reveals Alarming Extinction Rate," *Nature* 570, no. 7760 (2019):
148.

7. Quentin D. Wheeler, "Introductory: Toward the New Taxonomy," in *The New Tax-
onomy*, ed. Quentin D. Wheeler (Boca Raton, Fla.: CBC, 2008), 10.

8. Geoffrey C. Bowker and Susan Leigh Star, *Sorting Things Out: Classification and Its
Consequences* (Cambridge, Mass.: MIT Press, 1999), 10, 3, 44.

9. Farber, *Finding Order*, 2.

10. Michel Foucault, *The Order of Things: An Archaeology of the Human Sciences* (1966;
New York: Vintage, 1994), 158.

11. Mary Louise Pratt, *Imperial Eyes: Travel Writing and Transculturation*, 2nd ed. (1992;
New York: Routledge, 2008), 4, 31.

12. Kathryn Yusoff, *A Billion Black Anthropocenes or None* (Minneapolis: University
of Minnesota Press, 2018), loc. 109, 119, 1388 of 1943, Kindle.

13. Letter from Alexander Garden to Linnaeus, quoted in Susan Scott Parrish, *Ameri-
can Curiosity: Cultures of Natural History in the Colonial British Atlantic World*
(Chapel Hill: University of North Carolina Press, 2006), 7n7.

14. Christoph Irmscher, *The Poetics of Natural History: From John Bartram to William
James* (New Brunswick, N.J.: Rutgers University Press, 1999), 6; Monique Allewaert,
Ariel's Ecology: Plantations, Personhood, and Colonialism in the American Tropics
(Minneapolis: University of Minnesota Press, 2013).

15. Aaron Sachs, *The Humboldt Current: Nineteenth-Century Exploration and the Roots
of American Environmentalism* (New York: Penguin, 2006).

16. For more on these controversies, see Geoffrey C. Bowker, *Memory Practices in the
Sciences* (Cambridge, Mass.: MIT Press, 2005); Farber, *Finding Order*, 126f; Foucault,
Order of Things; Harriet Ritvo, *The Platypus and the Mermaid and Other Figments
of the Classifying Imagination* (Cambridge, Mass.: Harvard University Press, 1997).
Buffon's vituperative comments against Linnaeus, published in 1749, also give a taste
of the contentious atmosphere surrounding these queries; see Georges Louis Leclerc,
comte de Buffon, and John Lyon, "The 'Initial Discourse' to Buffon's 'Histoire
Naturelle': The First Complete English Translation," *Journal of the History of Biol-
ogy* 9, no. 1 (1976): 151.

17. *Topographie* first appeared as a pamphlet to accompany an exhibition of Spoer-
ri's "snare-pictures," which are "objects found in chance positions, in order or
disorder . . . fixed ('snared') as they are." Daniel Spoerri, *An Anecdoted Topogra-
phy of Chance (Re-Anecdoted Version)*, trans. Emmett Williams (1962; New York:
Something Else, 1966), 181. Hereafter cited parenthetically.

18. Spoerri is not alone among his avant-garde colleagues in pursuing the productive
limitations of classification. See also Jorge Luis Borges's "On Exactitude in Science,"
"Pierre Menard, Author of the Quixote," and "The Analytical Language of John
Wilkins," among other stories, in *Collected Fictions*, trans. Andrew Hurley (1944;
New York: Penguin, 1998); Georges Perec, "Think/Classify," in *Species of Spaces and
Other Pieces*, ed. and trans. John Sturrock (1982; New York: Penguin, 1999).

19. Michael Smithson, "Social Theories of Ignorance," in *Agnotology: The Making and Unmaking of Ignorance*, ed. Londa Schiebinger and Robert N. Proctor (Stanford: Stanford University Press, 2008), 210.

3. CLASSIFICTIONS

1. Cormac McCarthy, *Blood Meridian, or, the Evening Redness in the West* (New York: Vintage, 1985), 127.
2. My thanks to Delia Byrnes for encouraging me to call out this feature of the titles.
3. See also Julian Barnes's *Flaubert's Parrot* (1984), Richard Flanagan's *Gould's Book of Fish* (2001), Elizabeth Gilbert's *The Signature of All Things* (2013), Leslie Marmon Silko's *Gardens in the Dunes* (1999), and Hanya Yanagihara's *The People in the Trees* (2013). In the domain of poetry, Timothy Donnelly, Jynne Dilling Martin, Lisa Olstein, Tommy Pico, Eleanor Stanford, and Jeffrey Yang contribute to new naturalism.
4. My concern with narration overlaps here and in chapter 6 with Kate Marshall's in her forthcoming *Novels by Aliens*. We both investigate contemporary writers' appeals to nineteenth-century intellectual and cultural forms as they experiment with what Marshall terms "nonhuman narration." Marshall, "The Old Weird," *Modernism/Modernity* 23, no. 3 (2016): 638.
5. McCarthy, *Blood Meridian*, 36. Hereafter cited parenthetically.
6. On imperialism in *Blood Meridian*, see Dan Sinykin, "Evening in America: *Blood Meridian* and the Origins and Ends of Imperial Capitalism," *American Literary History* 28, no. 2 (2016): 362–80.
7. McCarthy's oeuvre is full of assertions that more worlds exist than the one we inhabit. On this trope, see David Holmberg, "'In a Time before Nomenclature Was and Each Was All': *Blood Meridian*'s Neomythic West and the Heterotopian Zone," *Western American Literature* 44, no. 2 (2009): 140–56.
8. This line underscores Dana Phillips's point that McCarthy is "a writer not of the 'modern' or 'postmodern' eras but of the Holocene, with a strong historical interest in the late Pleistocene and even earlier epochs." Phillips, "History and the Ugly Facts of Cormac McCarthy's *Blood Meridian*," *American Literature* 68, no. 2 (1996): 452. In this respect, we might think of him as a progenitor of the literary mode Kate Marshall defines as "new novels of a newly self-aware geological epoch" in "What Are the Novels of the Anthropocene? American Fiction in Geological Time," *American Literary History* 27, no. 3 (2015): 524.
9. Quoted in Phillips, "History and the Ugly Facts," 443.
10. Georg Guillemin, *The Pastoral Vision of Cormac McCarthy* (College Station: Texas A&M University Press, 2004), 78; Mark McGurl, "The New Cultural Geology," *Twentieth-Century Literature* 57, no. 3–4 (2011): 382.
11. Ann Banfield, "Describing the Unobserved: Events Grouped Around an Empty Centre," in *The Linguistics of Writing: Arguments Between Language and Literature*, ed. Nigel Fabb et al. (New York: Methuen, 1987), 276, 266, 274.
12. My point also accords with Phillips's that "traditional concepts of the narrator as a 'person' or 'voice' . . . do not apply to *Blood Meridian*" in "History and the Ugly Facts," 443.
13. Banfield, "Describing," 266.

14. See, for instance, pp. 45, 109, 148, and 163.
15. Take, for example, passives such as "they were stood" (98), prolepses such as "there [was] tattooed a number which Toadvine would see . . . when he would cut down the man's torso" (87–88), and tense shifts evident in this verb progression: "Only now *is* the child finally divested. . . . His origins *are become* remote . . . and not again in all the world's turning *will there be*" (4, my italics).
16. On the title, see Sinykin, "Evening," 362–63.
17. Phillips, "History and the Ugly Facts," 442.
18. Reif Larsen, *The Selected Works of T. S. Spivet* (New York: Penguin, 2009), 143. Hereafter cited parenthetically.
19. Sianne Ngai, *Ugly Feelings* (Cambridge, Mass.: Harvard University Press, 2005), 28.
20. Larsen appears to have invented this beetle species and nomenclature.
21. Lorraine Daston and Peter Galison, *Objectivity* (New York: Zone, 2007), 40–41.
22. Lorraine Daston, "Description by Omission: Nature Enlightened and Obscured," in *Regimes of Description: In the Archive of the Eighteenth Century*, ed. John Bender and Michael Marrinan (Stanford: Stanford University Press, 2005), 16.
23. Londa Schiebinger, *Plants and Empire: Colonial Bioprospecting in the Atlantic World* (Cambridge, Mass.: Harvard University Press, 2004), 195.
24. For an engaging account of this process, see Wallace Stegner, *Beyond the Hundredth Meridian: John Wesley Powell and the Second Opening of the West* (Boston: Houghton Mifflin, 1954; New York: Penguin, 1992).
25. Daston and Galison, *Objectivity*, 17, 63, 60.
26. Susan Stewart, *On Longing: Narratives of the Miniature, the Gigantic, the Souvenir, the Collection* (Durham, N.C.: Duke University Press, 1993), 23.
27. David L. Eng and David Kazanjian, "Introduction: Mourning Remains," in *Loss: The Politics of Mourning*, ed. David L. Eng and David Kazanjian (Berkeley: University of California Press, 2003), 3–4.
28. On spatial simultaneity and grief, see Judith Butler, "Afterword: After Loss, What Then?," in *Loss: The Politics of Mourning*, ed. David L. Eng and David Kazanjian (Berkeley: University of California Press, 2003), 467–73.
29. William Cronon, "The Trouble with Wilderness; Or, Getting Back to the Wrong Nature," in *Uncommon Ground: Rethinking the Human Place in Nature*, ed. William Cronon (New York: Norton, 1995), 80.
30. Ashlee Cunsolo and Neville S. Ellis, "Ecological Grief as a Mental Health Response to Climate Change-Related Loss," *Nature Climate Change* 8 (April 2018): 279.
31. Tim Lanzendörfer, "Irreducible Complexity: The Ironies of Reif Larsen's *The Selected Works of T. S. Spivet*," *Post45 Peer Reviewed*, October 2, 2014, http://post45.research .yale.edu/2014/10/irreducible-complexity-the-ironies-of-reif-larsens-the-selected -works-of-t-s-spivet/.
32. Because grief for these environmental losses is ongoing, *Spivet*'s ending rings false. I share Ron Charles's opinion that "the boy's complicated, emotionally fraught troubles with his parents, which have been so sensitively developed throughout the story, evaporate into gassy sentimentality." Ron Charles, review of *The Selected Works of T. S. Spivet*, by Reif Larsen, *Washington Post*, May 6, 2009, http:// www.washingtonpost.com/wp-dyn/content/article/2009/05/05/AR2009050503817 .html.

33. Verlyn Klinkenborg, *Timothy; or, Notes of an Abject Reptile* (New York: Vintage, 2006), 159. Hereafter cited parenthetically.

34. Brian Ogilvie, *The Science of Describing: Natural History in Renaissance Europe* (Chicago: University of Chicago Press, 2008), 5.

35. For a fascinating study of this point, see Mel Y. Chen, *Animacies: Biopolitics, Racial Mattering, and Queer Affect* (Durham, N.C.: Duke University Press, 2012), chap. 2.

36. Schiebinger, *Plants and Empire*, 195.

37. Thomas Richards, *The Imperial Archive: Knowledge and the Fantasy of Empire* (New York: Verso, 1993), 1.

38. Cunsolo and Ellis, "Ecological Grief," 276.

39. Jonathan Flatley, *Affective Mapping: Melancholia and the Politics of Modernism* (Cambridge, Mass.: Harvard University Press, 2008), 3.

40. Flatley, 3.

4. VISUALIZING LOSS FOR A "FRAGMENTED SURVIVAL"

1. The Natural History Museum, "About: The Natural History Museum," http://thenaturalhistorymuseum.org/about/. List of advisory board members as of November 15, 2019.

2. Mieke Bal, "Telling, Showing, Showing Off," *Critical Inquiry* 18, no. 3 (1992): 588, 560.

3. Mark Jacobson, "Nature Boy," *New York Magazine*, October 21, 2002, http://nymag.com/nymetro/arts/art/n_7839/.

4. See Mark Dion, Natacha Pugnet, and Magnus Jensner, *Mark Dion: The Natural History of the Museum*, trans. Thomas Andersson, William Jewson, and Charles Penwarden (Paris: Archibooks, 2007); Bénédicte Ramade, "Mark Dion: Curiosité Naturelle," *L'oeil* (2007): 72–75.

5. Maria Whiteman, "Taxonomia: A Photo Essay," *Minnesota Review* 78 (N.S.) (2012): 58.

6. Richard Conniff, "Our Natural History, Endangered," *New York Times*, April 3, 2016, http://www.nytimes.com/2016/04/03/opinion/ournatural-history-endangered.html/.

7. Whiteman, "Taxonomia," 57.

8. Wordsworth quoted in Margaret Ronda, "Mourning and Melancholia in the Anthropocene," *Post45 Peer Reviewed*, June 10, 2013, http://post45.research.yale.edu/2013/06/mourning-and-melancholia-in-the-anthropocene/.

9. Ursula K. Heise, *Imagining Extinction: The Cultural Meanings of Endangered Species* (Chicago: University of Chicago Press, 2016), 13.

10. Phrase drawn from Emma Marris, *Rambunctious Garden: Saving Nature in a Post-Wild World* (New York: Bloomsbury, 2011).

11. Christopher Looby, "The Constitution of Nature: Taxonomy as Politics in Jefferson, Peale, and Bartram," *Early American Literature* 22, no. 3 (1987): 258.

12. James Prosek, "The Failure of Names," *Orion*, March/April 2008, 48, https://orionmagazine.org/article/the-failure-of-names/.

13. "Un-Natural History" exhibited at the Bellarmine Museum of Art, Fairfield University, Fairfield, Conn., from October 21 to December 21, 2011.

14. James Prosek, email message to author, February 24, 2015.
15. The "Taxonomy" section elaborates: "Some authorities have preferred to maintain the parrotfishes as a family-level taxon." Wikipedia, s.v. "Parrotfish," last modified July 10, 2019, https://en.wikipedia.org/wiki/Parrotfish.
16. Bellarmine Museum of Art, *James Prosek: Un-Natural History* (Fairfield, Conn.: Bellarmine Museum of Art, Fairfield University, 2011), exhibition catalog, 7, http://www.troutsite.com/pdf/Bellarmine_exhibition_catalog.pdf.
17. On Audubon's composition methods, see Christoph Irmscher, *The Poetics of Natural History: From John Bartram to William James* (New Brunswick, N.J.: Rutgers University Press, 1999), 217–32.
18. Robert Penn Warren quoted in Irmscher, 207.
19. Bellarmine Museum of Art, *James Prosek*, 7.
20. Timothy Morton, *Ecology Without Nature: Rethinking Environmental Aesthetics* (Cambridge, Mass.: Harvard University Press, 2007), 31.
21. Lorraine Daston and Peter Galison, *Objectivity* (New York: Zone, 2007), 17.
22. Irmscher, *Poetics*, 8.
23. Harriet Ritvo, *The Platypus and the Mermaid and Other Figments of the Classifying Imagination* (Cambridge, Mass.: Harvard University Press, 1997), 130.
24. In another *Cockatool*, from 2011, these tools appear in place of the bird's primary feathers.
25. Geoffrey C. Bowker and Susan Leigh Star, *Sorting Things Out: Classification and Its Consequences* (Cambridge, Mass.: MIT Press, 1999), 31.
26. Lorraine Daston, "Type Specimens and Scientific Memory," *Critical Inquiry* 31, no. 1 (2004): 155–56, 158, 179.
27. In this respect, Prosek's paintings anticipate the speculative fictions I study in chapter 6.
28. Anna Lowenhaupt Tsing, "Blasted Landscapes (and the Gentle Arts of Mushroom Picking)," in *The Multispecies Salon*, ed. Eben Kirksey (Durham, N.C.: Duke University Press, 2014), 92.
29. Bowker and Star, *Sorting*, 313.
30. Jamie Lorimer, *Wildlife in the Anthropocene: Conservation After Nature* (Minneapolis: University of Minnesota Press, 2015), 9.
31. National Audubon Society, "History of Audubon and Science-Based Bird Conservation," Audubon.org, http://www.audubon.org/content/history-audubon-and-waterbird-conservation.
32. Lynne Hoppe, ed., *Audubon Annual Report 2013: Visualizing the Future of Conservation* (New York: National Audubon Society, Inc., 2013), 16, http://www.audubon.org/sites/default/files/documents/2013_annual_report_low-res.pdf.
33. Hoppe, 2, 14.
34. Jennifer Gabrys, *Program Earth: Environmental Sensing Technology and the Making of a Computational Planet* (Minneapolis: University of Minnesota Press, 2016), 19.
35. Gabrys, 3–4.
36. Hoppe, *Audubon Annual Report*, 14–18.
37. Gabrys, *Program Earth*, 129.
38. Johanna Drucker, *Graphesis: Visual Forms of Knowledge Production* (Cambridge, Mass.: Harvard University Press, 2014), [7].

39. Hoppe, *Audubon Annual Report*, 2.
40. Drucker, *Graphesis*, 65.
41. Bryan James, *In Pieces*, 2015, http://species-in-pieces.com/.
42. IUCN, The IUCN Red List of Threatened Species, version 2019-2, accessed November 15, 2019, https://www.iucnredlist.org. According to IUCN's methodology, "threatened" encompasses the "critically endangered," "endangered," and "vulnerable" categories; see IUCN, "Summary Statistics," version 2019-2, accessed November 15, 2019, https://www.iucnredlist.org/resources/summary-statistics.
43. "What Is EDGE?," EDGE of Existence, https://www.edgeofexistence.org/what-is -edge/. For more on their methodology, see "EDGE Science," EDGE of Existence, https://www.edgeofexistence.org/science/.
44. Ursula K. Heise, "Lost Dogs, Last Birds, and Listed Species: Cultures of Extinction," *Configurations* 18, no. 1–2 (2010): 53.
45. Geoffrey C. Bowker, *Memory Practices in the Sciences* (Cambridge, Mass.: MIT Press, 2005), 149, 141.
46. On the guiding principles and key challenges of extinction science, see also Heise, *Imagining Extinction*; Dan L. Perlman and Glenn Adelson, *Biodiversity: Exploring Values and Priorities in Conservation* (Malden, Mass.: Blackwell Science, 1997).
47. Lorimer, *Wildlife*, 40.
48. Frédéric Ducarme, Gloria M. Luque, and Franck Courchamp, "What Are 'Charismatic Species' for Conservation Biologists?," *BioSciences Master Reviews* (July 2013): 2.
49. Lorimer, *Wildlife*, 58.
50. On multispecies biopolitics, see Cary Wolfe, *Before the Law: Humans and Other Animals in a Biopolitical Frame* (Chicago: University of Chicago Press, 2012); Rafi Youatt, *Counting Species: Biodiversity in Global Environmental Politics* (Minneapolis: University of Minnesota Press, 2015).
51. Michel Foucault, *The History of Sexuality*, vol. 1: *An Introduction*, trans. Robert Hurley (New York: Pantheon 1978; Vintage, 1990), 1, 143.
52. Ian Hacking, "Our Neo-Cartesian Bodies in Parts," *Critical Inquiry* 34 (Autumn 2007): 78.
53. James, *In Pieces*.
54. See Jonathan S. Adams, *The Future of the Wild: Radical Conservation for a Crowded World* (Boston: Beacon, 2006); Ben A. Minteer, *The Fall of the Wild: Extinction, De-Extinction, and the Ethics of Conservation* (New York: Columbia University Press, 2019).
55. Marris, *Rambunctious Garden*, 125.
56. Juliana Spahr, *well then there now* (Boston: Black Sparrow, 2011), 86.
57. Heise, *Imagining Extinction*, 208.
58. From splash screen of Maya Lin, *What Is Missing?*, 2010–, http://www.whatismissing .net/. The interpretations in this chapter are based on the 2016 relaunch of *What Is Missing?*, though some content is dated more recently.
59. Maya Lin, "About Us," *What Is Missing?*, 2018, http://whatismissing.net/info /about-us.
60. Bowker, *Memory Practices*, 7.
61. Among the entities memorialized in this view are Earth (period of endangerment beginning in 2010); clean oceans (2012); and "animal migrations in the air, on land, and in the sea" (2010).

62. "Island Extinctions, Mauritius 1662–1975," *What Is Missing?*, https://www.whatismissing.net/timeline/island-extinctions-mauritius.
63. Rita Raley, *Tactical Media* (Minneapolis: University of Minnesota Press, 2009), 103.
64. Sarah Chihaya, "What Is Missing: Cataloguing the End," *ASAP/Journal* 3, no. 3 (2018): 585.
65. The video screened at the REDD+ (Reducing Emissions from Deforestation and Degradation) gala at COP15.
66. Lin, "About Us."
67. These modules are labeled "What You Can Do," "Greenprint," and "Save 2 Birds" in the version of *WIM* accessed in November 2019.
68. Geoffrey C. Bowker, "Biodiversity Datadiversity," *Social Studies of Science* 30 (2000): 643–83. Ursula Heise describes a similar concept and refers to it as "'interdata' or 'convergence data'" in *Imagining Extinction*, 65.
69. Bowker, *Memory Practices*, 15.
70. Bowker, "Biodiversity Datadiversity," 645, 667.
71. Heise, *Imagining Extinction*, 65.
72. Lauren R. Kolodziejski, "*What Is Missing?* Reflections on the Human–Nature Relationship in Maya Lin's Final Memorial," *Environmental Communication* 9, no. 4 (2015): 441.
73. Bowker, *Memory Practices*, 9.
74. Susan Stewart, *On Longing: Narratives of the Miniature, the Gigantic, the Souvenir, the Collection* (Durham, N.C.: Duke University Press, 1993).
75. Stewart, 151.
76. Stewart, 23.
77. Reif Larsen, *The Selected Works of T. S. Spivet* (New York: Penguin, 2009), 15.
78. Timothy Morton, "The Dark Ecology of Elegy," in *The Oxford Handbook of the Elegy*, ed. Karen Weisman (Oxford: Oxford University Press, 2010), 254.
79. Chihaya's reading of *WIM* shares my interest in the project's temporalities. "The ecological apocalypse . . . is now—and then—and now," she notes; *WIM* is "a work that imaginatively positions itself simultaneously in the midst of ongoing planetary crisis and at, or even after, its end." "What Is Missing," 574, 577.
80. Catriona Mortimer-Sandilands, "Melancholy Natures, Queer Ecologies," in *Queer Ecologies: Sex, Nature, Politics, Desire*, ed. Mortimer-Sandilands and Bruce Erickson (Bloomington: Indiana University Press, 2010), 333, 342.
81. Sigmund Freud, "Mourning and Melancholia (1917)," in *The Standard Edition of the Complete Psychological Works of Sigmund Freud*, ed. and trans. James Strachey (London: Hogarth, 1955), 245, 253.
82. Stewart, *On Longing*, 152.
83. Quoted phrase taken from Eben Kirksey, Brandon Costelloe-Kuehn, and Dorion Sagan, "Life in the Age of Biotechnology," in *The Multispecies Salon*, ed. Eben Kirksey (Durham, N.C.: Duke University Press, 2014), 185–220.
84. Marcus Canning also collaborated on designing the vessels used in *NoArk*.
85. The Tissue Culture & Art Project (TCA), *NoArk*, 2007, https://tcaproject.net/portfolio/noark/.
86. Allison Carruth, "Culturing Food: Bioart and In Vitro Meat," *Parallax* 19, no. 1 (2013): 89.
87. TCA, *NoArk*.

88. Fundación Telefónica, "Vida Art and Artificial Life International Awards: *NoArk*," December 3, 2012, https://vida.fundaciontelefonica.com/en/project/noark/.

89. Kirksey, Costelloe-Kuehn, and Sagan, "Life," 198–99.

90. Kirksey, Costelloe-Kuehn, and Sagan, 185.

91. Quoted in Evelyn Tsitas, "Tissue Culture and Art Project, by Oron Catts and Ionat Zurr," https://www.rmit.edu.au/about/our-locations-and-facilities/facilities /exhibition-spaces/rmit-gallery/news-and-media-releases/2009/november/tissue -culture-and-art-project.

92. Karin Knorr Cetina, *Epistemic Cultures: How the Sciences Make Knowledge* (Cambridge, Mass: Harvard University Press, 1999), 64. For a related study of uncertainty in the sciences, see Peter Galison and David J. Stump, eds., *The Disunity of Science: Boundaries, Contexts, and Power* (Stanford: Stanford University Press, 1996).

93. Roy Dilley, "Reflections on Knowledge Practices and the Problem of Ignorance," *Journal of the Royal Anthropological Institute (N.S.)* 16 (2010): 176–92; Londa Schiebinger and Robert N. Proctor, eds., *Agnotology: The Making and Unmaking of Ignorance* (Stanford: Stanford University Press, 2008). I see calls to become "undisciplined" as a related trend within cultural theory that I take up in the epilogue.

94. Robert N. Proctor, "Agnotology: A Missing Term to Describe the Cultural Production of Ignorance (and Its Study)," in *Agnotology: The Making and Unmaking of Ignorance*, ed. Londa Schiebinger and Robert N. Proctor (Stanford: Stanford University Press, 2008), 5.

95. From F. T. Marinetti's "Manifesto of Futurism," English translation published in *Le Figaro*, February 20, 1909.

96. Stuart Firestein, *Ignorance: How It Drives Science* (New York: Oxford University Press, 2012), 45.

97. Anahid Nersessian, "Literary Agnotology," *ELH* 84, no. 2 (2017): 356.

PREFACE, PART 3

1. Juliana Spahr, *well then there now* (Boston: Black Sparrow, 2011), 19. Hereafter cited parenthetically.

2. William Park, "The Ancient Peruvian Mystery Solved from Space," BBC Future, April 8, 2016, http://www.bbc.com/future/story/20160408-the-ancient-peruvian -mystery-solved-from-space.

3. Margaret Wickens Pearce and Renee Pualani Louis, "Mapping Indigenous Depth of Place," *American Indian Culture and Research Journal* 32, no. 3 (2008): 107.

4. Robert A. Rundstrom, "GIS, Indigenous Peoples, and Epistemological Diversity," *Cartography and Geographic Information Systems* 22, no. 1 (1995): 45. On indigenous uses of geographical technomedia, see also Mac Chapin, Zachary Lamb, and Bill Threlkeld, "Mapping Indigenous Lands," *Annual Review of Anthropology* 34 (2005): 619–39; Mark H. Palmer, "Engaging with *Indigital* Geographic Information Networks," *Futures* 41 (2008): 33–40. For an instructive study that contests "the supposed planned and rational character of technoscientific knowledge" obtained through cartographic, engineering, and other practices, see David Turnbull, *Masons, Tricksters and Cartographers: Comparative Studies in the Sociology of Scientific and Indigenous Knowledge* (Amsterdam: Harwood Academic, 2000).

5. Rundstrom, "GIS," 46.
6. Pearce and Louis, "Mapping," 111.
7. Rita Raley, *Tactical Media* (Minneapolis: University of Minnesota Press, 2009), 6.
8. See Caren Kaplan, *Aerial Aftermaths: Wartime from Above* (Durham, N.C.: Duke University Press, 2018); Mary Louise Pratt, *Imperial Eyes: Travel Writing and Transculturation*, 2nd ed. (1992; New York: Routledge, 2008); Paul K. Saint-Amour, *Tense Future: Modernism, Total War, Encyclopedic Form* (New York: Oxford University Press, 2015); Paul Virilio, *War and Cinema: The Logistics of Perception*, trans. Patrick Camiller (1984; London: Verso, 1989).
9. While the first two terms are hard to pin down, the others are attributable to, respectively, Denis Cosgrove, Mary Louise Pratt, John Pickles, Bruce Robbins, Thomas Nagel via Donna Haraway, Jennifer Gabrys, Paul Virilio, Helen Couclelis, and Theodor Adorno.
10. See Palmer, "Engaging with *Indigital*."
11. Denis Cosgrove, *Apollo's Eye: A Cartographic Genealogy of the Earth in the Western Imagination* (Baltimore: Johns Hopkins University Press, 2001), x.
12. Studies of the canonization of vision—and its "denigration"— are thick on the ground. See Nicole Fleetwood, *Troubling Vision: Performance, Visuality, and Blackness* (Chicago: University of Chicago Press, 2011); Hal Foster, ed., *Vision and Visuality* (Seattle: Bay, 1988); Martin Jay, *Downcast Eyes: The Denigration of Vision in Twentieth-Century French Thought* (Berkeley: University of California Press, 1993); Nicholas Mirzoeff, *The Right to Look: A Counterhistory of Visuality* (Durham, N.C.: Duke University Press, 2011); Barbara Maria Stafford, *Good Looking: Essays on the Virtue of Images* (Cambridge, Mass.: MIT Press, 1996).
13. Pratt, *Imperial Eyes*, 198, 197.
14. Jenifer Van Vleck, *Empire of the Air: Aviation and the American Ascendency* (Cambridge, Mass.: Harvard University Press, 2013), 11.
15. Aerial photography from kites followed the balloon vogue with Arthur Batut's photographs in the 1880s.
16. Bruce Robbins, *Feeling Global: Internationalism in Distress* (New York: New York University Press, 1999), 2.
17. Virilio, *War and Cinema*, 88.
18. Elizabeth DeLoughrey, "Satellite Planetarity and the Ends of the Earth," *Public Culture* 26, no. 2 (2014): 258. Ecocritics are increasingly studying the entanglements of militarism, surveillance, and environmental management; see Robert P. Marzec, *Militarizing the Environment: Climate Change and the Security State* (Minneapolis: University of Minnesota Press, 2015).
19. Kaplan, *Aerial Aftermaths*, 29. Kaplan shares my interest not only in the idea of the aftermath, though in the context of war rather than environmental crisis, but also in how aerial technomedia do not "simply sit on one side or the other between . . . the division between evidence and affect, intention and accident, fact and aura" (181).
20. Quoted in DeLoughrey, "Satellite," 257.
21. Lisa Parks, *Cultures in Orbit: Satellites and the Televisual* (Durham, N.C.: Duke University Press, 2005), 78. Landsat endures: NASA and the U.S. Geological Survey plan to launch Landsat 9 in 2020.
22. John Pickles, *A History of Spaces: Cartographic Reason, Mapping and the Geo-Coded World* (London: Routledge, 2004), 80.

23. Laura Kurgan, *Close Up at a Distance: Mapping, Technology, and Politics* (Brooklyn, N.Y.: Zone, 2013), 40.

24. For a survey of the uses and responses to new geovisualization technologies, see the triptych of articles by Sarah Elwood beginning with "Geographic Information Science: New Geovisualization Technologies—Emerging Questions and Linkages with GIScience Research," *Progress in Human Geography* 33, no. 2 (2009): 256–63.

25. For a taste of this art practice, see Janet Abrams and Peter Hall, eds., *Else/Where: Mapping New Cartographies of Networks and Territories* (Minneapolis: University of Minnesota Design Institute, 2006); Lize Mogel and Alexis Bhagat, eds., *An Atlas of Radical Cartography* (Los Angeles: Journal of Aesthetics & Protest Press, 2007); Nato Thompson, ed. *Experimental Geography: Radical Approaches to Landscape, Cartography, and Urbanism* (Brooklyn, N.Y.: Melville House; New York: Independent Curators International, 2009).

26. Yann Arthus-Bertrand, Marilyn Bridges, Edward Burtynsky, and Alex Maclean are just some of the contemporary artists whose success depends on the allure of the aerial.

27. Rundstrom, "GIS," 46.

5. ENVIRONMENTAL AFTERMATHS FROM THE SKY

1. Stephanie LeMenager, *Living Oil: Petroleum Culture in the American Century* (New York: Oxford University Press, 2014), 104.

2. Rob Nixon, *Slow Violence and the Environmentalism of the Poor* (Cambridge, Mass.: Harvard University Press, 2011), 2.

3. LeMenager, *Living Oil*, 3.

4. Kimbra Cutlip, "Satellites Leave No Place to Hide for Rogue Thai Fishing Fleet," SkyTruth, January 16, 2017, https://www.skytruth.org/2017/01/satellites-leave-no-place-to-hide-for-rogue-thai-fishing-fleet/; SkyTruth, "Home," 2016, https://www.skytruth.org/.

5. SkyTruth, "About SkyTruth: History," 2016, https://www.skytruth.org/about/.

6. Charles Perrow, *Normal Accidents: Living with High-Risk Technologies* (New York: Basic Books, 1984).

7. Rita Raley, *Tactical Media* (Minneapolis: University of Minnesota Press, 2009), 6.

8. Lisa Parks, *Cultures in Orbit: Satellites and the Televisual* (Durham, N.C.: Duke University Press, 2005), 13. "Artist-activist" riffs on Nixon's phrase "writer-activist" in *Slow Violence*, 14–16, passim.

9. Caren Kaplan, *Aerial Aftermaths: Wartime from Above* (Durham, N.C.: Duke University Press, 2018), 2–3, 7, 18.

10. Kaplan, 3.

11. Denis Cosgrove, *Apollo's Eye: A Cartographic Genealogy of the Earth in the Western Imagination* (Baltimore: Johns Hopkins University Press, 2001), 3.

12. Opening sentence of the "Purpose" statement, *Whole Earth Catalog*, Fall 1968.

13. See Jody Berland, *North of Empire: Essays on the Cultural Technologies of Space* (Durham, N.C.: Duke University Press, 2009); Ursula K. Heise, *Sense of Place and Sense of Planet: The Environmental Imagination of the Global* (New York: Oxford University Press, 2008); Sheila Jasanoff, "Image and Imagination: The Formation of Global

Environmental Consciousness," in *Changing the Atmosphere: Expert Knowledge and Environmental Governance*, ed. Clark A. Miller and Paul N. Edwards (Cambridge, Mass.: MIT Press, 2001), 303–37; Sheila Jasanoff and Marybeth Long Martello, "Heaven and Earth: The Politics of Environmental Images," in *Earthly Politics: Local and Global in Environmental Governance*, ed. Sheila Jasanoff (Cambridge, Mass.: MIT Press, 2004), 31–52; Laura Kurgan, *Close Up at a Distance: Mapping, Technology, and Politics* (Brooklyn, N.Y.: Zone, 2013).

14. Overview Institute, "Declaration of Vision and Principles," 2018, http://www.overviewinstitute.org/about-us/declaration-of-vision-and-principles.

15. Donna Haraway, "Situated Knowledges: The Science Question in Feminism and the Privilege of Partial Perspective," *Feminist Studies* 14, no. 3 (1988): 582, 581, 582–83, 579.

16. DigitalGlobe, "About Us," 2019, https://www.digitalglobe.com/company/about-us, and "Our Constellation," accessed December 18, 2018, http://www.digitalglobe.com/about/our-constellation (page removed). DigitalGlobe was acquired by Maxar Technologies in 2017.

17. Available at Digital Globe, https://discover.digitalglobe.com.

18. Eyal Weizman and Ines Weizman, *Before and After: Documenting the Architecture of Disaster* (Moscow: Strelka, 2014), loc. 178 of 468, Kindle.

19. Weizman and Weizman, loc. 169–71.

20. Weizman and Weizman, loc. 186–88.

21. Jennifer Gabrys, *Program Earth: Environmental Sensing Technology and the Making of a Computational Planet* (Minneapolis: University of Minnesota Press, 2016), 270.

22. SkyTruth, "About."

23. Gabrys, *Program Earth*, 71.

24. Ralph K. M. Haurwitz, "Hurricane Harvey's Pollution Toll on Air, Water Slowly Comes Into Focus," *Austin American-Statesman*, September 16, 2017, https://www.statesman.com/news/20170916/hurricane-harveys-pollution-toll-on-air-water-slowly-comes-into-focus.

25. Available at SkyTruth, https://skytruth.ushahidi.io/views/map.

26. Overview Institute, "Declaration."

27. Chevron holds the majority stake at Frade; the other shares belong to state-run Petroleo Brasileiro SA and the Japanese venture Frade Japão.

28. I have gathered these details from Kimbra Cutlip, "Impact Story: Chevron Spill May Have Reset the Tone for Oil Boom in Brazil," SkyTruth, July 1, 2016, http://www.skytruth.org/2016/07/chevron-spill-may-have-reset-the-tone-for-oil-boom-in-brazil/.

29. Weizman and Weizman, *Before and After*, loc. 11–12, 6–8.

30. Parks, *Cultures*, 91.

31. Parks, 14.

32. Weizman and Weizman, *Before and After*, loc. 16–18. This interpretive work is just one aspect of the "forensic architecture" performed by Eyal Weizman and the eponymous research group he founded.

33. Weizman and Weizman, loc. 70–71.

34. Gabrys, *Program Earth*, 270.

35. See Kenneth Goldsmith, *Uncreative Writing: Managing Language in the Digital Age* (New York: Columbia University Press, 2011).

36. Paul Virilio, *War and Cinema: The Logistics of Perception*, trans. Patrick Camiller (1984; London: Verso, 1989), 3.

37. Kurgan, *Close Up*, 11–12. Hereafter cited parenthetically.

38. John Pickles, *A History of Spaces: Cartographic Reason, Mapping and the Geo-Coded World* (London: Routledge, 2004), 87.

39. The legacies of militarization are everywhere in commercial satellite image production. Space Imaging was a venture of weapons producers Raytheon and Lockheed Martin.

40. James C. Scott, *Seeing Like a State: How Certain Schemes to Improve the Human Condition Have Failed* (New Haven, Conn.: Yale University Press, 1998), 25.

41. Scott, 4.

42. Jenifer Van Vleck, *Empire of the Air: Aviation and the American Ascendency* (Cambridge, Mass.: Harvard University Press, 2013), 11.

43. Eyal Weizman and Fazal Sheikh, *The Conflict Shoreline: Colonization as Climate Change in the Negev Desert* (Göttingen, Ger.: Steidl, 2015), 77.

44. Parks, *Cultures*, 91.

45. Kaplan, 206, 3.

46. Quoted in Denis Wood, *Rethinking the Power of Maps* (New York: Guilford, 2010), 44.

47. I will follow Sheikh and Weizman's practice of using the Hebrew *Negev*, rather than the Arabic *Naqab*, to refer to the desert region.

48. The forensic importance of Sheikh and Weizman's project became evident when content from *Conflict Shoreline* entered proceedings before the Truth Commission on the Responsibility of Israeli Society for the Events of 1948–1960 in the South that was called by the NGO Zochrot in 2014. Weizman elaborates on forensic analysis of this sort in *Forensic Architecture: Violence at the Threshold of Detectability* (New York: Zone, 2017).

49. William L. Fox, *Aereality: On the World from Above* (Berkeley: Counterpoint, 2009), 6.

50. Weizman and Weizman, *Before and After*, loc. 114.

51. Scott, *Seeing*, 11. On how verticality becomes political and is controlled in Israel, see Eyal Weizman, "Politics of Verticality," *openDemocracy*, April 23, 2002, https://www.opendemocracy.net/ecology-politicsverticality/article_801.jsp/.

52. Weizman and Sheikh, *Conflict Shoreline*, 12. Hereafter cited parenthetically.

53. A similar idea was used to convince homesteaders to settle in the U.S. High Plains and pursue wheat farming in the late nineteenth and early twentieth centuries. See Timothy Egan, *The Worst Hard Time: The Untold Story of Those Who Survived the Great American Dust Bowl* (New York: Houghton Mifflin, 2006).

54. I discuss only one image from the volume here. As I was finishing this book and read Kaplan's *Aerial Aftermaths*, I discovered that this photograph also drew her eye; it clearly has charisma. To the curious reader, I also recommend a photograph of sown and irrigated wheat fields that resonates with Kurgan's *Monochrome Landscapes* (*Desert Bloom*, plate 63); one of the narrow tributaries of the Hawarim River, which resemble cicatrices (*Desert Bloom*, plate 80); and one of the Badlands of a forest reserve whose crevices resemble lizards' feet (*Desert Bloom*, plate 73).

55. Sheikh explains the process for obtaining the images in the introduction to *Desert Bloom (Notes)* (Göttingen, Ger.: Steidl, 2015), [5].

56. Other photographs of savannization and afforestation share this effect. See, for example, *Meitar Forest, >200 MM RPA, October 9, 2011 (Conflict Shoreline*, 38–39; *Desert Bloom*, plate 70).

57. Sheikh, *Desert Bloom (Notes)*, 16, [7].

58. Weizman and Weizman, *Before and After*, loc. 16–18.

59. Kaplan, *Aerial Aftermaths*, 205.

60. Weizman elaborates that, even below the threshold, the presence of an object such as a human body could disturb the image; it could "affect the tone of a single grain and make it darker," thus suggesting a presence of some kind (77).

61. Sheikh, *Desert Bloom (Notes)*, [6].

6. THE AFTERLIVES OF INFORMATION
IN SPECULATIVE FICTION

1. Colson Whitehead, *Zone One* (New York: Anchor, 2011), 240. See also 246. Hereafter cited parenthetically.

2. Wendy Hui Kyong Chun, "Crisis, Crisis, Crisis, or Sovereignty and Networks," *Theory, Culture & Society* 28, no. 6 (2011): 107. Chun develops this idea through reference to global climate models.

3. Kate Marshall, "What Are the Novels of the Anthropocene? American Fiction in Geological Time," *American Literary History* 27, no. 3 (2015): 533.

4. Kim Stanley Robinson, *New York 2140* (New York: Orbit, 2017), loc. 489–92 of 9660, Kindle. Hereafter cited parenthetically.

5. On this and other narrative temporalities of Anthropocene sf, see Ursula K. Heise, "Science Fiction and the Time Scales of the Anthropocene," *ELH* 86, no. 2 (2019): 275–304.

6. Naomi Klein, *The Shock Doctrine: The Rise of Disaster Capitalism* (New York: Picador, 2007).

7. Nancy Tuana, "Coming to Understand: Orgasm and the Epistemology of Ignorance," in *Agnotology: The Making and Unmaking of Ignorance*, ed. Londa Schiebinger and Robert N. Proctor (Stanford: Stanford University Press, 2008), 109.

8. N. Katherine Hayles, "Narrative and Database: Natural Symbionts," *PMLA* 122, no. 5 (2007): 1603. On the narrative impulses that structure databases, also see Ursula K. Heise, *Imagining Extinction: The Cultural Meanings of Endangered Species* (Chicago: University of Chicago Press, 2016), chap. 2.

9. Hayles, "Narrative and Database," 1603.

10. As cited in part 2, assisted migration and other strategies of "radical conservation" are well underway today. See Jamie Lorimer, *Wildlife in the Anthropocene: Conservation After Nature* (Minneapolis: University of Minnesota Press, 2015); Emma Marris, *Rambunctious Garden: Saving Nature in a Post-Wild World* (New York: Bloomsbury, 2011); Ben A. Minteer, *The Fall of the Wild: Extinction, De-Extinction, and the Ethics of Conservation* (New York: Columbia University Press, 2019).

11. Quoted in Robinson, *New York 2140*, 1168–69.

12. With this setup, Robinson's book is as much an apartment novel as it is a climate and financial novel.

288

6. THE AFTERLIVES OF INFORMATION IN SPECULATIVE FICTION

13. The *Oxford English Dictionary* defines "caisson" as "a large watertight case or chest used in laying foundations of bridges, etc., in deep water." OED Online, s.v. "caisson (*n.*)," accessed November 18, 2019, http://www.oed.com/view/Entry/26095.
14. See, for example, Dipesh Chakrabarty, "The Climate of History: Four Theses," *Critical Inquiry* 35, no. 2 (2009): 197–222; Heise, "Science Fiction"; Zach Horton, "Composing a Cosmic View: Three Alternatives for Thinking Scale in the Anthropocene," in *Scale in Literature and Culture,* ed. Michael Travel Clarke and David Wittenberg (New York: Palgrave Macmillan, 2017), 35–60; Marshall, "What Are"; Timothy Morton, *Hyperobjects: Philosophy and Ecology after the End of the World* (Minnesota: University of Minnesota Press, 2013); Julia Adeney Thomas, "History and Biology in the Anthropocene: Problems of Scale, Problems of Value," *American Historical Review* 119 (2014): 1587–1607.
15. Jeff VanderMeer, *The Strange Bird* (New York: Farrar, Straus and Giroux, 2017), 3, 72. Hereafter cited parenthetically.
16. Chun, "Crisis," 107, 100.
17. Allison Carruth, "Novel Ecologies" (book manuscript in preparation).
18. Gerry Canavan, "Utopia in the Time of Trump," *Los Angeles Review of Books,* March 11, 2017, https://lareviewofbooks.org/article/utopia-in-the-time-of-trump/.
19. Claire Vaye Watkins, *Gold Fame Citrus* (New York: Riverhead, 2015), 84. Hereafter cited parenthetically.
20. I have written about medicalization techniques in Heather Houser, *Ecosickness in Contemporary U.S. Fiction: Environment and Affect* (New York: Columbia University Press, 2014).
21. Kate Marshall, "How to Be an Alien: Ian Bogost's 'Alien Phenomenology, or, What It's Like to Be a Thing,'" *Los Angeles Review of Books,* November 19, 2013, https://lareviewofbooks.org/article/how-to-be-an-alien. For more of Marshall's argument on nonhuman narration, see "The Old Weird," *Modernism/Modernity* 23, no. 3 (2016): 631–49; "What Are."
22. Recall Lisa Parks on latency: "The satellite image is encoded with time coordinates that index the moment of its acquisition, but since most satellite image data is simply archived in huge supercomputers, its *tense is one of latency*. . . . much of what they register is never seen or known. The satellite image is not really produced, then, until it is sorted, rendered, and put into circulation." *Cultures in Orbit: Satellites and the Televisual* (Durham, N.C.: Duke University Press, 2005), 91.
23. OED Online, s.v. "stoss (*adj.*)," accessed November 18, 2019, http://www.oed.com/view/Entry/190990.
24. Harriet Ritvo, *The Platypus and the Mermaid and Other Figments of the Classifying Imagination* (Cambridge, Mass.: Harvard University Press, 1997), 11.
25. Indra Sinha, *Animal's People* (New York: Simon & Schuster, 2007), [383]. Hereafter cited parenthetically.
26. Rob Nixon, *Slow Violence and the Environmentalism of the Poor* (Cambridge, Mass.: Harvard University Press, 2011), chap. 1.
27. In Nixon's analysis, Animal's hijinks earn Sinha credit for the "single-handed invention of the environmental picaresque," a literary mode that "probes the underbelly of neoliberal globalization from the vantage point of an indigent social outcast." *Slow Violence,* 46.
28. Nixon, 55.

29. Upamanyu Pablo Mukherjee, *Postcolonial Environments: Nature, Culture and the Contemporary Indian Novel in English* (New York: Palgrave Macmillan, 2010), 152.
30. Pablo Mukherjee, "'Tomorrow There Will Be More of Us': Toxic Postcoloniality in *Animal's People*," in *Postcolonial Ecologies: Literatures of the Environment*, ed. Elizabeth DeLoughrey and George B. Handley (New York: Oxford University Press, 2011), 230.
31. Mukherjee, *Postcolonial Environments*, 152.
32. Mukherjee, 152.
33. Donna Haraway, "Situated Knowledges: The Science Question in Feminism and the Privilege of Partial Perspective," *Feminist Studies* 14, no. 3 (1988): 581.
34. Nixon, *Slow Violence*, 63.
35. Bruce Robbins, "The Sweatshop Sublime," *PMLA* 117, no. 1 (2002): 85.
36. Robbins, 85.
37. Virginia Woolf, "Flying Over London," in *The Captain's Death Bed and Other Essays* (London: Hogarth, 1950), 186. Hereafter cited parenthetically.
38. My comment is inspired by Mary Ann Doane, "Information, Crisis, Catastrophe," in *New Media, Old Media: A History and Theory Reader*, ed. Wendy Hui Kyong Chun and Thomas Keenan (New York: Routledge, 2006), 301–18.
39. Paul Saint-Amour, "Over Assemblage: *Ulysses* and the *Boîte-en-Valise* from Above," in *Cultural Studies of James Joyce*, ed. R. Brandon Kershner (Amsterdam: Rodopi, 2003), 35, 34. Hereafter cited parenthetically.
40. Sinha, *Animal's People*, 5, 3.
41. Watkins, *Gold Fame Citrus*, 121.
42. Robinson, *New York 2140*, loc. 348, 1115.

EPILOGUE

1. David Wallace-Wells, *The Uninhabitable Earth: Life After Warming* (New York: Tim Duggan, 2019), 9, Kindle.
2. Candis Callison, *How Climate Change Comes to Matter: The Communal Life of Facts* (Durham, N.C.: Duke University Press, 2014), 6.
3. Kari Marie Norgaard, *Living in Denial: Climate Change, Emotions, and Everyday Life* (Cambridge, Mass.: MIT Press, 2011), 5, 9.
4. Callison, *How Climate*, 171.
5. See Marisol de la Cadena, *Earth Beings: Ecologies of Practice Across Andean Worlds* (Durham, N.C.: Duke University Press, 2015).
6. As I write this in November 2019, I am exploring this "undisciplining" through two other projects: a special journal issue on "Becoming Undisciplined" in collaboration with Stephanie LeMenager, and a transdisciplinary research program, Planet Texas 2050 (https://bridgingbarriers.utexas.edu/planet-texas-2050/), which develops strategies for resilience in response to climate change and population growth. In addition to the environmental thinkers I honor here, the following projects exemplify the move to the undisciplined: Rita Felski, *The Limits of Critique* (Chicago: University of Chicago Press, 2015); Judith Halberstam, *The Queer Art of Failure* (Durham, N.C.: Duke University Press, 2011); Christina Sharpe, *In the Wake: On Blackness and Being* (Durham, N.C.: Duke University Press, 2016); Susan M. Squier,

Epigenetic Landscapes: Drawings as Metaphor (Durham, N.C.: Duke University Press, 2017).

7. "Public Sediment," Resilient by Design, 2018, http://www.resilientbayarea.org/public -sediment/.

8. I first learned about SCAPE's "oyster-tecture" through a *99% Invisible* podcast episode and have drawn this material from it. Emmett FitzGerald, "Oyster-tecture," October 31, 2017, in *99% Invisible*, produced by Roman Mars et al., podcast, MP3 audio, 32:21, https://99percentinvisible.org/episode/oyster-tecture/. For a critical take on SCAPE's work in disaster resilience, see Ashley Dawson, *Extreme Cities: The Peril and Promise of Urban Life in the Age of Climate Change* (New York: Verso, 2017), chap. 4.

9. Donna J. Haraway, "Otherworldly Conversations, Terran Topics, Local Terms," in *Material Feminisms*, ed. Susan J. Hekman and Stacy Alaimo (Bloomington: Indiana University Press, 2008), 158.

WORKS CITED

Abrams, Janet, and Peter Hall, eds. *Else/Where: Mapping New Cartographies of Networks and Territories*. Minneapolis: University of Minnesota Design Institute, 2006.

Adams, Jonathan S. *The Future of the Wild: Radical Conservation for a Crowded World*. Boston: Beacon, 2006.

Adams, Paul C., and Astrid Gynnild. "Environmental Messages in Online Media: The Role of Place." *Environmental Communication* 7, no. 1 (2013): 113–30.

Alexander, Clarence, Nora Bynum, Elizabeth Johnson, Ursula King, Tero Mustonen, Peter Neofotis, Noel Oettlé, et al. "Linking Indigenous and Scientific Knowledge of Climate Change." *BioScience* 61, no. 6 (2011): 477–84.

Allewaert, Monique. *Ariel's Ecology: Plantations, Personhood, and Colonialism in the American Tropics*. Minneapolis: University of Minnesota Press, 2013.

Archer, David. *The Long Thaw: How Humans Are Changing the Next 100,000 Years of Earth's Climate*. Princeton, N.J.: Princeton University Press, 2009.

Bakhtin, M. M. "The *Bildungsroman* and Its Significance in the History of Realism (Toward a Historical Typology of the Novel)." In *Speech Genres and Other Late Essays*, ed. Caryl Emerson and Michael Holquist, 10–59. Austin: University of Texas Press, 1986.

Bal, Mieke. "Telling, Showing, Showing Off." *Critical Inquiry* 18, no. 3 (1992): 556–94.

Banfield, Ann. "Describing the Unobserved: Events Grouped Around an Empty Centre." In *The Linguistics of Writing: Arguments Between Language and Literature*, ed. Nigel Fabb, Derek Attridge, Alan Durant, and Colin MacCabe, 265–85. New York: Methuen, 1987.

Barad, Karen. *Meeting the Universe Halfway: Quantum Physics and the Entanglement of Matter and Meaning*. Durham, N.C.: Duke University Press, 2007.

Bartram, Lyn, Abhisekh Patra, and Maureen Stone. "Affective Color in Visualization." In *Proceedings of the 2017 CHI Conference on Human Factors in Computing Systems*, comp. Association for Computing Machinery, 1364–74. New York: ACM, 2017.

Bateson, Gregory. *Steps to an Ecology of Mind*. 1972. Chicago: University of Chicago Press, 2000.

Bell, Daniel. "Axial Age of Technology: Foreword 1999." In *The Coming of Post-Industrial Society: A Venture in Social Forecasting*, ix–lxxxv. 1976. Reprint with new foreword, New York: Basic Books, 1999.

Bellarmine Museum of Art, The. *James Prosek: Un-Natural History*. Fairfield, Conn.: Bellarmine Museum of Art, Fairfield University, 2011. Exhibition catalog. http://www.troutsite.com/pdf/Bellarmine_exhibition_catalog.pdf.

Benjamin, Walter. "On Some Motifs in Baudelaire." In *Illuminations: Essays and Reflections*, ed. Hannah Arendt, trans. Harry Zohn, 155–200. 1968. Reprint, New York: Schocken, 2007.

Berland, Jody. *North of Empire: Essays on the Cultural Technologies of Space*. Durham, N.C.: Duke University Press, 2009.

Bertini, Enrico, and Denis Lalanne. "Surveying the Complementary Role of Automatic Data Analysis and Visualization in Knowledge Discovery." In *Proceedings of the ACM SIGKDD Workshop on Visual Analytics and Knowledge Discovery: Integrating Automated Analysis with Interactive Exploration*, comp. Association for Computing Machinery, 12–20. New York: ACM, 2009.

Blair, Ann M. *Too Much to Know: Managing Scholarly Information Before the Modern Age*. New Haven, Conn.: Yale University Press, 2010.

Borges, Jorge Luis. *Collected Fictions*. Trans. Andrew Hurley. New York: Penguin, 1998.

Bowker, Geoffrey C. "Biodiversity Datadiversity." *Social Studies of Science* 30 (2000): 643–83.

——. *Memory Practices in the Sciences*. Cambridge, Mass.: MIT Press, 2005.

Bowker, Geoffrey C., and Susan Leigh Star. *Sorting Things Out: Classification and Its Consequences*. Cambridge, Mass.: MIT Press, 1999.

Brand, Stewart, ed. *Whole Earth Catalog* (Fall 1968).

Brower, Jeffrey. "Medieval Theories of Relations." *Stanford Encyclopedia of Philosophy*. Last revised December 19, 2018. https://plato.stanford.edu/archives/win2018/entries/relations-medieval.

Buffon, Georges Louis Leclerc, comte de, and John Lyon. "The 'Initial Discourse' to Buffon's 'Histoire Naturelle': The First Complete English Translation." *Journal of the History of Biology* 9, no. 1 (1976): 133–81.

Butler, Judith. "Afterword: After Loss, What Then?" In *Loss: The Politics of Mourning*, ed. David L. Eng and David Kazanjian, 467–73. Berkeley: University of California Press, 2003.

Callison, Candis. *How Climate Change Comes to Matter: The Communal Life of Facts*. Durham, N.C.: Duke University Press, 2014.

Canavan, Gerry. "Utopia in the Time of Trump." *Los Angeles Review of Books*, March 11, 2017. https://lareviewofbooks.org/article/utopia-in-the-time-of-trump/.

CarbonSense. "Visualising Your Carbon Emissions." Accessed February 7, 2017. http://carbonsense.com/carbonvisibility.

Carbon Visuals. "New York's Carbon Emissions—in Real Time." Accessed February 7, 2017. http://carbonvisuals.com/work/new-yorks-carbon-emissions-in-real-time.

——. "What We Do." Accessed February 7, 2017. http://www.carbonvisuals.com/what-we-do/.

293

WORKS CITED

Carruth, Allison. "Culturing Food: Bioart and In Vitro Meat." *Parallax* 19, no. 1 (2013): 88–100.

——. "Novel Ecologies." Unpublished manuscript, last modified July 6, 2018.

Castree, Noel. "Global Change Research and the 'People Disciplines': Toward a New Dispensation." *South Atlantic Quarterly* 116, no. 1 (2017): 55–68.

Chakrabarty, Dipesh. "The Climate of History: Four Theses." *Critical Inquiry* 35, no. 2 (2009): 197–222.

——. "Postcolonial Studies and the Challenge of Climate Change." *New Literary History* 43, no. 1 (2012): 1–18.

Chapin, Mac, Zachary Lamb, and Bill Threlkeld. "Mapping Indigenous Lands." *Annual Review of Anthropology* 34 (2005): 619–39.

Charles, Ron. Review of *The Selected Works of T. S. Spivet*, by Reif Larsen. *Washington Post*, May 6, 2009. http://www.washingtonpost.com/wp-dyn/content/article/2009/05/05/AR2009050503817.html.

Chen, Mel Y. *Animacies: Biopolitics, Racial Mattering, and Queer Affect*. Durham, N.C.: Duke University Press, 2012.

Chihaya, Sarah. "What Is Missing: Cataloguing the End." *ASAP/Journal* 3, no. 3 (2018): 567–88.

Chun, Wendy Hui Kyong. "Crisis, Crisis, Crisis, or Sovereignty and Networks." *Theory, Culture & Society* 28, no. 6 (2011): 91–112.

Code, Lorraine. *Ecological Thinking: The Politics of Epistemic Location*. New York: Oxford University Press, 2006.

Cohen, Jeffrey Jerome, and Stephanie LeMenager. "Introduction: Assembling the Ecological Digital Humanities." *PMLA* 131, no. 2 (2016): 340–46.

Conniff, Richard. "Our Natural History, Endangered." *New York Times*, April 1, 2016. http://www.nytimes.com/2016/04/03/opinion/ournatural-history-endangered.html/.

Cosgrove, Denis. *Apollo's Eye: A Cartographic Genealogy of the Earth in the Western Imagination*. Baltimore: Johns Hopkins University Press, 2001.

Crichton, Michael. *State of Fear*. London: HarperCollins, 2004.

Cronon, William. "The Trouble with Wilderness; Or, Getting Back to the Wrong Nature." In *Uncommon Ground: Rethinking the Human Place in Nature*, ed. William Cronon, 69–90. New York: Norton, 1995.

Cruikshank, Julie. *Do Glaciers Listen?: Local Knowledge, Colonial Encounters, and Social Imagination*. Vancouver: UBC Press, 2005.

Cubitt, Sean. "Everybody Knows This Is Nowhere: Data Visualization and Ecocriticism." In *Ecocinema Theory and Practice*, ed. Stephen Rust, Salma Monani, and Sean Cubitt, 279–96. New York: Routledge/American Film Institute, 2013.

——. *Finite Media: Environmental Implications of Digital Technologies*. Durham, N.C.: Duke University Press, 2017.

Cunsolo, Ashlee, and Neville S. Ellis. "Ecological Grief as a Mental Health Response to Climate Change-Related Loss." *Nature Climate Change* 8 (April 2018): 275–81.

Cutlip, Kimbra. "Impact Story: Chevron Spill May Have Reset the Tone for Oil Boom in Brazil." SkyTruth. July 1, 2016. https://www.skytruth.org/2016/07/chevron-spill-may-have-reset-the-tone-for-oil-boom-in-brazil/.

——. "Satellites Leave No Place to Hide for Rogue Thai Fishing Fleet." SkyTruth. January 16, 2017. https://www.skytruth.org/2017/01/satellites-leave-no-place-to-hide-for-rogue-thai-fishing-fleet/.

Dalmedico, Amy Dahan. "Models and Simulations in Climate Change: Historical, Epistemological, Anthropological, and Political Aspects." In *Science Without Laws: Model Systems, Cases, Exemplary Narratives*, ed. Angela N. H. Creager, Elizabeth Lunbeck, and M. Norton Wise, 125–56. Durham, N.C.: Duke University Press, 2007.

Daston, Lorraine. "Description by Omission: Nature Enlightened and Obscured." In *Regimes of Description: In the Archive of the Eighteenth Century*, ed. John Bender and Michael Marrinan, 11–24. Stanford: Stanford University Press, 2005.

——. "Type Specimens and Scientific Memory." *Critical Inquiry* 31, no. 1 (2004): 153–82.

Daston, Lorraine, and Peter Galison. *Objectivity*. New York: Zone, 2007.

Dawson, Ashley. *Extreme Cities: The Peril and Promise of Urban Life in the Age of Climate Change*. New York: Verso, 2017.

De la Cadena, Marisol. *Earth Beings: Ecologies of Practice Across Andean Worlds*. Durham, N.C.: Duke University Press, 2015.

DeLoughrey, Elizabeth. "Satellite Planetarity and the Ends of the Earth." *Public Culture* 26, no. 2 (2014): 257–80.

Dickinson, Jonathan, and Andrea Tenorio, eds. *Inventory of New York City Greenhouse Gas Emissions, September 2011*. New York: Mayor's Office of Long-Term Planning and Sustainability, 2011. https://www1.nyc.gov/assets/sustainability/downloads/pdf/publications/GHG%20Inventory%20Report%20Emission%20Year%202010.pdf.

Diffenbaugh, Noah S., and Christopher B. Field. "Changes in Ecologically Critical Terrestrial Climate Conditions." *Science* 341, no. 6145 (2013): 486–92.

DigitalGlobe. "About Us." http://www.digitalglobe.com/company/about-us.

——. "Our Constellation." http://www.digitalglobe.com/about/our-constellation.

Dilley, Roy. "Reflections on Knowledge Practices and the Problem of Ignorance." *Journal of the Royal Anthropological Institute (N.S.)* 16 (2010): 176–92.

Dion, Mark, Natacha Pugnet, and Magnus Jensner. *Mark Dion: The Natural History of the Museum*. Trans. Thomas Andersson, William Jewson, and Charles Penwarden. Paris: Archibooks, 2007.

Doane, Mary Ann. "Information, Crisis, Catastrophe." In *New Media, Old Media: A History and Theory Reader*, ed. Wendy Hui Kyong Chun and Thomas Keenan, 301–18. New York: Routledge, 2006.

Drucker, Johanna. *Graphesis: Visual Forms of Knowledge Production*. Cambridge, Mass: Harvard University Press, 2014.

——. "Humanities Approaches to Graphical Display." *DHQ: Digital Humanities Quarterly* 5, no. 1 (2011). www.digitalhumanities.org/dhq/vol/5/1/000091/000091.html.

Ducarme, Frédéric, Gloria M. Luque, and Franck Courchamp. "What Are 'Charismatic Species' for Conservation Biologists?" *BioSciences Master Reviews* (July 2013): 1–8.

Dunaway, Finis. "Seeing Global Warming: Contemporary Art and the Fate of the Planet." *Environmental History* 14, no. 1 (2009): 9–31.

EDGE of Existence. "EDGE Science." https://www.edgeofexistence.org/science/.

——. "What Is EDGE?" https://www.edgeofexistence.org/what-is-edge/.

Edwards, Paul N. "Representing the Global Atmosphere: Computer Models, Data, and Knowledge About Climate Change." In *Changing the Atmosphere: Expert Knowledge and Environmental Governance*, ed. Clark A. Miller and Paul N. Edwards, 31–65. Cambridge, Mass.: MIT Press, 2001.

295

WORKS CITED

——. *A Vast Machine: Computer Models, Climate Data, and the Politics of Global Warming*. Cambridge, Mass.: MIT Press, 2010.
Egan, Timothy. *The Worst Hard Time: The Untold Story of Those Who Survived the Great American Dust Bowl*. New York: Houghton Mifflin, 2006.
Ekwurzel, Brenda. "Crichton Thriller *State of Fear*." Union of Concerned Scientists. 2005. http://www.ucsusa.org/global_warming/solutions/fight-misinformation /crichton-thriller-state-of.html.
Elwood, Sarah. "Geographic Information Science: New Geovisualization Technologies—Emerging Questions and Linkages with GIScience Research." *Progress in Human Geography* 33, no. 2 (2009): 256–63.
Eng, David L., and David Kazanjian. "Introduction: Mourning Remains." In *Loss: The Politics of Mourning*, ed. David L. Eng and David Kazanjian, 1–25. Berkeley: University of California Press, 2003.
Farber, Paul Lawrence. *Finding Order in Nature: The Naturalist Tradition from Linnaeus to E. O. Wilson*. Baltimore: Johns Hopkins University Press, 2000.
Felski, Rita. *The Limits of Critique*. Chicago: University of Chicago Press, 2015.
Finlay, Victoria. *Color: A Natural History of the Palette*. New York: Random House, 2002.
Firestein, Stuart. *Ignorance: How It Drives Science*. New York: Oxford University Press, 2012.
FitzGerald, Emmett. "Oyster-tecture." Produced by Roman Mars et al. *99% Invisible*, October 21, 2017. Podcast, MP3 audio, 32:21. https://99percentinvisible.org/episode /oyster-tecture/.
Flatley, Jonathan. *Affective Mapping: Melancholia and the Politics of Modernism*. Cambridge, Mass.: Harvard University Press, 2008.
Fleetwood, Nicole. *Troubling Vision: Performance, Visuality, and Blackness*. Chicago: University of Chicago Press, 2011.
Floridi, Luciana. *Information: A Very Short Introduction*. Oxford: Oxford University Press, 2010.
Foster, Hal, ed. *Vision and Visuality*. Seattle: Bay, 1988.
Foucault, Michel. *The History of Sexuality*, vol. 1: *An Introduction*. Trans. Robert Hurley. New York: Pantheon, 1978; Vintage, 1990.
——. *The Order of Things: An Archaeology of the Human Sciences*. 1966. New York: Pantheon, 1970; Vintage, 1994.
Fox, William L. *Aereality: On the World from Above*. Berkeley: Counterpoint, 2009.
Fraiman, Susan. *Unbecoming Women: British Women Writers and the Novel of Development*. New York: Columbia University Press, 1993.
Freud, Sigmund. "Mourning and Melancholia (1917)." Trans. James Strachey. In *The Standard Edition of the Complete Psychological Works of Sigmund Freud*, ed. James Strachey, 243–58. London: Hogarth, 1955.
Fundación Telefónica. "Vida Art and Artificial Life International Awards: *NoArk*." December 3, 2012. https://vida.fundaciontelefonica.com/en/project/noark/.
Gabrys, Jennifer. *Program Earth: Environmental Sensing Technology and the Making of a Computational Planet*. Minneapolis: University of Minnesota Press, 2016.
Galison, Peter, and David J. Stump, eds. *The Disunity of Science: Boundaries, Contexts, and Power*. Stanford: Stanford University Press, 1996.

Galli, Alessandro, Thomas Wiedmann, Ertug Ercin, Doris Knoblauch, Brad Ewing, and Stefan Giljum. "Integrating Ecological, Carbon and Water Footprint Into a 'Footprint Family' of Indicators: Definition and Role in Tracking Human Pressure on the Planet." *Ecological Indicators* 16 (2012): 100–12.

Garrard, Greg. "Worlds Without Us: Some Types of Disanthropy." *SubStance* 41, no. 1 (2012): 40–60.

Geophysical Fluid Dynamics Laboratory. "About GFDL." National Oceanic and Atmospheric Administration. Accessed November 20, 2019. http://www.gfdl.noaa.gov/.

Gitelman, Lisa, ed. *"Raw Data" Is an Oxymoron*. Cambridge, Mass.: MIT Press, 2013.

Gleick, James. *The Information: A History, a Theory, a Flood*. New York: Vintage, 2011.

Global Footprint Network. "Media Backgrounder." https://www.footprintnetwork.org /content/images/uploads/Media_Backgrounder_GFN.pdf.

Goddard Media Studios. "2018 Was the Fourth Hottest Year on Record." NASA's Goddard Space Flight Center. February 6, 2019. https://svs.gsfc.nasa.gov/13142.

Goldsmith, Kenneth. *Uncreative Writing: Managing Language in the Digital Age*. New York: Columbia University Press, 2011.

Grant, Benjamin. *Overview: A New Perspective on Earth*. Berkeley: Amphoto, 2016.

Greene, Thomas C., and Paul A. Bell. "Additional Considerations Concerning the Effects of 'Warm' and 'Cool' Wall Colours on Energy Conservation." *Ergonomics* (1980): 949–54.

Groes, Sebastian. "Information Overload in Literature." *Textual Practice* 31, no. 7 (2017): 1481–508.

Guillemin, Georg. *The Pastoral Vision of Cormac McCarthy*. College Station: Texas A&M University Press, 2004.

Hacking, Ian. "Our Neo-Cartesian Bodies in Parts." *Critical Inquiry* 34 (Autumn 2007): 78–105.

Halberstam, Judith. *The Queer Art of Failure*. Durham, N.C.: Duke University Press, 2011.

Haraway, Donna. "Otherworldly Conversations, Terran Topics, Local Terms." In *Material Feminisms*, ed. Susan J. Hekman and Stacy Alaimo, 157–87. Bloomington: Indiana University Press, 2008.

——. "Situated Knowledges: The Science Question in Feminism and the Privilege of Partial Perspective." *Feminist Studies* 14, no. 3 (1988): 575–99.

Hastrup, Kirsten. "Anticipating Nature: The Productive Uncertainty of Climate Models." In *The Social Life of Climate Change Models: Anticipating Nature*, ed. Kirsten Hastrup and Martin Skrydstrup, 1–29. New York: Routledge, 2013.

Haurwitz, Ralph K. M. "Hurricane Harvey's Pollution Toll on Air, Water Slowly Comes Into Focus." *Austin American-Statesman*, September 16, 2017. https://www.statesman .com/news/20170916/hurricane-harveys-pollution-toll-on-air-water-slowly-comes -into-focus.

Hawk, David, David M. Rieder, and Ollie Oviedo, eds. *Small Tech: The Culture of Digital Tools*. Minneapolis: University of Minnesota Press, 2008.

Hayles, N. Katherine. *How We Became Posthuman: Virtual Bodies in Cybernetics, Literature, and Informatics*. Chicago: University of Chicago Press, 1999.

——. "Narrative and Database: Natural Symbionts." *PMLA* 122, no. 5 (2007): 1603–8.

Heise, Ursula K. "Encounters with the Thing Formerly Known as Nature." *Public Books*, September 9, 2013. http://www.publicbooks.org/multigenre/encounters-with-the -thing-formerly-known-as-nature.

———. *Imagining Extinction: The Cultural Meanings of Endangered Species.* Chicago: University of Chicago Press, 2016.

———. "Lost Dogs, Last Birds, and Listed Species: Cultures of Extinction." *Configurations* 18 (2010): 49–72.

———. "Science Fiction and the Time Scales of the Anthropocene." *ELH* 86, no. 2 (2019): 275–304.

———. *Sense of Place and Sense of Planet: The Environmental Imagination of the Global.* New York: Oxford University Press, 2008.

Herrnstein Smith, Barbara. *Scandalous Knowledge: Science, Truth, and the Human.* Durham, N.C.: Duke University Press, 2005.

Holmberg, David. "'In a Time Before Nomenclature Was and Each Was All': *Blood Meridian*'s Neomythic West and the Heterotopian Zone." *Western American Literature* 44, no. 2 (2009): 140–56.

Hoppe, Lynne, ed. *Audubon Annual Report 2013: Visualizing the Future of Conservation.* New York: National Audubon Society, 2013. http://www.audubon.org/sites /default/files/documents/2013_annual_report_low-res.pdf.

Horton, Zach. "Composing a Cosmic View: Three Alternatives for Thinking Scale in the Anthropocene." In *Scale in Literature and Culture*, ed. Michael Travel Clarke and David Wittenberg, 35–60. New York: Palgrave Macmillan, 2017.

Houser, Heather. "The Aesthetics of Environmental Visualizations: More than Information Ecstasy?" *Public Culture* 26, no. 2 (2014): 319–37.

———. *Ecosickness in Contemporary U.S. Fiction: Environment and Affect.* New York: Columbia University Press, 2014.

———. "Managing Information and Materiality in *Infinite Jest* and Running the Numbers." *American Literary History* 26, no. 4 (2014): 742–64.

Howe, Joshua P. *Behind the Curve: Science and the Politics of Global Warming.* Seattle: University of Washington Press, 2014.

Hulme, Mike. "How Climate Models Gain and Exercise Authority." In *The Social Life of Climate Change Models: Anticipating Nature*, ed. Kirsten Hastrup and Martin Skrydstrup, 30–44. New York: Routledge, 2013.

Intergovernmental Panel on Climate Change. "Annex I: Glossary." In *Global Warming of 1.5°C.* https://www.ipcc.ch/site/assets/uploads/sites/2/2019/06/SR15_AnnexI_ Glossary.pdf.

———. *Global Warming of 1.5°C. An IPCC Special Report on the Impacts of Global Warming of 1.5°C Above Pre-industrial Levels and Related Global Greenhouse Gas Emission Pathways, in the Context of Strengthening the Global Response to the Threat of Climate Change, Sustainable Development, and Efforts to Eradicate Poverty,* ed. V. Masson-Delmotte, P. Zhai, H. O. Pörtner, D. Roberts, J. Skea, P. R. Shukla, A. Pirani, et al. Geneva: IPCC, 2018.

———. "Summary for Policymakers." In *Global Warming of 1.5°C.* https://www.ipcc.ch /site/assets/uploads/sites/2/2019/05/SR15_SPM_version_report_LR.pdf.

Irmscher, Christoph. *The Poetics of Natural History: From John Bartram to William James.* New Brunswick, N.J.: Rutgers University Press, 1999.

IUCN. The IUCN Red List of Threatened Species. Version 2019-2, accessed November 15, 2019. http://www.iucnredlist.org.

——. "Summary Statistics." Version 2019-2, accessed November 15, 2019. https://www.iucnredlist.org/resources/summary-statistics.

Jacobson, Mark. "Nature Boy." *New York*, October 21, 2002. http://nymag.com/nymetro/arts/art/n_7839/.

James, Bryan. *In Pieces*. 2015. http://species-in-pieces.com/.

Janich, Peter. *What Is Information?* Trans. Eric Hayot and Lea Pao. Minneapolis: University of Minnesota Press, 2018.

Jasanoff, Sheila. "Image and Imagination: The Formation of Global Environmental Consciousness." In *Changing the Atmosphere: Expert Knowledge and Environmental Governance*, ed. Clark A. Miller and Paul N. Edwards, 309–37. Cambridge, Mass.: MIT Press, 2001.

Jasanoff, Sheila, and Marybeth Long Martello. "Heaven and Earth: The Politics of Environmental Images." In *Earthly Politics: Local and Global in Environmental Governance*, ed. Sheila Jasanoff, 31–52. Cambridge, Mass.: MIT Press, 2004.

Jay, Martin. *Downcast Eyes: The Denigration of Vision in Twentieth-Century French Thought*. Berkeley: University of California Press, 1993.

Kahan, Dan M., Donald Braman, Paul Slovic, John Gastil, and Geoffrey L. Cohen. "The Second National Risk and Culture Study: Making Sense of—and Making Progress in—the American Culture War of Fact." GWU Legal Studies Research Paper No. 370; Yale Law School, Public Law Working Paper No. 154; GWU Law School Public Law Research Paper No. 370; Harvard Law School Program on Risk Regulation Research Paper No. 08-26. October 3, 2007. http://dx.doi.org/10.2139/ssrn.1017189.

Kant, Immanuel. *Critique of Judgment*. Trans. J. H. Bernard. New York: Hafner, 1951.

Kaplan, Caren. *Aerial Aftermaths: Wartime from Above*. Durham, N.C.: Duke University Press, 2018.

Kingsolver, Barbara. *Flight Behavior*. New York: Harper Perennial, 2012.

Kirksey, Eben, Brandon Costelleo-Kuehn, and Dorion Sagan. "Life in the Age of Biotechnology." In *The Multispecies Salon*, ed. Eben Kirksey, 185–220. Durham, N.C.: Duke University Press, 2014.

Klein, Lauren F., and Miriam Posner. "Editor's Introduction: Data as Media." *Feminist Media Histories* 3, no. 3 (2017): 1–8.

Klein, Naomi. *The Shock Doctrine: The Rise of Disaster Capitalism*. New York: Picador, 2007.

Klinkenborg, Verlyn. *Timothy; or, Notes of an Abject Reptile*. New York: Vintage, 2006.

Knorr Cetina, Karin. *Epistemic Cultures: How the Sciences Make Knowledge*. Cambridge, Mass.: Harvard University Press, 1999.

Kolbert, Elizabeth. *Field Notes from a Catastrophe*. New York: Bloomsbury, 2009.

Kolodziejski, Lauren R. "*What Is Missing?* Reflections on the Human–Nature Relationship in Maya Lin's Final Memorial." *Environmental Communication* 9, no. 4 (2015): 428–45.

Kurgan, Laura. *Close Up at a Distance: Mapping, Technology, and Politics*. Brooklyn, N.Y.: Zone, 2013.

Lahsen, Myanna. "Seductive Simulations?: Uncertainty Distribution around Climate Models." *Social Studies of Science* 35, no. 6 (2005): 895–922.

Lanzendörfer, Tim. "Irreducible Complexity: The Ironies of Reif Larsen's *The Selected Works of T. S. Spivet.*" *Post45 Peer Reviewed*, October 2, 2014. http://post45.research .yale.edu/2014/10/irreducible-complexity-the-ironies-of-reif-larsens-the-selected -works-of-t-s-spivet/.

Larsen, Reif. *The Selected Works of T. S. Spivet.* New York: Penguin, 2009.

Latour, Bruno. "Drawing Things Together." In *Representation in Scientific Practice*, ed. Michael Lynch and Steve Woolgar, 19–68. Cambridge, Mass: MIT Press, 1990.

——. *Politics of Nature: How to Bring the Sciences into Democracy.* Trans. Catherine Porter. Cambridge, Mass.: Harvard University Press, 2004.

Ledford, Heidi. "World's Largest Plant Survey Reveals Alarming Extinction Rate." *Nature* 570, no. 7760 (2019): 148–49.

Lee, Maurice S. *Overwhelmed: Literature, Aesthetics, and the Nineteenth-Century Information Revolution.* Princeton, N.J.: Princeton University Press, 2019.

LeMenager, Stephanie. *Living Oil: Petroleum Culture in the American Century.* New York: Oxford University Press, 2014.

Lin, Maya. *What Is Missing?* 2010–. http://www.whatismissing.net/.

Lippard, Lucy R., Stephanie Smith, Andrew Revkin, Boulder Museum of Contemporary, Art, and EcoArts. *Weather Report: Art and Climate Change.* Boulder, Colo.: Boulder Museum of Contemporary Art, 2007.

Longino, Helen E. *The Fate of Knowledge.* Princeton, N.J.: Princeton University Press, 2002.

Looby, Christopher. "The Constitution of Nature: Taxonomy as Politics in Jefferson, Peale, and Bartram." *Early American Literature* 22, no. 3 (1987): 252–73.

Lorimer, Jamie. *Wildlife in the Anthropocene: Conservation After Nature.* Minneapolis: University of Minnesota Press, 2015.

Mann, Michael, Raymond S. Bradley, and Malcolm K. Hughes. "Northern Hemisphere Temperatures During the Past Millennium: Inferences, Uncertainties, and Limitations." *Geophysical Research Letters* 26 (1999): 759–62.

Manovich, Lev. "Database as Symbolic Form." In *Database Aesthetics: Art in the Age of Information Overflow*, 39–60. Minneapolis: University of Minnesota Press, 2007.

——. "Data Visualization as New Abstraction and as Anti-Sublime." In *Small Tech: The Culture of Digital Tools*, ed. David Hawk, David M. Rieder, and Ollie Oviedo, 3–9. Minneapolis: University of Minnesota Press, 2008.

——. *The Language of New Media.* Cambridge, Mass.: MIT Press, 2001.

Mao, Douglas. *Fateful Beauty: Aesthetic Environments, Juvenile Development, and Literature, 1860–1960.* Princeton, N.J.: Princeton University Press, 2008.

Margot Lovejoy, Christiane Paul, and Victoria Vesna, eds. *Context Providers: Conditions of Meaning in Media Arts.* Bristol, UK: Intellect, 2011.

Marinetti, F. T. "Initial Manifesto of Futurism." English translation published in *Le Figaro*, February 20, 1909.

Marris, Emma. *Rambunctious Garden: Saving Nature in a Post-Wild World.* New York: Bloomsbury, 2011.

Marshall, Kate. "How to Be an Alien: Ian Bogost's 'Alien Phenomenology, or, What It's Like to Be a Thing.'" *Los Angeles Review of Books*, November 19, 2013. https:// lareviewofbooks.org/article/how-to-be-an-alien.

——. "The Old Weird." *Modernism/Modernity* 23, no. 3 (2016): 631–49.

———. "What Are the Novels of the Anthropocene? American Fiction in Geological Time." *American Literary History* 27, no. 3 (2015): 523–38.

Marzec, Robert P. *Militarizing the Environment: Climate Change and the Security State.* Minneapolis: University of Minnesota Press, 2015.

McCarthy, Cormac. *Blood Meridian, or, the Evening Redness in the West.* New York: Vintage, 1985.

McClintock, Anne. "Too Big to See with the Naked Eye." *Guernica*, December 20, 2012. http://www.guernicamag.com/daily/anne-mcclintock-too-big-to-see-with-the -naked-eye/.

McGurl, Mark. "The New Cultural Geology." *Twentieth-Century Literature* 57, no. 3–4 (2011): 380–90.

McKibben, Bill. "Global Warming's Terrifying New Math." *Rolling Stone*, July 19, 2012. http://www.rollingstone.com/politics/news/global-warmings-terrifying-new -math-20120719.

Merchant, Carolyn. *The Death of Nature: Women, Ecology, and the Scientific Revolution.* San Francisco: Harper & Row, 1980.

Miller, Clark A., and Paul N. Edwards, eds. *Changing the Atmosphere: Expert Knowledge and Environmental Governance.* Cambridge, Mass.: MIT Press, 2001.

Minteer, Ben A. *The Fall of the Wild: Extinction, De-Extinction, and the Ethics of Conservation.* New York: Columbia University Press, 2019.

Mirzoeff, Nicholas. *The Right to Look: A Counterhistory of Visuality.* Durham, N.C.: Duke University Press, 2011.

Mitchell, Robert, and Philip Thurtle, eds. *Data Made Flesh: Embodying Information.* New York: Routledge, 2004.

Mizruchi, Susan L. *The Science of Sacrifice: American Realism and Modern Social Theory.* Princeton, N.J.: Princeton University Press, 1998.

Mogel, Lize, and Alexis Bhagat, eds. *An Atlas of Radical Cartography.* Los Angeles: Journal of Aesthetics & Protest Press, 2007.

Moretti, Franco. *The Way of the World: The Bildungsroman in European Culture.* New York: Verso, 1987.

Morgan, Mary S., and Margaret Morrison. "Models as Mediating Instruments." In *Models as Mediators: Perspectives on Natural and Social Science,* ed. Mary S. Morgan and Margaret Morrison, 10–37. New York: Cambridge University Press, 1999.

Mortimer-Sandilands, Catriona. "Melancholy Natures, Queer Ecologies." In *Queer Ecologies: Sex, Nature, Politics, Desire,* ed. Catriona Mortimer-Sandilands and Bruce Erickson, 331–58. Bloomington: Indiana University Press, 2010.

Morton, Timothy. "The Dark Ecology of Elegy." In *The Oxford Handbook of the Elegy,* ed. Karen Weisman. Oxford: Oxford University Press, 2010.

———. *Ecology Without Nature: Rethinking Environmental Aesthetics.* Cambridge, Mass.: Harvard University Press, 2007.

———. *Hyperobjects: Philosophy and Ecology After the End of the World.* Minneapolis: University of Minnesota Press, 2013.

Moser, Susanne C., and Lisa Dilling, eds. *Creating a Climate for Change: Communicating Climate Change and Facilitating Social Change.* Cambridge: Cambridge University Press, 2007.

Mukherjee, Pablo. "'Tomorrow There Will Be More of Us': Toxic Postcoloniality in *Animal's People.*" In *Postcolonial Ecologies: Literatures of the Environment,* ed.

Elizabeth DeLoughrey and George B. Handley, 216–31. New York: Oxford University Press, 2011.

Mukherjee, Upamanyu Pablo. *Postcolonial Environments: Nature, Culture and the Contemporary Indian Novel in English*. New York: Palgrave Macmillan, 2010.

National Audubon Society. "History of Audubon and Science-Based Bird Conservation." http://www.audubon.org/content/history-audubon-and-waterbird-conservation.

Natural History Museum. "About: The Natural History Museum." http://thenatural historymuseum.org/about/.

Nersessian, Anahid. "Literary Agnotology." *ELH* 84, no. 2 (2017): 339–60.

Ngai, Sianne. *Our Aesthetic Categories: Zany, Cute, Interesting*. Cambridge, Mass.: Harvard University Press, 2012.

——. *Ugly Feelings*. Cambridge, Mass.: Harvard University Press, 2005.

Nixon, Rob. "Environmental Martyrdom and Defenders of the Forest." Lecture presented at The University of Texas at Austin, October 21, 2016.

——. *Slow Violence and the Environmentalism of the Poor*. Cambridge, Mass.: Harvard University Press, 2011.

Nocke, Thomas. "Images for Data Analysis: The Role of Visualization in Climate Research Processes." In *Image Politics of Climate Change: Visualizations, Imaginations, Documentations*, ed. Thomas Nocke and Birgit Schneider, 55–77. New York: Columbia University Press, 2014.

Norgaard, Kari Marie. *Living in Denial: Climate Change, Emotions, and Everyday Life*. Cambridge, Mass.: MIT Press, 2011.

OED Online. S.v. "Caisson (*n*.)." Accessed November 18, 2019. http://www.oed.com /view/Entry/26095.

——. S.v. "Stoss (*adj*.)." Accessed November 18, 2019. http://www.oed.com/view/Entry /190990.

Ogilvie, Brian. *The Science of Describing: Natural History in Renaissance Europe*. Chicago: University of Chicago Press, 2008.

Oreskes, Naomi. "The Scientific Consensus on Climate Change: How Do We Know We're Not Wrong?" In *Climate Change: What It Means for Us, Our Children, and Our Grandchildren*, ed. Joseph F. C. DiMento and Pamela Doughman, 65–99. Cambridge, Mass.: MIT Press, 2007.

Oreskes, Naomi, and Erik Conway. *Merchants of Doubt: How a Handful of Scientists Obscured the Truth on Issues from Tobacco Smoke to Global Warming*. New York: Bloomsbury, 2010.

Overview Institute. "Declaration of Vision and Principles." 2018. http://www .overviewinstitute.org/about-us/declaration-of-vision-and-principles.

Palmer, Mark H. "Engaging with *Indigital* Geographic Information Networks." *Futures* 41 (2008): 33–40.

Pandey, Divya, Madhoolika Agrawal, and Jai Shanker Pandey. "Carbon Footprint: Current Methods of Estimation." *Environmental Monitoring and Assessment* 178, no. 1–4 (2011): 135–60.

Park, William. "The Ancient Peruvian Mystery Solved from Space." BBC Future. April 8, 2016. http://www.bbc.com/future/story/20160408-the-ancient-peruvian -mystery-solved-from-space.

Parks, Lisa. *Cultures in Orbit: Satellites and the Televisual*. Durham, N.C.: Duke University Press, 2005.

Parrish, Susan Scott. *American Curiosity: Cultures of Natural History in the Colonial British Atlantic World.* Chapel Hill: University of North Carolina Press, 2006.

Peach, Sara. "Interactive Graphics Illustrate Benefits of Visualizations on Climate Change Issues." *Yale Climate Connections,* September 22, 2011. http://www.yale climatemediaforum.org/2011/09/visualizations-on-climate-change-issues-2/.

Pearce, Margaret Wickens, and Renee Pualani Louis. "Mapping Indigenous Depth of Place." *American Indian Culture and Research Journal* 32, no. 3 (2008): 107–26.

Perec, Georges. "Think/Classify." Trans. John Sturrock. In *Species of Spaces and Other Pieces,* ed. John Sturrock, 188–205. New York: Penguin, 1999.

Perlman, Dan L., and Glenn Adelson. *Biodiversity: Exploring Values and Priorities in Conservation.* Malden, Mass.: Blackwell Science, 1997.

Perrow, Charles. *Normal Accidents: Living with High-Risk Technologies.* New York: Basic Books, 1984.

Peters, John Durham. "Information: Notes Toward a Critical History." *Journal of Communication Inquiry* 12, no. 2 (1988): 9–23.

Phillips, Dana. "History and the Ugly Facts of Cormac McCarthy's *Blood Meridian.*" *American Literature* 68, no. 2 (1996): 433–60.

Pickering, Andrew. *The Mangle of Practice: Time, Agency, and Science.* Chicago: University of Chicago Press, 1995.

Pickles, John. *A History of Spaces: Cartographic Reason, Mapping and the Geo-Coded World.* London: Routledge, 2004.

Plumwood, Val. *Feminism and the Mastery of Nature.* New York: Routledge, 1993.

Poovey, Mary. *A History of the Modern Fact: Problems of Knowledge in the Sciences of Wealth and Society.* Chicago: University of Chicago Press, 1998.

Pratt, Mary Louise. *Imperial Eyes: Travel Writing and Transculturation.* 1992. 2nd ed. New York: Routledge, 2008.

Proctor, Robert N. "Agnotology: A Missing Term to Describe the Cultural Production of Ignorance (and Its Study)." In *Agnotology: The Making and Unmaking of Ignorance,* ed. Londa Schiebinger and Robert N. Proctor, 1–33. Stanford: Stanford University Press, 2008.

Prosek, James. "The Failure of Names." *Orion,* March/April 2008, 46–53. https://orionmagazine.org/article/the-failure-of-names/.

"Public Sediment." Resilient by Design. 2018. http://www.resilientbayarea.org/public-sediment/.

Raley, Rita. *Tactical Media.* Minneapolis: University of Minnesota Press, 2009.

Ramade, Bénédicte. "Mark Dion: Curiosité Naturelle." *L'oeil* (March 2007): 72–75.

Richards, Thomas. *The Imperial Archive: Knowledge and the Fantasy of Empire.* New York: Verso, 1993.

Ritvo, Harriet. *The Platypus and the Mermaid and Other Figments of the Classifying Imagination.* Cambridge, Mass.: Harvard University Press, 1997.

Robbins, Bruce. *Feeling Global: Internationalism in Distress.* New York: New York University Press, 1999.

——. "The Sweatshop Sublime." *PMLA* 117, no. 1 (2002): 84–97.

Robin, Libby, and William Steffen. "History for the Anthropocene." *History Compass* 5, no. 5 (2007): 1694–1719.

Robinson, Kim Stanley. *New York 2140.* New York: Orbit, 2017. Kindle.

Rogowitz, Bernice E., and Lloyd A. Treinsh. "Data Visualization: The End of the Rainbow." *IEEE Spectrum* 35, no. 12 (1998): 52–59.

Ronda, Margaret. "Mourning and Melancholia in the Anthropocene." *Post45 Peer Reviewed*, June 10, 2013. http://post45.research.yale.edu/2013/06/mourning-and-melancholia-in-the-anthropocene/.

Rundstrom, Robert A. "GIS, Indigenous Peoples, and Epistemological Diversity." *Cartography and Geographic Information Systems* 22, no. 1 (1995): 45–57.

Rust, Stephen, Salma Monani, and Sean Cubitt, eds. *Ecomedia: Key Issues*. New York: Routledge, 2016.

Sachs, Aaron. *The Humboldt Current: Nineteenth-Century Exploration and the Roots of American Environmentalism*. New York: Penguin, 2006.

Saint-Amour, Paul. "Over Assemblage: *Ulysses* and the *Boîte-En-Valise* from Above." In *Cultural Studies of James Joyce*, ed. R. Brandon Kershner, 21–58. Amsterdam: Rodopi, 2003.

——. *Tense Future: Modernism, Total War, Encyclopedic Form*. New York: Oxford University Press, 2015.

Sakakibara, Chie. "People of the Whales: Climate Change and Cultural Resilience Among Iñupiat of Arctic Alaska." *Geographical Review* 107, no. 1 (January 2017): 159–84.

Samsel, Francesca, Mark Petersen, Terece Geld, Greg Abram, Joanne Wendelberger, and James Ahrens. "Colormaps That Improve Perception of High-Resolution Ocean Data." *CHI 2015—Extended Abstracts Publication of the 33rd Annual CHI Conference on Human Factors in Computing Systems: Crossings*, comp. Association for Computing Machinery, 703–10. New York: ACM, 2015.

Sandalow, David B. "Michael Crichton and Global Warming." Brookings Institution. January 28, 2005. http://www.brookings.edu/research/opinions/2005/01/28energy-sandalow.

Schiebinger, Londa. *Plants and Empire: Colonial Bioprospecting in the Atlantic World*. Cambridge, Mass.: Harvard University Press, 2004.

Schiebinger, Londa, and Robert N. Proctor, eds. *Agnotology: The Making and Unmaking of Ignorance*. Stanford: Stanford University Press, 2008.

Schmidt, Gavin. "Michael Crichton's State of Confusion." RealClimate. December 13, 2004. http://www.realclimate.org/index.php?p=74.

Schneider, Birgit. "Burning Worlds of Cartography: A Critical Approach to Climate Cosmograms of the Anthropocene." *Geo: Geography and Environment* 3, no. 2 (2016): 1–15.

——. "Climate Model Simulation Visualization from a Visual Studies Perspective." *Wiley Interdisciplinary Reviews: Climate Change* 2 (March/April 2012): 185–93.

——. "Image Politics: Picturing Uncertainty. The Role of Images in Climatology and Climate Policy." In *Climate Change and Policy: The Calculability of Climate Change and the Challenge of Uncertainty*, ed. Gabriele Gramelsberger and Johann Feichter, 191–209. Berlin: Springer-Verlag, 2011.

Schrader, Paul, dir. *First Reformed*. New York: A24, 2017. Amazon Video. https://www.amazon.com/First-Reformed-Ethan-Hawke/dp/B07D6V7MRJ.

Scott, James C. *Seeing Like a State: How Certain Schemes to Improve the Human Condition Have Failed*. New Haven, Conn.: Yale University Press, 1998.

Segal, Michael. "The Missing Climate Change Narrative." *South Atlantic Quarterly* 116, no. 1 (2017): 121–28.

"Senate Dems Stage Landmark Filibuster for Climate Action; Scant Mention of Keystone Decision." *Democracy Now*, March 11, 2014. http://www.democracynow.org /2014/3/11/headlines.

Seymour, Nicole. *Bad Environmentalism: Irony and Irreverence in the Ecological Age*. Minneapolis: University of Minnesota Press, 2018.

Shackley, Simon. "Epistemic Lifestyles in Climate Change Modeling." In *Changing the Atmosphere: Expert Knowledge and Environmental Governance*, ed. Clark A. Miller and Paul N. Edwards, 107–33. Cambridge, Mass.: MIT Press, 2001.

Shannon, Claude E., and Warren Weaver. *The Mathematical Theory of Communication*. 1949. Urbana: University of Illinois Press, 1971.

Sharpe, Christina. *In the Wake: On Blackness and Being*. Durham, N.C.: Duke University Press, 2016.

Sheikh, Fazal. *Desert Bloom*. Vol. 3 of *The Erasure Trilogy*. Göttingen, Ger.: Steidl, 2015.

Sinha, Indra. *Animal's People*. New York: Simon & Schuster, 2007.

Sinykin, Dan. "Evening in America: *Blood Meridian* and the Origins and Ends of Imperial Capitalism." *American Literary History* 28, no. 2 (2016): 362–80.

SkyTruth. "About SkyTruth: History." 2016. https://www.skytruth.org/about/.

Slovic, Paul, and Scott Slovic, eds. *Numbers and Nerves: Information, Emotion, and Meaning in a World of Data*. Corvallis: Oregon State University Press, 2015.

Slovic, Scott. "Science, Eloquence, and the Asymmetry of Trust: What's at Stake in Climate Change." In *Numbers and Nerves: Information, Emotion, and Meaning in a World of Data*, ed. Paul Slovic and Scott Slovic, 115–35. Corvallis: Oregon State University Press, 2015.

Smith, Joel B., Stephen H. Schneider, Michael Oppenheimer, Gary W. Yohe, William Hare, Michael D. Mastrandrea, Anand Patwardhan, et al. "Assessing Dangerous Climate Change Through an Update of the Intergovernmental Panel on Climate Change (IPCC) 'Reasons for Concern.'" *Proceedings of the National Academy of Sciences* 106, no. 11 (2009): 4133–37.

Smith, Philip, and Nicolas Howe. *Climate Change as Social Drama: Global Warming in the Public Sphere*. New York: Cambridge University Press, 2015.

Smithson, Michael. "Social Theories of Ignorance." In *Agnotology: The Making and Unmaking of Ignorance*, ed. Londa Schiebinger and Robert N. Proctor, 209–29. Stanford: Stanford University Press, 2008.

Solnit, Rebecca. *The Faraway Nearby*. New York: Penguin, 2013.

Spacks, Patricia Meyer. *The Adolescent Idea: Myths of Youth and the Adult Imagination*. New York: Basic Books, 1981.

Spahr, Juliana. *well then there now*. Boston: Black Sparrow, 2011.

Spoerri, Daniel. *An Anecdoted Topography of Chance (Re-Anecdoted Version)*. Trans. Emmett Williams. New York: Something Else, 1966.

Squier, Susan M. *Epigenetic Landscapes: Drawings as Metaphor*. Durham, N.C.: Duke University Press, 2017.

Stafford, Barbara Maria. *Artful Science: Enlightenment Entertainment and the Eclipse of Visual Education*. Cambridge, Mass.: MIT Press, 1994.

———. *Good Looking: Essays on the Virtue of Images.* Cambridge, Mass.: MIT Press, 1996.

Star, Susan Leigh, and James R. Griesemer. "Institutional Ecology, 'Translations' and Boundary Objects: Amateurs and Professionals in Berkeley's Museum of Vertebrate Zoology, 1907–39." *Social Studies of Science* 19, no. 3 (1989): 387–420.

Stegner, Wallace. *Beyond the Hundredth Meridian: John Wesley Powell and the Second Opening of the West.* Boston: Houghton Mifflin, 1954. Reprint, New York: Penguin, 1992.

Stephens, Paul. *The Poetics of Information Overload: From Gertrude Stein to Conceptual Writing.* Minneapolis: University of Minnesota Press, 2015.

Sternfeld, Joel. "Artist's Statement: *When It Changed.*" Prix Pictet. Accessed August 14, 2019. http://www.prixpictet.com/portfolios/power-shortlist/joel-sternfeld/statement/.

———. *When It Changed.* Göttingen, Ger.: Steidl, 2008.

Stewart, Susan. *On Longing: Narratives of the Miniature, the Gigantic, the Souvenir, the Collection.* Baltimore: Johns Hopkins University Press, 1984. Reprint, Durham, N.C.: Duke University Press, 1993.

Stoekl, Allan. "'After the Sublime,' After the Apocalypse: Two Versions of Sustainability in Light of Climate Change." *Diacritics* 41, no. 3 (2013): 40–57.

Sunstein, Cass R. *Infotopia: How Many Minds Produce Knowledge.* New York: Oxford University Press, 2006.

Thomas, Julia Adeney. "History and Biology in the Anthropocene: Problems of Scale, Problems of Value." *American Historical Review* 119 (2014): 1587–607.

Thompson, Nato, ed. *Experimental Geography: Radical Approaches to Landscape, Cartography, and Urbanism.* Brooklyn, N.Y.; New York: Melville House; Independent Curators International, 2009.

Tissue Culture & Art Project, The. *NoArk.* 2007. https://tcaproject.net/portfolio/noark/.

Trexler, Adam. *Anthropocene Fictions: The Novel in a Time of Climate Change.* Charlottesville: University of Virginia Press, 2015.

Tsing, Anna Lowenhaupt. "Blasted Landscapes (and the Gentle Arts of Mushroom Picking)." In *The Multispecies Salon*, ed. Eben Kirksey, 87–109. Durham, N.C.: Duke University Press, 2014.

Tsitas, Evelyn. "Tissue Culture and Art Project." RMIT University. https://www.rmit.edu.au/about/our-locations-and-facilities/facilities/exhibition-spaces/rmit-gallery/news-and-media-releases/2009/november/tissue-culture-and-art-project.

Tuana, Nancy. "Coming to Understand: Orgasm and the Epistemology of Ignorance." In *Agnotology: The Making and Unmaking of Ignorance*, ed. Londa Schiebinger and Robert N. Proctor, 108–45. Stanford: Stanford University Press, 2008.

Turnbull, David. *Masons, Tricksters and Cartographers: Comparative Studies in the Sociology of Scientific and Indigenous Knowledge.* Amsterdam: Harwood Academic, 2000.

Turnbull, David, and Helen Watson. *Maps Are Territories: Science Is an Atlas.* Chicago: University of Chicago Press, 1993.

Turner, James Morton. "Counting Carbon: The Politics of Carbon Footprints and Climate Governance from the Individual to the Global." *Global Environmental Politics* 14, no. 1 (2014): 59–78.

VanderMeer, Jeff. *The Strange Bird.* New York: Farrar, Straus and Giroux, 2017.

Van Vleck, Jenifer. *Empire of the Air: Aviation and the American Ascendency*. Cambridge, Mass.: Harvard University Press, 2013.

Vesna, Victoria, ed. *Database Aesthetics: Art in the Age of Information Overflow*. Minneapolis: University of Minnesota Press, 2007.

Virilio, Paul. *War and Cinema: The Logistics of Perception*. Trans. Patrick Camiller. 1984. London: Verso, 1989.

Vollmann, William T. *No Immediate Danger*. Vol. 1 of *Carbon Ideologies*. New York: Penguin, 2018. Nook.

Wallace, David Foster. "Introduction: Deciderization 2007—Special Report." In *The Best American Essays 2007*, ed. David Foster Wallace, xii–xxiv. Boston: Houghton Mifflin, 2007.

Wallace-Wells, David. *The Uninhabitable Earth: Life After Warming*. New York: Tim Duggan, 2019. Kindle.

Watkins, Claire Vaye. *Gold Fame Citrus*. New York: Riverhead, 2015.

Weart, Spencer R. "The Development of General Circulation Models of Climate." *Studies in History and Philosophy of Modern Physics* 41, no. 3 (2010): 208–17.

——. *The Discovery of Global Warming*. Cambridge, Mass.: Harvard University Press, 2008.

Weizman, Eyal. *Forensic Architecture: Violence at the Threshold of Detectability*. New York: Zone, 2017.

——. "Politics of Verticality." *openDemocracy*. April 23, 2002. https://www.opendemocracy.net/ecology-politicsverticality/article_801.jsp/.

Weizman, Eyal, and Fazal Sheikh. *The Conflict Shoreline: Colonization as Climate Change in the Negev Desert*. Göttingen, Ger.: Steidl, 2015.

Weizman, Eyal, and Ines Weizman. *Before and After: Documenting the Architecture of Disaster*. Moscow: Strelka, 2014. Kindle.

Wheeler, Quentin D. "Introductory: Toward the New Taxonomy." In *The New Taxonomy*, ed. Quentin D. Wheeler. Boca Raton, Fla.: CRC, 2008.

Whitehead, Colson. *Zone One*. New York: Anchor, 2011.

Whiteman, Maria. "Taxonomia: A Photo Essay." *Minnesota Review* 78 (N.S.) (2012): 53–61.

Whyte, Kyle. "Indigenous Climate Change Studies: Indigenizing Futures, Decolonizing the Anthropocene." *English Language Notes* 55, no. 1–2 (2017): 153–62.

Wiedmann, Thomas, and Jan Minx. "A Definition of 'Carbon Footprint.'" In *Ecological Economics Research Trends*, ed. Carolyn C. Pertsova, 1–11. New York: Nova Science, 2007.

Wikipedia. S.v. "Parrotfish." Last modified July 10, 2019. https://en.wikipedia.org/wiki/Parrotfish.

Wilson, Jamie. "Novel Take on Global Warming." *Guardian*, September 29, 2005. https://www.theguardian.com/environment/2005/sep/29/comment.bookscomment.

Wilson, Stephen. *Information Arts: Intersections of Art, Science, and Technology*. Cambridge, Mass.: MIT Press, 2002.

Wohlforth, Charles. *The Whale and the Supercomputer: On the Northern Front of Climate Change*. New York: North Point, 2004.

Wolfe, Cary. *Before the Law: Humans and Other Animals in a Biopolitical Frame*. Chicago: University of Chicago Press, 2012.

Wood, Denis. *Rethinking the Power of Maps*. New York: Guilford, 2010.

Woods, Derek. "Accelerated Reading: Fossil Fuels, Infowhelm, and Archival Life." In *Anthropocene Reading: Literary History in Geologic Times*, ed. Tobias Menely and Jesse Oak Taylor, 202–19. University Park: Pennsylvania State University Press, 2017.

Woolf, Virginia. "Flying Over London." In *The Captain's Death Bed and Other Essays*, 186–92. London: Hogarth, 1950.

Wright, Alex. *Glut: Mastering Information Through the Ages*. Washington, D.C.: Joseph Henry, 2007.

Youatt, Rafi. *Counting Species: Biodiversity in Global Environmental Politics*. Minneapolis: University of Minnesota Press, 2015.

Yusoff, Kathryn. *A Billion Black Anthropocenes or None*. Minneapolis: University of Minnesota Press, 2018. Kindle.

Ziser, Michael, and Julie Sze. "Climate Change, Environmental Aesthetics, and Global Environmental Justice Cultural Studies." *Discourse* 29, no. 2–3 (2007): 384–410.

INDEX

Evidence, for natural history, 98–100
Evolution, 98–99, 152–53
Experience, 123, 158, 164–65, 178, 195; aesthetic strategies and, 26, 47; data and, 4, 23, 27–32, 42–43, 49, 55, 58, 60–63, 89, 92, 95, 164; in epistemology, 67–69, 82–85; information and, 16–17, 21, 24–26
Expertise, 35, 41, 71, 75–76, 88–91
Exploration, 118–19
Extinction, 53, 72, 228, 246, 249, 275n6; climate crisis and, 14, 24, 53, 72, 165, 171, 228; data of, 163, 166–67; epistemology of, 146; of humanity, 103; from hunting, 76–77; morality of, 113–14; in new natural history, 138, 146, 152–53, 160, 167; in poetry, 95, 97–98; visualizations of, 160, 163–67
Extractivism, 11, 17, 109, 113–15, 125, 128, 134, 177, 181, 184, 191–200, 197, 203, 206
Exxon Valdez oil spill, 187–88

Falsified cultural memory, 117–19
Farber, Paul, 99
Feelings, 28, 42–44, 68, 70; art and, 121, 126, 199, 237; around climate change, 22; emotions and, 24–25; of loss, 134, 157; visualizations and, 152, 154. See also Emotions
Feminist epistemology, 5–6, 9–11, 62–64
Fertility, 132
Fiction. See Climate fiction; specific fiction
Figuration, 33–38
Film. See specific films
First Reformed (Schrader), 2–5, 11, 31–32, 251–52
Flight Behavior (Kingsolver), 5–6, 12, 27, 62–75, 87, 250; analogies in, 65–75, 81–82, 89; metaphors in, 63–64; positivism in, 77–78
Floods, 64–65
"Flying Over London" (Woolf), 245–47
Footprint calculators, 54–60, 57
Ford, Walton, 137
Fossil fuels, 50–51, 56, 59. See also Crude oil; Extractivism

Foucault, Michel, 11, 67, 99–100, 155
Four Panels (Kelly), 202
Fragmentation, 8, 129, 131, 152–53, 155, 157, 167, 171

Gabrys, Jennifer, 148, 194, 200, 263n25, 283n9
Galison, Peter, 41, 117, 119, 265n42
General circulation models (GCMs), 35–36, 38, 79–80, 267n14
Geographic information systems (GIS), 148, 177–79, 181
Geophysical collapse, 176
Geophysical Fluid Dynamics Laboratory (GFDL), 38, 40, 43–49, 252. See also "Anomalies"
George, John Craighead, 76–77, 84
GFDL. See Geophysical Fluid Dynamics Laboratory
GFN. See Global Footprint Network
GHG emissions. See Greenhouse gas emissions
GIS. See Geographic information systems
Global deforestation, 161–62
Global Footprint Network (GFN), 14, 56–60, 57
Globalization, 288n27
Global North, 25, 30–31, 33, 85
Global Positioning System (GPS), 181, 203, 204–5, 206, 230
Global warming, 28–29, 74–75, 88, 89–92, 90
Goddard Space Flight Center, 38
God's-eye view. See Aerial perspectives
Gold Fame Citrus (Watkins), 5–6, 222, 235–39, 242, 247–48
Goodman, Nelson, 208
Google, 69; Earth, 181, 194; Maps, 50, 181, 193
Government, 16–17, 32, 88, 96, 184, 206, 219, 235, 240, 254, 271n88
GPS. See Global Positioning System
Grant, Benjamin, 191
Graphical objects, 33–34
Greenhouse gas (GHG) emissions, 50–53, 55–56, 59, 60, 85–86, 88–89, 91

INDEX

Whyte, Kyle Powys, 9

Wohlforth, Charles, 10, 27, 62–63, 252. *See also Whale and the Supercomputer*

Woolf, Virginia, 245–47

World War II, 9, 21

World Wildlife Fund (WWF), 48

Yusoff, Kathryn, 100, 137

Ziemlinski, Remik, 39–40, *40*. *See also* "Anomalies"

Zionism, 212

Zombification, 220–21, 231–32

Zone One (Whitehead), 220–22, 228–29, 232

Zoology, 99, 130–31, 143

Zurr, Ionat, 167, *168*, 169–70. *See also* Tissue Culture & Art Project